DAVID BUSCH'S SONY α A5000/ILCE-5000

GUIDE TO DIGITAL PHOTOGRAPHY

David D. Busch

Cengage Learning PTR

Professional • Technical • Reference

Australia, Brazil, Japan, Korea, Mexico, Singapore, Spain, United Kingdom, United States

Professional • Technical • Reference

David Busch's Sony® Alpha a5000/ILCE-5000 Guide to Digital Photography
David D. Busch

Publisher and General Manager, Cengage Learning PTR:
Stacy L. Hiquet

Associate Director of Marketing:
Sarah Panella

Manager of Editorial Services:
Heather Talbot

Product Team Manager:
Kevin Harreld

Project Editor:
Jenny Davidson

Series Technical Editor:
Michael D. Sullivan

Interior Layout Tech:
Bill Hartman

Cover Designer:
Mike Tanamachi

Indexer:
Katherine Stimson

Proofreader:
Sara Gullion

© 2015 David D. Busch

CENGAGE and CENGAGE LEARNING are registered trademarks of Cengage Learning, Inc., within the United States and certain other jurisdictions.

ALL RIGHTS RESERVED. No part of this work covered by the copyright herein may be reproduced, transmitted, stored, or used in any form or by any means graphic, electronic, or mechanical, including but not limited to photocopying, recording, scanning, digitizing, taping, Web distribution, information networks, or information storage and retrieval systems, except as permitted under Section 107 or 108 of the 1976 United States Copyright Act, without the prior written permission of the publisher.

> For product information and technology assistance, contact us at
> **Cengage Learning Customer & Sales Support, 1-800-354-9706**
>
> For permission to use material from this text or product, submit all requests online at **cengage.com/permissions**
> Further permissions questions can be emailed to
> **permissionrequest@cengage.com**

Sony is a registered trademark of Sony Corporation. All other trademarks are the property of their respective owners.

All images © David D. Busch unless otherwise noted.

Library of Congress Control Number: 2014949530

ISBN-13: 978-1-305-27197-5

ISBN-10: 1-305-27197-1

Cengage Learning PTR
20 Channel Center Street
Boston, MA 02210
USA

Cengage Learning is a leading provider of customized learning solutions with office locations around the globe, including Singapore, the United Kingdom, Australia, Mexico, Brazil, and Japan. Locate your local office at: **international.cengage.com/region**

Cengage Learning products are represented in Canada by Nelson Education, Ltd.

For your lifelong learning solutions, visit **cengageptr.com**

Visit our corporate website at **cengage.com**

Printed in Canada
1 2 3 4 5 6 7 16 15 14

For Cathy

Acknowledgments

Once again thanks to the folks at Cengage Learning PTR, who have pioneered publishing digital imaging books in full color at a price anyone can afford. Special thanks to product team manager Kevin Harreld, who always gives me the freedom to let my imagination run free with a topic, as well as my veteran production team, including project editor, Jenny Davidson, and series technical editor, Mike Sullivan. Also thanks to Bill Hartman, layout; Katherine Stimson, indexing; Sara Gullion, proofreading; Mike Tanamachi, cover design; and my agent, Carole Jelen, who has the amazing ability to keep both publishers and authors happy.

Also, big thanks to the folks at Campus Camera (www.campuscamera.net), who obtained a Sony a5000 for me when even Sony had none to provide. Their help made it possible for me to be using this great camera and putting together this book while most Sonyphiles were still waiting for delivery.

Thanks again to master photographer Nancy Balluck (www.nancyballuckphotography.com) for the back cover photo of yours truly.

About the Author

With more than two million books in print, **David D. Busch** is the #1 bestselling camera guide author, and the originator of popular series like *David Busch's Pro Secrets, David Busch's Compact Field Guides,* and *David Busch's Quick Snap Guides*. He has written more than 50 hugely successful guidebooks for Sony and other digital camera models, including the all-time #1 bestsellers for several different cameras, additional user guides for other camera models, as well as many popular books devoted to dSLRs, including *Mastering Digital SLR Photography, Fourth Edition* and *Digital SLR Pro Secrets*. As a roving photojournalist for more than 20 years, he illustrated his books, magazine articles, and newspaper reports with award-winning images. He's operated his own commercial studio, suffocated in formal dress while shooting weddings-for-hire, and shot sports for a daily newspaper and upstate New York college. His photos have been published in magazines as diverse as *Scientific American* and *Petersen's PhotoGraphic*, and his articles have appeared in *Popular Photography, Rangefinder, Professional Photographer*, and hundreds of other publications. He's also reviewed dozens of digital cameras for CNet Networks and CBS Interactive publications.

When About.com named its top five books on Beginning Digital Photography, debuting at the #1 and #2 slots were Busch's *Digital Photography All-In-One Desk Reference for Dummies* and *Mastering Digital Photography*. In 2013, he had as many as 18 books listed in the Top 100 of Amazon.com's Digital Photography Bestseller list—simultaneously! Busch's 200-plus other books published since 1983 include bestsellers like *David Busch's Quick Snap Guide to Using Digital SLR Lenses*.

Busch is a member of the Cleveland Photographic Society (www.clevelandphoto.org), which has operated continuously since 1887. Visit his website at http://www.dslrguides.com/blog.

Contents

Preface ... xiii

Introduction .. xv

Chapter 1
Getting Started with Your Sony a5000 1

Your Out-of-Box Experience ... 3
Initial Setup ... 6
 Battery Included ... 6
 Final Steps .. 7
 Formatting a Memory Card .. 10
Selecting a Shooting Mode ... 13
Choosing a Metering Mode ... 17
Choosing a Focus Mode .. 17
Selecting a Focus Area .. 18
Other Settings .. 19
 Adjusting White Balance and ISO .. 19
 Using the Self-Timer ... 19
 Using the a5000's Flash .. 20
An Introduction to Movie Making ... 21
Reviewing the Images You've Taken .. 22
Transferring Files to Your Computer .. 24

Chapter 2
Sony a5000 Roadmap 27

Front View..28
The Sony a5000's Business End......................................32
LCD Panel Data Displays..36
Going Topside..40
Underneath Your Sony a5000..41

Chapter 3
Camera Settings and Custom Settings Menus 43

Anatomy of the Menus..44
Camera Settings Menu..46
 Shoot Mode...47
 Image Size...47
 Aspect Ratio..48
 Quality...49
 Panorama: Size..52
 Panorama: Direction...53
 File Format...54
 Record Setting..54
 Drive Mode..55
 Flash Mode..56
 Flash Compensation..57
 Red Eye Reduction...57
 Focus Mode...58
 Focus Area..59
 AF Illuminator...60
 Exposure Compensation.......................................60
 ISO...60
 Metering Mode..61
 White Balance...61
 DRO/Auto HDR...64
 Creative Style..65
 Picture Effect..65

Focus Magnifier .69
High ISO Noise Reduction. .71
Lock-on AF .72
Smile/Face Detect. .72
Soft Skin Effect. .74
Auto Object Framing .74
SteadyShot .74
Color Space .75
Auto Slow Shutter .77
Audio Recording .77
Wind Noise Reduction .77
Shooting Tip List .78

Custom Settings Menu .78
Zebra .78
MF Assist .79
Focus Magnifier Time .80
Grid Line .80
Auto Review .80
DISP Button .81
Peaking Level .83
Peaking Color .83
Exposure Settings Guide. .84
Live View Display .85
Pre-AF .85
Zoom Setting .86
Release w/o Lens .88
AEL w/Shutter .88
Self-Portrait/ -Timer .89
Superior Auto Image Extract .90
Face Registration .90
Custom Key Settings .90
MOVIE Button .92
AF Micro Adjustment .93
Lens Compensation .93

Chapter 4
Application, Playback, and Setup Menus 95

Application Menu . 95
 Application List . 96
 Introduction . 96
Playback Menu . 99
 Delete. 99
 View Mode. 100
 Image Index . 100
 Display Rotation . 101
 Slide Show . 102
 Rotate . 102
 Enlarge Image . 102
 4K Still Image Playback . 102
 Protect . 103
 Specify Printing . 104
Setup Menu . 104
 Monitor Brightness . 104
 Volume Settings . 106
 Audio Signals . 106
 Tile Menu. 106
 Upload Settings . 107
 Delete Confirm. 107
 Power Save Start Time . 107
 Demo Mode. 107
 HDMI Resolution . 109
 CTRL for HDMI . 109
 USB Connection . 109
 USB LUN Setting . 110
 Language . 110
 Date/Time Setup. 111
 Area Setting . 111
 Format . 111
 File Number. 112
 Select REC Folder . 113

New Folder . 113
Folder Name . 113
Recover Image Database . 114
Display Media Information . 115
Version. 115
Setting Reset. 116

Chapter 5
Shooting Modes and Exposure Control 117

Getting a Handle on Exposure. 118
 Equivalent Exposure . 122
How the a5000 Calculates Exposure . 123
 Correctly Exposed . 123
 Overexposed . 124
 Underexposed . 125
 Metering Mid-Tones. 125
The Importance of ISO. 126
Choosing a Metering Method . 127
Choosing an Exposure Mode. 131
 Aperture Priority (A) Mode . 131
 Shutter Priority (S) Mode . 133
 Program Auto (P) Mode. 134
 Making Exposure Value Changes. 135
 Manual Exposure (M) Mode . 135
Exposure Bracketing . 138
Dealing with Digital Noise. 140
 High ISO Noise . 141
Exposure Evaluation with Histograms . 143
 The Live Histogram . 143
 The Playback Histograms. 144
 Histogram Interpretation . 145
Automatic and Specialized Shooting Modes. 147
 Auto and Scene Modes. 148
 Sweep Panorama Mode . 151

Chapter 6
Mastering the Autofocus Options — 153

Getting into Focus .. 153
 Focus Modes and Options .. 156
Focus Pocus ... 157
 Adding Circles of Confusion 158
 Making Sense of Sensors and AF Points 159
 Using Manual Focus ... 161
 Your Autofocus Mode Options 162
 Setting the AF Area .. 164
Useful Menu Items for AF .. 168
 Auto Object Framing .. 169
 AF Lock .. 171
 Focus Stacking ... 172

Chapter 7
Advanced Shooting — 175

Exploring Ultra-Fast Exposures 176
Long Exposures .. 179
 Working with Long Exposures 181
Delayed Exposures ... 185
Continuous Shooting ... 185
Setting Image Parameters .. 189
 Customizing White Balance 190
 Fine-Tuning Preset White Balance 193
 Setting White Balance by Color Temperature 194
 Setting a Custom White Balance 194
Image Processing .. 195
 D-Range Optimizer and In-Camera HDR 195
 Creating HDR Photos in Post-Processing 198
 Using Creative Styles .. 202

Chapter 8
Movie Making — 205

- Some Fundamentals 205
- Preparing to Shoot Video 207
 - More About Frame Rates and Formats 211
 - Steps During Movie Making 212
- Tips for Shooting Better Video 214
 - Keep Things Stable and on the Level 215
 - Shooting Script 215
 - Storyboards 215
 - Storytelling in Video 215
 - Composition 217
 - Lighting for Video 220
 - Audio 223
 - Lens Craft 224

Chapter 9
Working with Lenses — 227

- Don't Forget the Crop Factor 228
- Choosing a Lens 230
 - Sony's Carl Zeiss E-Mount Lenses 233
 - Using the LA-EA Series Adapters 234
 - Other Lens Options 237
 - Using the Lensbaby 239
- What Lenses Can Do for You 242
- Categories of Lenses 245
- Using Wide-Angle Lenses 245
 - Avoiding Potential Wide-Angle Problems 248
- Using Telephoto and Tele-Zoom Lenses 250
 - Avoiding Telephoto Lens Problems 252
 - Telephotos and Bokeh 253
- Fine-Tuning the Focus of Your Lenses 254
 - Lens Tune-Up 255
 - SteadyShot and Your Lenses 260

Chapter 10
Making Light Work for You — 263

Continuous Illumination versus Electronic Flash . 264
Continuous Lighting Basics . 269
 Daylight . 270
 Incandescent/Tungsten Light . 271
 Fluorescent Light/Other Light Sources . 272
 Adjusting White Balance . 273
Electronic Flash Basics . 273
 How Electronic Flash Works . 274
 Flash Exposure Compensation . 276
 Red Eye Reduction . 276

Chapter 11
Using Wi-Fi — 277

Making a Wi-Fi Connection . 277
 Using WPS Push . 278
 Registering Manually . 278
 Wi-Fi Settings . 282
Wi-Fi Functions . 282
 Sending Photos to a Smart Device . 283
 Wi-Fi Transfer to a Computer . 283
 Viewing Images on a TV . 285
 Downloading Apps to Your a5000 . 286
 Current Sony Apps . 288
 Near Field Communications (NFC) . 291

Index — 293

Preface

No wonder you're excited about the new Sony a5000/ILCE-5000 camera! You don't expect to take good pictures with such a camera—you demand *outstanding* photos. This camera is the mid-level model of Sony's Alpha E-mount product line combining a tiny, mirrorless body with the same large 20-megapixel sensor found in bulky digital "mirrored" models (like Sony's own SLT lines), interchangeable lenses, and the kind of full control over settings and features that serious photographers demand.

But your gateway to pixel proficiency is dragged down by the slim little book included in the box as a manual. You know everything you need to know is in there, somewhere, but you don't know where to start. In addition, the camera manual doesn't offer much information on photography or digital photography. Nor are you interested in spending hours or days studying a comprehensive book on digital photography that doesn't necessarily apply directly to your Alpha a5000/ILCE-5000.

What you need is a guide that explains the purpose and function of the Alpha's basic controls, how you should use them, and *why*. Ideally, there should be information about file formats, resolution, exposure, and special autofocus modes available, but you'd prefer to read about those topics only after you've had the chance to go out and take a few hundred great pictures with your new camera. Why isn't there a book that summarizes the most important information in its first two or three chapters, with lots of full-color illustrations showing what your results will look like when you use this setting or that?

Now there is such a book. If you want a quick introduction to the Alpha's focus controls, flash synchronization options, how to choose lenses, or which exposure modes are best, this book is for you. If you can't decide on what basic settings to use with your camera because you can't figure out how changing ISO or white balance or focus defaults will affect your pictures, you need this guide.

Introduction

Sony doesn't play it safe. Sony doesn't stick to the old digital camera paradigms and technology. At a time when the top dogs in the digital camera world are still mired in the race to produce the best digital SLRs, Sony has concentrated on non-dSLR cameras, including mirrorless models like the Sony Alpha a5000/ILCE-5000. (For simplicity, I'll generally refer to this camera as the a5000 throughout the book.)

This camera is part of a wave of new cameras that replace the entire NEX product line, and includes (so far) models dubbed, in the USA, a3000, a5000, and a6000. Sony has packaged up the most alluring features of advanced digital SLRs and stuffed them into a compact, highly affordable body, which boasts some features you won't find on other cameras. The a5000/ILCE-5000 boasts a body that is, minus your choice of lens, more compact than any digital SLR. But, tucked inside is a large 20-megapixel sensor with the same size, light gathering power, and resolution of those found in the typical digital SLR. Add in the ability to use an expanding roster of interchangeable E-mount lenses and a reasonably affordable price tag, and you have a compact camera that sacrifices nothing in terms of features and capabilities. The original products in the Alpha lineup were great, and the new camera is even better. Indeed, this shooter has many of the advanced features of the top-of-the-line Alpha 7/7r!

You'll find your new camera is loaded with facilities that few would have expected to find in such a basic camera. Indeed, the Alpha retains the ease of use that smoothes the transition for those new to digital photography. For those just dipping their toes into the digital pond, the experience is warm and inviting. The Sony Alpha a5000 isn't a snapshot camera—it is a point-and-shoot (if you want to use it in that mode) for the thinking photographer.

But once you've confirmed that you made a wise purchase, the question comes up, *how do I use this thing?* All those cool features can be mind-numbing to learn, if all you have as a guide is the manual furnished with the camera. Help is on the way. I sincerely believe that this book is your best bet for learning how to use your new camera, and for learning how to use it well.

If you're a Sony a5000 owner who's looking to learn more about how to use your camera, you've probably already explored your options. There are DVDs and online tutorials—but who can learn how to use a camera by sitting in front of a television or computer screen? Do you want to watch a movie or click on HTML links, or do you want to go out and take photos with your camera? Videos are fun, but not the best answer.

There's always the manual furnished with the a5000. It's compact and filled with information, but there's really very little about *why* you should use particular settings or features, and its organization may make it difficult to find what you need. Multiple cross-references may send you flipping back and forth between two or three sections of the book to find what you want to know. The basic manual is also hobbled by black-and-white line drawings and tiny monochrome pictures that aren't very good examples of what you can do.

Also available are third-party guides to the Alpha, like this one. I haven't been happy with some of these guidebooks, which is why I wrote this one. The existing books range from skimpy and illustrated with black-and-white photos to lushly illustrated in full color but too generic to do much good. Photography instruction is useful, but it needs to be related directly to the Sony Alpha as much as possible.

I've tried to make *David Busch's Sony Alpha a5000/ILCE-5000 Guide to Digital Photography* different from your other Alpha learn-up options. The roadmap sections use larger, color pictures to show you where all the buttons and dials are, and the explanations of what they do are longer and more comprehensive. I've tried to avoid overly general advice, including the two-page checklists on how to take a "sports picture" or a "portrait picture" or a "travel picture." Instead, you'll find tips and techniques for using all the features of your Sony Alpha to take *any kind of picture* you want. If you want to know where you should stand to take a picture of a quarterback dropping back to unleash a pass, there are plenty of books that will tell you that. This one concentrates on teaching you how to select the best autofocus mode, shutter speed, f/stop, or flash capability to take, say, a great sports picture under any conditions.

This book is not a lame rewriting of the manual that came with the camera. Some folks spend five minutes with a book like this one, spot some information that also appears in the original manual, and decide "Rehash!" without really understanding the differences. Yes, you'll find information here that is also in the owner's manual, such as the parameters you can enter when changing your Alpha's operation in the various menus. Basic descriptions—before I dig in and start providing in-depth tips and information—may also be vaguely similar. There are only so many ways you can say, for example, "Hold the shutter release down halfway to lock in exposure." But not *everything* in the manual is included in this book. If you need advice on when and how to use the most important functions, you'll find the information here.

David Busch's Sony Alpha a5000/ILCE-5000 Guide to Digital Photography is aimed at both Sony veterans as well as newcomers to digital photography. Both groups can be overwhelmed by the options the Alpha offers, while underwhelmed by the explanations they receive in their user's manual. The manuals are great if you already know what you don't know, and you can find an answer somewhere in a booklet arranged by menu listings and written by a camera vendor employee who last threw together instructions on how to operate a camcorder.

Why the Sony a5000 Needs Special Coverage

There are many general digital photography books on the market. Why do I concentrate on books about specific digital cameras like the Alpha? When I started writing digital photography books in 1995, advanced digital camera cost $30,000 and few people other than certain professionals could justify them. Most of my readers a dozen years ago were stuck using the point-and-shoot low-resolution digital cameras of the time—even if they were advanced photographers. I took thousands of digital pictures with an Epson digital camera with 1024 × 768 (less than 1 megapixel!) resolution, and which cost $500.

As recently as 2003 (years before the original Alpha was introduced), the lowest-cost enthusiast models were priced at $3,000 or more. Today, a fraction of that amount buys you a sophisticated model like the Sony a5000 (with lens). The advanced digital camera is no longer the exclusive bailiwick of the professional, the wealthy, or the serious photography addict willing to scrimp and save to acquire a dream camera. Digital models have become the favored camera for anyone who wants to go beyond point-and-shoot capabilities.

Who Am I?

After spending years as the world's most successful unknown author, I've become slightly less obscure in the past few years, thanks to a horde of camera guidebooks and other photographically oriented tomes. You may have seen my photography articles in *Popular Photography* magazine. I've also written about 2,000 articles for magazines like *Rangefinder*, *Professional Photographer*, and dozens of other photographic publications. But, first, and foremost, I'm a photojournalist and made my living in the field until I began devoting most of my time to writing books. Although I love writing, I'm happiest when I'm out taking pictures, which is why during past months I've taken off chunks of time to travel to Ireland and Salamanca, Spain. The past 18 months also took me to Zion National Park in Utah, the Sedona "red rocks" area and Grand Canyon in Arizona, Major League Baseball Spring training, and, for a few days, Las Vegas (I did a lot more shooting than gambling in Sin City). You'll find photos of some of these visual treats within the pages of this book.

Like all my digital photography books, this one was written by someone with an incurable photography bug. One of my first SLRs was a Minolta SRT-101, from the company whose technology was eventually absorbed by Sony in 2006. I've used a variety of newer models since then. I've worked as a sports photographer for an Ohio newspaper and for an upstate New York college. I've operated my own commercial studio and photo lab, cranking out product shots on demand and then printing a few hundred glossy 8 × 10s on a tight deadline for a press kit. I've served as a photo-posing instructor for a modeling agency. People have actually paid me to shoot their weddings and immortalize them with portraits. I even prepared press kits and articles on photography as a PR consultant

for a large Rochester, N.Y., company, which once an icon of photography, has fallen on harder times and shall remain nameless. My trials and travails with imaging and computer technology have made their way into print in book form an alarming number of times, including a few dozen on scanners and photography.

Like you, I love photography for its own merits, and I view technology as just another tool to help me get the images I see in my mind's eye. But, also like you, I had to master this technology before I could apply it to my work. This book is the result of what I've learned, and I hope it will help you master your Sony Alpha a5000, too.

In closing, I'd like to ask a special favor: let me know what you think of this book. If you have any recommendations about how I can make it better, visit my website at www.dslrguides.com/blog, click on the E-Mail Me tab, and send your comments, suggestions on topics that should be explained in more detail, or, especially, any typos. (The latter will be compiled on the Errata page you'll also find on my website.) I really value your ideas, and appreciate it when you take the time to tell me what you think! Some of the content of the book you hold in your hands came from suggestions I received from readers like yourself. If you found this book especially useful, tell others about it. Visit http://www.amazon.com and leave a positive review. Your feedback is what spurs me to make each one of these books better than the last. Thanks!

1

Getting Started with Your Sony a5000

Don't panic if you opened this book to the "Getting Started…" chapter and realized that you've already taken several hundred or a thousand (or two) photos. The information in this chapter is designed to get the rawest beginner up and running with the a5000 quickly. However, you'll find that the advice I'm about to offer is even more useful for those who have already become somewhat comfortable with this well-designed (yet complex) camera. You can zip right through the basics, and then dive into learning a few things you probably didn't know about your a5000.

Fortunately, this very sophisticated camera is incredibly easy to use in many aspects, right out of the box. In fact, it was designed to allow even the novice to start taking great pictures with about five seconds of effort. Just flick the power switch to On; it's concentric with the silver shutter release button. Then, press the control wheel center button and rotate the control wheel to select the yellow Superior Auto icon on the LCD monitor. (See Figure 1.1.) Frame the subject on the monitor. Press the shutter release button when you're ready to take your first shot.

Preparing for those steps by charging the battery, mounting a lens, and inserting a formatted Secure Digital or Memory Stick card isn't exactly rocket science, either. If you rotate the virtual on-screen mode selector to any position, such as P, A, or S mode, the camera displays a screen on the LCD indicating the mode's name and purpose. If you set the mode dial to the SCN position, press the control wheel's button on the camera back to cause the Scene Selection menu to appear on the LCD screen. You'll see a summary of the purpose of the Scene mode currently in use as well as a sample photo that illustrates the effect you might expect with that Scene mode. Scroll up/down among the Scene mode options with the control wheel, which is also a four way thumb-pad; press the top of

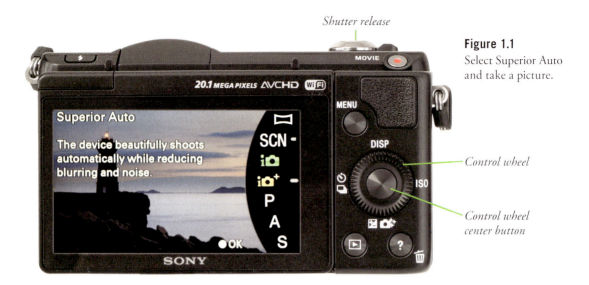

Figure 1.1
Select Superior Auto and take a picture.

the dial to scroll up, for example or rotate the dial to the left to scroll up. The Scene modes automatically make all camera settings to make it easy to take excellent shots of people, landscapes, flowers, night scenes, and more.

So, budding photographers are likely to muddle their way through getting the camera revved up and working well enough to take a bunch of pictures without the universe collapsing. Eventually, though, many may turn to this book when they realize that they can do an even better job with a little guidance.

Also, I realize that most of you didn't buy this book at the same time you purchased your Sony. As much as I'd like to picture thousands of avid photographers marching out of their camera stores with an a5000 box under one arm, and my book in hand, I know that's not going to happen *all* the time. A large number of you had your camera for a week, or two, or a month, became comfortable with it, and sought out this book in order to learn more. So, a chapter on "setup" seems like too little, too late, doesn't it?

In practice, though, it's not a bad idea, once you've taken a few orientation pictures with your camera, to go back and review the basic operations of the camera from the beginning, if only to see if you've missed something. This chapter is my opportunity to review the setup procedures for the camera for those among you who are already veteran users, and to help ease the more timid (and those who have never before worked with an interchangeable-lens camera) into the basic pre-flight checklist that needs to be completed before you really spread your wings and take off. For the uninitiated, as easy as it is to use initially, your Sony a5000 *does* have some dials, buttons, and menu items that might not make sense at first, but will surely become second nature after you've had a chance to review the instructions in this book.

But don't fret about wading through a manual to find out what you must know to take those first few tentative snaps. I'm going to help you hit the ground running with this chapter (or keep on running if you've already jumped right in). If you *haven't* had the opportunity to use your a5000 yet, I'll help you set up your camera and begin shooting in minutes. You won't find a lot of detail in this chapter. Indeed, I'm going to tell you just what you absolutely *must* understand, accompanied by some interesting tidbits that will help you become acclimated. I'll go into more depth and even repeat some of what I explain here in later chapters, so you don't have to memorize everything you see. Just relax, follow a few easy steps, and then go out and begin taking your best shots—ever.

Your Out-of-Box Experience

Your Sony a5000 comes in an attractive box filled with stuff, including a multi-purpose USB/charging cable, basic instructions, some pamphlets, and a few other items. The most important components are the camera and lens, battery/charger, and, if you're the nervous type, the neck strap. You'll also need a Secure Digital or Memory Stick card, as one is not included. If you purchased your camera from a camera shop, a sales associate may have attached the neck strap for you, run through some basic operational advice that you've already forgotten, tried to sell you a memory card, and then, after they'd given you all the help you could absorb, sent you on your way with a handshake.

Perhaps you purchased your Sony camera from one of those mass merchandisers that also sell washing machines and vacuum cleaners. In that case, you might have been sent on your way with only the handshake, or, maybe, not even that if you resisted their efforts to sell you an extended warranty. You save a few bucks at the big-box stores, but you don't get the personal service a professional photo retailer provides. It's your choice. There's a third alternative, of course. You might have purchased your camera from a mail order or Internet source, and your camera arrived in a big brown (or purple/red) truck. Your only interaction when you took possession of the a5000 was to scrawl your signature on an electronic clipboard.

In all three cases, the first thing to do is to carefully unpack the camera and double-check the contents with the checklist on one side of the box. While this level of setup detail may seem as superfluous as the instructions on a bottle of shampoo, checking the contents *first* is always a good idea. No matter who sells a camera, it's common to open boxes, use a particular camera for a demonstration, and then repack the box without replacing all the pieces and parts afterward. Someone actually might have helpfully checked out your camera on your behalf—and then mispacked the box. It's better to know *now* that something is missing so you can seek redress immediately, rather than discover a few days later before an important family event that the USB cable—essential for battery charging—was never in the box.

So, check the box at your earliest convenience, and make sure you have (at least) the following:

- **Sony a5000 body.** This is hard to miss. The camera is the main reason you laid out the big bucks, and it is tucked away inside a nifty protective envelope you should save for re-use in case the camera needs to be sent in for repair. It almost goes without saying that you should check out the camera immediately, making sure the color LCD on the back isn't scratched or cracked, the battery compartment and connection port doors open properly, and, when a charged battery is inserted and lens mounted, the camera powers up and reports for duty. Out-of-the-box defects in these areas are rare, but they can happen. It's probably more common that your dealer played with the camera or, perhaps, it was a customer return. That's why it's best to buy your camera from a retailer you trust to supply a factory-fresh camera.

- **Lens.** You may be able to buy the a5000 with or without a lens, although many retailers may stock only the "kit" form that includes the 16-50mm f/3.5-5.6 OSS retractable zoom, the most popular option with the a5000. It's unusually compact when the camera is powered off and offers two valuable benefits: an image stabilizer (Optical SteadyShot or OSS) to help compensate for camera shake and a cool power zooming feature. This is a lens I did not already own with my previous cameras. You should also be able to buy the camera in a kit with a different lens, such as the 20mm f/2.8 which is also incredibly compact. I'll discuss your many lens options in detail in Chapter 9.

- **Info-Lithium NP-FW50 battery.** The power source for your Sony camera is packaged separately. It should be charged as soon as possible (as described next) and inserted in the camera. It's smart to have more than one battery pack; a spare costs under $80 through major online photo retailers in the US, though prices may go down as more of the generic or "clone" batteries appear. This spare will ensure that you can continue shooting when your battery is discharged or, after many uses, peters out entirely. Make sure you get the NP-FW50 and not a similar model; as you can imagine, Sony makes many other batteries too, of various sizes and shapes.

- **Micro B USB 2.0 cable.** Use this cable to link your Sony to a computer when you need to transfer pictures but don't have an optional card reader accessory handy. While the camera is connected with the cable, the battery inside the body will also be charging. And you'll definitely need to make that USB connection between the a5000 and a computer when you have occasion to upgrade the camera's firmware.

 The USB cable can also be connected to the included AC adapter if you want to charge the battery using household power.

- **AC Adapter AC-UB10.** This is the device (shown in Figure 1.2) that you'll use to charge the battery with household power; the USB cable plugs into it and the adapter plugs into a wall socket. This eliminates the need to have a computer powered up to charge the battery using the method discussed in the previous paragraph. Note too that you can buy an optional Sony BC-VW1 external charger (see Figure 1.3), or the new BC-TRW Quick Charger; especially the latter makes charging the battery a much faster process.

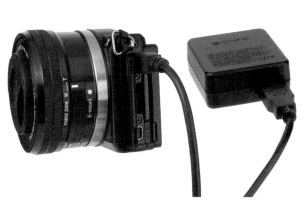
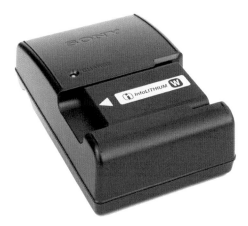

Figure 1.2 The AC Adapter AC-UB10 takes over four hours to provide a normal charge to a battery pack that was completely depleted.

Figure 1.3 The Sony BC-VW1 charger allows rejuvenating your battery outside the camera, so you can keep shooting with a spare battery.

- **Shoulder strap.** Sony provides a suitable neck or shoulder strap, with the Sony logo subtly worked into the design. While I am justifiably proud of owning a fine Sony camera, I never attach the factory strap to my camera, and instead opt for a more serviceable strap from UPstrap (www.upstrap-pro.com). If you carry your camera over one shoulder, as many do, I particularly recommend UPstrap (shown in Figure 1.4). It has a patented non-slip pad that offers reassuring traction and eliminates the contortions we sometimes go through to keep the camera from slipping off. I know several photographers who refuse to use anything else. If you do purchase an UPstrap, be sure to tell photographer-inventor Al Stegmeyer that I sent you hence.

Figure 1.4 Third-party neck straps, like this UPstrap model, are often preferable to the Sony-supplied strap.

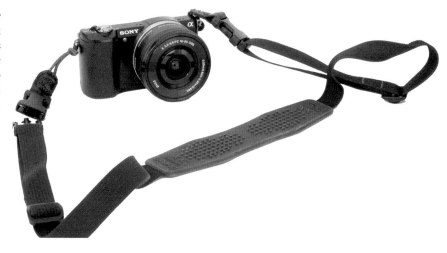

- **Application software.** Sony no longer includes a software CD in the package. The first time you power up the camera, it will display the current URL for your country where you can download imaging software for the a5000, such as the PlayMemories utility.
- **Printed instruction manual.** The camera comes with a brief printed instruction booklet; a longer guide to the camera's operation can be accessed from Sony's esupport.sony.com website. There will also be assorted pamphlets listing available accessories, lenses, as well as warranty and registration information.
- **Body cap.** This accessory will probably already be attached the camera body if you purchase your a5000 without a lens.

Initial Setup

The initial setup of your Sony is fast and easy. Basically, you just need to charge the battery, attach a lens (if that hasn't already been done), and insert a memory card. I'll address each of these steps separately, but if you already feel you can manage these setup tasks without further instructions, feel free to skip this section entirely. You should probably at least skim its contents, however, because I'm going to list a few options that you might not be aware of.

Battery Included

Your Sony a5000 is a sophisticated hunk of machinery and electronics, but it needs a charged battery to function, so rejuvenating the NP-FW50 lithium-ion battery pack should be your first step. A fully charged power source should be good for approximately 400 shots under normal temperature conditions. These estimates are based on standard tests defined by the Camera & Imaging Products Association (CIPA). If you often use the camera's Wi-Fi feature (discussed later), you can expect to take fewer shots before it's time for a recharge. This is an Info-Lithium battery so the camera can display the approximate power remaining with a graphic indicator.

Remember that all rechargeable batteries undergo some degree of self-discharge just sitting idle in the camera or in the original packaging. Lithium-ion power packs of this type typically lose a small amount of their charge every day, even when the camera isn't turned on. Li-ion cells lose their power through a chemical reaction that continues when the camera is switched off. So, it's very likely that the battery purchased with your camera, even if charged at the factory, has begun to poop out after the long sea voyage on a banana boat (or, more likely, a trip by jet plane followed by a sojourn in a warehouse), so you'll want to revive it before going out for some serious shooting.

Charging the Battery

When you're ready to charge the battery, turn the camera Off. Then, plug one end of the USB cable (with the smaller connector) into the top port under the door in the left end of the a5000; it will fit only when in the proper orientation. Plug the other end (with the familiar USB connector) into a computer's USB port. Turn the camera On and you'll see a note on the LCD screen, USB Mode;

this confirms that the connection has been made. As discussed earlier, you can also connect the camera to the AC adapter and plug that into a wall socket.

Whether you charge from a computer's USB port or household power, a Charge light next to the USB/charging port glows yellow-orange, without flashing. It continues to glow until the battery completes the charge and the lamp turns off. In truth, the full charge is complete about one hour *after* the charging lamp turns off, so if your battery was really dead, don't remove it from the charger until the additional time has elapsed. Be sure to plan for charging time before your shooting sessions, because it takes about 280 minutes in a warm environment to fully restore a completely depleted battery. (With the optional Quick Charger BC-TRW accessory discussed earlier, that should take much less time; it sells for about $50 through major online photo retailers in the US.)

If the charging lamp flashes after you insert the battery into the camera, that indicates an error condition. Make sure you have the correct model number of battery; remove it and re-insert it. To insert/remove it, slide the latch on the bottom of the camera, open the battery door, and press a blue lever in the battery compartment that prevents the pack from slipping out when the door is opened; then, ease the battery out. To insert it, do so with the three contact openings facing down into the compartment (see Figure 1.5).

Fast flashing that can't be stopped by reinserting the battery indicates a problem with the battery. Slow flashing (about 1.5 seconds between flashes) means the ambient temperature is too high or low for charging to take place.

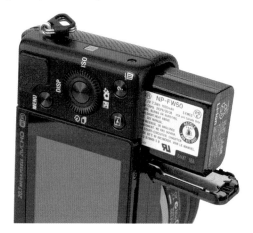

Figure 1.5 Insert the battery in the camera; it only fits one way.

Final Steps

Your Sony a5000 is almost ready to fire up and shoot. You'll need to select and mount a lens (if not previously done) and insert a memory card. Each of these steps is easy, and if you've used any similar camera in the past, such as a Sony or other brand of dSLR, you already know exactly what to do. I'm going to provide a little extra detail for those of you who are new to the Sony or interchangeable-lens camera worlds.

Mounting the Lens

Most buyers purchase the camera in a kit including a lens, but you may have bought it as a "body-only" configuration; that allows you to select any compatible (Sony E-mount) lens that you already own, as with any interchangeable lens camera. In any event, sooner or later you're likely to want to switch to a different lens for other photographic uses, so it's important to know how to do so.

As you'll see, my recommended lens mounting procedure emphasizes protecting your equipment from accidental damage, and minimizing the intrusion of dust. If your camera has no lens attached, select the lens you want to use and loosen (but do not remove) the rear lens cap. I generally place the lens I am planning to mount vertically in a slot in my camera bag, where it's protected from mishaps but ready to pick up quickly. By loosening the rear lens cap, you'll be able to lift it off the back of the lens at the last instant, so the rear element of the lens is covered until then.

After that, remove the body cap that protects the camera's exposed sensor by rotating the cap toward the shutter release button. You should always mount the body cap when there is no lens on the camera, because it helps keep dust out of the interior of the camera, where it potentially can find its way onto the sensor. This is a particular issue with the a5000, because, unlike dSLRs, there are no intermediate items protecting the sensor from exposure, such as the mirror that provides the dSLR with its view through the viewfinder or the shutter. (By the way, when buying my first Sony camera a few years ago, I found that a body cap was not included because the lens was already mounted on the camera. If your camera didn't come with a body cap, you should try to locate one through Sony or another vendor if you possibly can; a camera body should never be left with its sensor exposed.)

Once the body cap has been removed, remove the rear lens cap from the lens, set the cap aside, and then mount the lens on the camera by matching the raised white alignment indicator on the lens barrel with the white dot on the camera's lens mount (see Figure 1.6). Rotate the lens clockwise until it seats securely and clicks into place. (Don't press the lens release button during mounting.) Some lenses ship with a hood. If that accessory is included, and if it's bayoneted on the lens in the reversed position (which makes the lens/hood combination more compact for transport), twist it off and remount with the rim facing outward (see Figure 1.7). A lens hood protects the front of the lens from accidental bumps, and reduces flare caused by extraneous light arriving at the front element of the lens from outside the picture area.

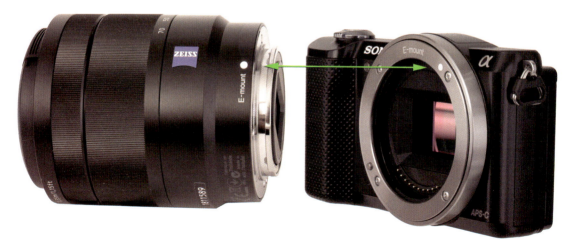

Figure 1.6 Match the raised white dot on the lens with the white dot on the camera mount to properly align the lens with the bayonet mount.

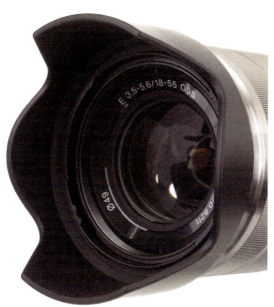

Figure 1.7
A hood protects the lens from extraneous light and from accidental bumps but not all lenses include this accessory.

Inserting a Memory Card

You can't take actual photos without a memory card inserted in your Sony camera. If you don't have a card installed, the camera will sound as if it's taking a photo and it will display that "photo." However, the image is only in temporary memory and not actually stored; you'll get a reminder about that with a NO CARD warning at the upper left of the LCD. If you go back later and try to view that image, it will not be there. So, be sure you have inserted a compatible card with adequate capacity before you start shooting stills or videos.

The a5000 accepts Secure Digital (SD), Secure Digital High Capacity (SDHC), Secure Digital Extra Capacity (SDXC), and Sony Memory Stick Pro Duo (or Memory Stick Pro-HG Duo) cards. The newest type of SD card, the super high-capacity (and super fast) SDXC type, at this writing, is available in capacities as high as 256GB. The SDXC cards are expensive but equally fast SDHC cards (with capacity up to 32GB) are quite affordable.

Note

If you decide to get a high-capacity SDXC card, you may find that your memory card reader accessory (or the one built into a computer) will not be compatible with this newer format. If you need the extra capacity that an SDXC card can provide, be sure to do some research to make sure there are no compatibility issues to surprise you.

Whichever card you decide on, it fits in the single slot underneath the battery compartment door on the bottom of the camera. You should remove the memory card only when the camera is switched off. Insert the card with the label facing toward the lens (for any type of SD card), or away from the lens if inserting any type of Memory Stick Pro card. (See Figure 1.8.) In either case, the metal contacts go into the slot first; the card simply will not fit into the slot if it is incorrectly oriented.

Close the door, and your pre-flight checklist is done! (I'm going to assume you'll remember to remove the lens cap when you're ready to take a picture!) When you want to remove the memory card later, just press down on the card edge that protrudes from the slot, and the card will pop right out.

Figure 1.8 The memory card is inserted in the slot on the bottom of the camera.

Turn on the Power

Locate the On/Off switch that is wrapped around the shutter release button and rotate it to the On position. The LCD display will be illuminated. After one minute of idling, the a5000 goes into the standby mode to save battery power. Just tap the shutter release button to bring it back to life. (The one-minute time is the default setting. You can select a longer time before power-save mode kicks in through the menu system, as I discuss in Chapter 4.)

When the camera first powers up, you may be asked to set the date and time. The procedure is fairly self-explanatory (although I'll explain it in detail in Chapter 4). You can use the left/right direction buttons to navigate among the date, year, time, date format, and daylight savings time indicator, and use the up/down buttons to enter the correct settings. When finished, press the center button to confirm the settings and return to the menu system.

Formatting a Memory Card

There are three ways to create a blank SD or Memory Stick Pro card for your Sony a5000, and two of them are at least partially wrong. Here are your options, both correct and incorrect:

- **Transfer (move) files to your computer.** You'll sometimes decide to transfer (rather than copy) all the image files to your computer from the memory card (either using a direct cable transfer or with a card reader and appropriate software, as described later in this chapter). When you do so, the image files on the card can be erased leaving the card blank. Theoretically. Unfortunately, this method does *not* remove files that you've labeled as Protected (by choosing Protect from the Playback menu during playback), nor does it identify and lock out parts of your card that have become corrupted or unusable since the last time you formatted the card. Therefore, I recommend always formatting the card, rather than simply moving the image files, each time you want to make a blank card. The only exception is when you *want* to leave the protected/unerased images on the card for a while longer, say, to share with friends, family, and colleagues.

- **(Don't) Format in your computer.** With the memory card inserted in a card reader or card slot in your computer, you can use Windows or Mac OS to reformat the memory card. Don't even think of doing this! The operating system won't necessarily arrange the structure of the card the way the camera likes to see it (in computer terms, an incorrect *file system* may be installed). The only way to ensure that the card has been properly formatted for your camera is to perform the format in the camera itself. The only exception to this rule is when you have a seriously corrupted memory card that your camera refuses to format. Sometimes it is possible to revive such a corrupted card by allowing the operating system to reformat it first, then trying again in the camera.
- **Setup menu format.** Use the recommended method to format a memory card in the camera, as described next.

To format a memory card, just follow these steps:

1. **Press the MENU button.** The a5000's "tile" menu screen will appear (unless you've disabled it, as I'll describe in Chapter 4). (See Figure 1.9.)
2. **Select Setup.** Use the left/right directional buttons to navigate to the Setup menu (a wrench/toolbox icon), and press the center button to open up the menu, shown in Figure 1.10. (If you've disabled the Tile menu, the conventional menu system will appear immediately, without the intermediate Step 2.)
3. **Navigate to the Setup 4 tab.** Use the directional buttons to move to the Setup icon (a toolbox) at the far right of the menu tabs. Then, press the down button to move into the Setup tab, followed by the left/right buttons to select Setup 4.
4. **Choose Format.** Rotate the control wheel to highlight Format and press the center button.
5. **Confirm.** A display will appear asking if you want to delete all data. If you're sure you want to do so, press up/down to choose OK, and press the center button to confirm your choice. This will begin the formatting process.

Figure 1.9
Choose Setup in the Tile menu.

Figure 1.10
Navigate to the Setup 4 menu.

Table 1.1 shows the typical number of shots you can expect using a good-sized 16GB memory card (which I expect will be a popular size card among camera users as prices continue to plummet). Take those numbers and cut them in half if you're using an 8GB card; or multiply by 25 percent if you're using a 4GB card. The numbers shown may differ from what you read in the camera's manual: I obtained them by formatting my own 16GB SDHC card and writing down the number of shots available at each setting.

Although the a5000 can shoot more than 10,000 images with a high-capacity card, the maximum number of recordable images displayed on the LCD will never exceed 9,999. Also note that, for movies, the times shown are total movie recording times that will fit on the card; you can record only up to about 29 minutes of video in any one recording.

Table 1.1 Typical Shots with a 16GB Memory Card

	3:2 Aspect Ratio			*16:9 Aspect Ratio*		
	Large	**Medium**	**Small**	**Large**	**Medium**	**Small**
JPEG Standard	3294	4780	6415	3638	5132	6588
JPEG Fine	2048	3533	5132	2321	3869	5417
RAW	751	N/A	N/A	745	N/A	N/A
RAW+JPEG	549	N/A	N/A	564	N/A	N/A

> **HOW MANY SHOTS?**
>
> The Sony a5000 provides a fairly accurate estimate of the number of shots that your memory card will hold. This information is visible near the top-left corner of the LCD (next to the memory card icon) in standard live view as a numeral. It is only an estimate, because the actual number will vary, depending on the capacity of your memory card, the aspect ratio (proportions) of the image (the a5000 can use both traditional 3:2 proportions and 16:9—HDTV—aspect ratios), and the content of the image itself. (Some photos may contain large areas that can be more efficiently squeezed down to a smaller size.) If you change the file format (from JPEG to RAW or from a large JPEG to a small JPEG, for example), the number will change.

Selecting a Shooting Mode

When it comes time to select the shooting mode and other settings on the a5000 camera, you may start to fully experience the "feel" of the user interface. Thanks to the virtual mode selector dial icons shown earlier in Figure 1.1, it's simple and quick to set a shooting mode. Press the center button and rotate the control wheel to spin the on-screen dial to a mode, such as P (Program Auto) and a screen appears with a brief summary as to how that mode works.

When you rotate the dial to the SCN position (for the fully automatic scene modes) a brief description appears about Scene Selection but now you get another option (see Figure 1.11, left). Press the center button and the Scene Selection screen appears (see Figure 1.11, right). If you later turn the camera on while it's set for SCN, rotate the control wheel to reveal the screen that shows the available scene modes.

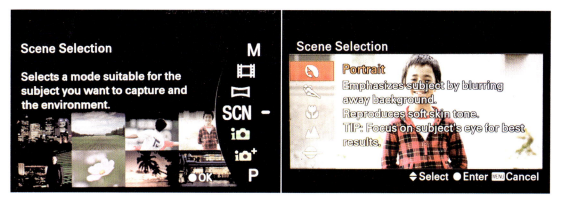

Figure 1.11 The a5000 is equipped with a virtual mode selector dial similar to one you'd find on a dSLR camera (left); choose SCN and you can select a scene mode (right).

Scroll up and down to reveal the various available scene modes (Portrait, Landscape, Sports Action, Sunset, etc.). Stop scrolling when the one you want appears. This scene mode will now be the one that's active when you touch the shutter release button. Two specialized scene modes are particularly worth noting: Anti Motion Blur and Hand-held Twilight; they differ in some aspects but both can produce surprisingly fine JPEGs in low light when a high ISO level is used.

There are several fully automatic shooting modes, including Intelligent Auto and Superior Auto, in addition to scene modes, in which the camera makes most of the decisions for you (except when to press the shutter). You'll also find four semi-automatic modes (Program, Aperture Priority, and Shutter Priority), which allow you to provide more input over the exposure and settings the camera uses. Sony also provided a fully Manual mode. The final mode that you can select with the dial is Sweep Panorama (an automatic mode that allows you to make an ultrawide image assembled from a series of photos). You'll find a complete description of the various shooting modes in Chapter 5.

If you're very new to digital photography, you might want to set the camera to Superior Auto (the yellow camera icon on the dial) or Intelligent Auto (the green camera icon) and start snapping away. Either of these Auto modes will make all the appropriate settings for you for many shooting situations. If you have a specific type of picture you want to shoot, you can try one of the scene modes indicated on the mode dial by SCN. If you want the camera to fire flash in a dark location, also raise the built-in flash by pressing the button marked with a lightning bolt symbol for about one second (this button is above the LCD screen). This is important because the a5000 will not automatically pop the flash into the up position in any shooting mode.

Note

The camera will never fire flash in certain scene modes where flash would be inappropriate, such as Landscape, Sunset, Night Scene, Sports, etc. Hence, it won't let you pop the flash up if you have set such a scene mode. If you had previously popped the flash up while using some other mode, it simply won't fire it when you take a shot, no matter how dark the scene might be.

- **Intelligent Auto.** In this mode, the a5000 makes the settings of aperture and shutter speed for you; it will fire flash in low light if the flash is in the up position. You still can make some decisions on your own, though, such as whether to use single shots or continuous shooting through a drive mode setting, whether to use the flash, and whether to use autofocus or manual focus. You can also set one of the options accessed with the lower part of the control wheel: Background Defocus, Brightness, Color (warm or cool), Vividness (color richness), and a Picture Effect (a special effect). I'll discuss this topic in more detail in Chapter 5.

- **Superior Auto.** Fully automatic like Intelligent Auto, this mode provides an extra benefit. In scenes that include extremely bright areas as well as shadow areas, the camera can activate its Auto HDR (high dynamic range) feature to provide more shadow detail. I'll discuss this feature in Chapter 5. In very dark locations, it can activate the Anti Motion Blur feature to create a photo with minimal digital noise.
- **Scene Selection.** The SCN position on the dial lets you choose any of nine different scene modes, each suited for a different type of subject or lighting condition. In scene modes, you do not get to control any aspect of the camera, except for the choice of autofocus or manual focus and flash. As mentioned earlier, flash will not fire when certain scene modes are in use. Here's a brief summary of the nine options.
 - **Portrait.** This is the first of the nine scene modes, selected as sub-choices under the SCN heading on the shooting mode dial. With the Portrait setting, the camera uses settings to blur the background and sharpen the view of the subject, while using soft skin tones. Flash will fire in low light if you have popped it into the up position.
 - **Sports Action.** Use this mode to freeze fast-moving subjects. The camera uses a fast shutter speed if possible; in a dark arena, for example, it simply won't be able to set a fast shutter speed so it will not be able to freeze the motion. The camera will fire continuously while the shutter button is held down. Flash will never fire in this mode.
 - **Macro.** This mode is helpful when you are shooting close-up pictures of a subject such as a flower, insect, or other small object. Flash will fire in low light if you have popped it into the up position, but the flash may be too bright for a subject that's very close to the camera.
 - **Landscape.** Select this scene mode when you want a maximum range of sharpness (instead of a blurred background) as well as vivid colors of distant scenes. Flash will never fire in this mode.
 - **Sunset.** This is a great mode to accentuate the warm (red/orange) colors of a sunrise or sunset. Flash will never fire in this mode.
 - **Night Scene.** This mode also is for night scenes, using slower shutter speeds to provide a useful exposure, but without using flash. You should use a tripod to avoid the effects of camera shake that can be problematic with a slow shutter speed.
 - **Hand-held Twilight.** This special mode is designed for use in low light. The camera will set a high ISO (sensitivity) level to enable it to use a fast shutter speed to minimize the risk of blurring caused by camera shake. (In extremely dark conditions however, the shutter speed may still be quite long.) When you press the shutter release button, the camera takes six shots in succession. The processor then composites them into one after discarding most of the digital noise (graininess) that is common in conventional photos made at high ISO. It provides one image that's of surprisingly fine quality. Flash is never fired in this mode.

- **Night Portrait.** Choose this mode when you want to illuminate a subject in the foreground with flash, but still allow the background to be exposed properly by the available light. Be prepared to use a tripod or to rely on the SteadyShot feature to reduce the effects of camera shake. If there is no foreground subject that needs to be illuminated by the flash, you may do better by using the Night View mode, discussed next. Remember that you must pop the flash into the up position before taking a shot if you want the flash to fire.
- **Anti Motion Blur.** Similar to Hand-held Twilight, this mode is also designed for use indoors or in low lighting, but it's more effective at reducing blurring that might be caused by a subject's motion or by a shaky camera. That's because the camera sets an even higher ISO level to be able to use an even faster shutter speed so you should not need to use a tripod. (Of course, in an extremely dark location, the shutter speed may still be a bit long.) Again, it fires a series of six shots and composites them into one with minimal digital noise.
- **Sweep Panorama.** This special mode lets you "sweep" the camera across a scene that is too wide for a single image. The camera takes multiple pictures while you move it; after taking a series of shots, its processor combines them into a single, wide (or long) panoramic final product.
- **Movie.** Allows shooting movie clips.

If you have more photographic experience, you might want to opt for one of the semi-automatic or manual modes, selecting it from the virtual mode dial. These, too, are described in more detail in Chapter 5. These modes, which let you apply more creativity to your camera's settings, are indicated by the letters P, A, S, and M. All overrides are available and flash will always fire if it's in the up position in any of the following:

- **P (Program auto).** This mode allows the a5000 to make the basic exposure settings, but you can still override the camera's settings to fine-tune your image.
- **A (Aperture Priority).** Choose this mode when you want to use a particular lens opening (called an aperture or f/stop), especially to control how much of your image is in focus. The camera will set the appropriate shutter speed after you have set your desired aperture using the control wheel.
- **S (Shutter Priority).** This mode is useful when you want to use a particular shutter speed to stop action or produce creative blur effects. You dial in your chosen shutter speed using the control wheel, and the camera will set the appropriate aperture (f/stop) for you.
- **M (Manual).** Select this mode when you want full control over the shutter speed and the aperture (lens opening), either for creative effects or because you are using a studio flash or another flash unit not compatible with the camera's automatic flash metering. You also need to use this mode if you want to use the Bulb setting for a long exposure, as explained in Chapter 5. You select both the aperture and shutter speed with the control wheel on the back of the camera, toggling between them by pressing the bottom edge of the control wheel before spinning. There's more about this mode, and the others, in Chapter 5.

Choosing a Metering Mode

You might want to select a particular exposure metering mode for your first shots, although the default high-tech Multi (short for multi-zone or multi-segment) metering is probably the best choice while getting to know your camera. If you want to select a different metering pattern, you must not be using one of the scene modes, Superior Auto or Intelligent Auto; in these modes, the camera uses Multi metering and that cannot be changed. To change the metering mode, press the MENU button and navigate to the Camera Settings menu (upper left corner in Figure 1.9), and thence to the Camera Settings 3 menu to the Metering Mode entry. Press the center button, then scroll up/down with the directional buttons to reach Multi, Center (for center weighted), or Spot selections. Press the center button to confirm your choice and return the camera to shooting mode. The three metering options are as follows:

- **Multi metering.** In this standard metering mode, the camera attempts to intelligently classify your image and choose the best exposure based on readings from 1,200 different zones or segments of the scene. You can read about this so-called "evaluative" metering concept, as well as the other two options, in Chapter 5.

- **Center metering.** The camera meters the entire scene, but gives the most emphasis (or weighting) to the central area of the frame.

- **Spot metering.** The camera considers only the brightness in a very small central spot so the exposure is calculated only based on that area.

Choosing a Focus Mode

The Camera Settings 3 menu also has entries to allow you to choose Focus Mode and Focus Area, and are accessed using the same navigation steps described earlier. Focus Mode is the easiest to understand; it determines *when* focus is established.

If you're using a scene mode or one of the two Auto modes, you do not get any options under Autofocus Mode; in fact it is grayed out since it's not available in these modes. The choices that are available when using P, A, S, or M mode are as follows:

- **Single-shot AF (AF-S).** This mode, sometimes called *single autofocus*, sets focus after you touch the shutter release button and the camera beeps to confirm focus (unless you've turned the beeps off). The active focus point(s) are shown in green on the screen and a green dot appears in the bottom left corner of the display. The focus will remain locked as long as you maintain contact with the shutter release button, or until you take the picture. If the autofocus system is unable to achieve sharp focus (because the subject is too close to the camera, for example), the focus confirmation circle will blink. This mode is best when your subject is relatively motionless as when you're taking a portrait or landscape photo.

- **Continuous AF (AF-C).** This mode, sometimes called continuous servo or continuous tracking focus by photographers, sets focus when you partially depress the shutter button, but continues to monitor the frame and refocuses if the distance between the camera and the subject changes. (This allows it to continuously focus on a person walking toward you, for example.) No beep sound is provided. Instead of the green focus confirmation dot, a green dot surrounded by two brackets (curved lines) appears to indicate that the camera is not having a problem achieving and maintaining focus. If the camera should fail to acquire focus, the green dot and the brackets will blink. Continuous AF is a useful mode for photographing moving subjects.
- **DMF (Direct Manual Focus).** Allows you to manually adjust focus after autofocus has been confirmed, using the focus ring on the lens.
- **Manual.** Focus by rotating the focus ring on the lens. The a5000 offers magnification, Zebra focus, and Focus Peaking as aids to manual focus. I'll describe their uses in Chapter 3.

Selecting a Focus Area

The Sony a5000 is equipped with a hybrid autofocus system that first uses 99 individual autofocus areas—also called *focus detection points* by many photographers—to identify a subject and to calculate approximate focus. Then, a second autofocus system with 25 focus detection points kicks in; it fine tunes the focus for maximum precision. All of this usually happens in a split second, except in a very dark location. By default, only the 25 focus areas are displayed on the screen, as discussed in a moment.

In scene modes, the focus area that will set focus is selected automatically by the camera; in other words, the AF system decides which part of the scene will be in sharpest focus. In the semi-automatic P, A, and S modes, and in the manual M mode, you can allow the camera to select the focus point automatically, or you can specify which focus point should be used with the Focus Area feature.

Set the camera to one of the four modes mentioned above, and select Focus Area from the Camera Settings 3 menu. By default, it will be set to Wide (multi-point autofocus). Scroll up/down until you reach the option you want to use and press the center button to confirm your selection. There are four autofocus area options, described in Chapter 6. Once you're in the Camera Settings menu, navigate to the Focus Area selection in the Camera Settings 3 tab, then press the center button, and select one of these three choices. Press the center button again to confirm. Here's a brief overview of the four options.

- **Wide.** The a5000 automatically chooses the appropriate focus area or areas; often several subjects will be the same distance from the camera as the primary subject. The active AF area or areas are then displayed in green on the LCD or in the viewfinder, depending on which display you're using.

- **Zone.** In this mode, a grid consisting of nine focus areas appears on the LCD while you're shooting. You can move this grid around the frame with the directional buttons, and the camera will select which of the focus areas to use to focus.
- **Center.** The camera always uses the focus area in the center of the frame, so it will focus on the subject that's closest to the center in your composition.
- **Flexible Spot.** After you select this option from Focus Area, you can use the left/right direction buttons to specify Small, Medium, or Large focus areas. Then, while viewing your subject, you can use the directional controls to move the focus frame (rectangle) around the screen to your desired location. Move the frame so it covers the most important subject in the scene; then press the center button to lock it into place. I'll discuss this topic in more detail in Chapter 6, where I'll cover many aspects of autofocus (as well as manual focus), including some not covered in this chapter.

Other Settings

There are a few other settings you can make if you're feeling ambitious, but don't feel bad if you postpone using these features until you've racked up a little more experience with your Sony a5000. By default, these camera features will be at Auto so the camera will make a suitable setting.

Adjusting White Balance and ISO

If you like, you can custom-tailor your white balance (overall color balance) and the ISO level (sensitivity) as long as you're not using one of the Auto or SCN modes. To start out, it's best to leave the white balance (WB) at Auto, and to set the ISO to ISO 200 for daylight photos or to ISO 400 for pictures on a dark, overcast day or indoors when you'll be shooting with flash. You'll find complete recommendations for both camera features in Chapters 5 (ISO) and 7 (white balance). You can adjust white balance with the White Balance entry in the Camera Settings 4 menu; the ISO can be set after pressing the ISO section of the control wheel (the right directional button). After accessing either feature, navigate (scroll) to make the desired setting with the direction buttons.

Using the Self-Timer

If you want to have time to get into the photo before the tripod-mounted camera takes the actual shot, the self-timer is what you need. You can get to this feature by pressing the drive mode button (the left direction button of the control wheel) and then scrolling up or down. The drive mode can also be selected from the Camera Settings menu, but it's quicker to use the direct access button.

When the Drive Mode screen is visible, scroll up/down through the various options until you reach the Self-timer 10 Sec option which will provide a ten-second delay. Press the center button to confirm your choice and a self-timer icon will appear on the live view display. Press the shutter release

to lock focus and exposure and to start the timer. The self-timer lamp will blink and the beeper will sound (unless you've silenced it in the menu) until the final two seconds when the lamp remains on and the beeper beeps more rapidly until the picture is taken.

There are a few options you can select to vary the operation of the self-timer. When the self-timer option is first highlighted, press the down key. Then scroll up/down to choose between 10-second and 2-second options. Also, on the Drive Mode screen, just below self-timer, there is an option labeled C3/C5; scroll to it and you'll see its called Self-timer (Cont.): 10 Sec. 3 Img (or 5 Img). That abbreviation means the camera will take three or five images after the self-timer's 10-second delay has run out. The multiple image option is handy if you are taking family group pictures with a few known inveterate blinkers to be pictured. Note that the self-timer setting is "sticky" and will still be in effect for multiple shots, even if you turn the camera off and power up again. When you're done using the self-timer, reset the camera to one of the other Drive Mode options.

In addition to the Self-timer, Continuous shooting, and Single-shot choices in the Drive menu, there also are exposure/white balance/dynamic range optimization bracketing options.

Using the a5000's Flash

Working with the built-in flash unit (see Figure 1.12) deserves a chapter of its own, and I'm providing one in Chapter 10. In basic operation, the a5000's flash is easy enough to work with that you can begin using it right away, either to provide the main lighting for a scene, or as supplementary illumination to fill in (brighten) the shadows. The a5000 will automatically balance the amount of light emitted from the flash so that it illuminates the shadows nicely, without overwhelming the highlights and producing a glaring "flash" look. (Think *Baywatch* when they're using too many reflectors on the lifeguards!)

Now, as you may have noticed, in producing the series, Sony has marched to the beat of a different drummer. This camera is quite different from non-mirrorless models, in its construction, appearance, extensive use of menus, and the like. When designing the built-in flash unit, Sony has

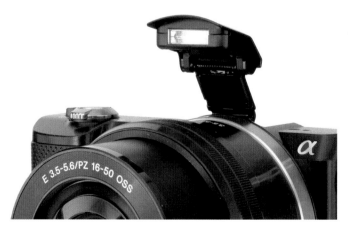

Figure 1.12
The Sony a5000 includes a small built-in flash unit.

continued its trend toward the unconventional with a complex design for the mechanism. In many cases, you won't need it, because the camera is equipped with strong tools for shooting in low light, including ISO settings that go all the way up to 16000 and the Anti Motion Blur and Hand-held Twilight modes. In both of those modes, the camera takes six shots in rapid succession to enhance its ability to capture images in low light that are not ruined by excessive visual noise (graininess or mottled color specks). However, there always will be occasions when flash is at least worthy of consideration as an option, so let's look at how to use it.

To elevate the flash, press the flash pop-up button located on the back upper left edge. You may need to press it for a second or more. If it still won't elevate, allow the camera to focus first and beep in confirmation; afterward, press the button for up to a full second, and the mechanism should respond. Sometimes you'll need to keep it depressed for longer or press it several times if it balks. The flash will refuse to pop up when the camera is set for Sports Action scene mode because flash will never fire in this mode. Surprisingly, it will pop up when you're in other scene modes where flash will not actually fire, such as Anti Motion Blur, and Hand-held Twilight mode, if you are persistent in pressing the button.

Once raised, the flash will automatically charge itself using the camera's internal battery. The Flash Mode item in the Camera Settings 2 menu provides options for using the flash, but these differ depending on the mode the camera is set to. For example, in Intelligent or Superior Auto mode, you can choose to have the flash Off, or set to Auto flash, so the camera decides when to fire it, or to Fill-flash so flash will fire for every shot even on a sunny day. The same options are available in two of the scene modes: Portrait and Macro. In the other scene modes, you have only one or two flash options.

In the less automatic P, A, S, and M modes, you also get the Fill-flash option and two others: Slow Sync and Rear Sync, to be discussed in Chapter 10. In those shooting modes, you don't get the Off option or the Auto flash option. That's not a problem. If you don't want flash to fire, simply push it down into place; when you want it to fire, pop it up and it will provide a burst of extra light for every photo.

An Introduction to Movie Making

I'm going to talk in more detail about your movie-making options with the a5000 camera in Chapter 8. For now, though, I'll give you enough information to get started, in case a cinematic subject wanders into your field of view before you get to that chapter. The overrides you have set for certain aspects while shooting still photos will apply to the video clip that you'll record; these include exposure compensation, the White Balance, any Picture Effect, and even the aperture if the camera is in A mode or the Shutter Speed if it's in S mode. You also get access to the settings for the movie file formats (AVCHD or MP4) and the resolution in the Record Setting item of the Camera Settings section of the menu.

After you start recording you can change the aperture or the shutter speed; either step will make your movie brighter or darker as you'll notice while making the change. However, you can also set plus or minus exposure compensation for that purpose while filming. The a5000 provides an effective Continuous Autofocus in Movie mode and sound is recorded in stereo with the built-in mics located on the top panel.

Let's save the discussion of those aspects for Chapter 8. For the moment, let's just make a basic movie. With the camera turned on, aim at your subject and locate the red Movie record button in the top right hand corner of the body. (You don't have to switch to Movie mode using the virtual mode dial; Movie mode simply gives you access to more movie-shooting controls.)

Compose as you wish and press that button once to start the recording, and again to stop it; don't hold the button down. You can record for up to about 29 minutes consecutively if you have sufficient storage space on your memory card and charge in your battery. The camera will adjust the focus and exposure automatically, and you can zoom while recording, if you have a zoom lens attached to the camera.

After you finish recording a video clip, you can view it by pressing the Playback button above the LCD screen. Let's say you have taken some still photos after making a movie; in that case, the movie is not the latest item available to play. In order to play it, you will need to use the index screen; see the last bullet of the section below on "Reviewing the Images You've Taken" for that procedure. While a movie is being played back, certain camera controls act like VCR buttons, as follows:

- **Pause/Resume.** Press the center button.
- **Fast-forward.** Press the right direction button, or turn the control wheel to the right.
- **Fast-reverse.** Press the left direction button, or turn the control wheel to the left.
- **Adjust sound volume.** Press the bottom direction button to activate the volume control screen; scroll upward to make it louder or downward for less volume. (You can scroll either by rotating the control wheel or by using the control's top and bottom buttons.)
- **Slow-forward.** While paused, turn the control wheel to the right.
- **Slow-reverse.** While paused, turn the control wheel to the left.

Reviewing the Images You've Taken

The Sony a5000 has a broad range of playback and image review options. I'll cover them in more detail in Chapters 2 and 4. Initially, you'll want to learn just the basics for viewing still photos so I'll assume you have taken only such images. After shooting some JPEG and/or RAW photos, here's how to view them, using the controls shown in Figure 1.13:

- Press the Playback button to display the most recently taken image on the LCD. (It's the small button with a > symbol above the LCD screen.)
- Press the left direction button, or scroll the control wheel to the left, to view a previous image.
- Press the right direction button, or scroll the control wheel to the right, to view the next image.

- While viewing a photo, press the DISP button (top direction button) repeatedly to cycle among the available displays: views that have no recording data, full recording data (f/stop, shutter speed, image quality/size, etc.), and a thumbnail image with histogram display. (I'll explain all these in Chapter 2.)
- Press the lower right button, labeled with a question mark and trash can icon, to delete the currently displayed image.
- While the image is displayed, press the MENU button and from the Playback 1 menu, select Rotate, followed by pressing the center button, to rotate the image on the screen 90 degrees. Successive presses of the center button rotate the image 90 degrees each time. (You won't likely need this feature unless you have disabled automatic rotation, which causes the camera to display your vertically oriented pictures already rotated. I'll explain how to activate/deactivate automatic rotation in Chapter 3.)
- Rotate the Zoom lever (labeled W and T) that's concentric with the shutter release to zoom in and out of the image. You can also scroll around inside the image using the direction buttons. To exit this screen and return to normal view, press the center button.
- While in Playback mode, press the Zoom lever to the far W position to display an index screen showing 12 or 30 thumbnail images (select the number using the Image Index option in the Playback 1 menu). Keep scrolling downward to view the thumbnails of the next images (assuming you have shot lots of photos). Scroll to the thumbnail of the photo you want to view and press the center button; the photo will then fill the screen. The a5000 arranges index images by date shot, and includes a calendar view you can use to look for pictures taken on a specific date. I'll explain those options in more detail in Chapter 4.

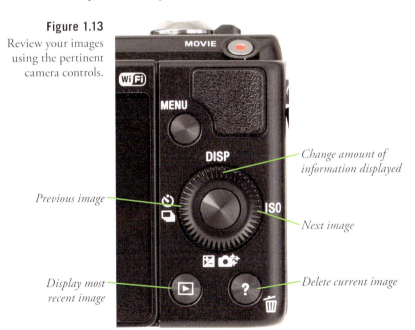

Figure 1.13
Review your images using the pertinent camera controls.

> **Note**
>
> If you have shot a few movie clips instead of still photos most recently, you can use the index feature as discussed in the last bulleted paragraph above. However, if you have recorded a movie and then a still photo and then a movie and then a still photo and so on, there will be a bit of complication. You can't display both movies and still images on the same index screen. When you press the Index button, the thumbnails will depict either the movies or still photos, depending on the type you most recently shot.
>
> If you want to view the other type in index view, scroll to the far left of the screen with the left direction button, so the narrow strip at the left side of the display is highlighted. A message will appear indicating that you can change between viewing stills or movies by pressing the center button. Press it and you'll be given a choice of three folders to view: Folder View (Still) for JPEG and RAW still photos, Folder View (MP4) for videos in MP4 format (MP4), and AVCHD view (for movies in that format). Scroll to one of the options with the direction buttons and then press the center button; the index display will then show thumbnails for only photos or movies.

Transferring Files to Your Computer

The final step in your picture-taking session will be to transfer the photos and/or movies you've taken to your computer for printing, further review, or editing. (You can also take your memory card to a retailer for printing if you don't want to go the do-it-yourself route.) Your a5000 allows you to print directly to PictBridge-compatible printers, without downloading the photos to a computer and to create print orders right in the camera. It also offers an option for selecting which images to transfer to your computer. I'll discuss those camera features in Chapter 3.

For now, you'll probably want to transfer your images by either using the USB cable from the camera to the computer or by removing the memory card from the a5000 and transferring the images with a card reader (shown in Figure 1.14). The latter option is ordinarily the best, because it's usually much faster and doesn't deplete the camera's battery. However, you might need to use a cable transfer when you have the cable and a computer but no card reader. (You might be using the computer at a friend's home or the one at an Internet café, for example.)

Here's how to transfer images from a memory card to the computer using a card reader:

1. Turn off the camera.
2. Slide open the memory card door, and press on the card, which causes it to pop up so it can be removed from the slot. (You can see a memory card being removed in Figure 1.8.)
3. Insert the memory card into a memory card reader accessory that is plugged into your computer. Your installed software detects the files on the card and offers to transfer them. The card can also appear as a mass storage device on your desktop; in that case, you can open that and then drag and drop the files to your computer.

Figure 1.14 A card reader accessory offers the fastest way to transfer photos.

Figure 1.15 Images can be transferred to your computer using a USB cable plugged into the USB port.

To transfer images from the camera to a Mac or PC computer using the USB cable:

1. Turn off the camera.
2. Open the port door on the left side of the camera (the upper door, marked with the candelabra-like USB symbol) and plug the USB cable furnished with the camera into the USB port inside that door. (See Figure 1.15.)
3. Connect the other end of the USB cable to a USB port on your computer.
4. Turn on the camera. From this point on, the method is the same as in paragraph 4 above.

Wireless File Transfer

Your a5000 is also equipped with built-in Wi-Fi which provides many options, including a method for wireless transfer of image files to a Mac or Windows computer when connected to a wireless network. This is a multi-faceted topic so I won't begin to discuss it here; instead, you'll find full coverage in Chapter 11.

The camera is also compatible with the Eye-Fi brand memory card that allows for wireless transfer of files to a computer. (It can also be used for wireless transfer to a smart device running a free app.) This card looks and acts exactly like an ordinary SDHC card, but with a big difference. Once you have the card set up with your local Wi-Fi (wireless) network, whenever you take a picture or record

a movie with this card in the camera, the card wirelessly connects to your computer over that network and transmits the file to any location you have specified. For example, you might set the Eye-Fi card to send any new JPEG or RAW photos directly to the Pictures folder on your computer and video clips to the Movies folder.

Since the a5000 already offers a wealth of Wi-Fi features, there's really no need to buy an Eye-Fi card. If you already own one for use with another camera however, it will work well with your Sony too. This will initially preclude the need to learn how to use the camera's own Wi-Fi features which can seem more complicated because of the sheer number of available options. If you decide that you want to buy an Eye-Fi card for wireless transfer to your computer, I strongly recommend getting the Pro X2 model; it's now available in a fast Class 10 version. The Pro X2 card allows for wireless transfer of RAW files while the older Eye-Fi cards are capable of handling only JPEG photos.

2

Sony a5000 Roadmap

While the a5000 is quite straightforward to operate when using its basic features, this is in unusually versatile camera with some uncommon amenities. Because of this aspect, there is a lot of information that needs to be discussed about how these controls can help you reach the results you want with your still images and videos.

Traditionally, there have been two ways of providing a roadmap to guide you through this maze of features. One approach uses a few tiny 2-inch black-and-white line drawings or photos impaled with dozens of callouts labeled with cross-references to the actual pages in the book that tell you what these components do. You'll find this tactic used in the pocket-sized manual Sony provides with the Sony a5000, and most of the other third-party guidebooks as well. Deciphering one of these miniature camera layouts is a lot like being presented with a world globe when what you really want to know is how to find the capital of Brazil.

I originated a more useful approach in my field guides, providing you, instead of a satellite view, a street-level map that includes close-up, full-color photos of the camera from several angles, with a smaller number of labels clearly pointing to each individual feature. And, I don't force you to flip back and forth among dozens of pages to find out what a particular component does. Each photo is accompanied by a brief description that summarizes the control, so you can begin using it right away. Only when a particular feature deserves a lengthy explanation do I direct you to a more detailed write-up later in the book.

So, if you're wondering what the left direction button on the control wheel does, I'll tell you up front, rather than have you flip to three different pages, as the Sony instruction manual does. This book is not a scavenger hunt. But after I explain how to use the drive mode button to select continuous shooting, I *will* provide a cross-reference to a longer explanation later in the book that clarifies the use of the various drive modes, the self-timer, and exposure bracketing. I've had some readers write me and complain about even my minimized cross-reference approach; they'd like to open the

book to one page and read everything there is to know about bracketing, for example. Unfortunately, it's impossible to understand some features without having a background in what related features do. So, I'll provide you with introductions in the earlier chapters, covering simple features completely, and relegating some of the really in-depth explanations to later chapters. I think this kind of organization works best for a camera as sophisticated as the Sony a5000.

By the time you finish this chapter, you'll have a basic understanding of every control and of the various roles it can take on. I'll provide a lot more information about items in the menus and submenus in Chapter 3, but the following should certainly satisfy the button pusher and dial twirler in you.

Front View

When thinking about any given camera, we always imagine the front view. That's the view that your subjects see as you snap away, and the aspect that's shown in product publicity and on the box. The frontal angle is, essentially, the "face" of a camera like the Sony a5000. But, not surprisingly, most of the "business" of operating the camera happens *behind* it, where the photographer resides. The front of the a5000 actually has very few controls and features to worry about. These few controls are most obvious in Figure 2.1:

- **Power switch.** Turn the camera on by rotating this switch to the On position.
- **Shutter release button.** Angled on top of the hand grip is the silver shutter release button. Touch it gently to activate the camera's circuits and, after composing a photo, maintain slight pressure on it to lock exposure and focus. (Focus lock is available in Single-shot autofocus mode, the one you would use for a subject that's not moving.) The a5000 assumes that when you tap or depress the shutter release, you are ready to take a picture, so the release can be tapped to activate the exposure meter or to exit from most menus.
- **AF illuminator/Self-timer lamp.** This bright LED flashes while your camera counts down the 2-second or 10-second self-timer. In 10-second mode, the lamp blinks at a measured pace off and on at first, then switches to a constant glow in the final moments of the countdown. When the self-timer is set to 2 seconds, the lamp stays lit throughout the countdown. It also serves as the AF (autofocus) Illuminator, shining its light in dark conditions to help the camera's autofocus system achieve sharp focus. Finally, this lamp functions as the Smile Shutter indicator, flashing on when the camera detects a smile and triggers the shutter. I'll discuss focus options in Chapter 6 and Smile Shutter in Chapter 3.
- **Hand grip.** This provides a comfortable hand-hold, and also contains the a5000's battery and memory card compartments.
- **Lens release button.** Press and hold this button to unlock the lens so you can rotate it in order to remove the lens from the camera.
- **Lens release locking pin.** Retracts when the release button is pressed, to allow removing the lens.

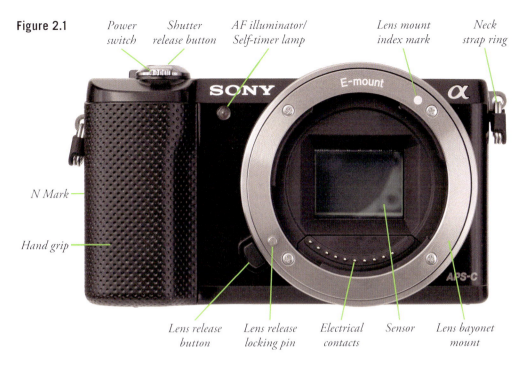

Figure 2.1

- **Lens mount index mark.** Match this recessed, white index button with a similar white indicator on the camera's lens mount to line the two up for attaching the lens to the a5000.
- **Lens bayonet mount.** Grips the matching mount on the rear of the lens to secure the lens to the camera body.
- **Electrical contacts.** These metal contact points match up with a similar set of points on the lens, allowing for communication with the camera about matters such as focus and aperture.
- **Neck strap ring.** Attach the strap that comes with your a5000 to this ring and its counterpart on the other side of the camera, or use a third-party strap of your choice.
- **Sensor.** This fairly ordinary-looking little rectangle is the heart and soul of your digital camera. On the Sony camera, this small marvel is a CMOS (complementary metal-oxide semiconductor) device, 23.5 × 15.6mm in size. That may not sound huge, but this so-called APS-C size is as large as the one you'll find in many of the much bulkier dSLR cameras so it's quite a big deal. This sensor, with a very respectable resolution of just over 20 megapixels, ensures that you'll get extremely high quality still and video pictures.
- **N Mark (on side of camera).** Although you can't see the N Mark in this view, it's emblazoned on the side of the camera, and indicates the touch point for connecting the a5000 with an NFC (Near Field Communication) device, such as a smartphone. When linked, the two devices can communicate directly using short-range wireless technology, as I'll describe later in the book.

In Figure 2.2 you can see the a5000's built-in pop-up flash, the power zoom switch included with the 16-50mm f/3.5-5.6 OSS kit lens, and the port cover, that provides a modicum of protection from dust and moisture for the components inside, shown in Figure 2.3.

- **Pop-up flash.** Press the button on the back of the camera (shown later in this chapter) to release the flash. Note that the flash is hinged, so you can, theoretically, adjust its angle to, say, use bounce flash. Unless you're bouncing the flash off a piece of white cardboard or some other close surface, the meager output of this unit is unlikely to provide much bounce for your buck. The a5000 does not have a connection to allow attaching an external flash.
- **Power zoom lever.** If you're using a zoom lens, you can always change the focal length by rotating the zoom ring on the lens barrel. Some lenses, including the 16-50mm f/3.5-5.6 OSS kit lens have a built-in motor to provide smooth power zoom (which is especially useful when you want to zoom while shooting movies). This lever, conveniently located under your right index finger, can be pressed to zoom in and out when a lens with power zoom is mounted on the a5000.

If you prefer, you can also zoom a power zoom lens using the W-T lever on top of the camera, located concentric to the shutter release button. As I'll explain in Chapter 3, you can also add *digital* zoom capabilities to any lens with the Zoom Setting entry in the Custom 3 menu.

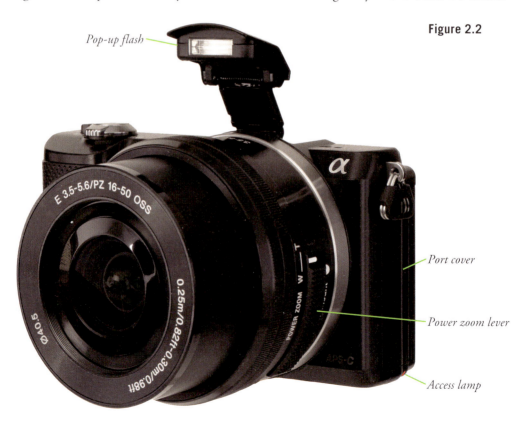

Figure 2.2

Figure 2.3

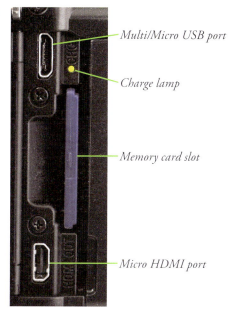

- **Access lamp.** Flashes red while the memory card is being written to. This lamp's location on the lower edge of the side is not ideal. (I like to use the access lamp as a confirmation that a camera is actually taking pictures and saving them to the memory card.) However, it is located next to the port cover door you must open before removing a memory card, so you should notice its red glow *before* you make the mistake of changing cards before the current image(s) are saved.
- **Port cover.** Fold back this cover to reveal the two ports, charge lamp, and memory card slot described next.
- **Multi/Micro USB port.** Connect the a5000 to your computer using this port, with the USB cable that's supplied with the camera. That connection can be used to upload images to the computer, to charge the battery while it's in the camera, and to upgrade the firmware to the latest version available for the a5000, using a file downloaded from the Sony support website (www.esupport.sony.com). The same port serves as a charging port when the USB cable is connected to the included charger, or plugged into a powered USB port.
- **Charge lamp.** This yellow LED flashes while battery charging is underway.
- **Micro HDMI port.** If you'd like to see the images from your camera on a television screen, you'll need to buy an HDMI cable (not included with the camera) to connect this port to an HDTV set or monitor. Be sure to get a Type C cable; it has a male mini-HDMI connector at the camera end and a standard male HDMI connector at the TV end. Once the cable is connected, you can not only view your stored images on the TV in Playback mode, you can also

see what the camera sees by viewing your TV screen. So, in effect, you can use your HDTV set as a large monitor to help with composition, focusing, and the like.

One unfortunate point is that the cameras no longer support video output to an old-style TV's yellow composite video jack. If for some reason it's *really* important to you to connect the camera to one of those inputs, you'll need to find a device that can "down-scale" the HDMI signal to composite video. I have done this successfully with a device by Gefen called the HDMI to Composite Scaler, which costs somewhat more than $200 at newegg.com, svideo.com, and other sites.

The good news is that if you own a TV that supports Sony's Bravia sync protocol, you can use your Bravia remote control to control image display, mark images for printing, switch to index view, or perform other functions.

- **Memory card slot.** You can insert a Secure Digital or Memory Stick Pro Duo card in this slot.

The Sony a5000's Business End

The back panel of the Sony is where most of the camera's physical controls reside. There aren't that many of them, but, as I noted earlier, some of them can perform several functions, depending on the context.

Most of the controls on the back panel of the a5000 are clustered on the right side of the body, with several located on the top edge (see Figure 2.4).

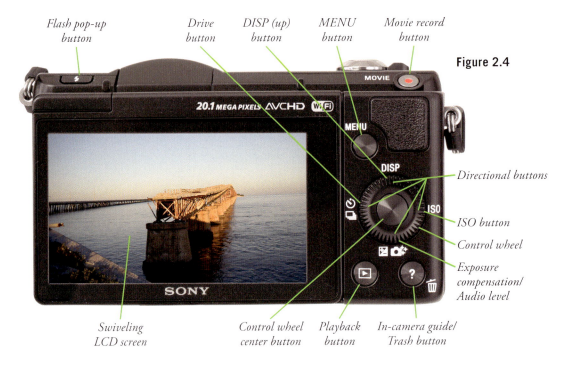

Figure 2.4

The key components labeled in Figure 2.4 include:

- **Flash pop-up button.** Press this button to elevate the built-in electronic flash unit. You'll find that the flash will sometimes refuse to pop up. In that case, allow the camera to focus first and beep in confirmation; then, press the button for up to a full second, or press it several times, and the flash should elevate. The flash will pop up even when the camera is set to SCN modes where flash will never fire, such as Anti Motion Blur, and Hand-held Twilight mode, if you are persistent in pressing the button. Use caution when the flash is up, and when retiring it back into the camera. It doesn't appear to have the most rugged mechanism I've seen.
- **Movie record button.** Another handy feature, this silver button with a central red dot is located on the right rear corner of the body and it's recessed. This design was intended to minimize the risk of inadvertently starting to record a video clip. When you want to make a movie, there is no need to change the shooting mode, or to fiddle with menu systems, as with some other cameras. Simply press the record button; when you're finished press it again to stop recording. I'll discuss your movie-making options in Chapter 8.
- **Swiveling LCD screen.** This screen can be used to preview images and to view them afterward, and to display/navigate menus. You can set the LCD monitor brightness with an item in the Setup menu, to be discussed in Chapter 3; there's a special feature that provides a super bright display, useful on bright days when the screen would otherwise be difficult to view. The monitor tilts 180 degrees to allow you to shoot self-portraits (see Figure 2.5, left), or to provide a waist-level view (Figure 2.5, right) or, by flipping the camera upside down, shoot images in "periscope" mode with the a5000 held overhead.

Figure 2.5 Swiveling LCD.

- **Playback button.** Displays the last picture taken. Thereafter, you can move back and forth among the available images by pressing the left/right direction buttons or spinning the control wheel to advance or reverse one image at a time. To quit playback, press this button again. The a5000 also exits playback mode automatically when you press the shutter release button halfway (so you'll never be prevented from taking a picture on the spur of the moment because you happened to be viewing an image).
- **Control wheel with direction keys.** This ridged dial, which surrounds the large center button, can be useful for navigating menu screens to get to the item or option you want to use. It performs several important functions and is the only control on the camera that can be activated in two different ways: you can turn the ridged part of the wheel to perform certain actions (such as changing shutter speed or aperture), and you can press in on the various direction buttons that are incorporated into the north, east, south, and west positions of the wheel while navigating through menu screens, for example.

 When an image is magnified in Playback, all four buttons can be used to move the viewing area around within the magnified image and within index screens during playback. When the image is not magnified, the left/right buttons move to the previous/next image on your memory card in playback mode.

 When the camera is set to either of the two Auto modes, scrolling down activates a new screen called Photo Creativity that allows you to control background blurring, brightness and color rendition, and to set one of the Picture Effect (special effects) filters. Settings are then made by turning the control wheel. I'll discuss this feature in Chapter 3. And, when the Autofocus Area is set to Flexible Spot, you can use all four of the direction buttons to move the focus bracket to any of its available positions on the screen. Each direction key also has a specific purpose and it's marked accordingly. Here's a brief summary.

 - **DISP (up) key.** The up button is labeled as DISP, for Display Contents, and it provides display-oriented functions. When the camera is in shooting mode, press the DISP button repeatedly to cycle among the three screens that display data in the electronic viewfinder display or the six screens that display information about current settings on the LCD screen.

 The default display for the LCD is called Display All Info. This provides a full information display with a great deal of data overlaid over the live preview to show the settings in effect as shown in Figure 2.6. The data provided when the camera is in a SCN mode or either Auto mode is quite limited; use P, A, S, or M mode to view all of the available data in each display option. Not all the information shown in the figure will be displayed at all times.

 When you keep pressing the DISP button, the a5000 LCD cycles through other viewing modes, including No Display Info, which actually provides a few bits of data, a Graphic Display that shows the shutter speed and aperture on two related scales along with some recording information, and a basic display with a histogram in the bottom right of the screen. You can enable/disable each of these information displays using the Custom 1 menu, as I'll explain in Chapter 3.

- In Playback mode, the DISP button offers different display options, as you would expect. When viewing still images in playback, press the DISP button to cycle among the three available playback screens: full recording data; histogram with recording data; and no recording data. When displaying a movie on the screen, the DISP button produces only two screens: with or without recording information; there is no histogram display available.
- **Exposure compensation/Audio level (down) key.** This button has several functions, which differ depending on the shooting mode you're using.

 When the mode dial is set to Program, Aperture Priority, Shutter Priority, or Sweep Panorama, pressing this button reveals the exposure compensation display. Scroll up/down among the plus and minus options by rotating the control wheel, or by pressing the direction buttons of the wheel. I'll discuss exposure compensation and other exposure-related topics in Chapter 5. In the two Auto modes (Intelligent Auto and Superior Auto), pressing the down button reveals a photo creativity screen that allows you to adjust parameters like brightness, vividness (saturation, or color richness), and Picture Effect. (This button has no function in the scene modes.) In Manual mode, pressing the down key toggles between shutter speed and aperture adjustments.

 In Playback mode, press the down button to change the audio output level of movie clips you are reviewing.
- **Drive mode (left) key.** One press of this button in a compatible shooting mode leads to a series of options that let you set the self-timer, enable the camera to shoot one frame at a time or continuously at a fast or very fast rate, or set up exposure bracketing. The latter causes the camera to automatically take a series of shots, varying the exposure for each to ensure you get the best exposure possible.
- When you scroll to the Self-timer or Bracket item, you can press the right key to adjust options for those drive modes, as discussed in Chapter 5. I'll discuss continuous shooting and the self-timer in Chapter 7 and Bracket (exposure bracketing) in Chapter 5.
- **ISO (right) key.** When not helping you navigate to the right through menus and other screens, this button lets you activate the ISO screen in a compatible shooting mode. You can then scroll up/down among the options by rotating the camera's control wheel or by pressing the wheel's direction buttons.

- **Center button.** The center button functions as the selection button; press it to select or confirm a choice from a menu screen.
- **In-camera guide/Trash button.** In shooting mode, this button produces an in-camera help guide (unless, as I recommend, you redefine the button for some other function). In Playback mode, the button serves as a delete key.

LCD Panel Data Displays

The Sony a5000 provides a tilting and expansive 3-inch color LCD with high resolution to display everything you need to see, from images to a collection of informational data displays. Some of the data is shown only when you are viewing the Display All Info screen (as in Figure 2.6), but even then, not every item of data will be available all the time. As discussed earlier, the electronic viewfinder display options provide much less data in order to avoid cluttering the live preview with numerals and icons during serious photography. Here's what the camera can display in the LCD in Display All Info when it's set for P, A, S, or M mode; less data is available in other display modes and when other shooting modes are being used.

- **Shooting mode.** Shows whether you're using Program auto, Aperture Priority, Shutter Priority, Manual, Panorama, one of the scene modes, or one of the two Auto modes.
- **Memory card/Uploading status.** Indicates whether a memory card is in the camera. (If you remove the card, a blinking NO CARD indicator will appear instead.) If the camera is connected using Wi-Fi, the indicator will display icons representing the upload status.
- **Exposures remaining.** Shows the approximate number of shots available to be taken on the memory card, assuming current conditions, such as image size and quality. When shooting a movie, the recordable time remaining is shown instead.
- **Aspect ratio/Image size.** Shows whether the a5000 is set for the 3:2 aspect ratio or wide-screen 16:9 aspect ratio (the image size icon changes to a "stretched" version when the aspect ratio is set to 16:9) and whether you're shooting Large, Medium, or Small resolution images. If you're shooting only RAW photos, not RAW & JPEG, there is no symbol shown, because there are no options for RAW photo size. In addition, when the camera is set to the 16:9 aspect ratio, the display has black bands at the top and the bottom, as you would expect with the longer/narrower format vs. the 3:2 aspect ratio which is closer to square in shape.
- **Image quality.** Your image quality setting (JPEG Fine, JPEG Standard, RAW, or RAW & JPEG) is displayed.
- **Frame rate/Movie recording settings.** These icons show what movie settings are in use such as 60i FH (full HD video at 60i). I'll discuss your movie-making options, including file formats and size, in Chapter 8.
- **NFC active indicator.** Shows when your a5000 is linked to another device using Near Field Communications.
- **Battery status.** The remaining battery life (in percent) is indicated by this icon.
- **Metering mode.** The icons represent Multi, Center, or Spot metering. (See Chapter 5 for more detail.)
- **Flash exposure compensation.** This icon is shown whenever flash is active to indicate the level of flash exposure compensation, if any, that you have set.

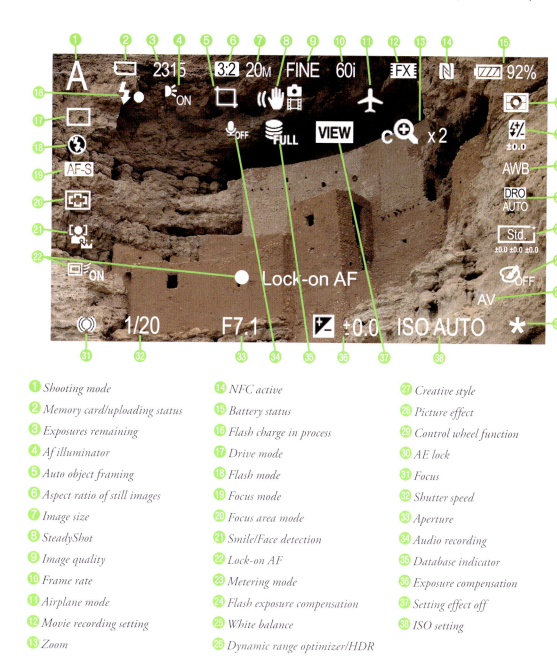

Figure 2.6 The Display All Info screen on the LCD.

① *Shooting mode*
② *Memory card/uploading status*
③ *Exposures remaining*
④ *Af illuminator*
⑤ *Auto object framing*
⑥ *Aspect ratio of still images*
⑦ *Image size*
⑧ *SteadyShot*
⑨ *Image quality*
⑩ *Frame rate*
⑪ *Airplane mode*
⑫ *Movie recording setting*
⑬ *Zoom*
⑭ *NFC active*
⑮ *Battery status*
⑯ *Flash charge in process*
⑰ *Drive mode*
⑱ *Flash mode*
⑲ *Focus mode*
⑳ *Focus area mode*
㉑ *Smile/Face detection*
㉒ *Lock-on AF*
㉓ *Metering mode*
㉔ *Flash exposure compensation*
㉕ *White balance*
㉖ *Dynamic range optimizer/HDR*
㉗ *Creative style*
㉘ *Picture effect*
㉙ *Control wheel function*
㉚ *AE lock*
㉛ *Focus*
㉜ *Shutter speed*
㉝ *Aperture*
㉞ *Audio recording*
㉟ *Database indicator*
㊱ *Exposure compensation*
㊲ *Setting effect off*
㊳ *ISO setting*

- **White balance.** Shows current white balance setting. The choices are Auto White Balance, Daylight, Shade, Cloudy, Incandescent, Fluorescent, Flash, Color Temperature, and Custom. I'll discuss white balance settings and adjustments in Chapter 3.
- **Dynamic Range Optimizer (DRO).** Indicates the type of dynamic range optimization (highlight/shadow detail enhancement) in use: Off, Auto DRO, levels 1-5 of DRO, or the special Auto HDR feature, all described in Chapter 5.
- **Creative style.** Indicates which of the six Creative Style settings (Standard, Vivid, Portrait, Landscape, Sunset, or Black-and-White) is being applied. I'll discuss the use of these settings in Chapter 7.
- **Picture effect.** Shows which of the special effects, such as Toy Camera, Pop Color, or Posterization is being applied. I'll explain these options in Chapter 3.
- **SteadyShot indicator.** Provides information as to whether the image stabilizer is On or Off if you're using a lens with the SteadyShot mechanism, and warns you that the shutter speed will be too long for the stabilizer to fully compensate for camera shake.
- **Control wheel function.** This icon lets you know the function of the control wheel in the shooting mode in use, such as aperture control in A mode. This icon disappears when the zoom magnification scale appears; that scale—not shown here because it's visible for only two seconds after you zoom the lens—depicts the focal length currently set or the amount of digital zoom in effect.
- **Flash charge in process.** This lightning bolt icon appears on the screen when the flash unit is active; a solid orange dot beside it indicates the flash has recycled (charged) and is ready to fire.
- **AF illuminator status.** This icon appears when conditions are dark enough that the AF Illuminator will be needed in order to light up the area so that the autofocus system can operate properly.
- **Flash mode.** Provides flash mode information when flash is active. The possible choices are Flash Off, Autoflash, Fill Flash, Slow Sync, Rear Curtain, and Wireless. Not all of these choices are available at all times. I'll discuss flash options in more detail in Chapter 10.
- **Drive mode.** Shows whether the camera is set for Single-shot, Continuous shooting, Speed Priority Continuous shooting, Self-timer, Self-timer with continuous shooting, or Exposure bracketing. There is one additional option available: Remote Commander, which sets up the camera to be controlled by an infrared remote control.
- **AE Lock.** Appears when autoexposure has been locked at the current setting.
- **ISO level.** Indicates the sensor ISO sensitivity currently set, either Auto ISO or a numerical value. I'll discuss this camera feature in Chapter 5.

- **Exposure compensation.** This indicator shows the amount of exposure compensation, if any, currently set.
- **Shutter speed.** Shows the current shutter speed, either as set by the camera's autoexposure system or, in Manual or Shutter Priority mode, as set by the user. If the camera's Graphic display is used, the screen illustrates that faster shutter speeds are better for action and slower speeds are fine for scenes with less movement.
- **Aperture.** Displays the current f/stop set by the camera or, in Manual or Aperture Priority mode, as set by the user. If you're viewing the Graphic display, icons indicate that wider apertures produce less depth-of-field (a "blurry" background) while smaller apertures provide a greater range of acceptable sharpness (increasing the odds of a more distinct background).
- **Focus indicator.** Flashes while focus is underway, and turns a solid green when focus is confirmed.
- **Drive mode.** Shows whether single-shot, continuous shooting, self-timer, or various bracketing modes are active.
- **Flash mode.** Shows status of the pop-up flash when it's elevated.
- **Focus mode.** Shows the currently selected focus mode, such as AF-S, AF-C, DMF (Direct Manual Focus), or MF (Manual Focus), as explained in Chapter 6.
- **Focus area mode.** Displays the active focus area mode, such as Wide, Zone, Center, or Flexible Spot, as explained in Chapter 6.
- **Smile/Face Detection mode.** Shows status of Smile or Face Detection modes. When these features are activated, the camera attempts to detect faces in the scene before it, and, if it does, it adjusts autofocus, exposure, and white balance accordingly. When the Face Registration feature is also in use, and if the camera has detected a face that you have registered as a favorite, the icon will differ slightly from the Face Detection icon. Smile Shutter looks for smiles and automatically takes a picture. I'll discuss these features in Chapter 6.
- **Lock-on AF mode.** Indicates that focus tracking is being used.
- **Auto object framing.** This icon indicates whether this camera feature is currently in use; if it's On, the camera will automatically crop a photo of a person for a more pleasing composition.
- **Zoom.** Shows when digital zoom modes are active.
- **View (not shown).** Indicates that the LCD does not apply any effects settings to the view, giving you a preview of what the picture will look like with the effects applied.
- **Database indicator.** This warning appears when your memory card's image database is full or has errors.
- **Audio recording.** Shows whether sound recording is enabled/disabled for movie shooting.
- **Airplane mode.** Appears when Airplane mode has disabled Wi-Fi and NFC communications.
- **Setting effect.** Indicates that the LCD shows the effects of any adjustments, including exposure, white balance, or Picture Effects.

Some of the same items of data are also available when other display options are selected with the DISP button, as discussed earlier in this chapter. When the Graphic Display option is used the camera provides an illustration of the value of a small or wide aperture, and a fast or slow shutter speed, as discussed in the previous section.

Going Topside

The top surface of the a5000 has several frequently accessed controls of its own. They are labeled in Figure 2.7:

- **Sensor focal plane.** Precision macro and scientific photography sometimes requires knowing exactly where the focal plane of the sensor is. The symbol etched on the top of the camera marks that plane.
- **Stereo microphones.** A pair of stereo microphones for recording sound during movie shooting are arrayed on either side of the lens mount.
- **Pop-up flash.** The top surface of the pop-up flash fits flush with the top of the camera so it's not visible until you elevate it.
- **Zoom switch.** In shooting mode, use to adjust digital zoom in and out when using any lens; or zoom optically when using a lens with a power zoom motor built in.
- **Power switch.** Rotate to the right to turn the on; to the left to switch it off.

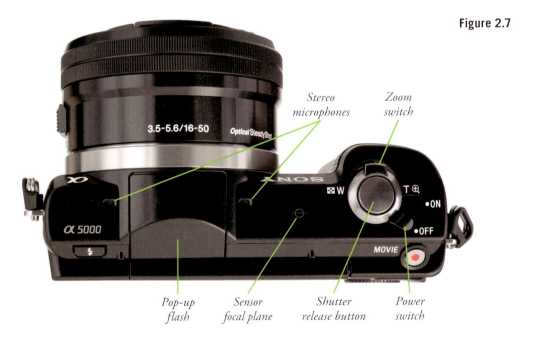

Figure 2.7

- **Shutter release button.** Partially depress this button to lock in exposure and focus. Press it all the way to take the picture. Hold this button down to take a continuous stream of images when the drive mode is set for Continuous shooting. Tapping the shutter release when the camera's power save feature has turned off the autoexposure and autofocus mechanisms reactivates both. When a review image or menu screen is displayed on the LCD, tapping this button removes that display returning the camera to the standard view and reactivating the autoexposure and autofocus mechanisms.

Underneath Your Sony a5000

The bottom panel of your a5000 has only two components, a tripod socket and the door to the battery compartment, illustrated in figure Figure 2.8.

- **Tripod socket**. Attach the camera to a vertical grip, flash bracket, tripod, monopod, or other support using this standard receptacle. The socket is positioned roughly behind the optical center of the lens, a decent location when using a tripod with a pan (side rotating) movement, compared to an off-center orientation. For most accurate panning, the socket would ideally be placed a little forward (actually in *front* of the camera body) so the pivot point is located *under* the optical center of the lens, but you can't have everything. There are special attachments you can use to accomplish this if you like.
- **Battery compartment door.** Slide the door open to access the battery and memory card.

Figure 2.8

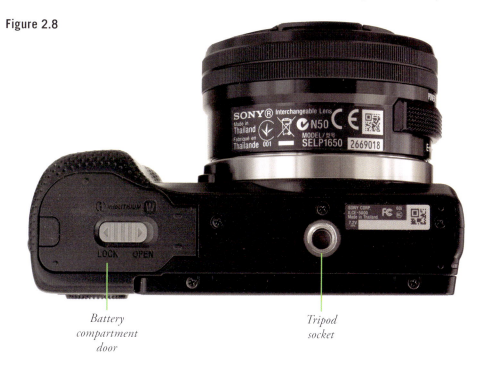

Battery compartment door

Tripod socket

3

Camera Settings and Custom Settings Menus

The a5000 has a remarkable number of features and options you can use to customize the way your camera operates. Not only can you change settings used at the time the picture is taken, but you can adjust the way your camera behaves. This chapter and the next will help you sort out the settings for all of the menus. These include the Camera Settings, Custom Settings, Wireless, Application, Playback, and Setup menus. This chapter details options with the Camera Settings and Custom Settings menus; the Application, Playback, and Setup menus will be addressed in Chapter 4. I've set aside the discussion of the Wireless menu for Chapter 11, where I explain both the menu options and how to use wireless functions in more detail.

If you haven't owned a Sony E-mount camera before (including the NEX predecessors of the current *aXXXX* lineup), you *really* need these chapters. Sony apparently thinks that even a complex camera like the a5000 is so easy to use that comprehensive printed manuals are no longer necessary. Only the briefest of quick start guides is included in the box, and the company offers a marginally more complete Help Guide that can be accessed over the internet—assuming you're using your camera alongside your computer or other internet capable device. (A PDF version of this Help Guide can sometimes be located for downloading, although, as I write this, not from Sony.)

And if you *have* used an older E-mount camera, you should know that Sony has seriously revamped the menu structure, eliminating the old Image Size and Brightness/Color menus of the NEX series and scattering their entries within the more conventional Camera, Custom Settings, and Setup menus of the a5000.

Unfortunately, I mean scattering quite literally. For example, the a5000 includes more than a dozen commands that apply directly to focusing/autofocusing functions, such as Focus Mode/Focus Area;

AF Illuminator; Focus Magnifier; Lock-on AF; Auto Object Framing; the Manual Focus Assist, and Peaking focus aids; Pre-AF; and several more. Rather than include them in a cluster of adjacent menu tabs, Sony has sprinkled these settings among six different Camera Settings and Custom Settings menu sections. These two chapters will help you find familiar functions in their new locations, and explain the new features added to the a5000.

I'm not going to waste a lot of space on some of the more obvious menu choices in these chapters. For example, you can probably figure out, even without my help, that the Beep option deals with the solid-state beeper in your camera that sounds off during various activities (such as the self-timer countdown). You can certainly decipher the import of the settings available for Beep (On and Off) which can be used to silence the camera so it makes no sounds while you're shooting.

Instead, I'll devote no more than a sentence or two to the blatantly obvious settings and concentrate on the more complex aspects of setup, such as autofocus. I'll start with an overview of using the camera's menus themselves.

Anatomy of the Menus

If you've used the menu systems of other cameras, including recent models from Sony, you'll find some familiar features in the menus of the a5000, such as the broad range of choices available for shooting, playback, and setup options. You'll also notice some significant differences, though. For example, this is one of the first interchangeable-lens Sony cameras to provide Wi-Fi, so it offers menu items specific to this feature, and a special menu section called Applications where you'll store the a5000's downloadable add-ons.

The menu system is quite easy to navigate, once you have figured out the new tabbed menu system, which I think is more convenient than the continuous menu design of the earlier NEX cameras. To enter the menu system, press the MENU button and, by default, a Tile menu with icons for each of the six main menu headings appears. (See Figure 3.1.) That screen, a throwback to the NEX design, is essentially useless, as the only thing you can do with it is move to the conventional menu system Sony has switched to. I recommend eliminating the extra step, using the Setup 1 menu's Tile Menu setting to disable it, described in the next chapter.

Thereafter, pressing the MENU button takes you without further ado directly to a screen similar to the one shown in Figure 3.2. When the upper tab bar is active, the currently selected menu tab will be highlighted in orange, as you can see in the figure. Press the down button or rotate the control wheel to move the highlighting down into the selected tab. You can choose any item in the displayed tab, and press the center button to produce a screen where you can adjust the highlighted entry. While navigating any menu tab, use the left/right keys to move to the next tab in that menu group, and then to wrap around to the first tab in the next group.

For example, if you are using the Camera Settings menu, the right key will take you from Camera Settings 1 to Camera Settings 2, Camera Settings 3, Camera Settings 4, Camera Settings 5, and Camera Settings 6, and thence onward to Custom Settings 1. Each of the main tabs may have

Figure 3.1
Pressing the MENU button by default reveals the Tile menu, which displays icons representing the six menu categories.

Figure 3.2
You can bypass the Tile menu and go directly to the a5000's conventional menu system.

several sub-tabs: the Camera Settings menu has tabs 1-6; Custom Settings menu has tabs 1-4; Wireless menu has tabs 1-2; Application menu has just one; Playback menu has 1-2; and Settings boasts tabs 1-5.

Of course, not everything has to be set using these menus. The a5000 has some convenient direct setting controls, such as the buttons of the control wheel that provide quick access to the drive modes, display information, the ISO options, and exposure compensation. These control features allow you to bypass the multi-tabbed menus for many of the most commonly used camera functions.

At times you will notice that some lines on various menu screens are "grayed out;" you cannot select them given the current camera settings. For example, if you decide to shoot a panorama photo, you may find that the Panorama: Size and Panorama: Direction choices are grayed out. Want to know why? Scroll to the grayed out item and press the center button. The camera then displays a screen that explains why this feature is not available: because the feature is not available when Shutter

Priority shoot mode is active, in this example. Unfortunately, that's not very helpful. The screen *should* have instead told you that the Panorama settings are not available when the Shoot mode is anything *other* than Sweep Panorama. Given the incomplete information (and lacking this book), you might have spent several frustrating minutes switching to other shooting modes, still to find that no Panorama settings are possible. In addition, there are many grayed out menu entries with advice that boils down to "Not Available" with no reason given. Thanks, Sony!

After this long intro, let's finally get to a description of every item in the six feature-packed menu categories. I do not intend the following to be a laundry list of items. Instead, it should be an important part of the education process into most aspects of the a5000; it should also guide you in setting up the camera with the most useful options that Sony has provided.

ABOUT THOSE ICONS

Menu entries are preceded by an icon, such as the "mountain" icon shown next to the Image Size, Aspect Ratio, and Quality entries in Figure 3.2. A mountain icon indicates that the particular menu entry applies *only* to still photography; an icon resembling a film frame shows that the menu entry applies *only* to movie making. Presumably, entries without any icon can be used with both. The Enlarge entry in the Playback menu, and Language entry in the Setup menu are preceded by magnifying glass and text icons, respectively and apparently are used just for decorative purposes.

Camera Settings Menu

Figure 3.2, earlier, shows the first screen of the Camera Settings menu. As you can see, at most only a half dozen items are displayed at one time. The items found in this menu include:

- Shoot Mode
- Image Size
- Aspect Ratio
- Quality
- Panorama: Size
- Panorama: Direction
- File Format
- Record Setting
- Drive Mode
- Flash Mode
- Flash Compensation
- Red Eye Reduction
- Focus Mode
- Focus Area
- AF Illuminator
- Exposure Compensation
- ISO
- Metering Mode
- White Balance
- DRO/Auto HDR
- Creative Style
- Picture Effect
- Focus Magnifier
- High ISO Noise Reduction
- Lock-on AF
- Smile/Face Detection
- Soft Skin Effect
- Auto Object Framing
- SteadyShot
- Color Space
- Auto Slow Shutter
- Audio Recording
- Wind Noise Reduction
- Shooting Tip List

Shoot Mode

Options: Intelligent Auto, Superior Auto, Program Auto, Aperture Priority, Shutter Priority, Manual Exposure, Movie, Sweep Panorama, Scene Selection

This menu entry summons the same virtual mode dial screen that appears when you press the center button when in shooting mode. There's no reason to use it, in most cases. The only dubious exception I can think of is if you should, for some reason, want to change shooting mode while reviewing images during Playback. You can press the MENU button in playback mode (the Playback menu pops up by default), and then navigate to the Camera Settings menu and this entry from there. I haven't figured out any circumstances where you might want to do so.

Image Size

Options: L, M, S

Default: L

Here you can choose between the a5000's Large, Medium, and Small settings for JPEG still pictures. The larger the size that's selected, the higher the resolution: the images are composed of more megapixels. (If you select RAW or RAW & JPEG for Quality [described shortly], you'll find that the Image Size option is grayed out, because the camera will always shoot large photos.) As you scroll among the options, you'll note that the Large size shows 20M for 20 megapixels, while Medium indicates 10 megapixels, and Small shows 5 megapixels as the size/resolution. This assumes that you are using the standard 3:2 aspect ratio; the image sizes are smaller if you set the 16:9 option. Both are discussed below in the Aspect Ratio item, but I'll provide Table 3.1 now as a comparison.

Scroll to this menu item, press the center button and scroll to the desired option: L, M, or S. Then press the center button to confirm your choice. The actual size of the images depends on the aspect ratio you have chosen in the subsequent menu item (discussed below), either the standard 3:2 or the wide screen 16:9 format.

Table 3.1 Image Sizes Available

Image Size	Megapixels 3:2 Aspect Ratio	Resolution 3:2 Aspect Ratio	Megapixels 16:9 Aspect Ratio	Resolution 16:9 Aspect Ratio
Large (L)	20 MP	5456 × 3632 pixels	17 MP	5456 × 3064 pixels
Medium (M)	10 MP	3872 × 2576 pixels	8.4 MP	3872 × 2176 pixels
Small (S)	5 MP	2736 × 1824 pixels	4.2 MP	2736 × 1536 pixels

There are few reasons to use a size other than Large with this camera, even if reduced resolution is sufficient for your application, such as photo ID cards or web display. Starting with a full-size image gives you greater freedom for cropping and fixing problems with your image editor. An 800 × 600-pixel web image created from a full-resolution (large) original often ends up better than one that started out as a small JPEG.

Of course, the Medium and Small settings make it possible to squeeze more pictures onto your memory card, and especially a 10 MP image (the Medium size) is nothing to sneeze at; this resolution approaches the maximum of some very fine dSLR cameras that were available a few years ago. The smaller image sizes might come in handy in situations where your memory cards are almost full and/or you don't have the opportunity to offload the pictures you've taken to your computer. For example, if you're on vacation and plan to make only 4 × 6-inch snapshot prints of the photos you shoot, setting a lower resolution will stretch your memory card's capacity. An 8GB memory card can hold roughly 1,600 of the 10 MP (Medium, 3:2) JPEG photos or roughly 3,500 of the 5MP photos. Even then, it makes more sense to simply buy and carry memory cards with higher capacity and use your a5000 at its maximum resolution.

Aspect Ratio

Options: 3:2, 16:9 aspect ratios

Default: 3:2

The aspect ratio is simply the proportions of your image as stored in your image file. The standard aspect ratio for digital photography is approximately 3:2; the image is two-thirds as tall as it is wide, as shown by the outer green rectangle in Figure 3.3. These proportions conform to those of the most common snapshot size in the USA, 4 × 6-inches. Of course, if you want to make a standard 8 × 10-inch enlargement, you'll need to trim some of the length of the image area since this format is closer to square; you (or a lab) would need 8 × 12-inch paper to print the full image area. The 3:2 aspect ratio was also the norm in photography with 35mm film.

If you're looking for images that will "fit" a wide-screen computer display or a high-definition television screen, you can use this menu item to switch to a 16:9 aspect ratio which is much wider than it is tall. The camera performs this magic by cutting off the top and bottom of the frame (as illustrated by the yellow boundaries in Figure 3.3), and storing a reduced resolution image (as shown in Table 3.1). Your 20 MP image becomes a 17 MP shot if you set the camera to shoot in 16:9 aspect ratio instead of using the default 3:2 option. If you need the wide-screen look, this menu option will save you some time in image editing, but you can achieve the same proportions (or any other aspect ratio) by trimming a full-resolution image with your software.

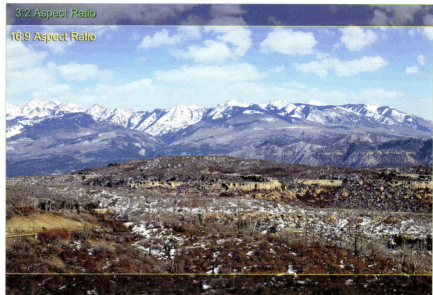

Figure 3.3
The 3:2 aspect ratio is shown by the outer green box. The yellow bars indicate the 16:9 aspect ratio (achieved either in-camera or later by cropping in software).

Quality

Options: RAW, RAW & JPEG, Fine, Standard

Default: Fine

This menu item lets you choose the image quality settings that will be used by the a5000 to store its still photo files. You have four options: RAW, RAW & JPEG, Fine, and Standard. In truth, RAW is a file format and not a quality item at all, but nearly all cameras include this option in the Quality section of their menus. (The Fine and Standard options are relevant only to JPEGs.) Here's what you need to know to choose intelligently:

- **JPEG compression.** To reduce the size of your image files and allow more photos to be stored on a given memory card, the camera's processor uses JPEG compression to squeeze the images down to a smaller size. This compacting reduces the image quality a little, so you're offered your choice of Fine compression and Standard compression. Standard compression is quite aggressive; the camera discards a lot of data. When you open a JPEG in a computer, the software restores the missing data, but this is an imperfect process so there's some loss of quality. You'll find that Fine provides better results so it should really be your *standard* when shooting JPEG photos.

- **JPEG, RAW, or both.** You can elect to store only JPEG versions of the images you shoot (Fine or Standard), or you can save your photos as "unprocessed" RAW files, which consume several times as much space on your memory card. Or, you can store both file types at once as you shoot. The JPEG will then be Large/Fine; the camera provides no options for modifying JPEG size or quality in the RAW & JPEG option.

 Many photographers elect to shoot *both* a JPEG and a RAW file (RAW & JPEG), so they'll have a JPEG version that might be usable as-is, as well as the original "digital negative" RAW file in case they will later want to make some serious editing of the photo with imaging software for reasons discussed shortly. If you use the RAW & JPEG option, the camera will save two different versions of the same file to the memory card: one with a .JPG extension, and one with the .ARW extension that signifies Sony's proprietary RAW format that consists of raw data.

As I noted under Image Size, there are some limited advantages to using the Medium and Small resolution settings, and similar space-saving benefits accrue to the Standard JPEG compression setting. All of these options help stretch the capacity of your memory card so you can shoehorn quite a few more pictures onto a single card. That can be useful when you're away from home and are running out of storage, or when you're shooting non-critical work that doesn't require full resolution (such as photos taken for real estate listings, web page display, photo ID cards, or similar applications).

But for most work, using lower resolution and extra compression is false economy. You never know when you might actually need that extra bit of picture detail. Your best bet is to have enough memory cards to handle all the shooting you want to do until you have the chance to transfer your photos to your computer or a personal storage device.

JPEG vs. RAW

You'll sometimes be told that RAW files are the "unprocessed" image information your camera produces, before it's been modified. That's nonsense. RAW files are no more unprocessed than your camera film is after it's been through the chemicals to produce a negative or transparency. A lot can happen in the developer that can affect the quality of a film image—positively and negatively—and, similarly, your digital image undergoes a significant amount of processing before it is saved as a RAW file. Sony even applies a name (BIONZ) to the digital image processor used to perform this magic in the Sony Alpha cameras.

A RAW file is closer in concept to a film camera's processed negative. It contains all the information, with no compression, no sharpening, no application of any special filters or other settings you might have specified when you took the picture. Those settings are stored with the RAW file so they can be applied when the image is converted to JPEG, TIF, or another format compatible with your favorite image editor. However, using RAW converter software such as Adobe Camera Raw (in Photoshop, Elements, or Lightroom) or Sony's Image Data Converter, you can override a RAW photo's settings (such as White Balance and Saturation) by applying other settings in the software.

You can make essentially the same changes there that you might have specified in your camera before taking a photo.

Making changes to settings such as White Balance is a non-destructive process in RAW converter since the changes are made before the photo is fully processed by the software program. Making a change in settings does not affect image quality, except for changes to exposure, highlight or shadow detail, and saturation; the loss of quality is minimal however, unless the changes you make for these aspects are significant.

The RAW format exists because sometimes we want to have access to all the information captured by the camera, before the camera's internal logic has processed it and converted the image to a standard file format. A RAW photo does take up more space than a JPEG and it preserves all the information captured by your camera after it's been converted from analog to digital form. Since we can make changes to settings after the fact while retaining optimal image quality, errors in the settings we made in-camera are much less of a concern than in JPEG capture. When you shoot JPEGs, any modification you make in software is a destructive process; there is always some loss of image quality, although that can be minimal if you make only small changes or are skilled with the use of adjustment layers.

Note too that JPEG provides smaller files by compressing the information in a way that loses some image data. (RAW compression is lossless, however.) The lost data is reconstructed when you open a JPEG in a computer, but this is not a perfect process. If you shoot JPEGs at the highest quality (Fine) level, compression (and loss of data) are minimal; you might not be able to tell the difference between a photo made with RAW capture and a Large/Fine JPEG. If you use the lower quality level, you'll usually notice a quality loss when making big enlargements or after cropping your image extensively.

JPEG was invented as a more compact file format that can store most of the information in a digital image, but in a much smaller size. JPEG predates most digital SLRs, and was initially used to squeeze down files for transmission over slow dialup connections and for use with computers that had one or two GB of storage capacity. These days, we have plenty of storage capacity with 1 to 4 terabyte hard drives, but it's still useful to be able to send JPEG images by e-mail. And you cannot upload a RAW file to a website. Of course you could simply shoot all your photos in RAW format and later convert them to JPEGs of a suitable size.

So, why don't we always use RAW? Although some photographers do save only in RAW format, it's more common to use either RAW plus the JPEG option or to just shoot JPEG and eschew RAW altogether. While RAW is overwhelmingly helpful when an image needs to be modified, working with a RAW file can slow you down significantly. The RAW images take longer to store on the memory card so you cannot shoot as many in a single burst. Also, after you shoot a series, the camera must pause to write them to the memory card so you may not be able to take any shots for a while (or only one or two at a time) until the RAW files have been written to the memory card. When you come home from a trip with numerous RAW files, you'll find they require more

post-processing time and effort in the RAW converter, whether you elect to go with the default settings in force when the picture was taken or make minor adjustments.

As a result, those who often shoot long series of photos in one session, or want to spend less time at a computer, may prefer JPEG over RAW. Wedding photographers, for example, might expose several thousand photos during a bridal affair and offer hundreds to clients as electronic proofs on a DVD disc. Wedding shooters take the time to make sure that their in-camera settings are correct, minimizing the need to post-process photos after the event. Given that their JPEGs are so good, there is little need for them to get bogged down working with RAW files in a computer. Sports photographers also avoid RAW files because of the extra time required for the camera to record a series of shots to a memory card and because they don't want to spend hours in extra post-processing. As a bonus, JPEG files consume a lot loss memory in a hard drive.

As I mentioned earlier, when shooting sports I'll switch to shooting Large/Fine JPEGs (with no RAW file) to minimize the time it takes for the camera to write a series of photos to the card; it's great to be able to take another burst of photos at anytime, with little or no delay. I also appreciate the fact that I won't need to wade through long series of photos taken in RAW format.

In most situations however, I shoot virtually everything as RAW & JPEG. Most of the time, I'm not concerned about filling up my memory cards, as I usually carry at least three 32GB memory cards with me. (A fast SanDisk Extreme 95MB/s card like this costs as little as $50 through some major online retailers in the U.S.) If I know I may fill up all those cards, I'll also carry a tiny battery-operated personal storage device that can copy a typical card in about 15 minutes. On the other hand, on my last trip to Europe, I took only RAW photos and transferred them onto my laptop computer each evening, since I planned on doing at least some post-processing on many of the images for a travel photography book I was working on.

Panorama: Size

Options: Standard, Wide

Default: Standard

This item is available only when the shooting mode is set to Sweep Panorama mode (usually abbreviated as Panorama). This item offers only two options: the default Standard and the optional Wide, which can produce a longer panorama photo.

With the Standard setting, if you are shooting a horizontal panorama, the size of your images will be 8192 × 1856 pixels. If your Standard panorama photos are vertical, the size will be 3872 × 2160 pixels. (The options for panorama direction are covered in the next section.) If you activate the Wide option instead, horizontal panoramas will be at a size of 12416 × 1856 pixels, and vertical panoramas will be 5536 × 2160 pixels. Of course, vertically panned panorama photos are actually "tall" rather than wide regardless of the option you select. Figures 3.4 and 3.5 show the relative proportions of the horizontal and vertical panoramas made in Standard and Wide format.

Figure 3.4 Horizontal wide format (yellow box) and standard format (green box).

Figure 3.5 Vertical "wide" format (yellow box) and standard format (green box).

Panorama: Direction

Options: Right, Left, Up, Down

Default: Right

When the shooting mode is set to Sweep Panorama, this menu item gives you four options for the direction in which the camera will prompt you to pan: right, left, up, or down. You have to select one of these so the camera will know ahead of time how to perform its processing of the many JPEGs you'll shoot while panning; they'll be stitched together into the final panorama photo. The default, right, is probably the most natural way to sweep the camera, at least for those of us who read from left to right. Of course, you may have occasions to use the other options, depending on the scene to be photographed; for a panorama photo of a very tall building, for example, you'd want to use one of the vertical options (up or down).

File Format

Options: AVCHD, MP4

Default: AVCHD

This is the first entry in the Camera Settings 2 menu. (See Figure 3.6.) The a5000 offers full HD (high-definition) video recording in the AVCHD format in addition to the somewhat lesser quality MP4 format. By default, movies are recorded in AVCHD but this menu item allows you to switch to MP4; this is a format that you can edit with many software programs and is more likely to be supported by older computers than AVCHD. The MP4 format is also more "upload friendly;" in other words, it's the format you'll want to use if you plan to post video clips on a website. I'll be discussing this and many other aspects of shooting video clips in Chapter 8.

Record Setting

Options: Varies

Default: 60i (FX) 24M; 60i (FH) 17M; 24p (FX) 24M; 24p (FH) 17M (in AVCHD); 1080 (1440 × 1080) 12M; VGA (640 × 480) 3M (in MP4)

This item allows you to choose from many options if you are using AVCHD but only two options if you set MP4 as the format you'll use. In MP4, the default is 1440 × 1080, 12M (megabits per second) at 30 fps or at 25 fps (frames per second) depending on the country where you bought the camera, with progressive scan. There's an option to shoot VGA (640 × 1080) 3M movies; such videos are really suitable only for web use. If you had set AVCHD with the previous menu item, you get a lot more options, as listed below, all at 1920 × 1080 (also called 1080p or Full HD).

- **60i 24M (Mbps, the average bit rate) FX:** this provides high quality with interlaced scan video
- **60i 17M FH:** the default, this option gives you fine quality, also with interlaced scan
- **24p 24M FX:** this is another option for maximum quality with progressive scan but employs a "cinematic" framing rate
- **24p 17M FH:** expect fine quality with this option, also at a cinematic framing rate and with progressive scan

The quality provided by the default (FH) in AVCHD is very good, but you can get even higher quality with some of the other options and you'll get a "cinematic" feel with a framing rate of 24 fps (or 25 fps). If you use the MP4 format instead, you'll get 30p (30 fps) in NTSC countries and 25p (25 fps) in PAL countries when recording with the high resolution option; the VGA option is always at 30p (30 fps). All of the terminology and concepts will make more sense when you read Chapter 8, which provides more of an education on many aspects of movie making.

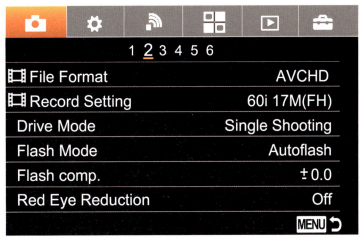

Figure 3.6
File Format is the first entry in the Camera Settings 2 menu.

ONLY 50p AND 50i IN SOME COUNTRIES

In countries where the PAL video format is the standard (including Europe), the a5000 is limited to 50p and 50i instead of the 60p and 60i in countries where NTSC is standard, including North America. (In truth NTSC is an analog format so most countries now use the digital ATSC for broadcasting, but this is only of academic interest.) As well, instead of 24p for a cinematic effect, cameras sold in PAL countries provide 25p. I doubt that you'd be able to see a difference in the quality of the video clips made by an a5000 purchased in Paris or Rio de Janeiro versus one you bought in Los Angeles or Toronto, for example.

Drive Mode

Options: Single Shooting, Cont. Shooting, Spd Priority Cont., Self-timer, Self-timer (Cont), Bracket: Cont., Single Bracket, White Balance Bracket, DRO Bracket

Default: Single Shooting

Just as with the drive (left) button on the back of the camera, there are several choices available through this single menu item. Your choices include:

- **Single shooting.** Takes one shot each time you press the shutter release button.
- **Continuous.** Captures images at a rate of up to 4 frames per second. Exposure and focus will change as necessary for each shot. If you'd like to use the same exposure for subsequent shots, change the AEL w/shutter entry in the Custom Settings 3 menu to Auto or Off.
- **Speed Priority Continuous.** This option allows capturing images at up to 10 fps while the shutter button is held down. However, the display of the scene on the LCD and EVF screen

shows the photo you just took, and not the subject as it appears at that instant. In other words, you do not have "real-time" live view at the very high framing speed. I don't usually find this to be a problem but if you insist on a real-time live view when shooting a fast-moving subject, use the conventional 4 fps drive mode instead.

Exposure and focus for the first shot in the sequence is fixed at the level locked in when the shutter release is pressed down all the way. Thereafter, focus is fixed at that point, but exposure will change if necessary for each shot. If you'd like to use the same exposure for subsequent shots, change the AEL w/shutter entry in the Custom Settings 3 menu to Auto or Off.

- **Self Timer (2 sec./10 sec.).** Takes a single picture after two or ten seconds have elapsed. When this choice is highlighted, press the left/right buttons to toggle between the two durations.
- **Self Timer Continuous.** The self-timer counts down, and then takes either 3 or 5 images. The left/right buttons toggle between the two.
- **Bracket Continuous.** Captures three images in one burst when the shutter release is held down, bracketing them 0.3, 0.7, 1.0, 2.0, or 3.0 stops apart. The left/right buttons are used to select the increment. In Manual Exposure (when ISO Auto is disabled), or in Aperture Priority, the shutter speed will change. If ISO Auto is set in Manual Exposure, the bracketed set will be created by changing the ISO setting. In Shutter Priority, the aperture will change. Use continuous mode when you want all the images in the set to be framed as similarly as possible, say, when you will be using them for manually assembled high dynamic range (HDR) photos.
- **Single Bracket.** Captures one bracketed image in a set of three each time you press the shutter release, bracketing them 0.3, 0.7, 1.0, 2.0, or 3.0 stops apart. The left/right buttons are used to select the increment. In this mode, you can separate each image by an interval of your choice. You might want to use this variation when you want the individual images to be captured at slightly different times, say, to produce a set of images that will be combined in some artistic way.
- **White Balance Bracket.** Shoots three image adjustments to the color temperature. While you can't specify which direction the color bias is tilted, you can select Lo (the default) for small changes, or Hi, for larger changes.
- **DRO Bracket.** Shoots three image adjustments to the dynamic range optimization. While you can't specify the amount of optimization, you can select Lo (the default) for small changes, or Hi, for larger changes.

Flash Mode

Options: Flash Off, Auto Flash, Fill Flash, Slow Sync., Rear Sync.

Default: Depends on shooting mode

This item offers options for the several flash modes that are available. Not all of the modes can be selected at all times as shown in Table 3.2. I'll describe the use of flash in detail in Chapter 10.

Table 3.2 Flash Modes

Exposure Mode	Flash Off	Auto Flash	Fill Flash	Slow Sync.	Rear Sync.	Flash Exposure Compensation	Red-Eye Reduction
Intelligent Auto	Yes	Yes	Yes	No	No	No	Yes
Superior Auto	Yes	Yes	Yes	No	No	No	Yes
Program Auto	No	No	Yes	Yes	Yes	Yes	Yes
Aperture Priority	No	No	Yes	Yes	Yes	Yes	Yes
Shutter Priority	No	No	Yes	Yes	Yes	Yes	Yes
Manual Exposure	No	No	Yes	Yes	Yes	Yes	Yes

Flash Compensation

Options: −2 to +2 in 1/3 EV steps

Default: 0.0

This feature controls the flash output. It allows you to dial in plus compensation for a brighter flash effect or minus compensation for a more subtle flash effect. If you take a flash photo and it's too dark or too light, access this menu item. Scroll up/down to set a value that will increase flash intensity (plus setting) or reduce the flash output (minus setting) by up to two EV (exposure value) steps. Flash compensation is "sticky" so be sure to set it back to zero after you finish shooting. This feature is not available when you're using Intelligent Auto, Superior Auto, Scene, or Sweep Panorama modes. I'll discuss this and many other flash-related topics in detail in Chapter 10.

Red Eye Reduction

Options: On, Off

Default: Off

When flash is used in a dark location, red-eye is common in pictures of people, and especially of animals. Unfortunately, your camera is unable, on its own, to *eliminate* the red-eye effects that occur when an electronic flash bounces off the retinas of your subject's eyes and into the camera lens. The effect is worst under low-light conditions (exactly when you might be using a flash) as the pupils expand to allow more light to reach the retinas. The best you can hope for is to *reduce* or minimize the red-eye effect.

It's fairly easy to remove red-eye effects in an image editor (some image importing programs will do it for you automatically as the pictures are transferred from your camera or memory card to your computer). But, it's better not to have glowing red eyes in your photos in the first place.

To use this feature, you first have to pop up the flash to its active position. When Red Eye Reduction is turned on through this menu item, the flash issues a few brief bursts prior to taking the photo, theoretically causing your subjects' pupils to contract, reducing the red-eye syndrome. Like any such system, its success ratio is not great.

Focus Mode

Options: Single-shot AF (AF-S), Continuous AF (AF-C), DMF (Direct Manual Focus), MF (Manual Focus)

Default: Single-shot AF (AF-S)

This is the first entry in the Camera Settings 3 menu (see Figure 3.7). This menu item can be used to set the way in which the camera focuses. I'll discuss focus options in detail in Chapter 6.

- **Single-shot AF (AF-S).** With this default setting, the camera will set focus and it will keep that focus locked as long as you maintain slight pressure on the shutter release button as discussed in the previous section; even if the subject moves before you take the photo, the focus will stay where it was set.
- **Continuous AF (AF-C).** The camera will continue to adjust the focus if the camera-to-subject distance changes, as when a cyclist approaches your shooting position. The camera will constantly adjust focus to keep the subject sharply rendered. It uses predictive AF to predict the moving subject's position at the time you'll take the next shot and focusing at that distance. This option is useful when you're photographing sports, active children, animals, or other moving subjects, making it possible to get a series of sharply focused shots.

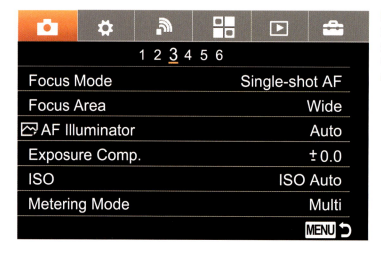

Figure 3.7
Focus Mode is the first entry in the Camera Settings 3 menu.

- **Direct Manual Focus (DMF).** Press the shutter button halfway down to let the camera start the focusing process; then, keeping the button pressed halfway, turn the focusing ring to fine-tune the focus manually. You might want to use DMF when you are focusing from a short distance on a small object, and want to make sure the focus point is exactly where you want it.
- **Manual Focus (MF).** If you select Manual focus, you turn the focusing ring on the lens to achieve the sharpest possible focus. With both DMF and Manual focus, the camera will show you an enlarged image to help with the focusing process, if you have the MF Assist option turned on through the Custom Settings 1 menu (described later).

Focus Area

Options: Wide, Zone, Center, Flexible Spot (Small, Medium, Large)

Default: Wide

When the camera is set to Autofocus, use this menu option to specify where in the frame the camera will focus when you compose a scene. Your options, which I'll explain in Chapter 6 in more detail (including illustrations of the focusing areas) include:

- **Wide.** The camera uses its own electronic intelligence to determine what part of the scene should be in sharpest focus, providing automatic focus point selection. Even if you set one of the other options, Wide is automatically selected in certain shooting modes, including both Auto and all SCN modes.
- **Zone.** Select one of nine focus areas, and the a5000 chooses which section of that zone to use to calculate sharp focus.
- **Center.** Choose this option if you want the camera to always focus on the subject in the center of the frame. Center the primary subject (like a friend's face in a wide-angle landscape composition); allow the camera to focus on it; maintain slight pressure on the shutter release button to keep focus locked; and re-frame the scene for a more effective, off-center, composition. Take the photo at any time and your friend (who is now off-center) will be in the sharpest focus.
- **Flexible Spot.** This mode allows you to move the camera's focus detection point (focus area) around the scene to any one of multiple locations using the directional buttons. When opting for Flexible Spot, you can use the left/right buttons to choose Small, Medium, or Large spots. This mode can be useful when the a5000 is mounted on a tripod and you'll be taking photos of the same scene for a long time, while the light is changing, for example. Move the focus area to cover the most important subject, and it will always focus on that point when you later take a photo.

AF Illuminator

Options: Auto, Off

Default: Auto

The AF illuminator is a red light projector that is activated when there is insufficient light for the a5000's autofocus mechanism to zero in on the subject. This light emanates from the same lamp on the front of the camera that provides the indicator for the self-timer and the Smile Shutter feature. The extra blast from the AF illuminator provides a bright target for the AF system to help the camera set focus.

The default setting, Auto, allows the AF illuminator to work any time the camera judges that it is necessary. Turn it off when you would prefer not to use this feature, such as when you don't want to disturb the people around you or call attention to your photographic endeavors. The AF illuminator doesn't work when the camera is set for manual focus or to AF-C (Continuous autofocus), when shooting movies or panoramas, or in certain other shooting modes, including the Landscape, Night View, or Sports Action varieties of SCN mode.

Exposure Compensation

Options: From +3 to –3

Default: 0.0

If you decide to access this item from the menu instead of using the other available access methods, go into the exposure compensation screen and scroll up/down using the control wheel or the up/down direction buttons. Scroll until you reach the value for the amount of compensation you want to set to make your shots lighter (with positive values) or darker (with negative values). I'll discuss exposure compensation in more detail in Chapter 5.

Remember that any compensation you set will stay in place until you change it, even if the camera has been powered off in the meantime. It's worth developing a habit of checking your display to see if any positive or negative exposure compensation is still in effect; return to 0.0 before you start shooting. Exposure compensation cannot be used when the camera is set to Intelligent Auto, Superior Auto, or one of the SCN modes.

ISO

Options: ISO Auto, options from 100 to 16000

Default: ISO Auto

This menu item can be used to specify the ISO (sensor sensitivity) but not when you're using Panorama mode or fully automatic modes since the camera always uses ISO Auto. One drawback to ISO Auto is that it cannot set an ISO higher than 1600. In a dark location, it's worth switching

to another mode if you need to use ISO 3200 or 6400, for example, to get an adequately fast shutter speed. Note too that ISO Auto is not available in M mode; you must set a numerical value. I'll discuss ISO in more detail in Chapter 5.

Metering Mode

Options: Multi, Center, Spot

Default: Multi

The metering mode determines how the camera will calculate the exposure for any scene. The a5000 is set by default to Multi, which is a multi-zone or multi-segment metering approach. No other options are available in either Auto mode or in SCN modes or when you're using digital zoom or the Smile Shutter.

- **Multi.** Evaluates many segments of the scene using advanced algorithms; often, it will be able to ignore a very bright area or a very dark area that would affect the overall exposure. It's also likely to produce a decent (if not ideal) exposure with a light-toned scene such as a snowy landscape, especially on a sunny day. While it's not foolproof, Multi is the most suitable when you must shoot quickly and don't have time for serious exposure considerations.
- **Center.** Center-weighted metering primarily considers the brightness in a large central area of the scene; this ensures that a bright sky that's high in the frame, for example, will not severely affect the exposure. However, if the central area is very light or very dark in tone, your photo is likely to be too dark or too bright (unless you use exposure compensation).
- **Spot.** When using Spot metering, the camera measures only the brightness in a very small central area of the scene; again, if that area is very light or very dark in tone, your exposure will not be satisfactory; it's important to spot meter an area of a medium tone. You'll learn how metering mode affects exposure in Chapter 5, which covers exposure topics in detail.

White Balance

Options: Auto WB, Daylight, Shade, Cloudy, Incandescent, Fluorescent (4 options), Flash, Underwater Auto, C.Temp/Filter, Custom, Custom Setup

Default: Auto (AWB)

This is the first entry in the Camera Settings 4 menu (see Figure 3.8). The various light sources that can illuminate a scene have light that's of different colors. A household lamp using an old-type (not Daylight Balanced) bulb, for example, produces light that's quite amber in color. Sunlight around noon is close to white but it's quite red at sunrise and sunset; on cloudy days, the light has a bluish bias. The light from fluorescents can vary widely, depending on the type of tube or bulb you're using. Some lamps, including sodium vapor and mercury vapor, produce light of unusual colors.

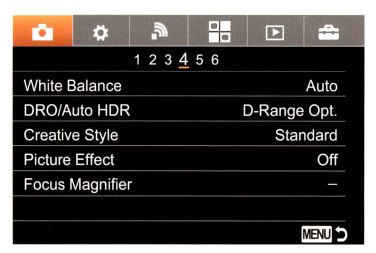

Figure 3.8
White Balance is the first entry in the Camera Settings 4 menu.

The Auto White Balance feature works well with the a5000, particularly outdoors and under artificial lighting that's daylight balanced. Even under lamps that produce light with a slight color cast such as green or blue, you should often get a pleasing overall color balance. One advantage of using AWB is that you don't have to worry about changing it for your next shooting session; there's no risk of having the camera set for, say, incandescent light, when you're shooting outdoors on a sunny day.

The a5000 also lets you choose a specific white balance option—often called a preset—that's appropriate for various typical lighting conditions, because the AWB feature does not always succeed in providing an accurate or the most pleasing overall color balance. Your choices include:

- **Daylight.** Sets white balance for average daylight.
- **Shade.** Compensates for the slightly bluer tones encountered in open shade conditions.
- **Cloudy.** Adjusts for the colder tones of a cloudy day.
- **Incandescent.** Indoor illumination is typically much warmer than daylight, so this setting compensates for the excessive red bias.
- **Fluorescent (four types).** You can choose from Warm White, Cool White, Day White, and Daylight fluorescent lighting.
- **Flash.** Suitable for shooting with the a5000's electronic flash unit.
- **Underwater Auto.** Although you may find a vendor offering an underwater housing for your a5000, it's more likely that your "underwater" shooting will involve photographing fish and other sea life through the glass of an aquarium of the commercial variety. This setting partially tames the blue-green tones you can encounter in such environments (see Figure 3.9, top), producing a warmer tone that some (but not all) may prefer (Figure 3.9, bottom).
- **C.Temp/Filter/Custom/Custom Setup.** These advanced features provide even better results once you've learned how to fine-tune color balance settings, which I'll explain in Chapter 7.

Figure 3.9 The Underwater Auto setting can reduce the blue cast of typical subsurface photos.

When any of the presets are selected, you can press the right button to produce a screen that allows you to adjust the color along the amber (yellow)/blue axis, the green/magenta axis, or both, to fine-tune color rendition even more precisely. The screen shown in Figure 3.10 will appear, and you can use the up/down and left/right buttons to move the origin point in the chart shown at lower right to any bias you want. The amount of your amber/blue and/or green/magenta bias are shown numerically above the chart.

If you shoot in RAW capture, though, you don't have to be quite as concerned about white balance, because you can easily adjust it in your software after the fact. Here again, as with ISO and exposure compensation, the white balance item is not available in either Auto mode or in SCN modes; when you use any of those, the camera defaults to Auto White Balance.

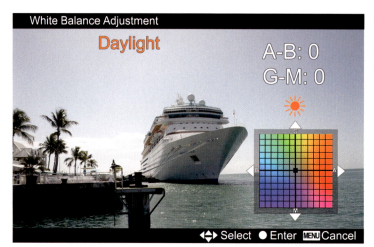

Figure 3.10
Fine-tune the color bias of your images using this screen.

DRO/Auto HDR

Options: D-R Off, DRO Auto, DRO Levels 1-5, AUTO HDR (1-6 EV interval)

Default: DRO Auto

The brightness/darkness range of many images is so broad that the sensor has difficulty capturing detail in both bright highlight areas and dark shadow areas. That's because a sensor has a limited dynamic range. However, the a5000 is able to expand its dynamic range using extra processing when dynamic range optimization (DRO) is active. It's on by default at the Auto level where the camera evaluates the scene contrast and decides how much extra processing to apply; this is the only available setting in certain automatic camera modes. In other modes, you can turn DRO off, or set it manually to one of five intensity levels. There's also an Auto HDR feature discussed in a moment.

When the DRO Auto option is highlighted, you can press the left/right keys to set the DRO to a specific level of processing, from 1 (weakest) to 5 (strongest). You'll find that DRO can lighten shadow areas; it may darken bright highlight areas too, but not to the same extent. By level 3, the photos you take will exhibit much lighter shadow areas for an obviously wide dynamic range; DRO Auto will never provide such an intense increase in shadow detail.

In addition, you'll find the Auto HDR (High Dynamic Range) feature, available only in the P, A, S, M shooting modes (Program, Aperture Priority, Shutter Priority, and Manual). If you select this option instead of DRO, the camera will take three photos, each at a different exposure level, and it will combine them into one HDR photo with lighter shadow areas and darker highlight areas than in a conventional shot. You can control the intensity of this feature. After scrolling to Auto HDR, press the left/right buttons to choose an exposure increment between shots, from 1.0 to 6.0 EV. The one you select will specify the difference in exposure among the three photos it will shoot: 1 EV (minor exposure difference) for a slight HDR effect to 6 EV (a huge exposure difference) for a dramatic high dynamic range effect. If you don't choose a level, the camera selects an HDR level for you. I'll provide tips and examples of DRO and HDR in Chapter 5.

Creative Style

Options: Standard, Vivid, Portrait, Landscape, Sunset, Black & White, Sepia

Default: Standard

This option gives you six different combinations of contrast, saturation, and sharpness: Standard, Vivid, Portrait, Landscape, Sunset, B/W (black-and-white), and Sepia. You can apply Creative Styles when you are using any shooting mode except Superior Auto, Intelligent Auto, or any of the scene modes. I discuss the use of this option in Chapter 5.

Picture Effect

Options: Off, Toy Camera, Pop Color, Posterization, Retro Photo, Soft High-key, Partial Color, High Contrast Monochrome, Soft Focus, HDR Painting, Rich Tone Monochrome, Miniature, Watercolor, Illustration

Default: Off

This camera feature allows you to create JPEG photos with special effects provided by the camera's processor in JPEG capture mode (but not in RAW or RAW & JPEG) when the camera is in P, A, S, or M mode. It's not available for use when shooting movies. Scroll through the options in this item and watch the change in the preview image display that reflects the effect that each option can provide if you activate it; if you find one that looks interesting, press the center button or touch the shutter release button to confirm your choice and return to shooting mode.

When some effects are highlighted, left/right triangles will appear next to their label, indicating you can press the left/right keys to select an option available for that effect. Not all provide this extra benefit.

- **Toy Camera.** Produces images like you might get with a Diana or Holga "plastic" camera, with vignetted corners, image blurring, and bright, saturated colors. It's at Normal by default but when you press the left/right buttons you can select Normal, Cool, Warm, Green, or Magenta.
- **Pop Color.** This setting adds a lot of saturation to the colors, making them especially vivid and rich looking. When used with subjects that have a lot of bright colors, the effect can be dramatic. Duller subjects gain a more "normal" appearance; try using this setting on an overcast day to see what I mean.
- **Posterization.** This option produces a vivid, high-contrast image that emphasizes the primary colors (as shown in Figure 3.11) or in black-and-white, with a reduced number of tones, creating a poster effect. The default rendition is Color, but a monochrome option also appears if you press the left/right keys.
- **Retro Photo.** Adds a faded photo look to the image, with sepia overtones.

Figure 3.11 Posterization creates an image with a reduced number of tones.

- **Soft High-key.** Produces bright images.
- **Partial Color.** Attempts to retain the selected color of an image, while converting other hues to black-and-white. (See Figure 3.12.) It's at Red by default indicating that photos will retain red tones but you can also choose Blue, Green, or Yellow.
- **High contrast Monochrome.** Converts the image to black-and-white and boosts the contrast to give a stark look to the image.
- **Soft Focus.** Creates a soft, blurry effect. It's at Mid by default (for a medium intensity); press the left/right buttons to specify Lo or Hi intensity.
- **HDR Painting.** Produces a painted look by taking three pictures consecutively and then using HDR techniques to enhance color and details. It's at Mid by default (for a medium intensity); press the left/right buttons to specify Lo or Hi intensity. The camera will quickly shoot three photos, at varying exposures, and combine them into one. (This is most suitable for static subjects; do not move the camera until all three shots have been fired.)

Figure 3.12 Partial color provides a monochrome photo but causes one hue to appear in color instead of shades of gray.

- **Rich-tone Monochrome.** Uses the same concept as the one above but creates a long-gradation black-and-white image (by darkening bright areas but keeping dark tones rich) from three consecutive exposures.
- **Miniature.** You select the area to be rendered in sharp focus using the Option button. The effect is similar to the tilt-shift look used to photograph craft models. (See Figure 3.13.) Press the left/right keys to position the blurry area to the left, right, top, bottom, or middle of the image; watch the preview display while scrolling among them to get a feel for the effect that each one can provide.
- **Watercolor.** Creates a look with blurring and runny colors, as if the image were painted using watercolors.
- **Illustration.** Emphasizes the edges of an image to show the outlines more dramatically. The left/right buttons can be used to adjust the effect from Low, to Mid, or High levels.

Figure 3.13 The Miniature effect simulates the use of limited depth-of-field in certain parts of the image to create a special look.

Focus Magnifier

Options: Activate

If you like to focus manually, this is a very useful aid, one of several that Sony generously offers to enhance the chore of achieving sharp focus without using autofocus features. (The others include Manual Focus Assist and Peaking Level.) Unfortunately, Sony has made implementation of this feature rather clumsy, and it can involve visiting as many as four different menu entries scattered among the Camera Settings and Custom Settings menu tabs. I'm going to show you how to simplify the process.

First, know that the focus magnifier is a feature that enlarges the LCD image so you can view the subject you are trying to bring into focus more easily. Activate the magnifier, and the screen image will look something like Figure 3.14. The image is enlarged, and a navigation window appears at lower left showing an orange rectangle that represents the current location of the blown-up section. A quartet of triangles surrounds the image, indicating that you can move the enlarged window around with the frame with the left/right/up/down keys. Pressing the center button enlarges the image from 1x to 6.8x and 13.6x.

That part is easy. The complication comes from the need, by default, to make the trip to menuland to access this feature, and the three additional menu entries needed to configure it. If you'll follow the steps that I outline next, your focus magnifier usage will be greatly simplified. But first, you should know the difference between the three manual focus aids that the a5000 includes:

- **Focus magnifier.** This is a feature that enlarges the LCD image so you can view the subject you are trying to bring into focus more easily. Activate the magnifier using this menu entry or a button you define, and the screen image will look something like Figure 3.14. The image is enlarged, and a navigation window appears at lower left showing an orange rectangle that represents the current location of the blown-up section. A quartet of triangles surrounds the image, indicating that you can move the enlarged window around with the frame with the left/right/

Figure 3.14
The focus magnifier makes manual focusing easier.

up/down keys. Pressing the center button enlarges the image from 1x to 6.8x and 13.6x. Rotate the lens's focus ring to achieve sharp focus. Focus magnifier works only when using manual focus. The advantage/disadvantage of this tool is that you can/must activate it when you want to use it, or set a time limit for its display (described next). If you'd prefer to zoom in only when you specifically want to, use the focus magnifier rather than manual focus assist.

- **Manual focus assist.** This feature, discussed later in this chapter, *automatically* provides a magnification of 6.8x (or 13.6x if you press the center button) when you rotate the lens focus ring while in Manual Focus *or* Direct Manual Focus mode. In that sense, it is easier to use because no special menu or button is needed to activate it and it works with both manual focus modes. However, if you only want to use magnification sometimes, you're better off with the focus magnifier. Visit the Custom Settings 1 menu, change MF Assist to On, and you're all set.
- **Peaking Level.** This option also operates in Manual focus or Direct Manual Focus modes. As I'll describe later, peaking outlines out of focus areas with your choice of red, yellow, or white highlighting. If you zoom in using the focus magnifier or manual focus assist, the colored highlighting is retained. This option is especially useful when attempting to manually focus in dark or dim conditions.

To use the focus magnifier, you can visit a few different menu tabs to configure it before putting it to work for the first time:

1. **Activate Manual Focus.** In the Camera Settings 3 menu, select Focus Mode and choose Manual Focus. You must do this *every* time you want to use the focus magnifier. The magnifier does not work in other focus modes. It is disabled when you've selected AF-S, AF-C, or DMF.
2. **Select activation time.** When you summon the focus magnifier, it will zoom in on your image for the amount of time you specify, then automatically return to full screen view when you're done manually focusing. You can select 2 seconds, 5 seconds, or No Limit. If you select No Limit, the image remains zoomed until you take a picture or press the shutter release halfway. Visit the Custom Settings 1 menu and select the Focus Magnif. Time entry.
3. **Choose an activation button.** The annoying thing about this feature is the need to visit the Camera Settings 4 menu each time you want to activate it. That's because the focus magnifier's "zoom" button (the center button) by default activates the virtual mode dial. It's easy to fix that by assigning focus magnifier to a custom key. Visit the Custom Settings 4 menu, select Custom Key Settings, highlight the ? Button entry, and choose Focus Magnifier as its definition.

 You can assign the focus magnifier to a different button instead, but the Help/Trash button makes the most sense. Once you've learned the functions of your camera, you won't need the ? (Help) button in shooting mode, anyway. And, even if you've redefined the button to summon the focus magnifier, it still functions as a Trash button in playback mode, so you've lost virtually nothing.
4. **Turn on MF Assist and/or Peaking Level (located in the Custom Settings 2 menu).** Set either or both of these if you'd like to use them along with the focus magnifier.

5. **Use the focus magnifier.** Once you've switched to manual focus, set activation time, and defined a button, just press your defined button. There's no need to visit the menu. You'll *still* need to press the center button to zoom in. (Sony should change the camera so that the defined Focus Magnifier button also zooms.) The focus magnifier is released after the specified activation time has elapsed, or when the shutter button is pressed halfway, and after you've taken a shot.

High ISO Noise Reduction

Options: Normal, Low

Default: Normal

This is the first entry in the Camera Settings 5 menu (see Figure 3.15). Digital noise is that awful graininess that shows up as multicolored specks in images, and these menu items help you manage it. In some ways, noise is like the excessive grain found in some high-speed photographic films. However, while photographic grain is sometimes used as a special effect, it's rarely desirable in a digital photograph.

The visual noise-producing process is something like listening to a CD in your car, and then rolling down all the windows. You're adding sonic noise to the audio signal, and while increasing the CD player's volume may help a bit, you're still contending with an unfavorable signal to noise ratio that probably mutes tones (especially higher treble notes) that you really want to hear.

The same thing happens when the analog signal is amplified: You're increasing the image information in the signal, but boosting the background fuzziness at the same time. Tune in a very faint or distant AM radio station on your car stereo. Then turn up the volume. After a certain point, turning up the volume further no longer helps you hear better. There's a similar point of diminishing returns for digital sensor ISO increases and signal amplification as well.

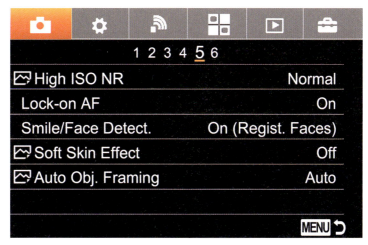

Figure 3.15
The Camera Settings 5 menu.

Your a5000 can reduce the amount of grainy visual noise in your photo with noise reduction processing. That's useful for a smoother look, but NR processing does blur some of the very fine detail in an image along with blurring the digital noise pattern. While noise can be caused by long exposures (a separate issue), too, this entry lets you adjust the amount of processing applied when shooting at a high ISO level (presumably at ISO 1600 and above, as with other Sony cameras, although Sony doesn't specify this for the a5000 camera). You can select Normal (the default) or Low, which offers less reduction, but also preserves more image detail, and reduces the time between shots because less processing must be done.

High ISO NR is grayed out when the camera is set to shoot only RAW format photos. The camera does not use this feature on RAW format photos since noise reduction—at the optimum level for any photo—can be applied in the software you'll use to modify and convert the RAW file to JPEG or TIFF. (If you shoot in RAW & JPEG, the JPEG images, but not the RAW files, will be affected by this camera feature.)

Lock-on AF

Options: On, Off, Start with Shutter

Default: Off

When activated, this setting tells the a5000 to track a moving subject nearest to the camera. When you select this feature from the Camera Settings 5 menu, a white box appears on the LCD. Move the camera to center the box on the subject you want to track and press the center button. The camera will then track that object as you reframe, or the subject moves, until you take a picture.

When the camera is set to AF-S focus mode, only On or Off can be selected. When AF-C is active, a third choice appears, On (Start w/Shutter). That option tells the camera to track a subject when the shutter button is pressed halfway.

Like the Focus Magnifier function, this feature isn't "live" all the time once you've set it. It requires a trip to the Camera Settings 5 menu each time you want to use it, unless you define a custom key to summon it. You can use the Help/Trash button if you don't want to apply it to the Focus Magnifier. Alternatively, choose another button that you don't use much while shooting. In my case, that's the ISO (right directional) button.

Smile/Face Detect.

Options: Face Detection Off, Face Detection On (Registered Faces), Face Detection, Smile Shutter (Normal Smile, Slight Smile, Big Smile)

Default: Off

Your camera can detect faces and zero in its focusing prowess on them. You can also tell the camera to use face detection to identify a face and look for a smile; it takes a photo each time it sees a smile

(actually, just an array of pearly white teeth). This is an interesting high-tech feature, because the subject's smile acts as a sort of remote control.

With this option activated, the camera will survey the subjects before it and try to determine if it is looking at any human faces. If it decides that it is, it sets focus, flash, exposure, and white balance settings for you. When a face is detected, the camera will select a main subject and place a white frame around that face. Press the shutter release halfway, and the frame around the priority face will turn green as the settings lock in. Other faces in the picture will be framed in gray, or, if that face has been logged using Face Registration (described next), a magenta frame will appear. Your options include:

- **Face Detection Off.** Disables all face detection.
- **Face Detection On (Registered Faces).** When set to On (Registered Faces), any faces previously logged will be given priority. As you press the shutter button to take the picture, the camera will attempt to set the exposure and white balance using the face it has selected as the main subject. If that result is not what you want, you can start over, or you may want to take control back from the camera by choosing Flexible Spot or Center for the Autofocus Area and placing the focus spot exactly where you want it. You'll need to register faces you want to recognize separately using a Face Registration option, and even assign a priority for up to eight faces (ranking them 1 to 8 on your face recognition speed dial). Sony has hidden the registration feature, as you might guess by now, in a completely different menu, specifically the Custom Settings 3 menu. Happy hunting! I'll describe the process later in this chapter.
- **Face Detection.** In this mode, the a5000 diligently looks for any human face it can find, and doesn't care who it belongs to. Use this option if you have few friends, or, more than eight that you don't want to offend.
- **Smile Shutter.** Activate this feature, and press the left/right buttons to specify Normal Smile (the default), Big Smile, and Slight Smile. Set Big Smile for example, and the camera won't take a photo when the detected face smiles only slightly; it will wait for a serious toothy grin. You will need to experiment to find out which level to use. The sensitivity of this feature depends on factors such as whether the subject shows his or her teeth when smiling, whether the eyes are covered by sunglasses, and others. I suggest leaving it at Normal Smile, changing it only if that does not work as you had expected.

 There is no limit to the number of smiles and images you can take with this feature; you, or whoever is in front of the camera, can keep smiling repeatedly, and the camera will keep taking more pictures until it runs out of memory storage or battery power. Of course, the main purpose of this feature is not to act as a remote control; it's really intended to make sure your subject is smiling before the photo is taken. Whenever Smile Shutter triggers the shutter release, it also flashes the red light of the AF Illuminator as a signal to the person that a picture is being taken.

Soft Skin Effect

Options: Off/On (Lo, Mid, Hi)

Default: Off

This item can be used to instruct the camera's processor to minimize blemishes and wrinkles in the detected face, which usually helps produce a more flattering picture. (I find it more suitable for photos of women than of men.) If you choose On, press the left/right buttons and select the low, middle, or high intensity for skin softening. This effect does not work when shooting movies or in any continuous shooting mode, including bracketing and continuous self-timer, nor when using the Sports Action scene mode, Sweep Panorama, or RAW capture mode.

Auto Object Framing

Options: Off/Auto

Default: Auto

When this feature is active, the a5000 analyzes three types of images: close-up shots, images taken using Lock-On AF (discussed earlier), and images containing faces (only when Face Detection is activated). When it's On and the camera detects a close-up subject, tracked object, or face, it takes the photo as you composed it but also makes another image and saves that to the memory card as well. This second photo is made after cropping the photo you had composed into one that the camera thinks is a more pleasing composition. If you have Setting Effect On specified in the Live View Display entry of the Custom Settings 2 menu, a white frame appears to show the cropped area before it is stored. The camera's processor uses the Rule of Thirds compositional technique when making its cropping decision so the eyes will not be in the center of the image area, for example.

Since cropping makes the image smaller, the processor adds pixels to ensure that the photo will be full size. It uses Sony's By Pixel Super Resolution Technology for the "up sampling;" this technology maintains very good image quality. Sure, Auto Portrait Framing is a feature intended to attract novices and inveterate snap shooters but I find it useful at parties when taking quick shots of friends; in most cases, the photo with automatic cropping is preferable to the original (sloppily composed) shot. Of course, both photos are available on the memory card so you can use either of them.

SteadyShot

Options: On, Off

Default: On

This is the first entry in the Camera Settings 6 menu (Figure 3.16). The a5000 does not have in-camera image stabilization; to benefit from SteadyShot stabilization, it must be used with a lens that has an OSS (optical stabilizer) designation to supply the anti-shake compensating feature. The OSS lenses are not equipped with a stabilizer on/off switch but you can use this menu item to turn the SteadyShot system off. It's on by default to help counteract image blur that is caused by camera

Figure 3.16
The Camera Settings 6 menu.

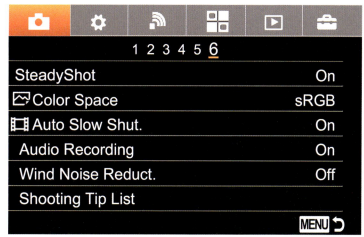

shake, but you should turn it off when the camera is mounted on a tripod, as the additional anti-shake feature is not needed, and slight movements of the tripod can sometimes "confuse" the system. In other situations however, I recommend leaving SteadyShot turned on at all times.

Color Space

Options: sRGB, Adobe RGB

Default: sRGB

This menu item gives you the choice of two different color spaces (also called color gamuts). One is named Adobe RGB, an abbreviation for Adobe RGB (1998), so named because it was developed by Adobe Systems in 1998, and the other is sRGB, supposedly because it is the *standard* RGB color space. These two color gamuts define a specific set of colors that can be applied to the images your Alpha captures.

You're probably surprised that the a5000 doesn't automatically capture all the colors we see. Unfortunately, that's impossible because of the limitations of the sensor and the filters used to capture the fundamental red, green, and blue colors, as well as that of the LEDs used to display those colors on your camera and computer monitors. Nor is it possible to print every color our eyes detect, because the inks or pigments used don't absorb and reflect colors perfectly.

Instead, the colors that can be reproduced by a given device are represented as a color space that exists within the full range of colors we can see. That full range is represented by the odd-shaped splotch of color shown in Figure 3.17, as defined by scientists at an international organization back in 1931. The colors possible with the camera's Adobe RGB option are represented by the larger, black triangle in the figure, while the sRGB gamut is represented by the smaller white triangle. As the illustration indicates, Adobe RGB (1998) is an expanded color space, because it can reproduce a range of colors that is spread over a wider range of the visual spectrum.

ADOBE RGB vs. sRGB

You might want to use sRGB, which is the default for the Sony camera, as it is well suited for the colors displayed on a computer screen and viewed over the Internet.

(It is possible to buy a specialized and very expensive computer monitor that's specifically designed to display nearly the entire Adobe RGB (1998) color gamut, such as the EIZO SX2762W which sells for about $1,500 in the US, but I doubt that many readers own a monitor of that type.) As well, images made in sRGB color space are fine for use with inexpensive inkjet printers that use three ink colors in a single cartridge. Note too that most mass market print-making services (including kiosks and online photofinishers) have standardized on sRGB because that is the color space that 95 percent of their customers use.

Adobe RGB's expanded color space is preferable for professional printing. Because it can reproduce a wider range of colors than sRGB, it's definitely a better choice if you own a high-end inkjet photo printer that employs five or more color ink cartridges. Since pro and custom printing labs also use machines of this type, they'll provide the best results in prints made from images in the Adobe color space. You'll get slightly richer cyan-green mid tones, a bit more detail in dark green tones, and more pleasing orange-magenta highlights (as in a sunset photo).

So, if you often make inkjet prints using a high-end machine, or order prints from custom or pro labs, it makes sense to set the camera to Adobe RGB. Later, if you decide to use some of the photos on a website, you can convert them to sRGB in your image-editing software.

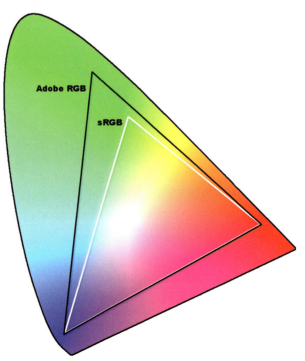

Figure 3.17
The outer figure shows all the colors we can see; the two inner outlines show the boundaries of Adobe RGB (black triangle) and sRGB (white triangle).

Regardless of which triangle—or color space—is used by the Sony a5000, you end up with 16.8 million different colors that can be used in your photograph. (No one image will contain all 16.8 million!) But, as you can see from the figure, the colors available will be different.

Auto Slow Shutter

Options: On, Off

Default: On

When shooting movies in very dark locations, the best way to ensure that the video clips are bright is to use a slow shutter speed. When this menu item is On, the camera can automatically switch to a slower shutter speed than its default. This is a useful feature, since it works in any camera operating mode; there's no need to use S mode and set a slow shutter speed yourself in dark locations.

Audio Recording

Options: On, Off

Default: On

Use this item to turn off sound recording when you're shooting videos, if desired. I have not used this option because I believe in capturing as much information as possible; the audio track can be deleted later, if desired, with software. However, I suppose there could be occasions when it's useful to disable sound recording for movies, if you know ahead of time that you will be dubbing in other sound, or if you have no need for sound, such as when panning over a vista of the Grand Canyon. At any rate, this option is there if you want to use it.

Wind Noise Reduction

Options: On, Off

Default: Off

Designed to muffle the howling sound produced by a loud wind passing over the built-in microphones, this item (when On) is for use when recording video. It's off by default because Wind Noise Reduction (provided by the camera's processor) does degrade sound quality, especially bass tones. As well, it's off because the recording volume is reduced when it's on in a situation where wind noise is not actually present. I would recommend setting it to On only when shooting in a location with loud wind noises.

Shooting Tip List

Options: Table of Contents

Default: None

This item provides access to many brief tutorials with advice on how to take better photos. Scroll down the table of contents to any option, press OK and then scroll to any of the options on the list that appears. Press OK again to view a screen with text and sometimes a sample photo with advice as to technique and/or as to useful a5000 features that you might use to achieve the intended effect. This feature also targets novices but occasionally it's useful for reminding you of a camera feature that you have not yet tried.

Custom Settings Menu

Custom Settings are adjustments that you generally don't make during a particular shooting session, but need to tweak more often than those in the Setup menu (discussed in the next chapter). The Custom Settings are as follows:

- Zebra
- MF Assist
- Focus Magnifier Time
- Grid Line
- Auto Review
- DISP Button
- Peaking Level
- Peaking Color
- Exposure Settings Guide
- Live View Display
- Pre-AF
- Zoom Setting
- Release w/o Lens
- AEL w/shutter
- Self portrait/ -timer
- Superior Auto Image Extraction
- Face Registration
- Custom Key Settings
- MOVIE Button
- AF Micro Adjust
- Lens Compensation

Zebra

Options: OFF, IRE 70, 75, 80, 85, 90, 95, 100, 100+

Default: OFF

This feature, the first entry in the Custom Settings 1 menu (shown in Figure 3.18), warns you when highlight levels in your image are brighter than a setting you specify in this menu option. It's somewhat comparable to the flashing "blinkies" that digital cameras have long used during image review to tell us, after the fact, which highlight areas of the image we just took are blown out.

Zebra patterns are a much more useful tool, because you are given an alert *before* you take the picture, and can actually specify exactly how bright *too bright* is. The Zebra feature has been a staple of professional video shooting for a long time, as you might guess from the moniker assigned to the unit used to specify brightness: IRE, a measure of video signal level, which stands for *Institute of Radio Engineers*.

Figure 3.18
Zebra is the first entry in the Custom Settings 1 menu.

When you want to use Zebra pattern warnings, access this menu entry and specify an IRE value from 70 to 100, plus 100+. Once you've been notified, you can adjust your exposure settings to reduce the brightness of the highlights, as I'll describe in Chapter 5.

So, exactly how bright *is* too bright? A value of 100 IRE indicates pure white, so any Zebra pattern visible when using this setting (or 100+) indicates that your image is extremely overexposed. Any details in the highlights are gone, and cannot be retrieved. Settings from 70–90 can be used to make sure facial tones are not overexposed. As a general rule of thumb, Caucasian skin generally falls in the 80 IRE range, with darker skin tones registering as low as 70, and very fair skin or lighter areas of your subject edging closer to 90 IRE. Once you've decided the approximate range of tones that you want to make sure do *not* blow out, you can set the a5000's Zebra pattern sensitivity appropriately and receive the flashing striped warning on the LCD of your camera. The pattern does not appear in your final image, of course—it's just an aid to keep you from blowing it, so to speak.

MF Assist

Options: On, Off

Default: On

When you are using manual focus or manual focus in the DMF mode, the camera enlarges the screen so you can better judge by eye whether the important part of your subject is in sharp focus. As you begin to focus manually by rotating the focus ring on the lens, the image on the LCD will appear at 6.8 times its normal size; this is called MF Assist. You can then scroll around the image using the four direction buttons. This feature makes it easier to check whether the most important subject area is in the sharpest focus. When you stop turning the focus ring, the image on the LCD display will revert back to normal (non-magnified) so you can see the entire area that the camera will record. You can turn this feature Off however, if you find that you don't need it.

Focus Magnifier Time

Options: 2 Sec., 5 Sec., No Limit

Default: 2 Sec.

This entry, described earlier under Focus Magnifier, can be used to specify the length of time that the MF Assist feature will magnify the image during manual focusing. If you find that it takes you longer than two seconds to manually focus using MF Assist, you can change the time to five seconds, or to No Limit; the latter will cause the image to remain magnified until you press the shutter release button.

Grid Line

Options: Rule of 3rds Grid, Square Grid, Diag.+Square Grid, Off

Default: Off

This feature allows you to activate one of three optional grids, so it's superimposed on the LCD or EVF display. The grid pattern can help you with composition while you are shooting. I sometimes use the Rule of Thirds grid to help with composition, but you might want to activate another option when composing images of scenes that include diagonal, horizontal, and perpendicular lines. (See Figure 3.19.)

Figure 3.19 Grid lines can help you align your images on the LCD.

Auto Review

Options: Off, 2 sec., 5 sec., 10 sec.

Default: 2 sec.

When this item is set to an option other than Off, the Sony a5000 can display an image on the LCD for your review immediately after the photo is taken. (When you shoot a continuous or bracketed series of images, only the last picture that's been recorded will be shown.) During this display, you can delete a disappointing shot by pressing the Delete button (lower soft key), or cancel picture review by tapping the shutter release or performing another function. (You'll never be prevented

from taking another picture because you were reviewing images on your LCD.) This option can be used to specify whether the review image appears on the LCD for 2, 5, or 10 seconds, or not at all.

Depending on how you're working, you might want a brief display or you might prefer to have time for a more leisurely examination (when you're carefully checking compositions). Other times, you might not want to have the review image displayed at all, such as when you're taking photos in a darkened theater or concert venue, and the constant flashing of images might be distracting to others. Turning off picture review or keeping the duration short also saves battery power. You can always review the last picture you took at any time by pressing the Playback button.

DISP Button

Options: Graphic Display, Display All Info., No Disp. Info., Histogram

Default: Graphic Display, Display All Info., No Disp. Info.

Use this item to specify which of the available display options will—and will not—be available in shooting mode when you use the LCD and press the DISP button to cycle through the various displays. (See Figure 3.20.) All of the options except for Histogram are on by default. If you want to add the Histogram as one of the display options, you can do so in this menu item. Scroll to Histogram and press the center button to add a checkmark beside this option.

You can also use this menu item to deselect one or more of the display options so it/they will never appear on the LCD when you press the DISP button. To make that change, scroll to an option and press the center button to remove the checkmark beside it. Naturally, at least one display option must remain selected. If you de-select all of them, the camera will warn you about this and it will not return to shooting mode until you add a checkmark to one of the options. If you turn the a5000 off while none are selected, the camera will interpret this as a Cancel command and return to your most recent display settings.

Figure 3.20
Select which display screens are shown on the LCD.

Here's a recap of the available display options for the monitor:

- **Graphic Display.** When selected, this display shows basic shooting information, plus a graphic display of shutter speed and aperture (except when Sweep Panorama is the mode in use). If you learn how to interpret it, you'll note that it indicates that a fast shutter speed will freeze motion, that a small aperture (large f/number) will provide a great range of acceptably sharp focus, and other information of this type. (See Figure 3.21.)
- **Display All Info.** The default screen when you first turn the camera on, this option displays many items of data about current settings for a complete overview of recording information. (See Figure 3.22.)
- **No Disp. Info.** In spite of its name, this display option provides the basic shooting information as to settings, in a conventional size. (See Figure 3.23.)
- **Histogram.** Activate this option if you want to be able to view a live luminance histogram to assist you in evaluating the exposure before taking a photo, a feature to be discussed in Chapter 5. The basic shooting data will appear in addition to the histogram. (See Figure 3.24.)

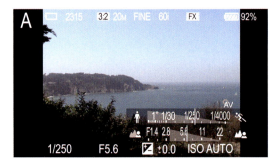

Figure 3.21 Graphic Display.

Figure 3.22 Display All Information.

Figure 3.23 The No Display Information option actually does provide some data.

Figure 3.24 Histogram Display.

Peaking Level

Options: High, Mid, Low, Off

Default: Off

This is the first item in the Custom Settings 2 menu (see Figure 3.25). It is a useful manual focusing aid (available only when focusing in Manual and Direct Manual modes) that's difficult to describe and to illustrate. You're going to have to try this feature for yourself to see exactly what it does. *Focus peaking* is a technique that outlines the area in sharpest focus with a color; as discussed below, that can be red, white, or yellow. The colored area shows you at a glance what will be very sharp if you take the photo at that moment. If you're not satisfied, simply change the focused distance (with manual focus). As the focus gets closer to ideal for a specific part of the image, the color outline develops around hard edges that are in focus. You can choose how much peaking is applied (High, Medium, and Low), or turn the feature off.

Peaking Color

Options: White, Red, Yellow

Default: White

Peaking Color allows you to specify which color is used to indicate peaking when you use manual focus. White is the default value, but if that color doesn't provide enough contrast with a similarly hued subject, you can switch to a more contrasting color, such as red or yellow. (See Figure 3.26 for an example using a white snake.)

Figure 3.25
The Custom Settings 2 menu.

Figure 3.26 You can choose any of three colors for peaking color (for manual focus), but only if you have activated the Peaking Level item. For this white snake, yellow was a better choice than white.

Exposure Settings Guide

Options: On, Off

Default: On

This mystery feature (Sony's manual provides nary a clue as to what sort of "guide" appears when it's enabled) is of most use to those with poor eyesight, but a convenience for all. All it does is show a scrolling scale on the LCD with the current shutter speed or aperture highlighted in orange. It more or less duplicates the display of both that already appears on the bottom line of the screen, but in a larger font and with the next/previous setting flanking the current value. In Aperture Priority, the scale shows f/stops. In Shutter Priority, you see shutter speeds. When using Manual Exposure, the down key alternates between f/stop and shutter speed display. I like to leave it switched on, as the display is a reminder of which parameter I'm fooling with at the moment.

Live View Display

Options: Setting Effect ON, Setting Effect OFF

Default: Setting Effect ON

As a mirrorless camera, the a5000 is always in "live view" mode, showing you what the sensor sees. Sony uses the term in a more precise sense, here: when activated (the default setting), the live preview display in the EVF or the LCD reflects the *exact* effects of any camera features that you're using to modify the view, such as exposure compensation and white balance. This allows for an accurate evaluation of what the photo will look like and enables you to determine whether the current settings will provide the effects you want.

The On option can be especially helpful when you're using any of the Picture Effects, because you can preview the exact rendition that the selected effect and its overrides will provide. It's also very useful when you're setting some exposure compensation, as you can visually determine how much lighter or darker each adjustment makes the image. And when you're trying to achieve correct color balance, it's useful to be able to preview the effect of your white balance setting.

If you'd like to preview the image without the effect of settings visible, you can set this feature to Off. Naturally, the display will no longer accurately depict what your photo will look like when it's taken. So, for most users, On is the most suitable option. Unfortunately, this setting has caused more than a few minutes of head-scratching among new users who switch to Manual Exposure mode and find themselves with a completely black (or utterly white) screen. The black screen, especially, may fool you into thinking your camera has malfunctioned.

Pre-AF

Options: Off, On

Default: Off

This setting tells the camera to attempt to adjust the focus even before you press the shutter button halfway, giving you a head start that's useful for grab shots. When an image you want to capture appears, you can press the shutter release and take the picture a bit more quickly. However, this pre-focus process uses a lot of juice, depleting your battery more quickly, which is why it is turned off by default. Reserve it for short-term use during quickly unfolding situations where the slight advantage can be useful.

Zoom Setting

Options: Optical Zoom Only, ClearImage Zoom, Digital Zoom

Default: Optical Zoom Only

This is the first entry in the Custom Settings 3 menu (see Figure 3.27). The a5000 has three different types of zoom settings: Optical Zoom, ClearImage Zoom, and Digital Zoom, and you can choose any one of them. The last two are not available when using Sweep Panorama, Smile Shutter, or when Image Quality is set to RAW or RAW & JPEG; Metering Mode is locked at Multi, and Focus Area setting is disabled (the focus area frame in the zoomed image is shown by a dotted line). Descriptions of each type of zoom follow.

Optical Zoom Only

This is what you get when you select Optical Zoom Only. Simply turn the zoom ring on the lens (or use the power zoom button on a lens equipped with one, such as the 16-50mm kit lens), or rotate the W/T lever that's concentric with the shutter release. Your zooming is limited to the focal length range(s) provided by the lens mounted on your camera. With the 16-50mm kit lens, you'll get only the field of view offered by the lens, and nothing more. If you have a fixed focal length lens mounted, you get no zooming at all.

This mode provides the best image quality, because the full 20 megapixels of the a5000's sensor are used (when Large Image Size is selected in the Camera 1 menu) to record the photo. The magnification range is determined by the lens itself. For example, the 16-50mm kit lens allows a roughly 1X to 3X zoom range.

You should always use the optical zoom to magnify your image first, before resorting to one of the "fake" zoom options, because optical zoom produces the least amount of image degradation.

Figure 3.27
Custom Settings 3 menu.

Indeed, with a good-quality zoom lens, you may notice little, if any, loss in sharpness as you zoom in and out. Note that if you have selected Optical Zoom Only and set Image Size to Medium or Small, the Smart Zoom version (described next) is available.

ClearImage Zoom

This digital zoom mode varies its magnification effect depending on the Image Size you select in the Camera Settings 1 menu:

Large Image Size. When ClearImage Zoom is activated, rotate the zoom ring on any E-mount zoom lens you have mounted, or use the power zoom switch on lenses that have them (such as the 16-50mm kit lens), or rotate the W/T lever concentric with the shutter release. The a5000 will use image processing to magnify the image, if required. A scale on the LCD is divided into two parts. The left-hand portion shows the amount of optical zoom applied using the actual zooming characteristics of a zoom lens; the focal length (say, 16-50mm) appears under the scale. When the indicator crosses the center portion of the scale, the focal length readout freezes at the maximum focal length of the lens (say, 50mm), and ClearImage Zoom kicks in, and the magnifying glass icon has a "C" next to it to show that additional magnification (from 1X to 2X) is being applied using image processing.

Medium/Small Image Size. However, if you choose Medium or Small Image Size, the zooming begins as before with the left-hand portion of the scale showing the optical zoom range. Once the indicator crosses the center point, the camera will first simply crop the image (without any processing) from 1X to 1.2X (Medium) or 1X to 1.9X (Small). Sony calls this Smart Zoom, and the magnifying glass shows an "S" label. If you continue zooming, then image processing will be used to provide additional zooming from 1.4X to 2.8X (Medium) or 2X to 4X (Small). The magnifying glass icon will then display a "C" to show the processing mode being used.

Clear Image Zoom provides a *simulated* zoom effect that operates even if you don't have a zoom lens! However, you could simply shoot Large JPEGs and later crop them with image-editing software in your computer to make the subject larger in the frame. This automated feature is useful if you do not own a sufficiently long telephoto lens, since it's possible to make a subject larger in the frame.

Digital Zoom

With this variation, the camera gives you even higher magnifications, up to 4X in Large JPEG photos creating more impressive simulated zooming effects to fill the frame with a distant subject. However, the higher the level of digital zoom that you use the greater the loss of image quality will be. That's because the camera crops the photo to simulate the use of a longer lens, discarding millions of pixels; the processor then uses interpolation (adding pixels) to restore the image to its original full size. That works well with Clear Image Zoom but above 2X magnification, the camera's processor can no longer use the most sophisticated technology (which Sony calls Bi-pixel Super Resolution) so the image quality suffers; it gets worse at each higher magnification level.

That's why I recommend leaving the Digital Zoom item at Off and using only Clear Image Zoom unless you absolutely must have greater magnification of a distant subject. If you often need telephoto focal lengths, you might want to save up and add such a lens to your arsenal, perhaps Sony's new 55-210mm f/4.5-6.3 OSS E-mount zoom, with built-in SteadyShot stabilizer. (In the U.S. you can buy this lens for about $350.)

Large Image Size. When Large is selected, Clear Image Zoom magnification, a high-quality image processing algorithm, will be used from 1X to 2X, while from 2.1X to 4X, the reduced image quality process, Digital Zoom, will be activated.

Medium Image Size. Select Medium resolution, and the highest quality Smart Zoom trimming will be applied from 1X to 1.3X, Clear Image Zoom from 1.4X to 2.9X, and Digital Zoom from 3X to 5.6X.

Small Image Size. Select Small and Smart Zoom trimming will be applied from 1X to 1.9X, Clear Image Zoom from 2.0X to 4.0X, and Digital Zoom from 4.1X to 8X.

Release w/o Lens

Options: Disable, Enable

Default: Disable

By default, the a5000 will refuse to try to take a photo when a lens is not mounted on the camera; this is a logical setting. If you choose Enable however, the a5000 will open its shutter when you depress the shutter release button when no lens is mounted. This option will be useful if you attach the camera to some accessory such as a telescope or third-party optic that's not recognized as a lens (perhaps a Lensbaby distortion lens). Otherwise you should leave it disabled to avoid causing problems for your camera's delicate inner workings.

AEL w/Shutter

Options: On, Off

Default: On

This item is On by default so the a5000 can lock the exposure (as well as the focus in AF-S mode) when you apply light pressure to the shutter release button. Point the camera at your primary subject, and maintain contact with the button while reframing for a better composition. This technique will ensure that both focus and exposure are optimized for the primary subject.

Set this item to Off and light pressure on the shutter release button will lock only focus, and not the exposure. After choosing Off, you'll need to depress a defined AEL button (I'll show you how later in this Custom Settings section) when you want to lock the exposure. (Light pressure on the shutter release button will still lock focus.) The only method for locking the exposure will be to press the AEL button you have set up.

You might want to choose the Off option because this will allow you to lock focus on one subject in the scene while locking the exposure for an entirely different part of the scene. To use this technique, focus on the most important subject and keep the focus locked by keeping your finger on the shutter release button while you recompose. You can then point the lens at an entirely different area of the scene to read the exposure, and lock in the exposure with pressure on the AEL button you've defined using the Custom Key Settings option in the Custom Settings 4 menu. Finally, reframe for the most pleasing composition and take the photo.

In your image, the primary subject will be in sharpest focus while the exposure will be optimized for the area that you metered. This technique makes most sense when your primary subject is very light in tone like a snowman or very dark in tone like a black Lab dog. Subjects of that type can lead to exposure errors, so you might want to expose for an area that's a middle tone, such as grass. I'll discuss exposure in detail in Chapter 5; then, the value of this menu option will be more apparent.

Self-Portrait/ -Timer

Options: On, Off

Default: Off

When On, you can quickly take a self-portrait (selfie). Just rotate the LCD screen 180 degrees upward, so it's directed at the front of the camera. That activates the self-timer, and a picture will be taken after three seconds. The LCD image inverts (see Figure 3.28) so you can see how the image is framed. You'll want to use a tripod or other firm support to keep the a5000 aimed appropriately.

Figure 3.28
You don't need a smart phone to shoot a selfie!

Superior Auto Image Extract

Options: Auto, Off

Default: Auto

Superior Auto is much smarter than Intelligent Auto! As you shoot, the a5000 evaluates a scene and selects a relevant SCN mode. If appropriate, the camera can snap off three consecutive shots when the shutter button is pressed, and then choose one or create a composite that has a higher dynamic range or improved digital noise than you'd get with Intelligent Auto alone. By default, only the final image is saved to the memory card, which makes a lot of sense. But if you want the camera to record all three of the photos it fired, as well as the final photo, choose the Off option. **Note:** No composite image can be saved if Image Quality is set to RAW or RAW & JPEG. When using Hand-Held Twilight, only one image is saved, even if this entry is set to Off. With Auto Object Framing active, two images are always saved, even if you select Auto here.

Face Registration

Options: New Registration, Order Exchanging, Delete, Delete All

Default: None

This menu entry is used to log into your camera's Face Detection memory the visages of those you photograph often. New Registration allows you to log up to eight different faces. Line up your victim (subject) against a brightly lit background, to allow easier detection of the face. A white box appears that you can use to frame the face. Press the shutter button. A confirmation message appears (or a Shoot Again warning suggests you try another time). When Register Face? appears, choose Enter or Cancel, and press the MENU button to confirm.

The Order Exchanging option allows you to review and change the priority in which the faces appear, from 1 to 8. The a5000 will use your priority setting to determine which face to focus on if several registered faces are detected in a scene. You can also select a specific face and delete it from the registry (say, you broke up with your significant other!) or delete *all* faces from the registry (your SO got custody of the camera). Face data remains in the camera when you delete individual faces, but is totally erased when you select Delete All.

Custom Key Settings

Options: Definitions for Help/Trash, Center Button, Left/Right/Down Buttons

Default: Various

This is the first entry on the Custom Settings 4 menu (see Figure 3.29). This entry is an essential one, as it allows you to fix what you might consider to be oversights on Sony's part (i.e., lack

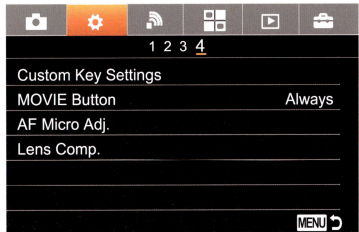

Figure 3.29 The fourth Custom Settings screen.

of an AEL—autoexposure lock—button), or to customize any of four keys so they provide functions that you prefer to have available with a dedicated key. Your custom key definitions override any default definitions for those buttons when in shooting mode; they retain their original functions in playback mode.

The functions you can assign include:

- Standard
- Shoot Mode
- Drive Mode
- Flash Mode
- Flash Compensation
- Focus Mode
- Focus Area
- Exposure Compensation
- ISO
- Metering Mode
- White Balance
- DRO/Auto HDR
- Creative Style
- Picture Effect

- Smile/Face Detect.
- Soft Skin Effect
- Auto Object Framing
- Steady Shot
- Image Size
- Aspect Ratio
- Quality
- In-Camera Guide
- AEL hold
- AEL toggle
- Center Point AEL Hold
- Center Point AEL Toggle
- AF/MF Control Hold
- AF/MF Ctrl Toggle

- Lock-on AF
- AF-On
- Aperture Preview
- Shot. Result Preview
- Focus Magnifier
- Zebra
- Grid Line
- Peaking Level
- Peaking Color
- Send to Smartphone
- Download Application
- Application List
- Monitor Brightness
- Not Set

Note: AEL Hold, Center Point AEL Hold, AF/MF Control Hold can be defined for the Help/Trash and Center Buttons only; Standard can be defined only for the center button.

There are four buttons you can assign specific functions to:

- **Help/Trash.** In shooting mode this button does nothing but produce a help screen, which you probably won't need after you've used the a5000 for a while, so it's ripe for redefinition. You can assign it to a function you use frequently, especially if you want to avoid a special trip to the menus to activate the feature, such as Focus Magnifier or Lock-On Focus.
- **Center Button.** By default, this button summons the virtual mode dial when in shooting mode. If you redefine it to another function, you'll need to visit the Camera Settings 1 menu to select a Shoot mode, or, you can define a different button to serve that function. Because the center button is so easily accessed, use it to adjust settings you use a lot, such as AEL (autoexposure lock).
- **Left.** If you rarely change drive modes, or are willing to visit the menu to do so, feel free to redefine this button. I like to use it for Aperture Preview, which provides a quick depth-of-field preview to show range of sharpness.
- **Right.** Should you rely on Auto ISO, you may not adjust your ISO settings very often, and can redefine this key to serve another function of your choice.
- **Down.** Most of us use exposure compensation frequently to make subsequent pictures darker or lighter, so you'll probably not want to redefine this key. But you can.

VARIATIONS ON A THEME

You have several options for assigning the very useful autoexposure lock (AEL) functions to one of the definable keys.

- **AEL hold.** Exposure is locked while the button is held down.
- **AEL toggle.** The AEL button can be pressed and released, and the exposure remains locked until the button is pressed again.
- **Center Point AEL hold.** Exposure is locked on the center point of the frame while the button is held down.
- **Center Point AEL Toggle.** Toggles exposure lock on/off using the center point of the frame.

MOVIE Button

Options: On, Off

Default: On

Movie recording can be started in any operating mode by pressing the record button. This feature is on by default, but if you find that you occasionally press the button inadvertently, you might want to choose the Off option. After you do so, pressing the button will have no effect; when you want to record a movie you'll need to access this menu item and set it to On.

AF Micro Adjustment

Options: AF Adjustment Setting, Amount, Clear

Default: None

If you've sprung for the $300 (in the US) required to purchase the optional LA-EA2 or LA-EA4 mount adapter and are using A-mount lenses on your a5000, you may find that some slight autofocus adjustment is necessary to fine-tune your lens. This menu item allows choosing a value from –20 (to focus closer to the camera) to +20 (to change the focus point to farther away). You can enable/disable the feature, and clear the value set for each lens. The camera stores the value you dial in for the lens currently mounted on the camera, and can log up to 30 different lenses (but each lens must be different; you can't register two copies of the same lens). Once you've "used up" the available slots, you'll need to mount a lesser-used lens and clear the value for that lens to free up a memory slot. This adjustment works reliably only with Sony, Minolta, and Konica-Minolta A-mount lenses. I'll show you how to use this feature in Chapter 9.

Lens Compensation

Options: Auto, Off

Default: Auto

This trio of menu entries optimizes lens performance by compensating for optical defects; they're useful because very few lenses in the world are even close to perfect in all aspects. All three items work only with E-mount lenses and not when using A-mount lenses with an adapter accessory.

- **Shading compensation.** This is an anti-vignetting correction feature, which can fully or partially compensate for darkened corners produced by some types of lenses, as illustrated in Figure 3.30. Because the default setting is Auto, you may never know that this feature is at work until you turn it off.
- **Chromatic aberration compensation.** This is a type of distortion caused by a lens's failure to focus all colors of light on the same plane. That can cause reduced sharpness or colored fringes along distinct edges in an image. By default, the camera corrects for this aberration, a useful feature in my opinion. (See Figure 3.31.)
- **Lens distortion compensation feature.** This feature corrects the inward or outward bowing of lines at the edges of images, caused by telephoto and wide-angle lenses (respectively). Both forms of distortion can also be fixed (somewhat) in an image editor like Photoshop, but allowing the camera to do so can save a lot of extra work. If the Distortion feature is grayed out with the lens you're using, you'll need to update the camera's firmware. (Newer lenses may not be compatible with Distortion Compensation without a firmware update.)

Figure 3.30 No shading (vignetting) correction (left); shading corrected (right).

Figure 3.31 Chromatic aberration displayed as green fringe (left); chromatic aberration corrected (right).

4

Application, Playback, and Setup Menus

Additional options are available from the Sony a5000's Application, Playback, and Setup menus, which allow you to run mini-programs on your camera; view, print, and protect images; and adjust important camera settings, such as monitor brightness or audio volume.

While the basic functions of the Application menu are covered here, you'll need to absorb Chapter 11, which details using the a5000's wireless capabilities, to take full advantage of the camera's app features. As the Application menu hints, the a5000 is Wi-Fi compatible and can run apps downloaded from the Sony Entertainment app store. In fact, quite a few menu items are relevant to the Wi-Fi feature; they're available only after you have connected the a5000 to a Wi-Fi network.

Application Menu

Unlike many cameras with a Wi-Fi feature, the a5000 can do more than simply transfer photos to a compatible smart device or computer. Connect it to the Internet (as discussed in the Setup menu items under the Network heading) and you can use its simple built-in browser to access the Sony PlayMemories Camera Apps page and download any that are of interest to you.

Set up an account with the Sony Entertainment Network website using your computer or tablet. In North America, you can find that website at http://www.sony.net/pmca. There you fill out an online form and set a password, and download/install a browser add-on. Once you've created an account, you can connect your a5000 to your computer with the included USB cable and download apps directly from your computer through the browser plug-in.

Or, you can establish Wi-Fi communication between your camera and your home network using the Wireless menu as described in Chapter 11, and download apps over your network to the camera without the need for a direct connection to your computer. After the Wi-Fi connection has been made, scroll to Application Menu (see Figure 4.1) where you'll see two choices: Application List and Introduction.

Figure 4.1
The Application menu.

Application List

Options: N/A

Default: N/A

Select Application List and a screen similar to Figure 4.2 appears. It displays any apps you have installed, plus two management entries: PlayMemories Camera Apps and Application Management.

Introduction

Options: Service Introduction, Service Availability

Default: N/A

Introduction provides two sections. Service Introduction shows you where to find the Sony Entertainment website and mentions that it's not available in a few countries; my camera shows www.sony.net/pmca as the shortcut to it. Service Availability provides details as to countries where Sony can supply apps.

Figure 4.2
The Application List.

PlayMemories Camera Apps
Options: N/A

Default: N/A

After you have established Wi-Fi communication and opened an account with the Sony Entertainment Network website, scroll to PlayMemories Camera Apps and press the center button. A screen will appear indicating the camera is searching for an access point (your wireless network). When that's found the screen will display a screen like the one shown in Figure 4.3. You can press the left/right buttons to move between the applications list at right, and the menu icons at left:

- **New.** Displays the most recent (new) apps.
- **All.** Shows all available apps, including free apps.
- **My App.** Shows only the apps installed on your camera.
- **Settings.** Allows you to sign into the Sony network or select your Country/Region.

Figure 4.3
PlayMemories Camera Apps.

Select an app that's already installed and press the center button to activate it. Or, scroll to an app you want to install, such as Picture Effect+ (which is free of charge) and press the center button. On the next screen scroll to Install and press the center button; this takes you to a screen where you enter your e-mail address to start the sign-in process (for the Sony app site). Scroll to the bottom of the page and enter your password in the field that appears, again using the on-screen keyboard that appears after you press the center button. (This is the password you had created with the Sony online app store.) Basically you follow the on-screen process which is quite intuitive although it is tedious to use the on-screen keyboard without a touch-screen LCD.

Scroll to Done and press the center button again. On the following screens agree to everything (if you do want to proceed) and the camera will begin downloading the app. Afterwards you'll see a screen indicating that the installation was successful. Scroll down to Use the Installed App, and it will appear. Picture Effect+ (for example) is similar to what you'd see if you had accessed the camera's conventional Picture Effect item, but there are some entirely new options that you can choose. Scroll among the options and a Help Guide will provide a brief summary of the one you scrolled to.

Application Management

Options: Sort, Manage and Remove, Display Account Information

Default: N/A

This section can be used after you have installed apps; it allows you to sort the apps, manage and remove apps, and to display your account information. (See Figure 4.4.) The latter also provides instructions on how to delete your account; the Initialize > Factory Reset item will do so, in addition to resetting all camera functions to the factory defaults.

Figure 4.4
Application Management.

Playback Menu

This menu controls functions for deleting, protecting, displaying, and printing images. You can bring it up on your screen more quickly by pressing the Playback button first, then the MENU button, which causes the Playback icon to be highlighted on the main menu screen. The first set of items that are visible on the screen when you activate the Playback menu are shown in Figure 4.5.

- Delete
- View Mode
- Image Index
- Display Rotation
- Slide Show
- Rotate
- Enlarge Image
- 4K Still Image Playback
- Protect
- Specify Printing

Delete

Options: Multiple Img, All in Movie or Still Folder, by AVCHD, or by Date

Default: Multiple Img.

Sometimes we take pictures or video clips that we know should never see the light of day. Maybe you were looking into the lens and accidentally tripped the shutter. Perhaps you really goofed up your settings. You want to erase that photo *now,* before it does permanent damage to your reputation as a good photographer. Unless you have turned Auto Review off through the Setup menu, you can delete a photo immediately after you take it by pressing the Trash key (Delete button). Also, you can use that method to delete any individual image that's being displayed on the screen in playback mode.

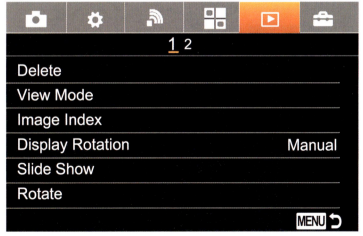

Figure 4.5
Playback 1 menu.

However, sometimes you need to wait for an idle moment to erase all pictures that are obviously not "keepers." This menu item makes it easy to remove selected photos or video clips (Multiple Images), or to erase all the photos or video clips taken, sorted by your currently active view mode (such as folder, or date). (Change the type of view using the View Mode option, described next.) Note that there is no delete method that will remove images tagged as Protected (as described below in the section on "Protect").

To remove one or more images (or movie files), select the Delete menu item, and use the up/down direction buttons or the control wheel to choose the Multiple Images option. Press the center button, and the most recent image *using your currently active view* will be displayed on the LCD.

Scroll left/right through your images and press the center button when you reach the image you want to tag for deletion; a checkmark then appears beside it and an orange checkmark appears in the bottom right corner of the screen. You can press the DISP button to see more information about a particular image.

The number of images marked for deletion is incremented in the indicator at the lower-right corner of the LCD, next to a trash can icon. When you're satisfied (or have expressed your dissatisfaction with the really bad images), press the MENU button, and you will be asked if you're sure you want to proceed. To confirm your decision, press the center button. The images (or video clips) you had tagged will now be deleted. If you want to delete ***everything*** on the memory card, it's quicker to do so by using the Format item in the Setup menu, as discussed later in this chapter.

View Mode

Options: Date View, Folder View (Still), Folder View (MP4), AVCHD View

Default: Folder View (Still)

Adjusts the way the a5000 displays image/movie files, which is useful for reviewing only certain types of files, or for deleting only particular types, as described above. You can elect to display files by Date View, Folder View (still photos only), Folder View (MP4 clips only), or AVCHD View (just AVCHD movies).

Image Index

Options: 12, 30

Default: 12

You can view an index screen of your images on the camera's LCD by pressing the down direction button (Index button) while in playback mode. By default, that screen shows up to 12 thumbnails of photos or movies; you can change that value to 30 using this menu item. Remember to use the View Mode menu item first, to identify the folder (stills, MP4 or AVCHD) that the index display should access; by default, it will show thumbnails of still photos but you might want to view thumbnails of your movie clips instead.

Display Rotation

Options: Manual, Off

You can use this function to determine whether a vertical image is rotated automatically during picture review. The options are somewhat confusingly named, as the Off setting actually means that vertical images *are* automatically rotated:

- **Manual.** With this setting, the image is always displayed on the LCD in the same orientation it was taken. That is, a vertically oriented photo will be displayed as shown at top in Figure 4.6. The image will be smaller in size, but the camera does not have to be tilted to view it. Landscape images are always displayed in landscape mode. You can manually rotate either type of image using the Rotate option discussed later in this section.
- **Off.** With this setting, both vertical and horizontal images are displayed in landscape mode, filling the screen as much as possible with the image. Vertical shots are larger, as shown at bottom in Figure 4.6, but the camera must be rotated.

Figure 4.6
Vertical images can be displayed in their normal orientation (top), or rotated to fill more of the screen (bottom).

Slide Show

Menu Options: Repeat, Interval: 1 second, 3 seconds, 5 seconds, 10 seconds, 30 seconds

Default: 3 seconds

Use this menu option when you want to display all the still images on your memory card in a continuous show. You can display still images in a continuous series, with each one displayed for the amount of time that you set. Choose the Repeat option to make the show repeat in a continuous loop. After making your settings, press the center button and the slide show will begin. You can scroll left or right to go back to a previous image or go forward to the next image immediately, but that will stop the slide show. The show cannot be paused, but you can exit by pressing the MENU button.

Rotate

Options: None

When you select this menu item, you are immediately presented with a new screen showing the current or most recently reviewed image along with an indication that the center button can be used to rotate the image. (This feature does not work with movies.) Scroll left/right to reach the image you want to rotate. Successive presses of the center button will now rotate the image 90 degrees at a time. The camera will remember whatever rotation setting you apply here. You can use this function to rotate an image that was taken with the camera held vertically, when you have set Display Rotation to Manual. Press the MENU button to exit.

Enlarge Image

Options: None

Default: N/A

This is the first entry on the second page of the Playback menu (see Figure 4.7). Whenever you are playing back still images (not movies), you can use this menu entry to magnify the image. Use the W/T (Wide/Telephoto) switch to zoom in and out, and you can scroll around inside the enlarged image using the four direction buttons.

4K Still Image Playback

Options: None

Default: N/A

This menu choice sends JPEG images in 4K format to a compatible 4K television connected using an HDMI cable. It does not work with non 4K HDTV equipment. If you send a RAW image, it will be displayed in HD quality, rather than 4K resolution.

Figure 4.7
The second page of the Playback menu.

Protect

Options: Multiple Images, All with Current View Mode, Cancel All Images

Default: None

You might want to protect certain images or movie clips on your memory card from accidental erasure, either by you or by others who may use your camera from time to time. This menu item enables you to tag one or more images or movies for protection so a delete command will not delete it. (Formatting a memory card deletes everything, including protected content.) This menu item also enables you to cancel the protection from all tagged photos or movies.

To use this feature, make sure to specify whether you want to do so for stills or movies; use the View Mode item in the Playback menu to designate the desired view mode, as described earlier. Then, access the Protect menu item, choose Multiple Images, and press the center button. An image (or thumbnail of a movie) will appear; scroll among the photos or videos to reach the photo you want to tag for protection; press the center button to tag it. (If it's already tagged, pressing the button will remove the tag, eliminating the protection you had previously provided.)

After you have marked all the items you want to protect, press the MENU button to confirm your choice. A screen will appear asking you to confirm that you want to protect the marked images; press the center button to do so. Later, if you want, you can go back and select the Cancel All Images option to unprotect all of the tagged photos or movies.

Specify Printing

Options: Multiple Images, Cancel All, Print Setting

Default: N/A

Most digital cameras are compatible with the DPOF (Digital Print Order Format) protocol, which enables you to tag JPEG images on the memory card (but not RAW files or movies) for printing with a DPOF compliant printer; you can also specify whether you want the date imprinted as well. Afterwards, you can transport your memory card to a retailer's digital photo lab or do-it-yourself kiosk, or use your own DPOF-compatible printer to print out the tagged images in the quantities you've specified.

Choose multiple images using the View Mode filters described earlier to select to view either by Date or by Folder. Press the center button to mark an image for printing, and the MENU button to confirm when you're finished. The Print Setting entry lets you choose to superimpose the date onto the print. The date will be added during printing by the output device, which controls its location on the final print.

Setup Menu

Use the lengthy Setup menu to adjust infrequently changed settings, such as language, date/time, and power saving options. The first five items in the Setup menu are shown in Figure 4.8.

- Monitor Brightness
- Volume Settings
- Audio Signals
- Tile Menu
- Delete Confirm
- Power Save Start Time
- Demo Mode
- HDMI Resolution
- CTRL for HDMI
- USB Connection
- USB LUN Setting
- Language
- Date/Time Setup
- Area Setting
- Format
- File Number
- Select REC Folder
- New Folder
- Folder Name
- Recover Image Database
- Display Media Information
- Version
- Setting Reset

Monitor Brightness

Options: Manual, Sunny Weather

Default: Manual

When you access this menu item, two controls appear. The first is a Brightness bar (shown just above the grayscale/color patches in Figure 4.9). It's set to Manual adjustment by default, but press the center button and you can change it to Sunny Weather for a brighter display. You might resort to this setting if you're shooting outdoors in bright sun and find it hard to view the LCD even when shading it with your hand.

Figure 4.8 The Setup menu.

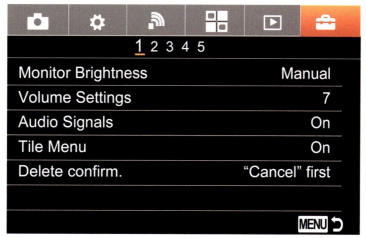

Figure 4.9 Adjust monitor brightness.

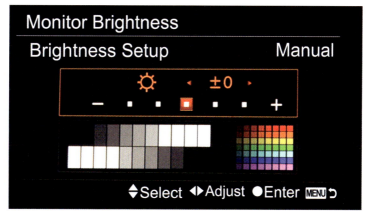

If you set Sunny Weather, the LCD brightness will automatically increase, making the display easier to view in very bright light. This makes the display unusually bright so use it only when it's really necessary. Remember too that it will consume a lot more battery power, so have a spare battery available.

The grayscale steps and color patches can be used as you manually adjust the screen brightness using the left/right direction buttons. Scroll to the right to make the LCD display brighter or scroll to the left to make the LCD display darker, in a range of plus and minus 2 (arbitrary) increments. As you change the brightness, keep an eye on the grayscale and color chart in order to visualize the effect your setting will have on various tones and hues. The zero setting is the default and it provides the most accurate display in terms of exposure, but you might want to dim it when the bright display is distracting while shooting in a dark theater, perhaps. A minus setting also reduces battery consumption but makes your photos appear to be underexposed (too dark).

I prefer to choose Manual but then to leave the display at the zero setting. This ensures the most accurate view of scene brightness on the LCD for the best evaluation of exposure while previewing the scene before taking a photo.

Volume Settings

Options: 0-15

Default: 2

This menu item affects only the audio volume of movies that are being played back in the camera. It's grayed out unless you have selected movies, as opposed to stills, with the Still/Movie Select menu item. When you select Volume Settings, the camera displays a scale of loudness from 0 to 15; scroll up/down to the value you want to set and it will remain in effect until changed.

You might want to use this menu item to pre-set a volume level that you generally prefer. However, you can also adjust the volume whenever you're displaying a movie clip, to set it to just the right level. To do so, press the down direction button and use the up/down direction buttons to raise or lower the volume.

Audio Signals

Options: On, Off

Default: On

Use this item to turn off sound recording when you're shooting videos, if desired. I have not used this option because I believe in capturing as much information as possible; the audio track can be deleted later, if desired, with software. However, I suppose there could be occasions when it's useful to disable sound recording for movies, if you know ahead of time that you will be dubbing in other sound, or if you have no need for sound, such as when panning over a vista of the Grand Canyon. At any rate, this option is there if you want to use it.

Tile Menu

Options: On, Off

Default: On

The Tile menu is a holdover from the NEX era, and features icons representing the six main menu tabs. While it might be marginally useful when you first begin working with your a5000, it's really an unnecessary intermediate step. Turn it Off and when you press the MENU button, you'll be whisked to the conventional menu system, where you can quickly navigate to the tab you want.

Upload Settings

Options: On, Off

Default: On

The Upload Settings for Eye-Fi cards (not shown in Figure 4.8) does not appear in the menu unless you have inserted an Eye-Fi card into the camera's memory card slot. An Eye-Fi card is a special type of SD card that connects to an available wireless (Wi-Fi) network and uploads the images from your memory card to a computer on that network. The Upload Settings option on the Setup menu lets you either enable or disable the use of the Eye-Fi card's transmitting capability. So, if you want to use an Eye-Fi card just as an ordinary SD card, simply set this item to Off, which saves a bit of power drawn by the card's Wi-Fi circuitry.

Delete Confirm

Options: Delete First, Cancel First

Default: Cancel First

Determines which choice is highlighted when you press the trash button to delete an image. The default Cancel First is the safer option, as you must deliberately select Delete and then press the center button to actually remove an image. Delete First is faster; press the trash button, then the center button, and the unwanted image is gone. You'd have to scroll down to Cancel if you happened to have changed your mind or pressed the trash button by mistake.

Power Save Start Time

Options: 30 minutes, 5 minutes, 2 minutes, 1 minute, 10 seconds

Default: 1 minute

This is the first item on the second page of the Setup menu. (See Figure 4.10.) This item lets you specify the exact amount of time that should pass before the camera goes to "sleep" when not being used. The default of 1 minute is a short time, useful to minimize battery consumption. You can select a much longer time before the camera will power down, or a much shorter time.

Demo Mode

Options: On, Off

Default: Off

This is a semi-cool feature that allows your camera to be used as a demonstration tool, say, when giving lectures or showing off at a trade show. When activated, if the camera is idle for about one minute it will begin showing a protected AVCHD movie, which is not impressive on the camera's built-in LCD, but can have a lot more impact if the a5000 is connected to a large-screen HDTV through the HDMI port.

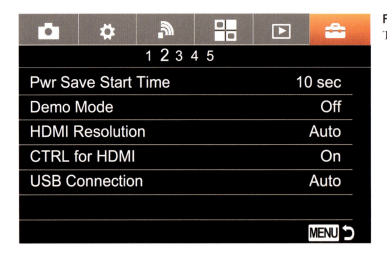

Figure 4.10
The Setup 2 menu.

Just follow these steps:

1. Use the File Format entry in the Camera Settings 2 menu and select AVCHD as the movie format, as explained in Chapter 3. Demo Mode works only with AVCHD files.
2. Shoot the clip that you want to use as your demonstration, in AVCHD format.
3. In the Playback 1 menu, access the View Mode and select AVCHD View so that only AVCHD videos will appear.
4. In the Playback 2 menu, choose Protect and select the demo clip, which should be the movie file with the oldest recorded date and time.
5. Connect the a5000 to the optional AC-PW20 AC adapter. Because Demo Mode uses a lot of juice, it operates only when the external power source is connected.
6. Demo Mode will no longer be grayed out in the Setup 2 menu. Select it and choose On.
7. After about one minute of idling, the demo clip will begin playing. Note that, because the AC adapter is connected, your automatic power saving setting is ignored, and that Demo Mode will not operate if no movie file is stored on your memory card.

HDMI Resolution

Options: Auto, 1080p, 1080i

Default: Auto

The camera can adjust its output for display on a high-definition television when at the Auto setting. This usually works well with any HDTV. If you have trouble getting the image to display correctly, you can set the resolution manually here to 1080p or to 1080i; the latter should work fine with any HDTV.

CTRL for HDMI

Options: On, Off

Default: On

You can view the display output of your camera on a high-definition television (HDTV) when you connect it to the a5000 if you make the investment in an HDMI cable (which Sony does not supply); get the Type C with a mini-HDMI connector on the camera end. (Still photos can also be displayed using Wi-Fi, without cable connection, as discussed earlier.) When connecting HDMI-to-HDMI, the camera automatically makes the correct settings. If you're lucky enough to own a TV that supports the Sony Bravia synchronization protocol, you can operate the camera using that TV's remote control when this item is On. Just press the Link Menu button on the remote, and then use the device's controls to delete images, display an image index of photos in the camera, display a slide show, protect/unprotect images in the camera, specify printing options, and play back single images on the TV screen.

The CTRL for HDMI option on the Setup menu can also be useful when you have connected the camera to a non-Sony HDTV and find that the TV's remote control produces unintended results with the camera. If that happens, try turning this option Off, and see if the problem is resolved. If you later connect the camera to a Sony Bravia sync-compliant HDTV, set this menu item back to On.

USB Connection

Options: Auto, Mass Storage, MTP, PC Remote

Default: Auto

This entry allows you to select the type of USB connection protocol between your camera and computer.

- **Auto.** Connects your a5000 to your computer or other device automatically, choosing either Mass Storage or MTP connection as appropriate.
- **Mass Storage.** In this mode, your camera appears to the computer as just another storage device, like a disk drive. You can drag and drop files between them.

- **MTP.** This mode, short for Media Transfer Protocol is a newer version of the PTP (Picture Transfer Protocol) that was standard in earlier cameras. It allows better two-way communication between the camera and the computer and is useful for both image transfer and printing with PictBridge compatible printers.
- **PC Remote.** This setting is used with Sony's Remote Camera Control software to adjust shooting functions and take pictures from a linked computer.

USB LUN Setting

Options: Multi, Single

Default: Multi

This setting, the first on the Setup 3 menu (see Figure 4.11), specifies how the a5000 selects a Logical Unit Number when connecting to a computer through the USB port. Normally, you'd use Multi, which allows the camera to adjust the LUN as necessary, and is compatible with the PlayMemories Home software. Use Single to lock in a LUN if you have trouble making a connection between your camera and a particular computer. PlayMemories Home software will usually not work when this setting is active. But don't worry; Single is rarely necessary.

Language

Options: English, French, Spanish, Italian, Japanese, Chinese languages

Default: Language of country where camera is sold

If you accidentally set a language you cannot read and find yourself with incomprehensible menus, don't panic. Just find the Setup menu, the one with the red tool box for its icon, and scroll down to the line that has a symbol that looks like an alphabet block "A" to the left of the item's heading. No

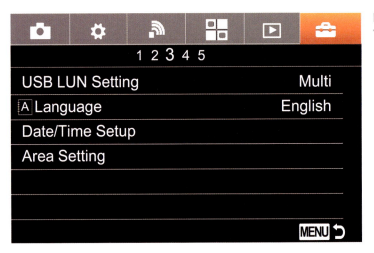

Figure 4.11
The Setup 3 menu.

matter which language has been selected, you can recognize this menu item by the "A". Scroll to it, press the center button to select this item and scroll up/down among the options until you see a language you can read.

Date/Time Setup

Options: Year, Day, Month, Hour, Minute, Date Format, Daylight Savings Time

Default: None

Use this option to specify the date and time that will be embedded in the image file along with exposure information and other data. Having the date set accurately also is important for selecting movies for viewing by date. Use the left/right direction buttons to navigate through the choices of Daylight Savings Time On/Off; year; month; day; hour; minute; and date format. You can't directly change the AM/PM setting; you need to scroll the hours past midnight or noon to change that setting. Use the up/down direction buttons or rotate the control wheel to change each value as needed.

Area Setting

Options: World time zones

Default: None

When you select this option, you are presented with a world map on the LCD. Use the left/right direction buttons to scroll until you have highlighted the time zone that you are in. Once the camera is set up with the correct date and time in your home time zone, you can use this setting to change your time zone during a trip, so you will record the local time with your images without disrupting your original date and time settings. Just scroll back to your normal time zone once you return home.

Format

Options: OK, Cancel

Default: None

This is the first entry on the Setup 4 menu. (See Figure 4.12.) As you'd guess, you'll use Format to reformat your memory card while it's in your a5000. To proceed with this process, choose the Format menu item and select "OK" and press the center button to confirm, or Cancel to chicken out.

Use the Format command to erase everything on your memory card and to set up a fresh file system ready for use. This procedure removes all data that was on the memory card, and reinitializes the card's file system by defining anew the areas of the card available for image storage, locking out defective areas, and creating a new folder in which to deposit your images. It's usually a good idea

Figure 4.12
The Setup 4 menu.

to reformat your memory card in the camera (not in your camera's card reader using your computer's operating system) before each use. Formatting is generally much quicker than deleting images one by one. Before formatting the card however, make sure that you have saved all your images and videos to another device; formatting will delete everything, including images that were protected.

File Number

Options: Series, Reset

Default: Series

The default for the File Number item is Series, indicating that the a5000 will automatically apply a file number to each picture and video clip that you make, using consecutive numbering; this will continue over a long period of time, spanning many different memory cards, and even if you reformat a card. Numbers are applied from 0001 to 9999; when you reach the limit, the camera starts back at 0001. The camera keeps track of the last number used in its internal memory. So, you could take pictures numbered as high as 100-0240 on one card, remove the card and insert another, and the next picture will be numbered 100-0241 on the new card. Reformat either card, take a picture, and the next image will be numbered 100-0242. Use the Series option when you want all the photos you take to have consecutive numbers (at least, until your camera exceeds 9999 shots taken).

If you want to restart numbering back at 0001 frequently, use the Reset option. In that case, the file number will be reset to 0001 *each* time you format a memory card or delete all the images in a folder, insert a different memory card, or change the folder name format (as described in the next menu entry). I do not recommend this since you will soon have several images with exactly the same file number.

Select REC Folder

Options: Folder

Default: None

This entry allows you to create a new storage folder. Although your a5000 will create new folders automatically as needed, you can create a new folder at any time, and switch among available folders already created on your memory card. (Of course, a memory card must be installed in the camera.) This is an easy way to segregate photos by folder. For example, if you're on vacation, you can change the Folder Name convention to Date Form (described next). Then, each day, create a new folder (with that date as its name), and then deposit that day's photos and video clips into it. A highlighted bar appears; press the up/down buttons to select the folder you want to use, and press the center button.

New Folder

Options: N/A

Default: None

This item will enable you to create a brand new folder. Press the center button, and a message like "10100905 folder created" or "102MSDCF folder created" appears on the LCD. The alphanumeric format will be determined by the Folder Name option you've selected (and described next), either Standard Form or Date Form.

Folder Name

Options: Standard Form, Date Form

Default: Standard Form

If you have viewed one of your memory card's contents on a computer, you noticed that the top-level folder on the card is always named DCIM. Inside it, there's another folder created by your camera. Different cameras use different folder names, and they can coexist on the same card. For example, if your memory card is removed from your Sony camera and used in, say, a camera from another vendor that also accepts Secure Digital or Memory Stick cards, the other camera will create a new folder using a different folder name within the DCIM directory.

By default, the Alpha creates its folders using a three-number prefix (starting with 100), followed by MSDCF. As each folder fills up with 999 images, a new folder with a prefix that's one higher (say, 101) is used. So, with the "Standard Form," the folders on your memory card will be named 100MSDCF, 101MSDCF, and so forth.

You can select Date Form instead, and the Alpha will use a *xxxymmdd* format, such as 10040904, where the 100 is the folder number, 4 is the last digit of the year (2014), 09 is the month, and 04 is the day of that month. If you want the folder names to be date-oriented, rather than generic, use the Date Form option instead of Standard Form. This entry allows you to switch back and forth between them, both for folder creation (using the New Folder entry described above) and REC folder preference (also described above).

> **Tip**
>
> Whoa! Sony has thrown you a curveball in this folder switching business. Note that if you are using Date Form naming, you can *create* folders using the date convention, but you can't switch among them—but only when Date Form is active. If you *do* want to switch among folders named using the date convention, you can do it. But you have to switch from Date Form back to Standard Form. *Then* you can change to any of the available folders (of either naming format). So, if you're on that vacation, you can select Date Form, and then choose New Folder each day of your trip, if you like. But if, for some reason, you want to put some additional pictures in a different folder (say, you're revisiting a city and want the new shots to go in the same folder as those taken a few days earlier), you'll need to change to Standard Form, switch folders, and then resume shooting. Sony probably did this to preserve the "integrity" of the date/folder system, but it can be annoying.

Recover Image Database

Options: OK, Cancel

Default: None

The Recover Image DB function is provided in case errors crop up in the camera's database that records information about your movies. According to Sony, this situation may develop if you have processed or edited movies on a computer and then resaved them to the memory card that's in your camera. I have never had this problem, so I'm not sure exactly what it would look like. But, if you find that your movies are not playing correctly in the camera, try this operation. Highlight this menu option and press the center button, and the camera will prompt you, "Check Image Database File?" Press the center button to confirm, or the MENU button to cancel.

Display Media Information

Options: None

Default: None

This entry, the first on the Setup 5 menu (see Figure 4.13), gives you a report of how many still images and how many movies can be recorded on the memory card that's in the camera, given the current shooting settings. This can be useful, but that information is already displayed on the screen when the camera is being used to shoot still photos (unless you have cycled to a display with less information), and the information about minutes remaining for movie recording is displayed on the screen as soon as you press the Record button. But, if you want confirmation of this information, this menu option is available.

Version

Options: None

Select this menu option to display the version number of the firmware (internal operating software) installed in your camera. From time to time, Sony updates the original firmware with a newer version that adds or enhances features or corrects operational bugs. When a new version is released, it will be accompanied by instructions, which generally involve downloading the update to your computer and then connecting your camera to the computer with the USB cable to apply the update. It's a good idea to check occasionally at the Sony website, www.esupport.sony.com, to see if a new version of the camera's firmware is available for download. (You can also go to that site to download updates to the software that came with the camera, and to get general support information.)

Figure 4.13
The Setup 5 menu.

Setting Reset

Options: Reset Default, Factory Reset

Default: Reset

If you've made a lot of changes to your a5000's settings, you may want to return their features to their defaults so you can start over without manually going back through the menus and restoring everything. This menu item lets you do that. Your choices are as follows:

- **Camera Settings Reset.** Resets the main shooting settings to their default values.
- **Initialize.** Resets *all* camera settings to their default settings, including the time/date and downloaded applications, but *not* including any AF Micro Adjustments you may have dialed in.

5

Shooting Modes and Exposure Control

When you bought your Sony a5000, you probably considered your days of worrying about getting the correct exposure were over. To paraphrase an old Kodak tagline dating back to the 19th Century—the goal is, "you press the button, and the camera does the rest." For the most part, that's a realistic objective. The a5000 is definitely intelligent when it comes to calculating the right exposure for most situations, using its default metering mode, Multi. You can generally choose one of the Auto or SCN modes, or spin the virtual mode selector to Program (P), Aperture Priority (A), or Shutter Priority (S), and shoot away.

So, why am I including an entire chapter on exposure? As you learn to use your a5000 creatively, you're going to find that the right settings—as determined by the camera's exposure meter and artificial intelligence—need to be *adjusted* sometimes to account for your creative decisions or special situations.

For example, when you shoot with the main light source behind the subject, you end up with *backlighting*, which can result in an overexposed background and/or an underexposed subject in such high contrast lighting. The Sony recognizes backlit situations, and does to some extent, compensate for them to produce a decent photo. Even so, a feature such as Dynamic Range Optimizer (discussed later) can be useful for preserving detail in especially the shadow areas of the image.

But what if you *intend* to underexpose the subject, to produce a silhouette effect? Or, perhaps, you might want to use the camera's flash to fill in (lighten) the shadows on your subject. The more you know about how to use your a5000, the more you'll run into situations where you'll decide to creatively tweak the exposure to provide a different look than you'd get with a straight shot.

This chapter discusses the fundamentals of exposure, so you'll be better equipped to override the a5000's default settings when you want to, or need to. After all, correct exposure is one of the foundations of good photography, along with accurate focus and sharpness, appropriate overall color balance, and freedom from unwanted noise and excessive contrast, as well as pleasing composition.

The a5000 gives you a great deal of control over all of these, although composition is entirely up to you. You must still frame the photograph to create an interesting arrangement of subject matter, but all the other parameters are basic functions of photography. You can let your camera set them for you automatically, you can fine-tune how the camera applies its automatic settings, or you can make them yourself, manually. The amount of control you have over exposure, sensitivity (ISO levels), white balance, focus, and image parameters like sharpness, color saturation, and contrast make the a5000 a versatile tool for creating images.

In the next few pages I'm going to give you a grounding in one of those foundations, and explain the basics of exposure, either as an introduction or as a refresher course, depending on your current level of expertise. When you finish this chapter, you'll understand most of what you need to know to take well-exposed photographs creatively in a broad range of situations.

Getting a Handle on Exposure

In the most basic sense, exposure is all about light. Exposure can make or break your photo. Correct exposure brings out the detail in the areas you want to picture, providing the range of tones and colors you need to create the desired image. Poor exposure can cloak important details in murky shadow, or wash them out in glare-filled featureless expanses of white. However, getting the perfect exposure requires some intelligence—either that built into the camera or the smarts in your head—because digital sensors can't capture all the tones we are able to see. If the range of tones in an image is extensive, embracing both inky black shadows and bright highlights, we often must settle for an exposure that renders most of those tones—but not all—in a way that best suits the photo we want to produce.

For example, look at two exposures presented in Figure 5.1. For the image on the left, the highlight areas (chiefly the clouds at upper left and the top-left edge of the skyscraper) are well exposed, but everything else in the shot is seriously underexposed. The version on the right, taken an instant later with the tripod-mounted camera, shows detail in the shadow areas of the buildings, but the highlights are completely washed out. The camera's sensor simply can't capture detail in both dark areas and bright areas in a single shot.

With digital camera sensors, it's often tricky to capture detail in both highlights and shadows in a single image, because the number of tones, the *dynamic range* of the sensor, is limited. The solution, in this particular case, was to resort to a technique called High Dynamic Range (HDR) photography, in which the two exposures from Figure 5.1 were combined in an image editor such as Photoshop, or a specialized HDR tool like Photomatix (about $100 from www.hdrsoft.com).

The resulting shot is shown in Figure 5.2. The Auto HDR feature of your a5000, found in the DRO/Auto HDR entry of the Camera Settings 4 menu, lets you accomplish a decent approximation of HDR processing right in the camera. For now, though, I'm going to concentrate on showing you how to get the best exposures possible without resorting to such tools, using only the ordinary exposure related features of your a5000.

Figure 5.1 At left, the image is exposed for the highlights, losing shadow detail. At right, the exposure captures detail in the shadows, but the highlights are washed out.

Figure 5.2 Combining the two exposures in HDR software produces the best compromise image.

To understand exposure, you need to appreciate the aspects of light that combine to produce an image. Start with a light source—the sun, a household lamp, or the glow from a campfire—and trace its path to your camera, through the lens, and finally to the sensor that captures the illumination. Here's a brief review of the things within our control that affect exposure, listed in "chronological" order (that is, as the light moves from the subject to the sensor):

- **Light at its source.** Our eyes and our cameras—film or digital—are most sensitive to that portion of the electromagnetic spectrum we call visible light. That light has several important aspects that are relevant to photography, such as color and harshness (which is determined primarily by the apparent size of the light source as it illuminates a subject). But, in terms of exposure, the important attribute of a light source is its intensity. We may have direct control over intensity, which might be the case with an interior light that can be brightened or dimmed. Or, we might have only indirect control over intensity, as with sunlight, which can be made to appear dimmer by introducing translucent light-absorbing or reflective materials in its path.

- **Light's duration.** We tend to think of most light sources as continuous. But, as you'll learn in Chapter 10, the duration of light can change quickly enough to modify the exposure, as when the main illumination in a photograph comes from an intermittent source, such as an electronic flash.

- **Light reflected, transmitted, or emitted.** Once light is produced by its source, either continuously or in a brief burst, we are able to see and photograph objects by the light that is reflected from our subjects toward the camera lens; transmitted (say, from translucent objects that are lit from behind); or emitted (by a candle or television screen). When more or less light reaches the lens from the subject, we need to adjust the exposure. This part of the equation is under our control to the extent we can increase the amount of light falling on or passing through the subject (by adding extra light sources or using reflectors), or by pumping up the light that's emitted (by increasing the brightness of the glowing object).

- **Light passed by the lens.** Not all the illumination that reaches the front of the lens makes it all the way through. Filters can remove some of the light before it enters the lens. Inside the lens barrel is a variable-sized diaphragm that dilates and contracts to produce an aperture that controls the amount of light that enters the lens. You, or the Alpha's autoexposure system, can vary the size of the aperture to control the amount of light that will reach the sensor. The relative size of the aperture is called the f/stop. (See Figure 5.3, which is a graphic representation of the relative size of the lens opening, not an actual photo of the aperture of a lens.)

- **Light passing through the shutter.** Once light passes through the lens, the amount of time the sensor receives it is determined by the a5000's shutter; this mechanism can remain open for as long as 30 seconds (or even longer if you use camera's Bulb setting) or as briefly as 1/4,000th second.

Figure 5.3
Top row (left to right): f/2, f/2.8, f/4; bottom row, f/5.6, f/8, f11.

- **Light captured by the sensor.** Not all the light falling onto the sensor is captured. If the number of photons reaching a particular photosite doesn't pass a set threshold, no information is recorded. Similarly, if too much light illuminates a pixel in the sensor, then the excess isn't recorded or, worse, spills over to contaminate adjacent pixels. We can modify the minimum and maximum number of pixels that contribute to image detail by adjusting the ISO setting. At higher ISO levels, the incoming light is amplified to boost the effective sensitivity of the sensor.

These four factors—quantity of light, light passed by the lens, the amount of time the shutter is open, and the sensitivity of the sensor—all work proportionately and reciprocally to produce an exposure. That is, if you double the amount of light, increase the aperture size by one stop, make the shutter speed twice as long or double the ISO, you'll get twice as much exposure. Similarly, you can reduce any of these and reduce the exposure when that is preferable.

As we'll see however, changing any of those aspects in P, A, or S mode does not change the exposure; that's because the camera also makes changes when you do so, in order to maintain the same exposure. That's why Sony provides other methods for modifying the exposure in those modes.

> **F/STOPS AND SHUTTER SPEEDS**
>
> Especially if you're new to advanced cameras, it's worth quickly reviewing some essential concepts. For example, the lens aperture, or f/stop, is a ratio, much like a fraction, which is why f/2 is larger than f/4, just as 1/2 is larger than 1/4. However, f/2 is actually *four times* as large as f/4. (Think back to high school geometry where we learned that to double the area of a circle, you multiply its diameter by the square root of two: 1.4.)
>
> The full f/stops available with an f/2 lens are f/2, f/2.8, f/4, f/5.6, f/8, f/11, f/16, and f/22. Each higher number indicates an aperture that's half the size of the previous number. Hence, it admits half as much light as the one before, as shown in Figure 5.3. (Of course, you can also set intermediate apertures with the a5000 such as f/6.3 and f/7.1, both falling between f/5.6 and f/8.)
>
> Shutter speeds are actual fractions (of a second), so that 1/60, 1/125, 1/250, 1/500, 1/1000, and so forth represent 1/60th, 1/125th, 1/250th, 1/500th, and 1/1000th second. Each higher number indicates a shutter speed that's half as long as the one before. (And yes, intermediate shutter speeds can also be used, such as 1/640 or 1/800th second.) To avoid confusion, the Sony uses quotation marks to signify long exposures: 0.8", 2", 2.5", 4", and so forth; these examples represent 0.8, 2 second, 2.5 second, and 4 second exposures, respectively.

Equivalent Exposure

One of the most important aspects in this discussion is the concept of "equivalent exposure." This term means that exactly the same amount of light will reach the sensor at various combinations of aperture and shutter speed. Whether we use a small aperture (large f/number) with a long shutter speed or a wide aperture (small f/number) with a fast shutter speed, the amount of light reaching the sensor can be exactly the same. Table 5.1 shows equivalent exposure settings using various shutter speeds and f/stops; in other words, any of the combination of settings listed will produce exactly the same exposure.

When you set the a5000 to P mode, the camera sets both the aperture and the shutter speed that should provide a correct exposure, based on guidance from the light metering system. In P mode, you cannot change the aperture or the shutter speed individually, but you can shift among various aperture/shutter speed combinations by rotating the control wheel. And if you change the ISO, the camera will set a different combination automatically. As the concept of equivalent exposure indicates, the image brightness will be exactly the same in every photo you shoot with the various combinations because they all provide the same exposure.

In Aperture Priority (A) and Shutter Priority (S) modes, you can change the aperture or the shutter speed, respectively. The camera will then change the other factor to maintain the same exposure. I'll cover all of the operating modes and the important aspects of exposure with each mode in this chapter.

Table 5.1 Equivalent Exposures

Shutter speed	f/stop	Shutter speed	f/stop
1/30th second	f/22	1/250th second	f/8
1/60th second	f/16	1/500th second	f/5.6
1/125th second	f/11	1/1,000th second	f/4

How the a5000 Calculates Exposure

Your camera calculates exposure by measuring the light that passes through the lens and reaches the sensor, based on the assumption that each area being measured reflects about the same amount of light as a neutral gray card that reflects a "middle" gray of about 12- to 18-percent reflectance. (The photographic "gray cards" you buy at a camera store have an 18-percent gray tone; your camera is calibrated to interpret a somewhat darker 12-percent gray. I'll explain more about this later.) That "average" 12- to 18-percent gray assumption is necessary, because different subjects reflect different amounts of light. In a photo containing, say, a white cat and a dark gray cat, the white cat might reflect five times as much light as the gray cat. An exposure based on the white cat will cause the gray cat to appear to be black, while an exposure based only on the gray cat will make the white cat washed out.

This is more easily understood if you look at some photos of subjects that are dark (they reflect little light), those that have predominantly middle tones, and subjects that are highly reflective. The next few figures show some images of actual cats (actually, the same off-white cat rendered in black, gray, and white varieties through the magic of Photoshop), with each of the three strips exposed using a different cat for reference.

Correctly Exposed

The three pictures shown in Figure 5.4 represent how the black, gray, and white cats would appear if the exposure were calculated by measuring the light reflecting from the middle, gray cat, which, for the sake of illustration, we'll assume reflects approximately 12 to 18 percent of the light that

Figure 5.4
When exposure is calculated based on the middle-gray cat in the center, the black and white cats are rendered accurately, too.

> **Note**
>
> The examples in Figure 5.4 were made using Center-weighted metering, which works exactly as discussed in the previous paragraph. The a5000 also offers Multi metering which applies artificial intelligence when calculating the exposure, as discussed shortly. That system applies algorithms that can produce a good exposure even when part of a scene is white or another light tone. Since Center metering does not use such "trickery," the results you get are more predictable, making this type of metering useful when learning the concepts of exposure. Later in this chapter, I'll describe the three metering modes, each employing a different "strategy," as well as the various a5000 features you can use to get a good exposure in difficult situations.

strikes it. The exposure meter sees an object that it thinks is a middle gray, calculates an exposure based on that, and the feline in the center of the strip is rendered at its proper tonal value. Best of all, because the resulting exposure is correct, the black cat at left and white cat at right are rendered properly as well.

Overexposed

The strip of three images in Figure 5.5 show what would happen if the exposure were calculated based on metering the leftmost, black cat. The light meter sees less light reflecting from the black cat than it would see from a gray middle-tone subject, and so figures, "Aha! I need to add exposure to brighten this subject up to a middle gray!" That lightens the black cat, so it now appears to be gray.

But now the cat in the middle that was *originally* middle gray is overexposed and becomes light gray. And the white cat at right is now seriously overexposed, and loses detail in the highlights, which have become a featureless white.

Figure 5.5
When exposure is calculated based on the black cat at the left, the black cat looks gray, the gray cat appears to be a light gray, and the white cat is seriously overexposed.

Underexposed

The third possibility in this simplified scenario is that the light meter might measure the illumination bouncing off the white cat, and try to render that feline as a middle gray. A lot of light is reflected by the white kitty, so the exposure is *reduced*, bringing that cat closer to a middle gray tone. The cats that were originally gray and black are now rendered too dark. Clearly, measuring the gray cat—or a substitute that reflects about the same amount of light—is the only way to ensure that the exposure is precisely correct. (See Figure 5.6.)

Figure 5.6
When exposure is calculated based on the white cat on the right, the other two cats are underexposed.

Metering Mid-Tones

As you can see from the examples using felines, the best way to guarantee a perfect exposure is to measure the light reflected by a mid-tone subject. That need not be gray like our furry friend in the center of the three strips of photos. Any mid-tone subject—including green grass or a rich, medium-blue sky—also reflects about 12 to 18 percent of the light. Metering such an area should ensure that the exposure for the entire scene will be correct or close to correct.

In some scenes (like a snowy landscape or a lava field) you won't have a mid-tone to meter. Unless the gray cat has come along for the ride, you might want to use the evenly illuminated gray card mentioned earlier. But, the standard Kodak gray card reflects 18 percent of the light while your camera is calibrated for a somewhat darker 12-percent tone. If you insisted on getting a perfect exposure, you would need to add about one-half stop more exposure than the value provided by taking the light meter reading from the card.

Another substitute for a gray card is the palm of a human hand (the backside of the hand is too variable). But a human palm, regardless of ethnic group, is even brighter than a standard gray card, so instead of one-half stop more exposure, you need to add one additional stop. Let's say you're using the camera's M mode. If the meter reading (based on your palm) is 1/500th of a second at f/8, switch to a shutter speed of 1/250th second. If you prefer, switch to f/5.6 instead, while continuing to use 1/500th second shutter speed. Whether you set a one step longer shutter speed or a one stop wider aperture, the photo will be brighter by exactly the same amount. (Both exposures are equivalent.)

If you actually wanted to use a gray card, place it in your frame near your main subject, facing the camera, and with the exact same even illumination falling on it that is falling on your subject. Then,

use the Spot metering function (described in the next section) to take a light meter reading only from the card. Of course, in most situations, it's not necessary to do this. Your camera's light meter will do a good job of calculating the right exposure, especially if you use the exposure tips in the next section. But, I felt that explaining exactly what is going on during exposure calculation would help you understand how your a5000's metering system works.

In serious photography, you'll want to choose the *metering mode* (the pattern that determines how brightness is evaluated) and the *exposure mode* (determines how the appropriate shutter speed and aperture is set). I'll describe both aspects in later sections.

WHY THE GRAY CARD CONFUSION?

Why are so many photographers under the impression that cameras and meters are calibrated to the 18-percent "standard," rather than the true value, which may be 12 to 14 percent, depending on the vendor? You'll find this misinformation in an alarming number of places. I've seen the 18-percent "myth" taught in camera classes; I've found it in books, and even been given this wrong information from the technical staff of camera vendors. (They should know better—the same vendors' engineers who design and calibrate the cameras have the right figure.)

The most common explanation is that during a revision of Kodak's instructions for its gray cards in the 1970s, the advice to open up an extra half stop was omitted, and a whole generation of shooters grew up thinking that a measurement off a gray card could be used as-is. The proviso returned to the instructions by 1987, it's said, but by then it was too late. Next to me is a (c)2006 version of the instructions for KODAK Gray Cards, Publication R-27Q, and the current directions read (with a bit of paraphrasing from me in italics):

- For subjects of normal reflectance increase the indicated exposure by 1/2 stop.
- For light subjects use the indicated exposure; for very light subjects, decrease the exposure by 1/2 stop. (*That is, you're measuring a cat that's lighter than middle gray.*)
- If the subject is dark to very dark, increase the indicated exposure by 1 to 1-1/2 stops. (*You're shooting a black cat.*)

The Importance of ISO

Another essential concept when discussing exposure, ISO control allows you to change the sensitivity of the camera's imaging sensor. Sometimes photographers forget about this option, because the common practice is to set the ISO once for a particular shooting session (say, at ISO 100 or 200 for bright sunlight outdoors, or ISO 800 or 1600 when shooting indoors) and then forget about ISO. Or some shooters simply leave the camera set to ISO Auto. That enables the camera to change the ISO it deems necessary, setting a low ISO in bright conditions or a higher ISO in a darker location. That's fine but sometimes you'll want to set a specific ISO yourself. That will be essential sometimes, since ISO Auto cannot set the highest ISO levels that are available when you use manual ISO selection.

> **TIP**
>
> When shooting in the Program (P), Aperture Priority (A) and Shutter Priority (S) modes, all discussed soon, changing the ISO does not change the exposure. If you switch from using ISO 100 to ISO 1600 in A mode for example, the camera will simply set a different shutter speed. If you change the ISO in S mode, the camera will set a different aperture, and in P mode, it will set a different aperture and/or shutter speed. In all of these examples, the camera will maintain the same exposure. If you want to make a brighter or a darker photo in P, A, or S mode, you would need to set + or - exposure compensation, as discussed later.
>
> However, when you use the Manual (M) mode, changing the ISO also changes the exposure, as discussed shortly.

While any camera provides the best possible image quality in the ISO 50 to 400 range, we use higher ISO levels such as ISO 1600 in low light and ISO 6400 in a very dark location because it allows us to shoot at a faster shutter speed. That's often useful for minimizing the risk of blurring caused by camera shake or by the movement of the subject.

Although you can set a desired ISO level yourself, the a5000 also offers an ISO Auto option. When set, the camera will select an ISO that should be suitable for the conditions: a low ISO on a sunny day and a high ISO in a dark location. In fully automatic operating modes, ISO Auto is the only available option. The camera will set an ISO no higher than 3200, except in the Anti Motion Blur Scene and Hand-held Twilight scene modes where it can set ISO 6400.

Over the past few years, there has been something of a competition among the manufacturers of digital cameras to achieve the highest ISO ratings—sort of a non-military version of the "missile gap" of years gone by. The highest announced ISO numbers have been rising annually, from 1600 to 3200 and 6400; a few cameras even allow you to set an ISO higher than 100000. Sony is a bit more conservative but the a5000 offers all of the ISO options you're ever likely to need, up to ISO 16000.

Choosing a Metering Method

The Sony a5000 has three different schemes for evaluating the light received by its exposure sensors. The quickest way to choose among them is to assign Metering Mode to a key using the Custom Key settings in the Custom Settings 4 menu, as described in Chapter 3. Then, you can press the defined key to produce the Metering Mode screen; then scroll up/down among the options. (See Figure 5.7.) Without a custom key, the default method for choosing a metering mode is to use the Camera Settings 3 menu entry.

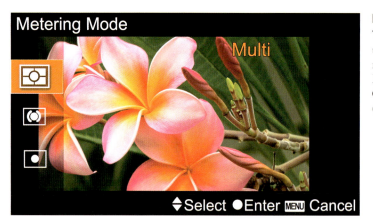

Figure 5.7
The a5000 provides three options for metering mode: Multi (the default), Center, and Spot (left, top to bottom).

The three modes are as follows:

- **Multi.** In this "intelligent" (multi-segment) metering mode, the Alpha slices up the frame into 1,200 different zones, as shown in Figure 5.8. The camera evaluates the measurements to make an educated guess about what kind of picture you're taking, based on examination of exposure data derived from thousands of different real-world photos. For example, if the top section of a picture is much lighter than the bottom portions, the algorithm can assume that the scene is a landscape photo with lots of sky. This mode is the best all-purpose metering method for most pictures. A typical scene suitable for Multi metering is shown in Figure 5.9.

 The Multi system can recognize a very bright scene and it can automatically increase the exposure to reduce the risk of a dark photo. This will be useful when your subject is a snow-covered landscape or a close-up of a bride in white. Granted, you may occasionally need to use a bit of exposure compensation, but often, the exposure will be close to accurate even without it. (In my experience, the Multi system is most successful with light-toned scenes on bright days. When shooting in dark, overcast conditions, it's more likely to underexpose a scene of that type.)

- **Center.** Mentioned earlier, this (center-weighted) metering was the only available option with cameras some decades ago. In this mode you get conventional metering without any "intelligent" scene evaluation. The light meter considers brightness in the entire frame but places the greatest emphasis on a large area in the center of the frame, as shown in Figure 5.10, on the theory that, for most pictures, the main subject will not be located far off-center.

 Of course, Center metering is most effective when the subject in the central area is a mid-tone. Even then, if your main subject is surrounded by large, extremely bright or very dark areas, the exposure might not be exactly right. (You might need to use exposure compensation, a feature discussed shortly.) However, this scheme works well in many situations if you don't want to use one of the other modes, for scenes like the one shown in Figure 5.11.

Figure 5.8 Multi metering uses 1,200 zones.

Figure 5.9 Multi metering is suitable for complex scenes like this one.

- **Spot.** This mode confines the reading to a very small area in the center of the image, as shown in Figure 5.12. (When you use Flexible Spot autofocus however, the spot metering will be at the area where the camera sets focus.) The Spot meter does not apply any "intelligent" scene evaluation. Because the camera considers only a small target area, and completely ignores its surroundings, Spot metering is most useful when the subject is a small mid-tone area. For example, the "target" might be a tanned face, a medium red blossom, or a gray rock in a wide-angle photo; each of these is a mid-tone. And that is important as you will recall from our example involving the cats.

 The spot metering technique is simple if you want to Spot meter a small area that's dead center in the frame. If the "target" is off-center, you would need to point the lens at it and use the AE Lock technique discussed later in this chapter. (Lock exposure on your target before re-framing for a better composition so the exposure does not change.) For Figure 5.13, Spot metering was used to base the exposure on the musician's face.

 If you Spot meter a light-toned area or a dark-toned area, you will get underexposure or overexposure respectively; you would need to use an override for more accurate results. On the other hand, you can Spot meter a small mid-tone subject surrounded by a sky with big white clouds or by an indigo blue wall and get a good exposure. (The light meter ignores the subject's surroundings so they do not affect the exposure.) That would not be possible with Center-weighted metering, which considers brightness in a much larger area.

Figure 5.10 Center metering calculates exposure based on the full frame, but emphasizes the center area.

Figure 5.11 Scenes with the important tones in the center of the frame lend themselves to Center metering.

Figure 5.12 Spot metering calculates exposure based on a spot that's only a small percentage of the image area.

Figure 5.13 Meter from precise areas in an image, such as facial features, using Spot metering.

Choosing an Exposure Mode

After you set a desired metering mode, you have several methods for choosing the appropriate shutter speed and aperture semi-automatically or manually. Just press the center button and spin the virtual mode selector dial (shown in Figure 5.14) to the exposure mode that you want to use. Your choice of which is best for a given shooting situation will depend on aspects like your need for extensive or shallow depth-of-field (the range of acceptably sharp focus in a photo) or the desire to freeze action or to allow motion blur. Especially the semi-automatic Aperture Priority and Shutter Priority modes discussed in the next section emphasize one aspect of image capture or another, but the following sections introduce you to all four of the modes that photographers often call "creative."

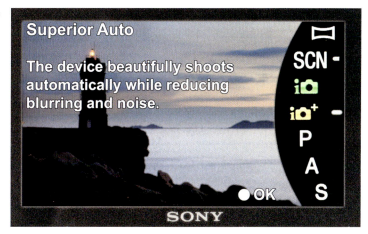

Figure 5.14
Set the desired exposure (operating) mode with the mode selector dial.

Aperture Priority (A) Mode

When using the A mode, you specify the lens opening (aperture or f/stop) with the control wheel. After you do so, the a5000 (guided by its light meter) will set a suitable shutter speed considering the aperture and the ISO in use. If you change the aperture, from f/5.6 to f/11 for example, the camera will automatically set a longer shutter speed to maintain the same exposure, using guidance from the built-in light meter. (I discussed the concept of equivalent exposure earlier and provided the equivalent exposure chart).

Aperture Priority is especially useful when you want to use a particular lens opening to achieve a desired effect. Perhaps you'd like to use the smallest aperture (such as f/22) to maximize depth-of-field (DOF), to keep the entire subject sharp in a close-up picture. Or, you might want to use a large aperture (small f/number like f/4) to throw everything except your main subject out of focus as in Figure 5.15. Maybe you'd just like to "lock in" a particular f/stop, such as f/8, because it allows your lens to provide the best optical quality. Or, you might prefer to use f/2.8 with a lens that has a maximum aperture of f/1.4, because you want the best compromise between shutter speed and optical quality.

Figure 5.15 Use Aperture Priority mode to "lock in" a wide aperture (denoted by a large f/number) when you want to blur the background.

Aperture Priority can even be used to specify a *range* of shutter speeds you want to use under varying lighting conditions, which seems almost contradictory. But think about it. You're shooting a soccer game outdoors with a telephoto and want a relatively fast shutter speed, but you don't care if the speed changes a little should the sun duck behind a cloud. Set your a5000's shooting mode to A, and adjust the aperture using the control wheel until a shutter speed of, say, 1/1,000th second is selected at the ISO level that you're using. (In bright sunlight at ISO 400, that aperture is likely to be around f/11.) Then, go ahead and shoot, knowing that your Alpha will maintain that f/11 aperture (for sufficient DOF as the soccer players move about the field), but will drop down to 1/800th or 1/500th second if necessary should a light cloud cover part of the sun.

When the camera cannot provide a good exposure at the aperture you have set, the +/- symbol and the shutter speed numeral will blink in the LCD display. The blinking warns that the a5000 is unable to find an appropriate shutter speed at the aperture you have set, considering the ISO level in use and over- or underexposure will occur. That's the major pitfall of using Aperture Priority: you might select an f/stop that is too small or too large to allow an optimal exposure with the available shutter speeds.

Here are a couple of examples where you might encounter a problem. Let's say you set an aperture of f/2.8 while using ISO 400 on an extremely bright day (perhaps at the beach or in snow); in this situation, even your camera's fastest shutter speed might not be able to cut down the amount of light reaching the sensor to provide the right exposure. (The solution here is to set a lower ISO or a smaller aperture, or both, until the blinking stops.) Or, let's say you have set f/16 in a dark arena while using ISO 100; the camera cannot find a shutter speed long enough to provide a correct exposure so your photo will be underexposed. (In low light, the solution is to set a higher ISO or a wider aperture, or both, until the blinking stops.) Aperture Priority is best used by those with a bit of experience in choosing settings. Many seasoned photographers leave their Alpha set on Aperture Priority all the time.

Shutter Priority (S) Mode

Shutter Priority is the inverse of Aperture Priority. You set the shutter speed you'd like, using the control wheel , and the camera sets an appropriate f/stop considering the ISO that's in use. When you change the shutter speed, the camera will change the aperture to maintain the same (equivalent) exposure using guidance from the built-in light meter. Shutter Priority mode gives you some control over how much action-freezing capability your digital camera brings to bear in a particular situation. In other cases, you might want to use a slow shutter speed to add some blur to a sports photo that would be mundane if the action were completely frozen (see Figure 5.16).

Figure 5.16 Set a slow shutter speed when you want to introduce blur into an action shot, as with this panned image of a cyclist.

Take care when using a slow shutter speed such as 1/8th second, because you'll get blurring from camera shake unless you're using a tripod or other firm support. Of course, this applies to any mode but in most modes the camera displays a camera shake warning icon when the shutter speed is long. That does not appear in S mode however, perhaps because Sony assumes that users of Shutter Priority are aware of the potent ional problem caused by camera shake. The SteadyShot stabilizer in OSS-designated lenses is useful but it cannot work miracles.

As in Aperture Priority, you can encounter a problem in Shutter Priority mode; this happens when you select a shutter speed that's too long or too short for correct exposure under certain conditions. I've shot outdoor soccer games on sunny fall evenings and used Shutter Priority mode to lock in a 1/1,000th second shutter speed, only to find that my Alpha refused to produce the correct exposure when the sun dipped behind some trees and there was no longer enough light to shoot at that speed, even with the lens wide open.

In cases where you have set an inappropriate shutter speed, the aperture numeral and the +/- symbol will blink on the LCD. When might this happen? Let's say you set 1/15th second shutter speed while using ISO 400 on that extremely bright day; in this situation, even the smallest aperture available with your lens might not be able to cut down the amount of light reaching the sensor to provide a correct exposure. (The solution here is to set a lower ISO or a faster shutter speed, or both, until the blinking stops.) Or, let's say you have set 1/250th second in the arena while using ISO 100; your lens does not offer an aperture that's wide enough to enable the camera to provide a good exposure so you'll get the blinking and your photo will be underexposed. (In low light, the solution is to set a higher ISO or a longer shutter speed, or both, until the blinking stops.)

Program Auto (P) Mode

The Program mode uses the camera's built-in smarts to set an aperture/shutter speed combination, based on information provided by the light meter. If you're using Multi metering, the combination will often provide a good exposure. Rotate the control wheel and you can switch to other aperture/shutter speed combinations, all providing the same (equivalent) exposure.

In the unlikely event that the correct exposure cannot be achieved with the wide range of shutter speeds and apertures available, the shutter speed and aperture will both blink. (The solution is to set a lower ISO in bright light and a higher ISO in dark locations until the blinking stops.) The P mode is the one to use when you want to rely on the camera to make reasonable basic settings of shutter speed and aperture, but you want to retain the ability to adjust many of the camera's settings yourself. All overrides and important functions are available, including ISO, white balance, metering mode, exposure compensation, and others.

Making Exposure Value Changes

Sometimes you'll want a brighter or darker photo (more or less exposure) than you got when relying on the camera's metering system. Perhaps you want to underexpose to create a silhouette effect, or overexpose to produce a high-key (very light) effect. It's easy to do so by using the a5000's exposure compensation control. This feature is available only in P, A, S, and Panorama mode; you cannot modify exposure in fully automatic modes and there are different methods for doing so in the fully manual M mode.

Press the +/- button (the down direction button) and a scale appears. Using the direction buttons, scroll up toward the + end of the scale if you want to take photos that will be brighter. Or scroll down to set minus compensation when you want to take photos that will be darker.

In my experience, adding exposure compensation is the option that's most often necessary. I'll often set +2/3 when using Multi metering if the camera underexposed my first photo of a light-toned scene. With Center-weighted or Spot metering, +1.3 or an even higher level of plus compensation is almost always necessary with a light-toned subject. Since the a5000 provides a live preview of the scene, it's easy to predict when the photo you'll take is likely to be obviously over or under exposed. When the histogram display is on, you can make a more accurate prediction about the exposure; I'll discuss this feature shortly. Of course, you can also use plus compensation when you want to intentionally overexpose a scene for a creative effect.

You won't often need to use minus compensation. This feature is most likely to be useful when metering a dark-toned subject, such as close-ups of black animals or dark blue buildings, for example. Since these dark-toned subjects lead the camera to overexpose, set –2/3 or –1 compensation (when using Multi metering) for a more accurate exposure. (The amount of minus compensation that you need to set may be quite different when using the other two metering modes.) Minus compensation can also be useful for intentionally underexposing a scene for a creative effect, such as a silhouette of a sailboat or a group of friends on a beach.

Any exposure compensation you set will remain active for all photos you take afterwards. The camera provides a reminder as to what value is currently set in some display modes. Turning the a5000 off and then back on does not set compensation back to zero; when you no longer need to use it, be sure to do so yourself. If you inadvertently leave it set for +1 or –1 for example, your photos taken under other circumstances will be over or under exposed.

Manual Exposure (M) Mode

Part of being an experienced photographer comes from knowing when to rely on your a5000's automation (including Intelligent Auto, Superior Auto, P mode, and SCN mode settings), when to go semi-automatic (with Shutter Priority or Aperture Priority), and when to set exposure manually (using M). Some photographers actually prefer to set their exposure manually. This is quite convenient since the camera is happy to provide an indication of when your settings will produce over- or underexposure, based on its metering system's judgment. It can even indicate how far off the "correct" (recommended) exposure your photo will be, at the settings you have made.

I often hear comments from novices first learning serious photography claiming that they must use Manual mode in order to take over control from the camera. That's really not necessary. For example, you can control all important aspects when using semi-automatic A or S mode as discussed in the previous sections. This allows you to control depth-of-field (the range of acceptable sharpness) or the rendition of motion (as blurred or as frozen). You can set a desired ISO level; that will not change the exposure. You would use exposure compensation when you want a brighter or a darker photo.

Manual mode provides an alternative that allows you to control the aperture and the shutter speed and the exposure simultaneously. For example, when I shot the windmill in Figure 5.17, I was not getting exactly the desired effect with A or S mode while experimenting with various levels of exposure compensation. So, I switched to M mode, set ISO 100 and then set an aperture/shutter speed that might provide the intended exposure. After taking a test shot, I changed the aperture slightly and the next photo provided the exposure for the interpretation of the scene that I wanted.

Manual mode is also useful when working in a studio environment using multiple flash units. The additional flash units are triggered by slave devices (gadgets that set off the flash when they sense the light from another flash, or, perhaps from a radio or infrared remote control). In some cases, M mode is the only suitable choice. You might be working in a studio environment using multiple flash units. The additional flash units are triggered by slave devices (gadgets that set off the flash when they sense the light from another flash, or, perhaps from a radio or infrared remote control). Your camera's exposure meter doesn't compensate for the extra illumination, and can't interpret the flash exposure at all, so you need to set the aperture and shutter speed manually.

The Basic M Mode Technique

Depending on your proclivities, you might not need to use M mode very often, but it's still worth understanding how it works. Here are your considerations:

- Press the center button and rotate the virtual mode selector dial to M.
- Use the control wheel to adjust both shutter speed and aperture. Press the down button to toggle between them, and the setting that is currently active will be highlighted in orange.
- If you have Exposure Set Guide in the Custom Settings 2 menu set to On, enlarged labels showing the changing shutter speed or aperture will be displayed near the bottom of the screen, unless you choose the Graphic display mode with the DISP button. In that case, scales will show the current shutter speed and aperture at the same time.
- Any change you make to either factor affects the exposure, of course, so if you have Live View Display in the Custom Settings 2 menu set to Setting Effect ON, you'll see the display getting darker or brighter as you change settings.
- If the display you're viewing includes the histogram graph, that will provide an even better indication of the exposure you'll get as you set different apertures or shutter speeds. I'll explain histograms later in this chapter.

Chapter 5 ■ Shooting Modes and Exposure Control 137

Figure 5.17
Manual mode allowed setting the exact exposure for this silhouette shot, by metering the subject and then underexposing.

Adjusting Exposure with ISO Control in M Mode

As mentioned in the previous section, changing the ISO level is another method of changing the exposure in M mode. Most photographers control the aperture and/or shutter speed for this purpose, sometimes forgetting about the option to adjust ISO. The common practice is to set the ISO once for a particular shooting session (say, at ISO 100 outdoors on bright days or ISO 1600 when shooting indoors). There is also a tendency to use the lowest ISO level possible because of a concern that high ISO levels produce images with obvious digital noise (such as a grainy effect). However, changing the ISO is a valid way of adjusting exposure in M mode, particularly with the a5000, which produces good results at high ISO levels that create grainy, unusable pictures with some other camera models.

Indeed, I find myself using ISO adjustment as a convenient alternate way of adding or subtracting EV (exposure values) when shooting in Manual mode, and as a quick way of choosing equivalent exposures when in automatic or semi-automatic modes. For example, I've selected a manual exposure with both f/stop and shutter speed suitable for my image using, say, ISO 400. I can change the exposure in full stop increments by pressing the ISO button (right cursor button), and spinning the control wheel one click at a time. The difference in image quality/noise is not much different at ISO 200 or ISO 800 than at ISO 400 and this method of exposure control method allows me to shoot at my preferred f/stop and shutter speed while retaining control of the exposure.

Or, perhaps, I am using Shutter Priority mode and the metered exposure at ISO 400 is 1/500th second at f/11. If I decide on the spur of the moment I'd rather use 1/500th second at f/8, I can press the ISO button and quickly switch to ISO 200. Of course, it's a good idea to monitor your ISO changes, so you don't end up at ISO 6400 or above accidentally; a setting like that will result in more digital noise (graininess) in your image than you would like. In M mode, Auto ISO is not available. (If you were shooting with ISO Auto in another mode and then switch to M mode, the ISO will be set at 100 by the camera.) You can set any ISO level as high as 16000 but I rarely need to go above 6400. The higher ISO levels are necessary only when shooting in a very dark location where a fast shutter speed is important; this might happen during a sports event in a dark arena, for example.

Exposure Bracketing

The exposure compensation feature works well as discussed earlier but sometimes, you'll want to quickly shoot a series of photos at various exposures in a single burst. Doing so increases the odds of getting one photo that will be exactly right for your needs, and is particularly useful when assembling high dynamic range (HDR) composite images manually. This technique is called bracketing.

Years ago, before high-tech cameras became the norm, it was common to bracket exposures when shooting color slide film especially, taking three (or more) photos at different exposures in Manual mode. Eventually, exposure compensation became a common feature as cameras gained

semi-automatic modes; it was then possible to bracket exposures by setting a different compensation level for each shot in a series, such as 0, –1, and +1 or 0, –1/3 and +2/3.

Today, cameras like the a5000 give you a lot of options for automatically bracketing exposures. When Bracket is active, you can take three consecutive photos: one at the metered ("correct") exposure, one with less exposure, and one with more exposure. Figure 5.18 shows an image with the metered exposure (center), flanked by exposures of 2/3 stop more (left), and 2/3 stop less (right).

Bracketing cannot be performed when using Auto mode, any SCN mode, Panorama mode, or when using the Smile Shutter or Auto HDR features. If the flash is popped up, it will be forced off and will not fire while bracketing is active. Exposure bracketing can be used with both RAW and JPG capture. When it's set, the camera will fire the three shots in a sequence if you keep the shutter release button depressed; you can also decide to shoot the photos one at a time.

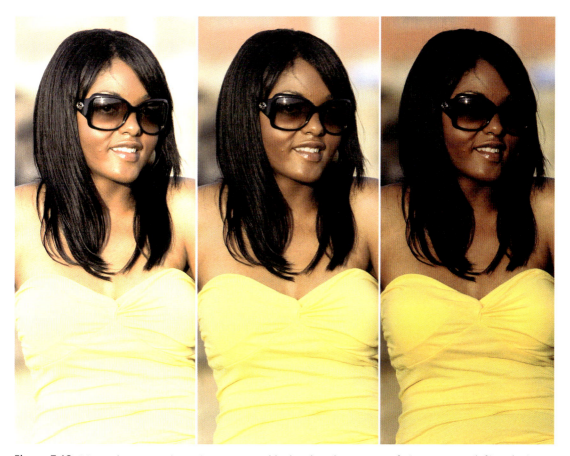

Figure 5.18 Metered exposure (center) accompanied by bracketed exposures of 2/3 stop more (left) and 2/3 stop less (right).

Here are some points to keep in mind about bracketing:

- **Drive, he said.** You'll find the bracketing choices on the Drive mode menu. Press the drive mode button (left direction button). Scroll down to Bracket: Cont. You can then use the left/right buttons to choose among the available options for bracketing, such as BRK C0.3EV (three shots with a 1/3 EV exposure variance) or BRK C1.0EV (three shots with 1 EV exposure variance). Use 0.3 EV if you want to fine-tune exposure, or 1.0 EV if you'd like more obvious changes in exposure between shots.
- **HDR isn't hard.** The 1.0 EV option is the one you might try first when bracketing if you plan to perform High Dynamic Range magic later on in Photoshop (with Merge to HDR), Elements (with Photomerge), or with another image editor that provides an HDR feature. That will allow you to combine images with different exposures into one photo with an amazing amount of detail in both highlights and shadows. To get the best results, mount your camera on a tripod, shoot in RAW format, and use BRK C1.0EV to get three shots with a 1 EV of difference in exposure. Of course, with this camera, you also have the option of using the Auto HDR feature as well; this can provide very good results in the camera without the need to use any special HDR software.
- **Adjust the base value.** You can bracket your exposures based on something other than the base (metered) exposure value. Set any desired exposure compensation, either a plus or a minus value. Then set the Bracketing level you want to use. The camera will bracket exposures as over, under, and equal to the *compensated* value.
- **What changes?** In Aperture Priority mode, exposure bracketing will be achieved by changing the shutter speed if possible, and then by changing the ISO if necessary. In Shutter Priority mode, bracketing will be done using different f/stops if possible, and then by using different ISO levels if that's necessary. When you're using Manual mode, bracketing is applied by changing the shutter speed. In Program mode shutter speed and aperture will vary, and sometimes the ISO. Choose your shooting mode before you set bracketing based on your creative intention: whether you want to keep a particular aperture for all of the photos (say, for selective focus), or keep a certain shutter speed (to blur or stop action).

Dealing with Digital Noise

Visual noise is that random grainy look with colorful speckles that some like to use as a visual effect, but most consider to be objectionable. That's because it robs your image of detail even as it adds that "interesting" texture. Noise is caused by two different phenomena: high ISO levels and long exposures. The a5000 offers a menu item to minimize high ISO noise. In Chapter 3, I discussed the Camera Settings 5 menu item that you can use to modify the noise reduction processing; you might want to review the sections about High ISO NR and Long Exposure NR as a refresher.

High ISO Noise

Digital noise commonly appears when you set an ISO above ISO 400 with some cameras or above ISO 1600 with the a5000; with this camera it's not really problematic until much higher ISO levels. High ISO noise appears as a result of the amplification needed to increase the sensitivity of the sensor. While higher ISOs do pull details out of dark areas, they also amplify non-signal information randomly, creating noise.

This makes High ISO Noise Reduction very useful, although at default, it also tends to make images slightly softer; blurring the noise pattern also blurs some intricate details. The higher the ISO, the more aggressive the processing will be. The Low level for NR provides images that are more grainy but with better resolution of fine detail.

High ISO NR is grayed out when the camera is set to shoot only RAW format photos. The camera does not use this feature on RAW format photos since noise reduction—at the optimum level for any photo—can be applied in the software you'll use to modify and convert the RAW file to JPEG or TIFF. (If you shoot in RAW & JPEG, the JPEG images, but not the RAW files, will be affected by this camera feature.) I'll discuss Noise Reduction with software in more detail in the next section.

Figure 5.19 shows two pictures that I shot at ISO 12800. For the first, I used the default (Normal) High ISO NR and for the second shot, I set the NR to Low. (I've exaggerated the differences between the two so the grainy/less grainy images are more evident on the printed page. The halftone screen applied to printed photos tends to mask these differences.)

Long Exposure Noise

A similar digital noise phenomenon occurs during long time exposures, which allow more photons to reach the sensor, increasing your ability to capture a picture under low-light conditions. However, the longer exposures also increase the likelihood that some pixels will register as random, "phantom" photons, often because the longer an imager is "hot" that heat can be mistaken by the sensor as actual photons. The a5000 tries to minimize this type of noise automatically; there is no separate control you can adjust to add more or less noise reduction for long exposures.

CMOS imagers like the one in the a5000 contain millions of individual amplifiers and A/D (analog to digital) converters, all working in unison through the BIONZ X digital image processor chip. Because these circuits don't necessarily all process in precisely the same way all the time, they can introduce something called fixed-pattern noise into the image data.

Long exposure noise reduction is used with JPEG exposures longer than one full second. (This feature is not used on RAW photos and in continuous shooting, bracketing, Panorama mode the Sports Action and Hand-held Twilight Scene modes.) When it's active, long exposure noise reduction processing removes random pixels from your photo but some of the image-making pixels are unavoidably vanquished at the same time.

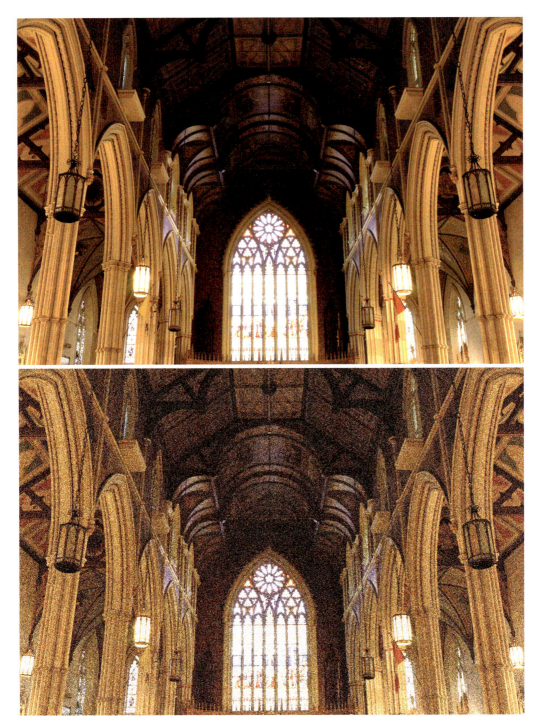

Figure 5.19 The Normal level for High ISO NR (top) produces a smoother (less grainy) image than one made with Low NR (bottom), but the latter also maintains better sharpness of intricate details.

It's possible that you prefer the version made without NR, and you can achieve that simply by shooting RAW. Indeed, noise reduction can be applied with most image editing programs. You might get even better results with an industrial-strength product like Nik Dfine, part of Google's Nik collection or Topaz DNoise or Enhance (www.topazlabs.com). Noise Ninja, a long-time favorite, was discontinued some time ago. You can apply noise reduction to RAW photos with Sony's Image Data Converter or any other versatile converter software. Some products are optimized for NR with unusually sophisticated processing, such as Photo Ninja (www.picturecode.com) and DXO Optics Pro's version 9 or higher (www.dxo.com).

> ### SPECIAL MODES FOR FINE HIGH ISO QUALITY
>
> As I'll discuss in the section on scene modes, the a5000 offers two modes for use in low light at high ISO for superior image quality. When you use Hand-held Twilight and Anti Motion Blur, the camera shoots a series of photos and composites them into one after discarding most of the digital noise. These are automatic modes so they're not ideal for all types of serious photography but they certainly provide the "cleanest" images possible at high ISO with your camera.

Exposure Evaluation with Histograms

While you may be able to improve poorly exposed photos in your image editing software, it's definitely preferable to get the exposure close to correct in the camera. This will minimize the modifications you'll need to make in post-processing which can be very time consuming and will degrade image quality, especially with JPEGs. A RAW photo can tolerate more significant changes with less adverse effects, but for optimum quality, it's still important to have an exposure that's close to correct.

You can roughly estimate the exposure by viewing the live preview on the LCD or the EVF but this is not always accurate. The brightness level you've set for the screen can affect the brightness of the image; and if you're using the LCD for composing photos and for image playback, glare from ambient light may make the display difficult to see. That's why the a5000 provides a histogram option on the LCD.

The Live Histogram

The histogram offers the most reliable method for judging the exposure. This is a graph that provides a scientific indication as to the distribution of tones: the number of tones recorded at each brightness level. A live histogram is also available for display on the LCD screen but you need to activate it with the DISP Button (Monitor) item in the Custom Settings 1 menu, as discussed in Chapter 3, and shown at left in Figure 5.20. It's worth activating that now, before you read on. After doing so, press the DISP button a few times while using the external LCD to reach the display that includes the histogram, as you can see at right in Figure 5.20.

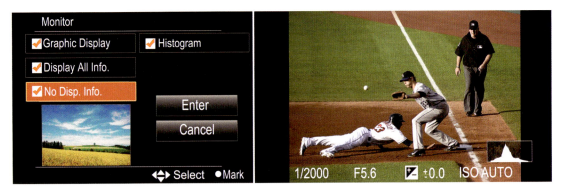

Figure 5.20 Use the Custom Settings 1 menu (left) to activate the shooting mode histogram (right). It provides the most important histogram (luminance or brightness) with the distribution of tones in dark, mid-tone, and bright parts of the image.

In shooting mode, you'll get a luminance (brightness) histogram that shows the distribution of tones and brightness levels across the image given the current camera settings, including exposure compensation, Dynamic Range Optimizer (DRO) level in use, or the aperture, shutter speed, and ISO that you have set if using Manual mode. This live histogram (displayed before taking a photo) is useful for judging whether the exposure is likely to be satisfactory or whether you should use a camera feature to modify the exposure. When the histogram looks better, take the photo.

The Playback Histograms

You can view histograms in Playback mode too; press the DISP button until the display shown in Figure 5.21 appears. The top graph, called the luminance or brightness histogram, is conventional, showing the distribution of tones across the image. Each of the other three histograms is in a specific color: red, green, and blue. That indicates the color channel you're viewing in that histogram: red, green, or blue. These additional graphs allow you to see the distribution of tones in the three individual channels. It takes a lot of expertise to interpret those extra histograms and frankly the conventional luminance histogram is the only one that many photographers use.

As a bonus in playback mode, another feature is available when the histograms are visible: any areas of the displayed image that are excessively bright, or excessively dark, will blink. This feature, often called "blinkies," warns that you may need to change your settings to avoid loss of detail in highlight areas (such as a white wedding gown) or in shadow areas (such as a black animal's fur). The a5000 also includes the Zebra feature to indicate overexposure, as discussed in Chapter 3. You can use the histogram information along with the flashing blinkie and Zebra alerts to guide you in modifying the exposure, and/or setting the DRO feature (discussed shortly), before taking the photo again.

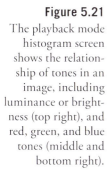

Figure 5.21
The playback mode histogram screen shows the relationship of tones in an image, including luminance or brightness (top right), and red, green, and blue tones (middle and bottom right).

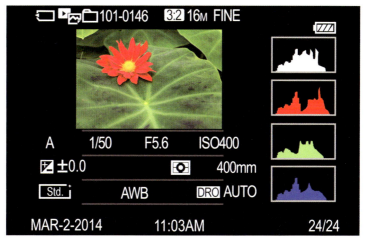

Histogram Interpretation

A histogram graph includes a *representation* of up to 256 vertical lines on a horizontal axis (but not 256 actual lines; only the general shape of the resulting curve is shown). The graph shows the number of pixels in the image at each brightness level, from 0 (black) on the left side to 255 (white) on the right. The 3-inch LCD doesn't have enough pixels to show each and every one of the 256 lines; instead, it provides a representation of the shape of the curve, often resembling a mountain range. The more pixels at a given level, the higher the "peak" will be at that position. If no bar appears at a particular position along the scale in the graph, there are no pixels at that particular brightness level.

A typical histogram produces a mountain-like shape, with most of the pixels bunched in the middle tones, with fewer pixels at the dark and light ends of the scale. Ideally, though, there will be at least some pixels at either extreme, so that your image has both a true black and a true white representing some details. Learn to spot histograms that represent over- and underexposure, and add or subtract exposure using exposure compensation as described earlier. (The D-Range Optimizer is also a useful feature when you want to get more detail in shadow areas; it can also slightly increase the amount of detail in highlight areas.)

For example, Figure 5.22 shows the histogram for an image that is badly underexposed. Most of the tones in this image are dark or black, as you can see from the shape of the histogram; this indicates that many of the dark tones have been clipped off, so there's a loss of detail. There's plenty of room on the right side for additional pixels to reside without having them become overexposed. A histogram for an overexposed photo might look like Figure 5.23, which indicates that most of the pixels are in the bright area and that you'll have a loss of detail in the highlights. In either case, you can increase or decrease the exposure using exposure compensation in P, A, or S mode. In M mode, you can do so by changing the f/stop or shutter speed or ISO or a combination of those factors.

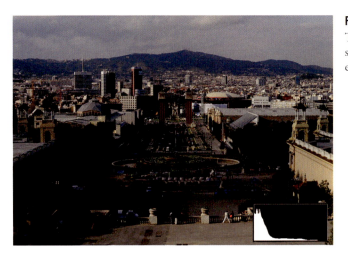

Figure 5.22
This histogram shows an underexposed image.

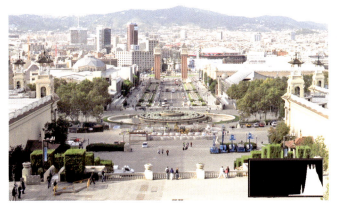

Figure 5.23
This histogram reveals that the image is overexposed.

Figure 5.24
A histogram for a properly exposed image should look something like this.

The key is to make settings that will produce a histogram with a more even distribution of tones. The corrected histogram is shown in Figure 5.24. It exhibits a mountain-like shape with a tall wide peak in the center of the scale (denoting the many mid-tone areas), and a good distribution of tones overall. This histogram indicates that the image exhibits detail in both the dark and the light tones since there's no spike at either end of the graph. Typically, this is the type of histogram you want for an accurate exposure. Of course, you'll sometimes want to create a special effect like a silhouette or a high-key look (mostly light tones); then your histogram will look entirely different.

The histogram can also warn you of very high or very low contrast in an image. If all the tones are bunched up in one area of the graph (usually around the center), the photo will be low in contrast. You can increase the contrast level with the Creative Style item in the Brightness/Color menu as discussed in Chapter 3 or do so later with software.

Excessive contrast is more of a problem since it's difficult to fix with image editing software if you're shooting JPEG photos. If the histogram shows most of the tones at the two ends of the graph, you have a situation with very high contrast; you can expect a harsh image, with very dark tones and very light tones and few mid-tones. You can set a lower level for contrast with the Creative Style menu item, but you'll often get better results with a high level for the D-Range Range Optimizer (Dynamic Range Optimizer or DRO) available with the DRO/Auto HDR item in the Brightness/Color menu.

Since D-Range Optimizer is not an exposure control tool per se, I won't be discussing it in detail until Chapter 7. In a nutshell, DRO can adjust the relative brightness range of JPEG images as they are taken. It's useful primarily in harsh lighting when a photo will exhibit high contrast: very dark areas and very bright areas. You can moderate that with DRO. It's active by default at the Auto level so the camera will automatically process the photo in order to provide some increase in shadow detail and a very slight increase in highlight detail. However, with the a5000, you can set a D-Range Optimizer level yourself; the higher levels will provide a more obvious increase in shadow detail.

Automatic and Specialized Shooting Modes

After the long discussion of exposure control and other issues, let's get back to the remaining shooting modes. When you set the Intelligent Auto or the Superior Auto mode, the camera will use its programmed intelligence to try to identify the type of scene and set itself accordingly. These "auto-pilot" modes are useful when you suddenly encounter a picture-taking opportunity and don't have time to decide exactly what settings you might want to make in a semi-automatic or manual mode. Instead, you can spin the mode dial to one of the Auto modes, or, if you have a little more time, to the most appropriate scene mode, and fire away, knowing that you have a fighting chance of getting a usable or very good photo.

The a5000 also offers more specialized modes, for use in particular situations: Sweep Panorama and two special scene modes that provide surprisingly fine quality at high ISO levels—Handheld Twilight and Anti Motion Blur.

Auto and Scene Modes

The two Auto modes and the scene modes are especially helpful when you're just learning to use your a5000, because they let you get used to composing and shooting, and obtaining excellent results, without having to struggle with unfamiliar controls to adjust things like shutter speed, aperture, ISO, and white balance. Once you've learned how to make those settings, you'll probably prefer to use P, A, S, and M modes since they provide more control over shooting options.

The fully automatic modes may give you few options for overrides, or none at all. For example, the AF mode, AF area, ISO, white balance, Dynamic Range Optimizer, and metering mode are all set for you. In most modes, you can select the drive setting and the flash mode, though not all settings for those options are available. You cannot adjust exposure compensation or Creative Styles in any of these modes. Here are some essential points to note about the Intelligent Auto, Superior Auto, and SCN modes:

- **Intelligent Auto.** This is the setting to use when you hand your camera to a total stranger and ask him or her to take your picture posing in front of the Eiffel Tower. All the photographer has to do is press the shutter release button. Every other decision is made by the camera's electronics, and many settings, such as ISO, white balance, metering mode, and autofocus mode are not available to you for adjustment. However, you still are able to set the drive mode to Continuous shooting, self-timer, or Remote Commander (but not to Bracketing), and you can set the flash mode to Auto Flash or Flash Off.

 Press the downward button of the control wheel and you'll get a screen that offers several options. These allow you to set the amount of Background Defocus (blurred or sharp), the Brightness, Color (warm or cool), Vividness (color richness), and a Picture Effect (a special effect). All are intuitive to use. Scroll to the one you want and scroll up and down the scale to achieve the intended effect, such as a more blurred background, brighter image, warmer (slightly amber) overall color balance, or richer colors, for example. The final option allows you to activate one of the special effects "filters" such as Toy Camera, Partial Color, Retro Photo, and so on.

- **Superior Auto.** This mode is exactly like Intelligent Auto, but provides an extra benefit. In scenes that include extremely bright areas as well as shadow areas, the camera can activate its Auto HDR (high dynamic range) feature to provide more shadow detail. And in dark locations, when an extremely high ISO will be used, the camera can activate a special mode that fires several shots and composites them into one after discarding the digital noise data.

- **Portrait.** The first of the scene modes that you'll encounter, this one tends to use wide apertures (large f/numbers) and faster shutter speeds. This is intended to try to provide shallow depth-of-field to blur the background while minimizing the risk of blurry photos caused by

camera shake or subject movement. It's also optimized to provide "soft" skin tones. The drive mode cannot be set to Continuous shooting, though you can set the self-timer to take three shots; you can use the Remote Commander; you can set AF, MF, or DMF in the Function sub-menu; and you can set the flash mode to Auto Flash, Fill Flash, or forced off.

- **Landscape.** The Alpha tries to use smaller apertures for more depth-of-field to try to render the entire scene sharply; it also boosts saturation slightly for richer colors. You have some control over flash and can use the self-timer; most other settings are not available in this mode.

- **Macro.** This mode is similar to the Portrait setting, favoring wider apertures to isolate your close-up subjects, and fast shutter speeds to eliminate the camera shake that's accentuated at close focusing distances. However, if your camera is mounted on a tripod or if you're using a lens with SteadyShot, you might want to use Aperture Priority mode instead. That will allow you to specify a smaller aperture (larger f/number) for additional depth-of-field to keep an entire three-dimensional subject within the range of acceptably sharp focus.

- **Sports action.** In this mode, the Alpha favors fast shutter speeds to freeze action and it switches to Continuous drive mode to let you take a quick sequence of pictures with one press of the shutter release button. Continuous Autofocus is activated to continually refocus as a subject approaches the camera or moves away from your shooting position. You can find more information on autofocus options in Chapter 6.

- **Sunset.** Increases saturation to emphasize the red tones of a sunrise or sunset. You can use the Fill Flash or Flash Off settings, but most other adjustments are unavailable to you.

- **Night Portrait.** This mode is intended for taking people pictures in dark locations with flash using a long shutter speed. The Flash mode is set to Slow Sync. A nearby subject will be illuminated by flash while a distant background (such as a city skyline) will be exposed by the available light during the long exposure. Because the shutter speed will be long, it's necessary to use a tripod or set the camera on something solid like the roof of a car. If using an OSS-designated lens with a SteadyShot stabilizer, make sure it's on, unless the camera is mounted on a tripod; in that case, turn the stabilizer off using the SteadyShot item in the Setup menu. You can use the Self-timer or the Remote Commander in Night Portrait mode.

- **Night Scene.** This is another mode for low-light photography. Similar to Night Portrait, but the flash is forced off. Use a tripod if at all possible or set the camera on a solid object, because the shutter speed will be long in low light. Most settings are not available, other than the Self-timer and Remote Commander.

- **Hand-held Twilight.** This is one of the two special modes designed for use in low light when hand-holding the a5000. The camera will set a high ISO (sensitivity) level to enable it to use a fast shutter speed to minimize the risk of blurring caused by camera shake. (In extremely dark conditions however, the shutter speed may still be quite long.) When you press the shutter release button, the camera takes six shots in a quick series. The processor then composites them into one after discarding most of the digital noise data for a "cleaner" image than you'd get in

Figure 5.25 The Hand-held Twilight or Anti Motion Blur mode is very useful in dark locations when you cannot use a tripod and must shoot at a high ISO for a fast shutter speed. The image quality is surprisingly fine as indicated in the bottom photo, a small portion of the full ISO 6400 image (top).

a conventional high ISO photo. You'll get one image that's of surprisingly fine quality. (See Figure 5.25.) Flash is never fired in this mode and you have access to virtually no camera options.

- **Anti Motion Blur.** Similar to Hand-held Twilight, this mode is also designed for use in dark locations, but it's more effective at reducing blurring that might be caused by a subject's motion or by a shaky camera. That's because the camera will set an even faster shutter speed; that may require it to set a higher ISO level. (Of course, in an extremely dark location, the shutter speed may still be a bit long.) Again, the camera fires a series of six shots and composites them into one with minimal digital noise.

Sweep Panorama Mode

A conventional panorama mode has been available for several years with many other cameras, especially those with a built-in lens. That allows you to shoot a series of photos, with framing guided by an on-screen display; make sure they overlap correctly and you can then "stitch" them together in special software to make a single, very wide, panoramic image. Some cameras can even do this for you with in-camera processing but most (though not all) require you to use a tripod. Your Sony camera offers the most convenient type of panorama mode; it's automatic (but allows you to use some overrides) and it can produce very good results without a tripod. Of course, it's easier to keep the camera perfectly level while shooting the series when using a tripod but that's not always practical. Here are a few tips to consider:

- **Choose a direction.** You can select one of four directions for your panorama: right, left, up, or down. Select any of these options in the Still Shooting 1 menu, using the Panorama Direction item. It's only available when the camera is set to Sweep Panorama mode. The default setting, right, is probably the most natural for many people; it requires you to pan the camera from the left to the right across a wide vista. Occasionally, you might want to use one of the other options. The up or down motion is the one you'll need to make a panoramic photo of very tall subjects, such as skyscrapers and nearby mountains.

- **Change settings while in Panorama mode.** When you select this shooting mode, the camera presents you with a large arrow and urgent-sounding instructions to press the shutter button and move the camera in the direction of the arrow. Don't let the camera intimidate you with this demand; what it is neglecting to tell you is that you can take all the time you want, and that you are free to change certain settings before you shoot.

 Press the MENU button and you can set the focus mode, white balance, and metering mode. Other useful functions include exposure compensation, Image Size in the Image Size menu which lets you set either the Standard or the Wide panorama option and the Creative Style modes in the Brightness/Color menu. Once you have those settings fine-tuned to your satisfaction, *then* go ahead and press the shutter release button.

- **Smooth and steady does it.** While keeping the shutter release button depressed, immediately start moving the camera smoothly and steadily in an arc; pivot your feet or the camera on a tripod head and keep going until the shutter stops clicking. If you moved the camera at a speed that was too fast or too slow, you'll get an error message and the camera will prompt you to start over.
- **Beware of moving objects.** The Sweep Panorama mode is intended for stationary subjects, such as mountain ranges, city skylines, or expansive gardens. Figure 5.26 (top) is an example of one of my landscape panoramas. There's nothing to stop you from shooting a scene that contains moving cars, people, or other objects, but be aware of problems that can arise in that situation. Because you're taking multiple overlapping shots that are then stitched into a single image, the camera may capture the same car or person two or more times in slightly different positions; this can result in a truncated or otherwise distorted picture of that particular subject.

Of course, you can certainly experiment with moving subjects for creative purposes. Occasionally, you'll get lucky and the photo will be "really cool" instead of just "really weird" as in Figure 5.26 (bottom). Press the Playback button to view your just completed panorama; press the center button to view a moving playback of the image.

Figure 5.26 The top image is an example of a conventional photo made with Sweep Panorama. The bottom photo is less typical, taken by panning with the movement of a single cyclist, who was recorded several times; cropping the image removed extraneous parts of the cyclist at the beginning and the end of the series.

6

Mastering the Autofocus Options

One of the most useful and powerful features of modern digital cameras is their ability to lock in sharp focus faster than the blink of an eye. Sometimes. Although autofocus has been with us for more than 20 years, it's not exactly perfect in every respect. Camera manufacturers are giving us faster and more precise autofocus systems, like the full-time autofocus possible with mirrorless technology. Granted, the sheer number of options can confuse even the most advanced photographers.

One key problem with autofocus is that the camera doesn't really know, for certain, what subject you want to be in sharp focus. It may select an object and lock in focus with lightning speed—even though it's not the center of interest in your photograph. Or, the camera may lock focus too soon, or too late. This chapter will help you choose the options available with your Sony a5000 in order to help the camera understand what you want to focus on, when, and maybe even why.

Getting into Focus

Learning to use the Sony a5000's autofocus system is easy, but you do need to fully understand how the system works to get the most benefit from it. Once you're comfortable with autofocus, you'll know when it's appropriate to use the manual focus option, too. The important thing to remember is that focus isn't absolute. For example, some things that appear to be in sharp focus at a given viewing size and distance might not be in focus at a larger size and/or closer distance. In addition, the goal of optimum focus isn't always to make things look sharp. For some types of subjects, not all of an image need be sharp. Controlling exactly what is sharp and what is not is part of your

creative palette. Use of depth-of-field characteristics to throw part of an image out of focus while other parts are sharply focused is one of the most valuable tools available to a photographer. But selective focus works only when the desired areas of an image are in focus properly. For the digital camera photographer, correct focus can be one of the trickiest parts of the technical and creative process.

There are two major focusing methods used by modern digital cameras: *Phase detection*, used by Sony Alpha SLT models and some advanced mirrorless models that incorporate the technology into their sensors and *contrast detection*, which is the primary focusing method employed by the unadorned a5000. Contrast detection focusing is illustrated by Figure 6.1. At top in the figure, the transitions between the edges of the vertical wood grain grooves are soft and blurred because of the low contrast between them. The focus system looks only for contrast between edges, and those edges can run in any direction. At the bottom of the figure, the image has been brought into sharp focus, and the edges have much more contrast; the transitions are sharp and clear. Although this example is a bit exaggerated so you can see the results on the printed page, it's easy to understand that when maximum contrast in a subject is achieved using contrast detection, it can be deemed to be in sharp focus.

Phase detection is an alternative focusing method used in many advanced cameras including current Sony Alpha SLT models. It is also used with the a5000 when you attach the optional LA-EA2 or LA-EA4 A-mount lens adapters, which each have their own built-in phase detection autofocus systems. That focusing method operates quite differently. Each autofocus sampling area within the separate AF sensor is divided into two halves by a microlens in the autofocus sensor. The two halves are compared, much like (actually, exactly like) a two-window rangefinder used in surveying, weaponry, and non-SLR cameras like the venerable Leica M film models. The contrast between the two images changes as focus is moved in or out, until sharp focus is achieved when the images are "in phase," or lined up.

Figure 6.1

Using the contrast detection method of autofocus, the Sony Alpha can evaluate the increase in contrast in the edges of subjects, starting with a blurry image (top) and producing a sharp, contrasty image (bottom).

Figure 6.2 When an image is out of focus, the split lines don't align precisely.

Figure 6.3 Using phase detection, a camera can align the features of the image and achieve sharp focus quickly.

You can visualize how phase detection autofocus works if you look at Figures 6.2 and 6.3. (This is a greatly simplified view just for illustration purposes.) In Figure 6.2, a typical horizontally oriented focus sensor is looking at a series of parallel vertical lines in a weathered piece of wood. The lines are broken into two halves by the sensor's rangefinder prism, and you can see that they don't line up exactly; the image is slightly out of focus. The rangefinder approach of phase detection tells the camera exactly how much out of focus the image is, and in which direction (focus is too near, or too far), thanks to the amount and direction of the displacement of the split image. The camera can snap the image into sharp focus and line up the vertical lines, as shown in Figure 6.3, in much the same way that rangefinder cameras align two parts of an image to achieve sharp focus.

In designing the a5000 and other mirrorless cameras, Sony sought to keep the camera body as small and light as possible, and thereby eliminated some of the mechanisms used for the phase detection focusing method, such as a mirror and a separate autofocus sensor. (You'll find those components in the LA-EA2 and LA-EA-4 A-mount adapters.)

Although the phase detection approach to focusing is generally considered state-of-the art because of its speed and efficiency, the contrast detection approach has certain advantages of its own:

- **Works with more image types.** Contrast detection doesn't require subject matter rotated 90 degrees from the sensor's orientation to work optimally, as phase detection does. Any subject that has edges can be used to achieve sharp focus.

- **Focus on any points.** Whereas phase detection focus can be achieved *only* at the points that fall under one of the special autofocus sensors, with contrast detection any portion of the image can be used as a focus point. Focus is achieved with the actual sensor image, so focus point selection is simply a matter of choosing which part of the sensor image to use. (This point is highlighted by the fact, discussed below, that in Flexible Spot mode, you can move the Autofocus Area to virtually any part of the LCD, whereas with a phase detection system, you can move the Autofocus Area only to a small number of specific locations where the special autofocus sensors used for phase detection are located.)

- **Potentially more accurate.** Phase detection can fall prey to the vagaries of uncooperative subject matter: if suitable lines aren't available, the system may have to hunt for focus or achieve less than optimal focus. Contrast detection focus is more clear-cut. In most cases, the camera is able to determine clearly when sharp focus has been achieved.

Although contrast detection systems have the reputation of being slower than phase detection systems, Sony's implementation of contrast detection in the a5000 leaves little or no room for complaint. This camera is equipped with a system that is very quick and effective at achieving focus under a great variety of conditions. And, as I'll discuss later in Chapter 8, the a5000's focusing system works admirably when you're shooting movies as well, which is unusual for a camera that is designed primarily for shooting still images. With this camera, it appears that contrast detection focusing has advanced to the stage at which it can compare very favorably to the phase detection approach.

Focus Modes and Options

Now that you understand the fundamental principles of how the a5000 achieves focus, let's discuss the practical application of these principles to your everyday picture-taking activities by setting the various modes and options for use of the autofocus system. We'll also discuss the use of manual focus, and when that method might be preferable to autofocus.

As you've come to appreciate by now, the a5000 offers many options for your photography. Focus is no exception. Of course, as with other aspects of this camera, you can set the shooting mode to either Auto option or a scene mode such as Sports Action, and the camera will do just fine in most situations, using its default settings for autofocus. But, if you want more creative control, the choices are there for you to make. In fact, with the camera, even in the fully automatic modes, you always have the option of choosing manual focus. (If you select autofocus in those shooting modes, though, you have no further choices available; the autofocus method and Autofocus Area are set for you.)

So, no matter what shooting mode you're using, your first choice is whether to use autofocus or manual focus. Yes, there's also a Direct Manual Focus (DMF) option, discussed in Chapter 3, but that still provides autofocus, with the option of fine-tuning focus manually before taking the shot. Until quite recently, manual focus was the only choice available to photographers. That was the only option from the nineteenth century days of Daguerreotypes until about the 1980s, when autofocus started becoming available. Manual focus presents you with great flexibility along with the

challenge of keeping the image in focus under what may be challenging conditions, such as rapid motion of the subject, darkness of the scene, and the like. Later in this chapter, I'll cover manual focus as well as DMF. For now, I'll assume you're going to rely on the camera's conventional AF mode.

The Sony a5000 has two basic AF modes: AF-S (Single-shot autofocus) and AF-C (Continuous autofocus). Once you have decided on which of these to use, you also need to tell the camera how to set the AF frame. In other words, after you tell the camera how to autofocus, you also have to tell it where to direct its focusing attention. I'll explain all of these points in more detail later in this section.

MANUAL FOCUS

When you select manual focus (MF) in the Focus Mode entry in the Camera Settings 3 menu, the a5000 lets you set the focus yourself by turning the focus ring on the lens. There are some advantages and disadvantages to this approach. While your batteries will last slightly longer in manual focus mode, it will take you longer to focus the camera for each photo. And unlike older 35mm film SLRs, digital cameras' viewfinders and LCDs are not designed for optimum manual focus. Pick up any advanced film camera and you'll see a big, bright viewfinder with a focusing screen that's a joy to focus on manually. So, although manual focus is still an option for you to consider in certain circumstances, it's not as easy to use as it once was. I recommend trying the various AF options first, and switching to manual focus only if AF is not working for you. And then be sure to take advantage of the focus peaking feature and the automatic frame enlargement (MF Assist) which can make it easier to determine when the focus is precisely on the most important subject element. And remember, if you use the DMF mode, you can fine-tune the focus after the AF system has finished its work.

Focus Pocus

Although some cameras added autofocus capabilities in the 1980s, back in the days of film cameras, prior to that focusing was always done manually. Honest. Even though 35mm SLR cameras' viewfinders were bigger and brighter than they are today and usually offered a split-image or other focusing aid, some photographers still bought special focusing screens and magnifiers, and other gadgets were often used to help the photographer achieve correct focus. Imagine what it must have been like to focus manually under demanding, fast-moving conditions such as sports photography.

Focusing was problematic because our eyes and brains have poor memory for correct focus, which is why your eye doctor must shift back and forth between sets of lenses and ask "Does that look sharper or was it sharper before?" in determining your correct prescription. Similarly, manual focusing involves jogging the focus ring back and forth as you go from almost in focus, to sharp focus, to almost focused again. The little clockwise and counterclockwise arcs decrease in size until you've

zeroed in on the point of correct focus. What you're looking for is the image with the most contrast between the edges of elements in the image.

The Sony a5000's system can assess sharpness quickly, and it's also able to remember the progression perfectly, making the entire process fast and precise. Unfortunately, even this high-tech system doesn't really know with any certainty *which* object should be in sharpest focus. Is it the closest object? The subject in the center of the frame? Something lurking *behind* the closest subject? A person standing over at the side of the picture? Many of the techniques for using autofocus effectively involve telling the a5000 exactly what it should be focusing on.

Adding Circles of Confusion

But there are other factors in play, as well. You know that increased depth-of-field brings more of your subject into focus. But more depth-of-field also makes autofocusing (or manual focusing) more difficult because the contrast is lower between objects at different distances. So, autofocus with a 300mm lens (or zoom setting) may be easier than at a 16mm focal length (or zoom setting) because the longer lens has less apparent depth-of-field. By the same token, a lens with a maximum aperture of f/1.8 will be easier to autofocus (or manually focus) than one of the same focal length with an f/4 maximum aperture, because the f/4 lens has more depth-of-field and a dimmer view. It's also important to note that lenses with a maximum aperture smaller than f/5.6 would give your Sony Alpha's autofocus system fits, because the smaller opening (aperture) would allow less light to enter or to reach the autofocus sensor.

To make things even more complicated, many subjects aren't polite enough to remain still. They move around in the frame, so that even if the a5000's lens is sharply focused on your main subject, the subject may change position and require refocusing. An intervening subject may pop into the frame and pass between you and the subject you meant to photograph. You (or the a5000) have to decide whether to focus on this new subject, or to remain focused on the original subject. Finally, there are some kinds of subjects that are difficult to bring into sharp focus because they lack enough contrast to allow the a5000's AF system (or our eyes) to lock in. Blank walls, a clear blue sky, or other low-contrast subject matter may make focusing difficult even with the Hybrid AF system.

If you find all these focus factors confusing, you're on the right track. Focus is, in fact, measured using something called a *circle of confusion*. An ideal image consists of zillions of tiny little points, which, like all points, theoretically have no height or width. There is perfect contrast between the point and its surroundings. You can think of each point as a pinpoint of light in a darkened room. When a given point is out of focus, its edges decrease in contrast and it changes from a perfect point to a tiny disc with blurry edges (remember, blur is the lack of contrast between boundaries in an image). (See Figure 6.4.)

If this blurry disc—the circle of confusion—is small enough, our eye still perceives it as a point. It's only when the disc grows large enough that we can see it as a blur rather than as a sharp point that a given point is viewed as being out of focus. You can see, then, that enlarging an image, either by

Figure 6.4
When a pinpoint of light (left) goes out of focus, its blurry edges form a circle of confusion (center and right).

displaying it larger on your computer monitor or by making a large print, also magnifies the size of each circle of confusion. Moving closer to the image does the same thing. So, parts of an image that may look perfectly sharp in a 5 × 7-inch print viewed at arm's length, might appear blurry when blown up to 11 × 14 inches and examined at the same distance. Take a few steps back, however, and the image may look sharp again.

To a lesser extent, the viewer also affects the apparent size of these circles of confusion. Some people see details better at a given distance and may perceive smaller circles of confusion than someone standing next to them. For the most part, however, such differences are small. Truly blurry images will look blurry to just about everyone under the same conditions.

Technically, there is just one plane within your picture area, parallel to the back of the camera (actually the sensor) that is in sharp focus. That's the plane in which the points of the image are rendered as precise points. At every other plane in front of or behind the focus plane, the points show up as discs that range from slightly blurry to extremely blurry. In practice, the discs in many of these planes will still be so small that we see them as points, and that's where we get depth-of-field: the range of planes that includes discs that we perceive as points rather than blurred splotches. The size of this range increases as the aperture is reduced in size and is allocated roughly one-third in front of the plane of sharpest focus, and two-thirds behind it. (See Figure 6.5.)

Making Sense of Sensors and AF Points

The number and type of focus detection points can affect how well the system operates. In phase detection systems, as discussed earlier, above, the AF points are determined by the locations of the special focus detection sensors or AF areas. The more focus detection points available, the more easily the camera can differentiate among areas of the frame. The a5000 uses 25 focus detection points. This means that there are 25 locations where the camera will attempt to direct its focus when you leave it up to the system. However, if you decide to use Flexible Spot AF, you can position the focus detection point at any one of 176 locations. This allows for maximum precision in specifying the exact area that should be in the sharpest focus.

Figure 6.5 The focused plane (the nose of the train) is sharp but the area in front of that (the lettering on its side) and behind it (the background) are blurred because the depth-of-field (the range of acceptably sharp focus) is shallow in this image.

As the camera collects contrast information from the focus detection points, it evaluates the data to determine whether the desired sharp focus has been achieved. The calculations may include whether the subject is moving, and whether the camera needs to "predict" where the subject will be at the instant the shutter opens in order to take the photo. The speed of focus evaluation, and of moving lens elements to the proper position to set the sharpest focus, determines AF speed.

Although your Sony a5000 will almost always focus more quickly than a human eye, there are types of shooting situations where that's not fast enough. For example, if you're having problems shooting sports because the a5000's autofocus system manically follows each moving subject, a better choice might be to shift into manual focus and pre-focus on a spot where you anticipate the action will be, such as a goal line or soccer net. At night football games, for example, when I am shooting with a telephoto lens almost wide open, I often focus manually on one of the referees who happens to be standing where I expect the action to be taking place (say, a halfback run or a pass reception). When I am less sure about what is going to happen, I may switch to Continuous AF and let the camera decide.

Using Manual Focus

As I noted earlier, manual focus is not as straightforward as with an older manual focus 35mm SLR, equipped with a focusing screen optimized for this purpose and a readily visible focusing aid. But Sony's designers have done a good job of letting you exercise your initiative in the focusing realm, with features that make it easy to determine whether you have achieved precise focus. It's worth becoming familiar with the techniques for those occasions when it makes sense to take control in this area.

> **Note**
>
> Nearly all zoom lenses are equipped with a zoom ring as well as a manual focus ring. When you use the 16-50mm f/3.5–5.6 PZ OSS lens however, there's only one ring. It's used for zooming when autofocus is active, but when you use manual focus in MF or DMF mode, this ring controls focus.

Here are the basic steps for quick and convenient setting of focus:

- **Select Manual Focus.** After you do so (in the Focus Mode entry in the Camera Settings 3 menu), the letters MF will appear in the LCD display when you're viewing the default display that includes a lot of data. (You can change display modes by pressing the DISP button.)

- **Aim at your subject and turn the focusing ring on the lens.** As soon as you start turning the focusing ring, the image on the LCD is enlarged (magnified) to help you assess whether the center of interest of your composition is in focus. (That is, unless you turned off this feature, called MF Assist, through the Custom Settings 1 menu.) Use the up/down/left/right direction controls to move around the magnified image area until you're viewing the most important subject element, such as a person's eyes. Turn the focusing ring until that appears to be in the sharpest possible focus.

 The enlargement lasts two seconds before the display returns to normal; you can increase that with the MF Assist Time menu item. In situations where you want to use manual focus without enlargement of the preview image, you can turn this feature off in the Custom Settings menu, using the MF Assist item.

- **If you have difficulty focusing, zoom in if possible and focus at the longest available focal length.** If you're using a zoom lens, you may find it easier to see the exact effect of slight changes in focus while zoomed in. Even if you plan to take a wide-angle photo, zoom to telephoto and rotate the ring to set precise focus on the most important subject element. When you zoom back out to take the picture, the center of interest will still be in sharp focus.

- **Use Peaking of a suitable color.** On by default in shooting mode, focus peaking provides a colored overlay around edges that are sharply focused; this makes it easier to determine when your subject is precisely focused. The overlay is white, but you can change that to another color when necessary. The alternate hue may be needed to provide a strong contrast between the peaking highlights and the color of your subject. Access the Peaking Color item of the Setup menu to adjust the color. To make the overlay even more visible, select High in the Peaking Level item; you can also turn peaking Off with this item, if desired.
- **Consider using the DMF option.** Your third option is DMF, or Direct Manual Focus. Activate it and the camera will autofocus with Single-shot AF and lock focus when you press the shutter release button half way. As soon as focus is confirmed, you can turn the focusing ring to make fine-tuning adjustments, as long as you maintain slight pressure on the shutter release button. The MF Assist magnification will be activated immediately.

 This method gives you the benefit of autofocus but gives you the chance to change the exact point of focus, to a person's eyes instead of the tip of the nose, for example. This option is useful in particularly critical focusing situations, when the precise focus is essential, as in extremely close focusing on a three-dimensional subject. Because depth-of-field is very shallow in such work, you'll definitely want to focus on the most important subject element, such as the pistil or stamen inside a large blossom. This will ensure that it will be the sharpest part of the image.

Your Autofocus Mode Options

Most serious photographers would not buy a camera if it could not provide manual focus, but autofocus is likely to be your choice in the great majority of shooting situations. Choosing the right AF mode and the way in which focus points are selected is your key to success. Using the wrong mode for a particular type of photography can lead to a series of pictures that are all sharply focused—on the wrong subject. When I first started shooting sports with an autofocus camera (back in the film camera days), I covered one baseball game alternating between shots of base runners and outfielders with pictures of a promising young pitcher, all from a position next to the third base dugout. The base runner and outfielder photos were great, because their backgrounds didn't distract the autofocus mechanism. But all my photos of the pitcher had the focus tightly zeroed in on the fans in the stands behind him. Because I was shooting with film instead of a digital camera, I didn't know about my gaffe until the film was developed. A simple change, such as locking in focus or focus zone manually, or even manually focusing, would have done the trick.

But autofocus isn't some mindless beast out there snapping your pictures in and out of focus with no feedback from you. There are several settings you can modify that return a fair amount of control to you. Your first decision should be whether you set the autofocus mode to Single-shot or Continuous AF. Press the MENU button, go to the Camera Settings 3 menu, and navigate to the line for Focus Mode. Press the center button, then highlight your choice from the submenu, and press the center button again.

Single-Shot AF (AF-S) Mode

If you have set the a5000 for AF-S in the Camera Settings menu and Pre-AF in the Custom Settings 2 menu, you may notice something that seems strange: the camera's autofocus mechanism will begin seeking focus even before you touch the shutter release button. This is definitely not the norm with the vast majority of cameras. But the Sony a5000 is different in various ways, and this is one of them. No matter which AF mode is selected, the camera will continually alter its focus as it is aimed at various subjects, *until* you press the shutter release button halfway. At that point, the camera locks focus, in Single-shot AF mode.

> **Note**
>
> In this chapter, I'm assuming that you're using P, A, S, or M mode where you have full control over the camera features. This is important because the a5000 will use only AF-S in either Auto mode, in any scene mode except Sports Action, in Sweep Panorama, and whenever the Smile Shutter feature is active. And it will set Continuous AF (AF-C) only in SCN mode.

The difference between Single-shot AF and Continuous AF comes at the point the shutter release button is pressed halfway. In AF-S mode, focus is locked. By keeping the shutter button depressed halfway, you'll find you can reframe the image by moving the camera to aim at another angle; the focus (and exposure) will not change. Maintain pressure on the shutter release button and focus remains locked even if you recompose or if the subject begins running toward the camera, for example.

When sharp focus is achieved in AF-S mode, a solid green circle will appear on the lower-left corner of the screen and you'll hear a little beep. One or more green focus confirmation frames will also appear to indicate the area(s) of the scene that will be in sharpest focus. If for some reason the camera cannot achieve sharp focus, such as in a dark or low-contrast environment, the green circle will flash and you will not hear a focus confirmation beep. However, unlike some cameras, which lock the shutter if focus cannot be achieved, the a5000 will let you take a shot even if it will be out of focus. I suppose the theory is that a slightly blurred photo is better than no photo at all in difficult situations.

For non-action photography, AF-S is usually your best choice, as it minimizes out-of-focus pictures (at the expense of spontaneity). Because of the small delay while the camera zeroes in on correct focus, you might experience slightly more shutter lag. This mode uses less battery power than Continuous AF.

Continuous AF (AF-C) Mode

Switch to this mode when photographing sports, young kids at play, and other fast-moving subjects. In this mode, as with Single-shot AF, the autofocus system is operating constantly even before you depress the shutter release button halfway. The camera can lock focus on a subject if it is not moving

toward the camera or away from your shooting position; when it does, you'll see a green circle surrounded by brackets. (There will be no beep.) But if the camera-to-subject distance begins changing, the camera instantly begins to adjust focus to keep it in sharp focus, making this the more suitable AF mode with moving subjects.

Setting the AF Area

So far, you have allowed the a5000 to choose which part of the scene will be in the sharpest focus using its focus detection points called AF Areas by Sony. However, you can also specify a single focus detection point that will be active. There are four basic AF Area options. (A fifth option is Face Detection, which I'll discuss shortly.) Press the MENU button, navigate to the Focus Area item in the Camera Settings 3 menu, press the center button, and select one of the four options. Press the center button again to confirm. Here is how the three AF Area options work:

- **Wide.** The a5000 chooses the appropriate focus area(s) in order to set focus on a certain subject in the scene. There are no focus brackets visible on the screen until you press the shutter release button halfway to lock focus. At that point, the camera displays one or more pairs of green focus brackets to show what area(s) of the image it has used to set focus on. (See Figure 6.6.) If Face Detection is active, the AF system will prioritize faces when making its decision as to where it should set focus. You'll see several pairs of brackets when several parts of the scene are at the same distance from the camera. When most of the elements of a scene are at roughly the same distance, the camera displays a single, large green focus bracket around the entire edge of the screen. Even if you set one of the other options, Wide is automatically selected in certain shooting modes, including both Auto and all SCN modes. Use this mode to give the camera complete control over where to focus.

Figure 6.6
With Wide AF Area, the camera either displays one large green bracket indicating that most of the scene is at the same distance to the camera or it displays one or more smaller brackets to indicate the specific area(s) of the scene that will be in sharpest focus.

- **Zone.** A 3 × 3 array of nine focus areas, represented in orange, is shown on the screen (see Figure 6.7). You can use the directional buttons to shift the array to one of nine overlapping areas, three at the top of the frame, three at the bottom of the frame, and three in the middle. Select one of those nine focus areas, and the a5000 chooses which sections within that zone to use to calculate sharp focus. Those individual areas will be highlighted in green. Use this mode when you know your subject is going to reside in a largish area of the frame, and want to allow the a5000 to select the exact focus zone.
- **Center.** Activate this AF Area and the a5000 will use only a single focus detection point in the center of the frame to set focus. Initially a pair of black focus brackets appears on the screen. Touch the shutter release button and the camera sets and locks focus on the subject in the center of the image area; the brackets then turn green to confirm the area that will be in the sharpest focus in your image. (See Figure 6.8.) Choose this option if you want the camera to always

Figure 6.7
In Zone mode, an array of nine areas appears, and you can move the zone to nine different locations on the screen. The a5000 selects one or more focus zones within that array.

Figure 6.8
In the Center AF Area mode, the camera displays the focus brackets in the center of the screen; the brackets turn green after focus has been set.

focus on the subject in the center of the frame. Center the primary subject (like a friend's face in a wide-angle landscape composition), allow the camera to focus on it, maintain slight pressure on the shutter release button to keep focus locked, and reframe the scene for a more effective, off-center composition. Take the photo at any time and your friend (who is now off-center) will be in the sharpest focus.

- **Flexible Spot.** This mode enables you to move the camera's focus detection point (focus area) around the scene to any one of multiple locations, using the directional buttons. When opting for Flexible Spot, you can use the left/right buttons to choose Small, Medium, or Large spots. This mode can be useful when the a5000 is mounted on a tripod and you'll be taking photos of the same scene for a long time, while the light is changing, for example. Move the focus area to cover the most important subject, and it will always focus on that point when you later take a photo.

 When you initially select this AF Area mode, a small pair of focus brackets appears in the center of the screen along with four triangles pointing toward the four sides of the screen. (See Figure 6.9.) The triangles merely indicate that the AF Area can be moved in any direction.

 Use the directional controls to move the orange brackets around the screen. A full 176 positions are available for great versatility in the placement of the active focus detection point. Move the orange brackets until they cover the most important subject area and touch the shutter release button. The brackets will turn green and the camera will beep to confirm that focus has been set on the intended area.

Just as you're limited in the use of the AF mode in certain operating modes, there's a limitation with AF Area as well. For example, Flexible Spot is not available for selection in automatic modes. In either Auto mode or any SCN mode, the camera will always use Multi as the AF Area mode.

Figure 6.9
When the Flexible Spot AF Area mode is initially selected, the active focus detection point is delineated with brackets that turn green when focus is confirmed and locked; the arrows at each side of the screen indicate that you can move the brackets in any of the four directions.

Face Detection

As hinted already, the a5000 has one more trick up its sleeve for setting the AF Area. By default, Face Detection in the Camera Settings menu is on, enabling the a5000 to attempt to identify any human faces in the scene. If it finds one or more faces, the camera will surround each one (up to eight in all) with a white frame on the screen. (Later, I'll discuss a feature that allows you to specify favorite faces that the camera should prioritize.) If it judges that autofocus is possible for one or more faces, it will turn the frames around those faces orange. When you press the shutter button halfway down to lock autofocus, the frames will turn green, confirming that they are in focus. The camera will also attempt to adjust exposure (including flash, if activated) as appropriate for the scene.

Face Detection is available only when you're using AF and when the Focus Area and the Metering mode are both set to Multi, the defaults. So, if the Face Detection option is grayed out on the Camera Settings menu, check those other settings to make sure they are in effect. Personally, I usually prefer to exercise my own control as to exactly where the camera should focus, but when shooting quick snaps during a party, Face Detection can be a useful feature. It's also an ideal choice if you need to hand the camera to someone to photograph you and your family or friends at an outing in the park.

Lock-On AF

The next magic the a5000 can perform is called Lock-On AF. It's designed to maintain focus on a specific subject as it moves around the scene that you're shooting. Don't confuse this feature with Continuous AF (AF-C), the mode you would use in action photography with a subject running toward you, for example. That feature is often called AF Tracking with other cameras and by many photographers. The a5000 offers that feature too, with AF-C mode autofocus.

The Lock-On AF function *can* change focus as a person approaches the camera, but it's not intended for that purpose with a fast action subject. And this feature is far more versatile than Continuous AF mode. Once the camera knows what your preferred subject is, it can maintain focus as it moves around the image area, as a person might do while mingling with a large group of friends at a party.

Choose lock-On AF in the Camera Settings 5 menu. (You cannot do so when the camera is set for Hand-held Twilight or Anti Motion Blur scene mode, or Sweep Panorama or manual focus.) When it's on, a small white square appears in the center of the screen as in Figure 6.10, left. Move the position of the square with the directional controls until it covers your intended subject and press the center button. The small square now changes to a larger double square (as shown in Figure 6.10, right) that's called the *target frame*. You have instructed the a5000 as to your preferred subject. If the camera is set to AF-C mode, the camera tracks a focus subject when the shutter button is pressed halfway.

Move the camera around to change your composition or wait until your targeted subject begins moving around. Note that the target frame will remain on your subject, confirming that it will be in the sharpest focus when you take a photo. Changes in lighting, lack of contrast with the

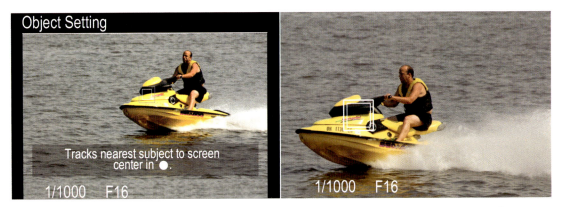

Figure 6.10 Left: Decide on the object the camera should track, center it, and press OK to instruct the a5000 as to your preferred target. Right: When Lock-On AF is active, the camera maintains focus on your preferred target, tracking it as it moves around the scene.

background, extra small or extra large subjects, and anything moving very rapidly can confuse Lock-On AF, but it's generally quite effective.

And there are a few other benefits with Lock-On AF when using the a5000 when Face Detection is also active. Let's say you have designated the intended target as your friend Jack's face. If Jack leaves the room while being tracked and then returns to the scene, Lock-On AF will remember it and focus on Jack again. Whenever a face is your target, the camera can continue tracking that person even if the face is not visible; it will then make the body the target for tracking. If you also activate the camera's Smile Shutter feature (in the Camera Settings menu) in addition to Face Detection, the a5000 will not only track the targeted face, but it will take a photo if your subject smiles.

And finally, the a5000 provides a face priority feature to instruct the camera to track a certain specific face in a scene where many faces are visible. Activate it in the Setup menu with the Face Priority Tracking item. (Face Detection must be on before you can do so.) The camera will then make the face that you first target its priority subject; it will make that its favorite, tracking the person whenever it's in the scene and continuing to track the person if it returns after leaving the scene for a while.

Useful Menu Items for AF

Here is a list of the a5000 autofocus features not yet mentioned, or not yet discussed in detail in this chapter, that you should keep in mind.

- **AF Illuminator.** This Setup menu item is set at Auto by default, indicating that the illuminator on the front of the camera will provide a burst of light in a dark location when using in AF-S mode. That provides a bright target for the autofocus system. Turn this feature off when you feel the red burst might be intrusive.

- **Face Registration.** Mentioned briefly earlier in this chapter, this Custom Settings 4 menu item is quite versatile, and was described in Chapter 3. You can register up to eight faces that should get priority in terms of autofocus and then specify the order of priority from the most important faces to the least important.

 To register a face, point the camera at the person's face, make sure it's within the large square on the screen, and press the shutter release button. Do so for several faces. When you're taking a photo of a scene that contains more than one registered face, the camera will prioritize faces based on which were the first to be registered in the process you used.

 Take advantage of the Order Exchanging option of this menu item so the faces you consider the most important are prioritized. When you access it, the camera displays the registered faces with a number on each; the lower the number the higher the priority. You can now change the priority in which the faces will be recognized, from 1 (say your youngest child) to 8 (perhaps your cousin twice removed). You can also use the Delete or the Delete All options to delete one or more faces from the registry, such as your ex and former in-laws.

- **Smile Shutter.** If you activate this feature in the Camera Settings menu, the face detection system will try to find smiling faces. In fact, it will not take a photo until it finds at least one. Press the OPTION button (the down directional key) and you get three options: Normal Smile, Big Smile, Small Smile. Set the one you want and the camera will watch for a smile of that magnitude; it will cover the relevant face(s) with an orange frame which will turn green after focus is set. And as mentioned earlier, when the camera will be tracking a face using the Lock-On AF feature while Smile Shutter is on, it will prioritize this face while doing so.

Auto Object Framing

While this is not an autofocus feature per se, I'll discuss it here because it works in conjunction with Face Detection. It's intended for use when shooting portrait photos (JPEGs only) quickly in situations where you won't have time to make a perfect composition. After it's activated with the Auto Port. Framing item in the Camera Settings menu, the a5000 determines when you are taking a photo of a person. After you compose such a photo, the Auto Portrait Framing icon on the screen turns green if the processor decides that it will be able to crop the photo in order to provide an improved composition. (If it cannot do so, try a different composition and make sure the person is well lit from the front.)

While practicing with this feature, take the shot when the icon is green. After you do so a frame showing the trimmed area will be displayed on the screen so you can see what has been cropped to provide a better composition. The cropping will usually eliminate extraneous areas around the subject and it will be done so the eyes in the photo will be off-center. The camera saves both the original image ("poor" composition) and the cropped (better composition) JPEG to the memory card. (See Figure 6.11.)

Figure 6.11 I intentionally made a poor composition (left) to test the value of Sony's Auto Object Framing technology. The processor cropped the photo for a better composition (right).

Just as you suspected, Auto Object Framing is another feature that cannot be activated under certain conditions: in some scene modes and in Panorama mode, in Continuous drive mode or bracketing, when manual focus is used, when certain effects are active, when digital zoom is in use, when Auto HDR is on, and when RAW or RAW&JPEG capture is being used.

Although cropping discards millions of pixels, the camera's processor ensures that the cropped image will be as large as the "poor" (original) image. That's achieved by adding pixels to restore it to the full size, using Sony's By Pixel Super Resolution Technology; this type of interpolation minimizes the loss of quality. Still, for the best results, it's worth setting Quality to Fine when using Auto Portrait Framing.

AF Lock

Like most cameras, the a5000 provides an autofocus lock (in AF-S mode), with light pressure on the shutter release button or when you depress an AF Lock button that you define using Custom Settings 4 menu's Custom Keys option, as described in Chapter 3. The most frequent use of this feature is when the camera struggles to focus on a desired subject; it works best when AF Area is set to Center. When the camera struggles, simply point the lens at an entirely different object that's the same distance from the camera. Use AF Lock to maintain focus at the desired distance; recompose and take the photo. Whether you used light pressure on the shutter release button, or depressed the button, both focus and exposure will be locked for the area in sharpest focus.

You might also want to use this lock technique for off-center compositions. Start by centering your subject and depressing the shutter release button partway; the focus and exposure are now locked. While using this technique, you can move the camera to get a better composition, placing the subject far off-center, for example. Since you're keeping both focus and exposure locked, neither aspect will change as you recompose. Both will be optimized for your intended subject.

You can also use this camera feature to expose for one part of a scene, such as a mid-tone like nearby grass, while focusing on another part of the scene, like a distant white statue in a park. (Both areas must be in the same light, as discussed in a moment.) Again, it works best when AF Area is set to Center. Simply follow these steps:

1. Point the camera at the part of the scene you want to meter, the nearby grass in the example just mentioned. Press the AEL button for autoexposure lock; keep it depressed (unless you have set it to act as a toggle switch with the Custom Key Settings in the Setup menu).
2. Reframe so your primary subject, the statue in our example, is now in the center of the screen.
3. Touch the shutter release button to lock focus on your target (while still keeping the AEL feature active). As you do so, the exposure will not change because you're using the AEL feature.
4. Move the camera again in order to make the best possible composition of the scene; there's no need to include the area you metered. Take the photo by depressing the shutter release button.

The technique discussed above should provide a photo with correct exposure and a sharply focused primary subject because you took the light meter reading from a mid-tone area (as discussed in Chapter 5) and set focus on the intended center of interest. When you try it, do remember the warning that the area you meter must be in the same light as the primary subject. In other words, do not meter a grassy area in dark shade when most of the scene, including the center of interest, is in an area lit by bright sunshine.

Focus Stacking

Although it's not a camera feature per se, there is a technique that can provide a very great range of sharp focus from the foreground to the background in macro (extreme close-up) photography of three-dimensional objects. In this situation, the depth-of-field will be extremely shallow. In some cases, it will be so shallow that it will be impossible to keep the entire subject in focus even if you use a small aperture such as f/22. Although having part of the image (the background) out of focus can be a pleasing effect for a portrait of a person, it is likely to be a hindrance when you are trying to make an accurate photographic record of a flower, insect, or small piece of precision equipment.

One technique that can provide a solution, focus stacking, is a procedure that can be considered like HDR translated for the world of focus. You'll take multiple shots with different settings and use software to combine the best parts from each image in order to make a whole that is better than the sum of the parts.

For example, see Figures 6.12 through 6.14, photographs of three colorful crayons made with a Sony macro lens. As you can see from these images, the depth-of-field was extremely shallow; only a small part of the subject was in focus for each shot.

Now look at Figure 6.15, in which the entire subject is in reasonably sharp focus. This image is a composite, made up of the three shots above, but also 10 others, each one focused on the same scene, but focused at a very slightly different distance from the camera's lens. All 13 images were then combined in Adobe Photoshop using the focus stacking procedure. Here are the steps you can take to combine shots for the purpose of achieving sharp focus (an incredibly extensive depth-of-field effect) throughout an entire subject or scene:

1. Set the camera firmly on a solid tripod or some equally firm support; this is absolutely essential for this procedure.
2. Use an infrared remote control if possible. If not, consider using the self-timer to avoid any movement of the camera when each image is captured.
3. Set the camera to manual focus mode.
4. Set the exposure, ISO, and white balance manually, using test shots if necessary to determine the best values. This step will help prevent visible variations from arising among the multiple shots that you'll be taking.
5. Set the quality of the images to RAW&JPEG or FINE.
6. Focus manually on the very closest point of the subject to the lens. Trip the shutter, using the remote control or self-timer.
7. Focus on a point slightly farther away from the lens and trip the shutter again.
8. Continue taking photographs in this way until you have covered the entire subject with in-focus shots.

Figure 6.12 **Figure 6.13** **Figure 6.14**

These three shots, as well as ten others not shown here, were all focused on different distances within the same scene. No single shot could bring the entire subject into sharp focus.

Figure 6.15
The series of 13 photos, each made at a different focused distance, have been merged with focus stacking in Adobe Photoshop, to produce a single image with sharp focus throughout the entire subject area.

9. In Photoshop, select Files > Scripts > Load Files into Stack. In the dialog box that then appears, navigate on your computer to find the files for the photographs you have taken, and highlight them all.

10. At the bottom of the next dialog box that appears, check the box that says, "Attempt to Automatically Align Source Images," then click OK. The images will load; it may take several minutes for the program to load the images and attempt to arrange them into layers that are aligned based on their content.

11. Once the program has finished processing the images, go to the Layers panel and select all of the layers. You can do this by clicking on the top layer and then Shift-clicking on the bottom one.

12. While the layers are all selected, in Photoshop go to Edit > Auto-Blend Layers. In the dialog box that appears, select the two options, Stack Images and Seamless Tones and Colors, then click OK. The program will process the images, possibly for a considerable length of time.

13. If the procedure worked well, the result will be a single image made up of numerous layers that have been processed to produce a sharply focused rendering of your subject. If it did not work well, you may have to take additional images the next time, focusing very carefully on small slices of the subject as you move progressively farther away from the lens.

Although this procedure can work very well in Photoshop, you also may want to try it with programs that were developed more specifically for focus stacking and related procedures, such as Helicon Focus (www.heliconsoft.com), PhotoAcute (www.photoacute.com), or CombineZM (a PC-only program) (www.hadleyweb.pwp.blueyonder.co.uk).

Advanced Shooting

Of the primary foundations of great photography, only one of them—the ability to capture a compelling image with a pleasing composition—takes a lifetime (or longer) to master. The art of *making* a photograph, rather than just *taking* a photograph, requires an aesthetic eye that sees the right angle for the shot, as well as a sense of what should be included or excluded in the frame; a knowledge of what has been done in the medium before (and where photography can be taken in the future); and a willingness to explore new areas. The more you pursue photography, the more you will learn about visualization and composition. When all is said and done, this is what photography is all about.

The other basics of photography—equally essential—involve more technical aspects: the ability to use your camera's features to produce an image with good tonal and color values; to achieve sharpness (where required) or unsharpness (when you're using selective focus); and to master appropriate white/color balance. It's practical to learn these technical skills in a time frame that's much less than a lifetime, although most of us find there is always room for improvement. You'll find the basic information you need to become proficient in each of these technical areas in this book.

You've probably already spent a lot of time learning your a5000's basic features, and setting it up to take decent pictures automatically, with little input from you. It probably felt great to gain the confidence to snap off picture after picture, knowing that a large percentage of them were going to be well exposed, in sharp focus, and rich with color. This Sony camera is designed to produce good, basic images right out of the box.

But after you were comfortable with your camera, you began looking for ways to add your own creativity to your shots. You explored ways of tweaking the exposure, using selective focus, and, perhaps, depending on what lens your camera has, experimenting with the different looks that various lens zoom settings (*focal lengths*) could offer.

The final, and most rewarding, stage comes when you begin exploring advanced techniques that enable you to get stunning shots that will have your family, friends, and colleagues asking you, "How did you *do* that?" These more advanced techniques deserve an entire book of their own, but there is plenty of room in this chapter to introduce you to some clever things you can do with your a5000.

Exploring Ultra-Fast Exposures

Fast shutter speeds (such as 1/1,000th second) can stop action because they capture only a tiny slice of time: a high-jumper frozen in mid-air, perhaps. The Sony a5000 has a top shutter speed of 1/4,000th second for ambient light exposures. Electronic flash can also freeze motion by virtue of its extremely short duration—as brief as 1/50,000th second or less. When you're using flash the short duration of the actual burst of light can freeze a moving subject; that can also give you an ultra-quick glimpse of a moving subject when the scene is illuminated only by flash.

The a5000 is fully capable of immobilizing all but the very fastest movement if you use a shutter speed of 1/4,000th second (without flash). Some cameras have speeds up to 1/8,000th second, but those are generally overkill when it comes to stopping action; I can rarely find a situation where even 1/4,000th second is required to freeze high-speed motion. For example, the image shown in Figure 7.1 required a shutter speed of just 1/2,000th second to freeze the runner as she cleared the hurdles.

Figure 7.1
A shutter speed of 1/2,000th second will freeze most action.

Virtually all sports action can be frozen at 1/2,000th second or a slower shutter speed, and for many sports a slower shutter speed is actually preferable—for example, to allow the wheels of a racing automobile or motorcycle, or the propeller on a classic aircraft, to blur realistically.

There may be a few situations where a shutter speed faster than 1/4,000th second is required. If you wanted to use an aperture of f/1.8 at ISO 100 outdoors in bright sunlight, say to throw a background out of focus with the shallow depth-of-field available at f/1.8, a shutter speed of 1/4,000th second would more than do the job. You'd need a faster shutter speed only if you set a higher ISO, and you probably wouldn't do that if your goal were to use the widest aperture possible. Under *less* than full sunlight, I doubt you'd even need to use a shutter speed of 1/4,000th second in any situations you're likely to encounter.

Electronic flash works well for freezing the motion of a nearby subject when flash is the only source of illumination. Since the subject is illuminated for only a split second, you get the effect that would be provided by a very fast shutter speed and also the high level of light needed for an exposure. This feature can be useful for stopping the motion of a nearby subject.

Of course, as you'll see in Chapter 10, the tiny slices of time extracted by the millisecond duration of an electronic flash exact a penalty. To use flash the a5000 employs a shutter speed no faster than 1/160th second, which is the fastest shutter speed—called sync speed—in flash photography with your a5000.

You can have a lot of fun exploring the kinds of pictures you can take using very brief exposure times, whether you decide to take advantage of the action-stopping shutter speeds (between 1/1,000th and 1/4,000th second) or the brief burst of light from flash that can freeze the motion of a nearby subject. Here are a few ideas to get you started:

- **Take revealing images.** Fast shutter speeds can help you reveal the real subject behind the façade, by freezing constant motion to capture an enlightening moment in time. Legendary fashion/portrait photographer Philippe Halsman used leaping photos of famous people, such as the Duke and Duchess of Windsor, Richard Nixon, and Salvador Dali, to illuminate their real selves. Halsman said, "*When you ask a person to jump, his attention is mostly directed toward the act of jumping and the mask falls so that the real person appears.*" Try some high-speed portraits of people you know in motion to see how they appear when concentrating on something other than the portrait.

- **Create unreal images.** High-speed photography can also produce photographs that show your subjects in ways that are quite unreal. A helicopter in mid-air with its rotors frozen or a motocross cyclist leaping over a ramp, but with all motion stopped so that the rider and machine look as if they were frozen in mid-air, makes for an unusual picture. (See the frozen rotors at top in Figure 7.2.) When we're accustomed to seeing subjects in motion, seeing them stopped in time can verge on the surreal.

- **Capture unseen perspectives.** Some things are *never* seen in real life, except when viewed in a stop-action photograph. M.I.T. professor Dr. Harold Edgerton's famous balloon burst photographs were only a starting point for the inventor of the electronic flash unit. Freeze a hummingbird in flight for a view of wings that never seem to stop. Or, capture the splashes as liquid falls into a bowl, as shown in Figure 7.3. No electronic flash was required for this image (and wouldn't have illuminated the water in the bowl as evenly). Instead, a clutch of high-intensity lamps bounced off a green card and an ISO setting of 1600 allowed the camera to capture this image at 1/2,000th second.

Figure 7.2 Freezing a helicopter's rotors with a fast shutter speed makes for an image that doesn't look natural (top); a little blur helps convey a feeling of motion (bottom).

Figure 7.3
A large amount of artificial illumination and an ISO 1600 setting made it possible to capture this shot at 1/2,000th second without use of electronic flash.

Long Exposures

Longer exposures are a doorway into another world, showing us how even familiar scenes can look much different when photographed over periods measured in seconds. At night, long exposures produce streaks of light from moving, illuminated subjects like automobiles or amusement park rides. Or, you can move the camera or zoom the lens to get interesting streaks from non-moving light sources, such as the holiday lights shown in Figure 7.4. Extra-long exposures of seemingly pitch-dark subjects can reveal interesting views using light levels barely bright enough to see by. At any time of day, including daytime (in which case you'll often need the help of neutral-density filters to make the long exposure practical), long exposures can cause moving objects to vanish entirely, because they don't remain stationary long enough to register in a photograph.

There are actually three common types of lengthy exposures: *timed exposures*, *bulb exposures*, and *time exposures*. The Sony a5000 offers only the first two. Because of the length of the exposure, both of the following techniques should be used with a tripod to hold the camera steady.

- **Timed exposure.** To take a long exposure, set the a5000 to Shutter Priority or Manual exposure and use the control wheel to set the shutter speed to the length of time you want, such as 1.0, 1.3, 1.6, 2.0, 2.5, 3.2, 4.0, 5.0, 6.0, 8.0, 10.0, 13.0, 15.0, 20.0, 25.0, and 30.0 seconds. The camera does all the calculating for you. There's no need for a stop-watch or any calculation as

to the correct exposure. After taking a photo, review it on the LCD. If it's too dark or too bright, set exposure compensation (or a different aperture in M mode) and try again with the exposure doubled or halved. The disadvantage of timed exposures is that you can't take a photo for longer than 30 seconds.

- **Bulb exposures.** This technique is so-called because in the olden days the photographer kept the shutter open by squeezing and holding an air bulb attached to a tube that provided force to keep the shutter open. Traditionally, a bulb exposure is one that lasts as long as the shutter release button is depressed; when you release the button, the exposure ends. The camera provides no automation nor any indication as to the shutter speed that will provide a good exposure when you're using a shutter speed longer than 30 seconds, as discussed shortly.

To make a bulb exposure with the a5000, set the camera on Manual mode and use the control wheel to set the shutter speed immediately after 30 seconds. BULB will be displayed on the LCD. (BULB is not available in Shutter Priority.) Then, press the shutter release button to start the exposure; keep it depressed and then release it to close the shutter.

Figure 7.4 Zooming during a long exposure can produce interesting streaks of light.

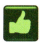

> **Tip**
>
> The camera's light meter is disengaged when you use the BULB setting so you'll need to use an external light meter to calculate the aperture and exposure time that will provide a good exposure of the scene you plan to photograph. If you don't have an accessory light meter, you can rely on the tips published in books or magazine articles about long exposure image making. Otherwise, you'll simply need to guess, as I do when shooting fireworks with the BULB setting, as discussed in a later section.

Working with Long Exposures

Because the a5000 produces such good images at longer timed exposures, and there are so many creative things you can do with long exposure techniques, you'll want to do some experimenting. Get yourself a tripod or another firm support and take some test shots with long exposure noise reduction both enabled and disabled in the Setup menu (to see whether you prefer low noise or high detail) and get started. Here are some things to try:

- **Make people invisible.** One very cool thing about long exposures is that objects that move rapidly enough won't register at all in a photograph, while the subjects that remain stationary are portrayed in the normal way. That makes it easy to produce people-free landscape photos and architectural photos at night, or even in full daylight if you use one or more dark neutral-density filters to allow an exposure of at least a few seconds. At ISO 100 and f/16 for example, a pair of 8X (three-stop) neutral-density filters will allow you to make an exposure of nearly two seconds on a sunny day. Overcast days and/or even more neutral-density filtration would work even better if daylight people-vanishing is your goal. They'll have to be walking *very* briskly and across the field of view (rather than directly toward the camera) for this to work. At night, it's much easier to achieve this effect with the 20- to 30-second exposures that are possible in low light without any filter.

- **Create streaks.** If you aren't shooting for total invisibility, long exposures with the camera on a tripod can produce some interesting streaky effects. Even a single 8X ND filter will let you shoot at f/22 and 1/6th second in daylight. Indoors, you can achieve interesting streaks with slow shutter speeds, as shown in Figure 7.5. I shot the ballet dancers using a 1/2-second exposure, triggering the shot at the beginning of a movement.

> **Tip**
>
> Neutral-density filters are gray (non-colored) filters that reduce the amount of light passing through the lens, without adding any color or effect of their own.

Figure 7.5
The shutter opened as the dancers began their movement from a standing position, and finished when they had bent over and paused.

Figure 7.6
I caught the fireworks after a baseball game from a half-mile away, using a four-second exposure to capture several bursts in one shot.

- **Produce light trails.** At night, car headlights, taillights, and other moving sources of illumination can generate interesting light trails. Your camera doesn't even need to be mounted on a tripod; hand-holding the Sony Alpha for longer exposures adds movement and patterns to your trails. If you're shooting fireworks, a longer exposure—with the camera on a tripod—may allow you to combine several bursts into one picture, as shown in Figure 7.6.
- **Show total darkness in new ways.** Even on the darkest, moonless nights, there is enough starlight or glow from distant illumination sources to see by, and, if you use a long exposure, there is enough light to take a picture, too. I was visiting a Great Lakes park hours after sunset, but found that a several-second exposure revealed the skyline scene shown in Figure 7.7, even though in real life, there was barely enough light to make out the boats in the distance. Although the photo appears as if it were taken at twilight or sunset, in fact the shot was made at 10 p.m.
- **Blur waterfalls, etc.** You'll find that waterfalls and other sources of moving liquid produce a special type of long-exposure blur, because the water merges into a fantasy-like veil that looks different at different exposure times, and with different waterfalls. Cascades with turbulent flow produce a rougher look at a given longer exposure than falls that flow smoothly. Although blurred waterfalls and rapids have become almost a cliché, there are still plenty of variations for a creative photographer to explore. Figure 7.8 illustrates the difference in this small waterfall when using a long shutter speed (bottom) of 1/8th second vs. a fast shutter speed (top) of 1/250th second.

Figure 7.7 A long exposure transformed this night scene into a picture apparently taken at dusk.

Figure 7.8 A fast shutter speed (top) freezes the droplets of moving water while a long exposure (bottom) can produce an impression of motion in a still photo that most viewers prefer.

Delayed Exposures

Sometimes it's desirable to have a delay of some sort before a picture is actually taken. Perhaps you'd like to get in the picture yourself, and would appreciate it if the camera waited 10 seconds after you press the shutter release to actually take the picture. Maybe you want to give a tripod-mounted camera time to settle down and damp any residual vibration after the release is pressed to improve sharpness for an exposure with a relatively slow shutter speed.

The a5000 has a built-in self-timer with 10-second and 2-second delays. Activate the timer by pressing the drive button (left direction button) and navigating with the up/down direction buttons or the control wheel to choose the self-timer icon. Then, press the left/right button to toggle between 2-second and 10-second delays. Press the center button to lock in your choice.

Compose the scene and press the shutter release button halfway to lock focus on your subjects (if you're taking a self-portrait, focus on an object at a similar distance and use focus lock). Depress the shutter release the rest of the way and the countdown will start (the focus will not change after this so you can walk away from the camera). The lamp on the front of the a5000 will blink slowly for eight seconds (when using the 10-second timer) and the beeper will chirp (if you haven't disabled it). During the final two seconds, the beeper sounds more rapidly and the lamp remains on until the picture is taken. (With the 2-second timer, you get a burst of rapid chirping accompanied by the lamp, which goes out just before the shutter is triggered.)

If you want to have the camera take multiple shots after the self-timer counts down, set a different option in the Drive menu: the icon that has C3 after it. The C indicates that Continuous shooting will be in effect; the number indicates the number of shots that will be taken. Press the directional buttons and you can switch to using C5. If you set C3, the camera will fire three shots in a burst after the self-timer has finished counting down while C5 will fire five shots instead. This is a handy way to get at least one family photo that's not spoiled by a blinker or yawner in the line-up.

Finally, although this feature may not have been intended for such use, the Smile Shutter feature of the a5000 camera acts as a self-timer of sorts. Set up the shot the way you want it using a tripod, then you and/or your subjects can stand in front of the camera and trigger it with your built-in remote controller: a smile. The operation of the Smile Shutter feature is discussed in Chapter 3.

Continuous Shooting

The a5000's Continuous shooting modes remind me how far digital photography has brought us. The first accessory I purchased when I worked as a sports photographer some years ago was a motor drive for my film SLR. It enabled me to snap off a series of shots at a three frames-per-second rate, which came in very handy when a fullback broke through the line and headed for the end zone. Even a seasoned action photographer can miss the decisive instant when a crucial block is made, or a baseball superstar's bat shatters and pieces of cork fly out. Continuous shooting simplifies taking a series of pictures, either to ensure that one has more or less the exact moment you want to capture or to capture a sequence that is interesting as a collection of successive images.

The a5000's "motor drive" capabilities are, in many ways, much superior to what you get with a film camera. For one thing, a motor-driven film camera can eat up film at an incredible pace, which is why many of them are used with cassettes that hold hundreds of feet of film stock. At three frames per second (typical of film cameras), a short burst of a few seconds can burn up as much as half of an ordinary 36 exposure roll of film. And as we'll see, the a5000 can fire at a blazing 10 frames per second that 35mm cameras could not match; that was just as well back when you'd expect to pay up to $10 for a roll of film with processing. Of course, digital cameras like the a5000, have reusable "film," so if you waste a few dozen shots on non-decisive moments, you can erase them and shoot more.

The increased capacity of digital film cards gives you a prodigious number of frames to work with. At an air show I covered earlier this year, I took more than 1,000 images in a couple hours. I was able to cram hundreds of Large/Fine JPEGs on a single memory card. That's a lot of shooting. Given an average burst of about eight frames per sequence (nobody really takes 15–20 shots or more of one pass, even with a slow-moving biplane as shown in Figure 7.9), I was able to capture more than 100 different sequences like the one shown before I needed to swap cards.

Figure 7.9
Air shows make a perfect subject for continuous bursts.

I took nearly a thousand shots at a cycle race recently, capturing the non-stop action as cyclists approached my position, made sharp turns in a curve, and so on. Figure 7.10 shows a six shot burst taken during the event. For some types of action (such as football), even longer bursts come in handy, because running and passing plays often last 5 to 10 seconds; there's also a change in character as the action switches from the quarterback dropping back to pass or hand off the ball, then to the receiver or running back trying to gain as much yardage as possible.

Figure 7.10 Continuous shooting allows you to capture an entire sequence of exciting moments as they unfold.

To use the a5000's continuous advance mode, press the drive button (left direction button) or go to the first item on the Camera Settings menu. Then navigate down the list with the up/down direction buttons until the Cont. Shooting option is selected. With this mode, you can shoot at up to about 3 frames per second when you hold down the shutter button. For greater framing speed, maneuver one notch further down in the Drive sub-menu to the Spd Priority Cont. mode. You'll then be able to shoot at about 10 frames per second (fps).

If you had set the AF mode (in the Function submenu) to AF-C, Continuous autofocus (with phase detection AF) will be available in either continuous drive mode but only as long as the subject is covered by the active focus detection point(s). This feature is useful when a moving subject is approaching the camera (as in Figure 7.10), or moving away from it; the a5000 will continuously adjust focus, tracking the subject as the distance changes, so the entire set of photos should be sharply focused. The AF system tends to be more successful in such situations when shooting at 3 fps, however.

> **Note**
>
> In the Speed Priority Continuous mode, the camera does not provide a real-time view of the subject. Instead, it displays the last recorded image, taken a split second earlier. That's rarely a problem unless a fast action subject (like a race car) is moving across your line of vision and you're panning the camera to get a series of shots of its progress. In this type of situation, it's useful to see a real-time live view since that enables you to keep the subject well-framed for all the photos. If that's more important than the ability to shoot at a very fast framing rate, you should switch to the Continuous Shooting (3 fps) drive mode.

Once you have decided on a continuous shooting mode and speed, press the center button to confirm your choice. Then, while you hold down the shutter button, the a5000 will fire continuously until it reaches the limit of its capacity to store images, given the image size and quality you have selected and other factors, such as the speed of your memory card and the environment you are shooting in. For example, if the lighting is so dim as to require an exposure of about one second, the camera clearly cannot fire the shutter at a rate of about 3 frames per second. (Sony suggests turning the Lens Comp.: Distortion feature Off in the Custom Settings 4 menu to ensure the full framing speed.) And to be able to shoot at 10 fps, you definitely need to be using a fast shutter speed. Another factor that will affect your continuous shooting is the use of flash, which needs time to recycle after each exposure before it can fire again.

There are no exact figures available for how many images you can shoot continuously, partly because there are so many variables that affect that number. Generally, you can maximize the number of continuous shots by using only JPEG capture (not RAW or RAW & JPEG) and by setting a lower JPEG quality and/or size. The reason the camera cannot let you shoot hundreds of photos in a single burst is that continuous images are first shuttled into the a5000's internal memory buffer, then doled out to the memory card as quickly as the card can write the data. Technically,

the a5000 takes the RAW data received from the digital image processor and converts it to the output format you've selected—either JPEG or RAW—and deposits it in the buffer ready to store on the card. In a quick test with a fast (90MB/s) SanDisk Extreme UHS-1 SD card, I was able to shoot 20 Large/Fine JPEGs or 10 RAW photos or 9 RAW & JPEG shots in a sequence in Continuous drive mode. I tried the 10 fps Speed Priority option and found that I could get about 13 Large/Fine JPEGs before the framing speed slowed noticeably.

The internal "smart" buffer can suck up photos much more quickly than the memory card and, indeed, some memory cards are significantly faster or slower than others. When the buffer begins to fill, the framing speed slows significantly; eventually the buffer fills and then you can't take any more continuous shots until the a5000 has dumped some of them to the card, making more room in the buffer. (If you often need to shoot long bursts, be sure to use a fast memory card, rated at least as Class 10 or 30MB/s since it can write images more quickly than a slower card, freeing up buffer space faster; this allows for shooting a longer series of photos.)

So, if you're in a situation in which continuous shooting is an issue, you may need to make some quick judgments. If you're taking photos at a breaking news event where it's crucial to keep the camera firing no matter what and quality of the images is not a huge issue, your best bet may be to set the image size to Small and the quality to Standard. On the other hand, if you're taking candid shots at a family gathering and want to capture a variety of fleeting expressions on people's faces, you may opt for taking Large size shots at the Fine quality setting, knowing that the drive speed may slow occasionally; if using a fast card however, I doubt you'll find that to be a problem unless you want to shoot several dozen photos in a burst (unlikely). A good point to bear in mind at all times is that the speeds given for the two Continuous shooting options are maximums that can be reached; you may find the speed slower when the camera has difficulty maintaining focus on an erratically moving subject (in AF-C mode) and it will definitely be slower when you're not using a fast shutter speed.

Setting Image Parameters

You can use camera features before shooting to fine-tune the images that you'll take in several different ways. For example, if you don't want to choose a predefined white balance such as Tungsten or Cloudy, you can set a custom white balance based on the illumination of the site where you'll be taking photos; you can also set a white balance based on color temperature. With the Creative Style options, you can select one that's most likely to produce the desired effect, such as Portrait or Landscape, and then set a custom level for saturation, contrast, and sharpness to meet your exact preferences. This section shows you how to use the available image parameters.

As you might expect, if the camera is set to one of the Auto or SCN modes, most of the customizing features will not be available; the camera will automatically make default settings, such as Automatic White Balance and the Standard Creative Style. While Chapter 3 described the method for setting the various camera features, I'll recap the procedure for making adjustments to the relevant features on the following pages.

Customizing White Balance

Back when we were shooting with 35mm cameras, color films were standardized, or balanced, for a particular "color" of light. Most were balanced for daylight but you could also buy "tungsten" balanced film for shooting under incandescent lamps that produced light of an amber color. This type of film had a bluish color balance, intended to moderate the effect produced by light that was amber. Nothing of this type is necessary with digital cameras like the Sony a5000 because you can set any white balance option that will be suitable considering the color of the light.

This is important because various light sources produce illumination of different "colors," although sometimes we are not aware of the difference. Indoor illumination tends to be somewhat amber when using light bulbs that are not daylight balanced, while noonday light outdoors is close to white, and the light early and late in the day is somewhat red/yellow.

White balance is measured using a scale called color temperature. Color temperatures were assigned by heating a theoretical "black body radiator" and recording the spectrum of light it emitted at a given temperature in degrees Kelvin. So, daylight at noon has a color temperature in the 5,500 to 6,000 degree range. Indoor illumination is around 3,400 degrees. Hotter temperatures produce bluer images (think blue-white hot) while cooler temperatures produce redder images (think of a dull-red glowing ember). Because of human nature, though, bluer images are actually called "cool" (think wintry day) and redder images are called "warm" (think ruddy sunset), even though their color temperatures are reversed.

Take a photo indoors under warm illumination with a digital camera sensor balanced for cooler daylight and the image will appear much too red/yellow. An image exposed outdoors with the white balance set for incandescent (tungsten) illumination will seem much too blue. These color casts may be too strong to remove in an image editor from JPEG files. Of course, if you shoot RAW photos, you can later change the WB setting to the desired value in RAW converter software; this is a completely "non destructive" process so full image quality will be maintained.

Mismatched white balance settings are easier to achieve accidentally than you might think, even for experienced photographers. I'd just arrived at a concert after shooting some photos indoors with electronic flash and had manually set WB for Flash. Then, as the concert began, I resumed shooting using the incandescent stage lighting—which looked white to the eye—and ended up with a few shots like Figure 7.11. Eventually, I caught the error during picture review, and changed my white balance. Another time, I was shooting outdoors, but had the camera white balance still set for incandescent illumination. The excessively blue image shown in Figure 7.12 resulted. (I suppose I should salvage my reputation as a photo guru by admitting that both these images were taken "incorrectly" deliberately, as illustrations for this book; in real life, I'm excessively attentive to how my white balance is set. You do believe me, don't you?)

Figure 7.11
An image exposed indoors with the WB set for daylight or electronic flash will appear too reddish.

Figure 7.12
An image exposed in daylight with the WB set for incandescent (tungsten) illumination will appear too blue.

The Auto White Balance (AWB) setting, available from the White Balance item of the Brightness/Color menu, examines your scene and chooses an appropriate value based on its perception of the color of the illumination and even the colors in the scene. However, the process is not foolproof (with any camera). Under bright lighting conditions, it may evaluate the colors in the image and still assume the light source is daylight and balance the picture accordingly, even though, in fact, you may be shooting under extremely bright incandescent illumination. In dimmer light, the camera's electronics may assume that the illumination is tungsten, and if there are lots of reddish colors present, set color balance for that type of lighting. With mercury vapor or sodium lamps, correct white balance may be virtually impossible to achieve with any of the so-called presets. In those cases, you should use flash instead, or Custom WB with JPEGs; or shoot in RAW format and make your corrections after importing the file into your image editor with a RAW converter.

The a5000 provides many WB options, often called presets by photographers, each intended for use in specific lighting conditions. You can choose from Daylight, Shade, Cloudy, Incandescent (often called Tungsten by photographers), four types of Fluorescent (Warm White, Cool White, Day White, and Daylight), and Flash. One of these presets is often useful, as it was in the photo shown in Figure 7.12. However, the a5000 also offers a method for setting a desired color temperature/filter as well as a custom WB feature.

The Daylight preset provides WB at 5,200K, while the Shade preset uses 7,000K to give you a warming effect that's useful in the bluish light of a deeply shaded area. The chief difference between direct sun and an area in shade, or even incandescent light sources, is nothing more than the proportions of red and blue light. The spectrum of colors used by the a5000 is continuous, but it is biased toward one end or the other.

However, some types of fluorescent lights produce illumination that has a severe deficit in certain colors, such as only particular shades of red. If you looked at the spectrum or rainbow of colors encompassed by such a light source, it would have black bands in it, representing particular wavelengths of light that are absent. You can't compensate for this deficiency by adding all tones of red. That's why the fluorescent setting of your Sony may provide less than satisfactory results with some kinds of fluorescent bulbs. If you take many photographs under a particular kind of non-compatible fluorescent light, you might want to investigate specialized filters intended for use under various types of fluorescent light, available from camera stores, or develop skills in white balance adjustment using an image editor or RAW converter software program. However, you do get four presets for fluorescent WB with the a5000 and one of these should provide close to accurate white balance with the common types of lights.

It's when you find that AWB and the various presets simply cannot produce pleasing white balance in certain lighting conditions that you'll need the other options (discussed shortly): use the white balance adjustment feature, set a specific color temperature, or calibrate the WB system to set a custom white balance.

Fine-Tuning Preset White Balance

After you scroll to any of the WB options (AWB, Daylight, Shade, etc.), pressing the right directional button reveals the White Balance Adjustment screen, with a grid, shown in Figure 7.13. This feature enables you to fine-tune the white balance by biasing it toward certain colors. Use any of the four directional keys to move the orange dot (cursor) from the center of the grid: upward to bias the WB toward green (G), downward toward magenta (M), right toward amber (A), or left toward blue (B). You can move the cursor 7 increments (although Sony doesn't reveal exactly what those increments are) in any of the four directions.

Naturally, you can also move the orange dot to any point within the grid: toward amber/magenta for example. While biasing the WB, examine the scene in the LCD or viewfinder preview display; stop making adjustments when the white balance looks fine. Tap the shutter release to escape from the WB settings adjustments. Let's look at the options in more detail:

- **Cooler or warmer.** Pressing the left/right directional buttons changes the white balance to cooler (left) or warmer (right) along the Blue/Amber scale. There are seven increments, and the value you "dial in" will be shown in the upper-left corner of the screen as an A-B value (yes, the labels are *reversed* from the actual scale at the right side of the screen). The red dot will move along the scale to show the value you've selected. Typically, blue/amber adjustments are what we think of as "color temperature" changes, or, "cooler" and "warmer." These correspond to the way in which daylight illumination changes: warm at sunrise and sunset, very cool in the shade (because most of the illumination comes from reflections of the blue sky), and at high noon. Indoor light sources can also be cooler or warmer, depending on the kind of light they emit.

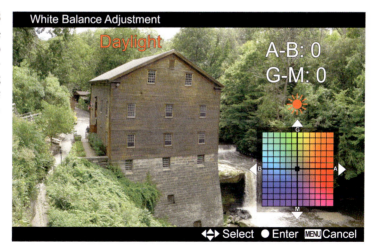

Figure 7.13
Use this feature when you want to fine-tune white balance when using AWB or any of the presets.

- **Green/magenta bias.** Press the up/down buttons to change the color balance along the green (upward) or magenta (downward) directions. Seven increments are provided here, too, and shown as vertical movement in the color balance matrix at the right of the screen. Color changes of this type tend to reflect special characteristics of the light source; certain fluorescent lights have a "green" cast, for example.
- **Either or both.** Because the blue/amber and green/magenta adjustments can be made independently, you're free to choose just one of them, or both if your fine-tuning requires it.
- **Never mind.** If you want to cancel all fine-tuning and shift back to neutral, just press the down directional button. The red dot in the color chart will be restored to the center position.

Setting White Balance by Color Temperature

If you want to set a specific white balance based on color temperature, choose C. Temp/Filter in the White Balance menu and press the right button. You'll see an adjustment screen similar to the one shown in Figure 7.13, but with a scrolling list of color temperatures displayed along the right edge of the screen. Here's how to use this feature.

- **Change color temperature.** Rotate the control wheel on the camera back to select a specific color temperature in 100K increments, from 2,500K (a level that makes your image much bluer, to compensate for amber illumination) to 9,900K (a level that makes images much redder to correct for light that is extremely blue in color). The live preview changes as you scroll to give you an indication as to the white balance you can expect at any K level. If you have a color temperature meter accessory, or reliable tips that guide you in making the optimal setting, this WB feature will be particularly useful. Even if you don't have that accessory or useful information, you may want to experiment with this setting using the live preview, especially if you are trying to achieve creative effects with color casts along the spectrum from blue to red.
- **Fine-tune the color temperature.** In addition to color temperature, you can change the blue/amber or green magenta bias, exactly as described earlier; move the cursor in any direction with the directional keys. If you change your mind, press the MENU button to cancel the bias adjustments you've made.

This feature corresponds to the use of CC (Color Compensation) filters that were used to compensate for various types of lighting when shooting film. When you use C. Temp/Filter, the color filter value you set takes effect in conjunction with the color temperature you set. In other words, both of these settings work together to give you very precise control over the degree of color correction you are using.

Setting a Custom White Balance

If you often shoot in locations that are illuminated by artificial light of unusual colors, the best bet is to set a custom white balance. This calls for teaching (calibrating) the WB system to render white as white under a specific type of illumination. When white is accurately rendered, other colors will

look accurate as well. You can use this feature under more common types of lighting too; it's very useful under tungsten lamps for example, when the Incandescent WB option does not adequately correct for the amber color of the light. Custom WB is the most accurate way of getting the right color balance, short of having a special meter that gives you a precise reading of color temperature. It's easy to do with the a5000. Just follow these steps:

1. Navigate to White Balance in the Shooting 4 menu.
2. Use the direction buttons or the control wheel to scroll up/down through the list of white balance options until the Custom Setup (not the Custom entry, which is located just above it) option is highlighted. Press the center button. The LCD will display a message telling you to press the shutter button to capture the white balance data. (Custom is used to *choose* the custom WB setting you have saved; Custom Setup *creates* that setting.)
3. Point the camera at a white object (such as a sheet of white paper) large enough to fill the small circle that's displayed in the center of the frame. Your target must be in the same light as the subject you plan to photograph, not in some entirely different part of the scene where the illumination is different.
4. Press the shutter release button. The target (such as the sheet of white paper) that you had aimed at, as well as the custom white balance data, appears on the LCD or EVF screen. (The image is not recorded to the memory card.)
5. Press the center button to return to the live view on the LCD.

The a5000 will retain the custom setting you just captured until you repeat the process to replace the setting with a new one. At any time in the future, you can activate this custom WB setting; that would make sense anytime you'll be shooting in the same type of lighting that was present when you calibrated the system. To do so, scroll to the Custom (not Custom Setup) option in the White Balance menu and press the center button to confirm your choice.

Image Processing

As I outlined in Chapter 3, the Sony camera offers several ways of customizing the rendition of your images. You can use the Dynamic Range Optimizer (aka D-Range Optimizer and DRO), or specify certain changes to contrast, saturation, and sharpness in the Creative Style menu. Both of these items are available in the Camera Settings 4 menu.

D-Range Optimizer and In-Camera HDR

This innovative DRO tool helps adjust the relative brightness range of your JPEG images as they are taken. The DRO has no effect on RAW images. (To apply dynamic range effects to RAW files, use the downloadable Image Data Converter SR or another RAW converter.) As you'd guess, DRO processing is available only when you are shooting in the Program, Aperture Priority, Shutter Priority, or Manual exposure mode. The DRO feature cannot be activated when one of the Picture

Effects is used. In Auto and SCN modes, the camera decides whether DRO will be activated, providing you with no control over this feature.

The DRO feature has been around for a while on Sony models and the a5000 offers a broad range of options when you access it. You get three basic options: Off, DRO, and HDR Auto; several sub-settings are available for the last two. You'll get the most dramatic enhancement with Auto HDR, much lighter shadow areas, and slightly darker highlight areas. This feature is entirely different than Dynamic Range Optimizer as discussed in a moment, but is accessed from the DRO menu item.

Once you have selected either DRO or Auto HDR, you can select further options by pressing the right directional button on the control wheel and then choosing level or EV increment (respectively). Figure 7.14 shows how DRO settings affect your image processing at four of its settings: Off, Auto, Level 3, and Level 6.

> **Note**
>
> The primary method for DRO processing is lightening the dark tones and mid tones of an image. The higher the level of DRO you set, the more significantly the processor will lighten those areas; that causes digital noise to be more and more noticeable, especially in photos made at ISO 800 and at higher ISO levels. This is one reason why you would not always want to set Level 4 or 5 for DRO, particularly when using a high ISO setting. The other reason is that very high DRO produces a somewhat unnatural looking effect with all shadow areas lighter than "normal." The Auto and Levels 1 to 3 retain the most natural-looking effect.

Here is how the DRO and Auto HDR features work:

- **D-R Off.** No optimization. You're on your own; the camera will not apply extra processing even to your JPEG photos. Of course, if you are shooting RAW (or RAW & JPEG) photos, you can apply DRO effects to your photo when converting it with the downloadable Image Data Converter SR software. (Other programs have different tools for lightening shadow areas and/or darkening highlight areas.) Use Off when shooting subjects of normal contrast, or when you want to capture an image just as you see it, without modification by the camera.

- **DRO.** Press the left/right buttons after scrolling to DRO: Auto and you can then set a specific intensity level for the Dynamic Range Optimizer, from Level 1 through Level 5.

 If you do not want to set a specific level, simply scroll to DRO: Auto and allow the camera to decide on the amount of increased dynamic range. With the Auto setting, the camera dives into your image, looking at various small areas to examine the contrast of highlights and shadows, making modifications to each section to produce the best combination of brightness and tones with detail. In my experience, Auto provides a mid level of DRO that's worth leaving on at all times. (See Figure 7.14 for some examples as to the effects you might expect.)

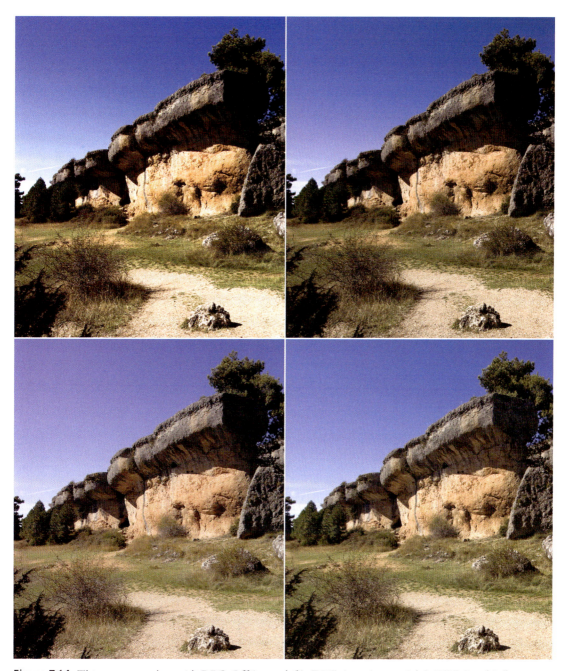

Figure 7.14 This scene was shot with DRO Off (upper left), DRO Auto (upper right), DRO Level 3 (lower left), and DRO Level 5.

- **HDR Auto.** In this mode, the a5000 creates a high dynamic range photo. It starts by taking three JPEG photos, each at a different exposure; the three are then composited into one by the processor using the best exposed areas from each photo. The final image will have a high dynamic range effect, with great detail in shadow areas and increased detail in bright areas. You can specify how dramatic the effect should be.

 After scrolling to HDR Auto, press the left/right buttons and set an HDR Level, from 1.0 EV to 6.0 EV. (One EV equals one stop of exposure.) The higher the level you set, the greater the exposure difference will be among the three photos the camera will shoot to produce one with High Dynamic Range. There's no "best" setting; it depends on your personal preference. At a very high EV level, the effect will be dramatic, but the photo may not appear to be "natural" looking.

When using the in-camera HDR Auto feature, whether you use the options or not, be sure to mount the camera on a tripod or other solid support to ensure that the three photos (views of the scene) that are taken are identical. For the same reason, your subject should be static; it should not be moving even slightly. If the a5000 detects obvious camera shake, it will provide an HDR! indicator in the LCD or EVF display. Until you set the camera on some firm support, you will not be able to proceed.

The HDR Auto feature, like DRO processing, is not available when shooting RAW or RAW & JPEG images. You'll find that in flash photography, the in-camera HDR feature does not produce much of a benefit even if used at a high level. Note too that in scenes with low contrast (flat lighting, without dark shadows and bright highlights) the camera will not take the shots to create an HDR image. It will provide an HDR! indicator in the LCD or EVF display and you will not be able to proceed. Unless the light changes soon, you might as well disable this feature.

Creating HDR Photos in Post-Processing

While my goal in this book is to show you how to take great photos *in the camera* rather than how to fix your errors in Photoshop, Adobe does provide some really useful tools for making HDR images: the Merge to HDR Pro feature in Adobe Photoshop. Photoshop Elements provides an HDR feature too but it's not as effective. (Other incredibly versatile HDR software is available too, including Photomatix Pro and Nik's HDR Efex Pro, but I'll discuss the process using Photoshop.) With Merge to HDR you get more versatility than with the a5000's in-camera HDR Auto feature since there are many useful tools for fine-tuning the image. Expect to get an HDR photo with a full, rich dynamic range that includes a level of detail in the highlights and shadows that can be difficult to match with the HDR Auto feature.

When might you want to try the HDR technique? Suppose you wanted to photograph a dimly lit room that had a bright window showing an outdoors scene. Proper exposure for the room might be on the order of 1/60th second at f/2.8 at ISO 200, while the outdoors scene probably would require f/11 at 1/400th second. That's almost a 7 EV step difference (approximately 7 f/stops) and well

beyond the dynamic range of any digital camera, including the a5000, even when used with DRO at Level 5.

When you're planning to use Merge to HDR Pro in Photoshop, you'd take three pictures, one for the shadows, one for the highlights, and perhaps two for the midtones. (Serious photographers might take as many as eight shots, varying the exposure by one stop for each, but for this example, I'm going to assume you're working with just four.) The photos should be identical, except for the exposure, so use a tripod and a remote release accessory; also make sure there is no subject movement. Then, you'll use the Merge to HDR Pro command to combine all of the images into one HDR image that integrates the well-exposed sections of each version.

The a5000 allows you to take only *three* bracketed images, and with no more than 3.0 EV difference between them. But if you like, you can take the four photos, setting a different level of exposure compensation for each; if you prefer, you can modify the exposure from one shot to the next by changing the shutter speed in Manual (M) mode, but that's not as intuitive. You can also shoot RAW when creating do-it-yourself HDR images. Here are the steps you'll use:

1. **Set up the camera.** Mount the a5000 on a tripod.
2. **Set the camera for Aperture Priority mode.** Rotate the mode selector to the A position.
3. **Choose an f/stop.** Rotate the control wheel and set a desired aperture that you'll use for all of the four photos. *And then leave this adjustment alone!* You don't want the aperture to change for your series, as that would change the depth-of-field. You want to adjust exposure *only* with the shutter speed, and exposure compensation will do exactly that.
4. **Choose manual focus.** You don't want the focus to change between shots, so use manual focus (MF).
5. **Choose RAW exposures.** Set the camera to take RAW photos only with the Quality item in the Image Size menu. This will enable you to achieve the widest range of tones.
6. **Take the first shot.** Press the button on the remote (or carefully press the shutter release) and take the first photo without an exposure compensation.
7. **Take the second shot at +1.** Set the exposure compensation to +2 and the camera will change the shutter speed (and not the aperture) when you take the second photo. It will be two stops lighter than the first photo.
8. **Take the third shot at –1.** Set this amount and take the third photo. It will be two stops darker than the original shot.
9. **Decide on a level of compensation for the fourth shot.** Before taking the last photo, decide whether shadow detail or highlight detail is the most important for this scene. For this example, let's say you'll set –1 for the fourth shot as well, to be certain that you'll retain texture in the puffy white clouds.
10. **Continue with Photoshop's Merge to HDR Pro steps listed next.** You now have a set of photos something like those shown in Figure 7.15 for merging. You can also use a different program, of course, if you know how to use it.

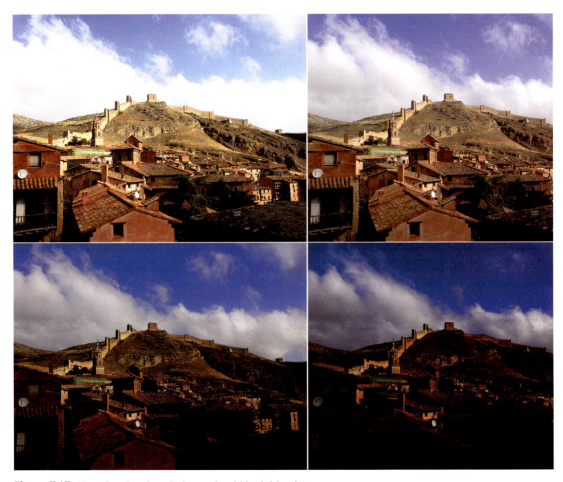

Figure 7.15 Your four bracketed photos should look like this.

The next steps show you how to combine the separate exposures into one merged high dynamic range image. The sample images in Figure 7.15 show the results you can get from a four-shot bracketed sequence.

1. **Copy your images to your computer.** If you use an application to transfer the files to your computer, make sure it does not make any adjustments to brightness, contrast, or exposure. You want the real raw information for Merge to HDR Pro to work with.
2. **Activate Merge to HDR Pro.** Choose File > Automate > Merge to HDR Pro.
3. **Select the photos to be merged.** Use the Browse feature to locate and select the four photos to be merged. You'll note a checkbox that can be used to automatically align the images if they were not taken with the camera mounted on a rock-steady support. This will adjust for any slight movement of the camera that might have occurred when you changed exposure settings.

Figure 7.16 You'll end up with an HDR photo (with extended dynamic range) like this one.

4. **Choose parameters (optional).** The first time you use Merge to HDR Pro, you can let the program work with its default parameters. Once you've played with the feature a few times, you can read the Adobe help files and learn more about the options than I can present in this non-software-oriented camera guide.
5. **Click OK.** The merger begins.
6. **Save.** Once HDR merge has done its thing, save the file to your computer.

If you've done everything correctly, you'll end up with a photo like the one shown in Figure 7.16, which took advantage of the shadow detail and the highlight detail captured in the series of four photos. In this example, I got full detail in the dark areas while retaining texture in the clouds which were much lighter than the land.

What if you don't have the opportunity, inclination, or skills to create several images at different exposures, as described? No problem. If you have a photo that you made in RAW format in the past, you can use Merge to HDR, working with a *single* original image file. What you do is import

the image into Photoshop several times, using Adobe Camera Raw (or another RAW converter) to create multiple copies of the file at different exposure levels.

For example, you'd use the RAW converter to create an extremely dark photo, an extremely light photo, a moderately dark photo, and a moderately light photo. Two of the photos will have plenty of detail in shadow areas while the other two will have detail in highlight areas. Then, you can use Merge to HDR exactly as discussed in the previous section. Combine the four and end up with a finished HDR image that has the extended dynamic range you're looking for. (This concludes the image-editing portion of the chapter. We now return you to our alternate sponsor: photography.)

Using Creative Styles

This feature, also found on the Brightness/Color menu, gives you six different preset looks, with different levels of contrast, saturation, and sharpness; these parameters are applied automatically based on the Style you have selected. You can opt for Standard, Vivid, Portrait, Landscape, Sunset, and B/W (black-and-white). Those are useful enough that you should make them a part of your everyday toolkit. You can apply Creative Styles *only* when you are not using one of the Alpha's Auto or SCN modes. (That is, you're shooting in Program, Aperture Priority, Shutter Priority, Manual, Anti Motion Blur, or one of the Panorama modes.) But wait, there's more. When working with Creative Styles, you can *adjust* the parameters within each preset option to fine-tune the rendition. First, look at the "stock" creative styles:

- **Standard.** This is, as you might expect, your default setting, with a good compromise of sharpness, color saturation, and contrast. Choose this, and your photos will have excellent colors, a broad range of tonal values, and standard sharpness that avoids the "oversharpened" look that some digital pictures acquire.
- **Vivid.** If you want more punch in your images, with richer colors, heightened contrast that makes those colors stand out, and standard sharpness, this setting is for you. It's good for flowers, seaside photos, any picture with expanses of blue sky, and on overcast days where a punchier image can relieve the dullness.
- **Portrait.** You'll get reduced saturation, contrast, and sharpness for a more "gentle" rendition that often works well for people pictures. This style is a good choice if you're planning on fine-tuning those aspects of your JPEG photos in your computer and don't want the camera to overdo any of them.
- **Landscape.** As with the Vivid setting, this option boosts saturation (especially in blues and greens) and contrast to give you rich scenery and purple mountain majesties, even when your subject matter is located far enough from your camera that distant haze might otherwise be a problem. There's extra sharpness, too, to give you added crispness when you're shooting Fall colors, for example.

- **Sunset.** Accentuates the red tones found in sunrise and sunset pictures.
- **B/W.** This is useful if you want to shoot monochrome photos in the camera, so you won't need to modify color photos in software. This style will allow you to change the contrast and sharpness, but not the saturation (because there are no colors to saturate).

To adjust the level of Contrast, Saturation, and/or Sharpness for any Creative Style, scroll to a style you want to use (in the Camera Settings 4 menu) and use the left/right keys to display a line at the bottom of the screen showing the available adjustments of the three parameters. Use the left/right direction buttons to scroll among them: Contrast, Saturation, and Sharpness. With the parameter you want to modify highlighted, press the up/down direction buttons to change the values in a range of –3 to +3. Press the center button to confirm. Here is a summary of how changing the parameters in a Creative Style will affect your images:

- **Sharpness.** Increases or decreases the contrast of the edge outlines in your image, making the photo appear more or less sharp, depending on whether you've selected 0 (no sharpening), +3 (extra sharpening), to –3 (softening). Remember that boosting sharpness also increases the overall contrast of an image, so you'll want to use this parameter in conjunction with the contrast parameter with caution.
- **Contrast.** Compresses the range of tones in an image (increase contrast from 0 to +3) or expands the range of tones (from 0 to –3) to decrease contrast. Higher-contrast images tend to lose detail in both shadows and highlights, whereas lower-contrast images retain the detail but appear more flat and dull, without any snap.
- **Color Saturation.** You can adjust the richness of the color from low saturation (0 to –3) to high saturation (0 to +3). Lower saturation produces a muted look that can be more realistic for certain kinds of subjects, such as humans. Higher saturation produces a more vibrant appearance, but can be garish and unrealistic if carried too far. Boost your saturation if you want a vivid image, or to brighten up pictures taken on overcast days. (Remember, however, Vivid and Landscape provide high saturation even at the zero level.) As I noted earlier, saturation cannot be changed for the Black & White Creative Style.

Don't confuse the Picture Effects feature with the Creative Styles. The Picture Effects are intended to provide special effects in-camera, such as Pop Color, Posterization, and Soft Focus. Since I have discussed them in detail in Chapter 3, I won't do so here. And you may remember that the a5000 can use apps, including some that can modify the look of your photos.

8

Movie Making

As we've seen during our exploration of its features so far, the a5000 is superbly equipped for taking still photographs of very high quality in a wide variety of shooting environments. But this camera's superior level of performance is not limited to stills. It's highly capable in the movie-making arena as well. It can shoot Full HD (high-definition) clips. Sony has also provided overrides for controlling all important aspects of a video clip.

So, even though you may have bought your a5000 primarily for shooting stationary scenes, you acquired a device that's also great for recording high-quality video clips. Whether you're looking to record informal clips of the family on vacation, the latest viral video for YouTube, or a set of scenes that will be painstakingly crafted into a cinematic masterpiece using editing software, the a5000 will perform admirably.

Some Fundamentals

Recording a video with the a5000 is extraordinarily easy to accomplish—just press the prominent silver button with the red dot at the upper right of the camera's back to start. You can do so in any exposure mode; there's no need to activate a special Movie mode. (If you start recording in Sweep Panorama mode, however, the camera will actually use P mode and the video won't be a panorama.) After you press the button, the camera will confirm that it's recording with a red REC and numerals showing the elapsed time. Press the button again when you want to stop recording.

Before you start, though, there are some settings to prepare the camera to record the scene the way you want it to. Setting up the camera for recording video can be a bit tricky, because it's not immediately obvious, either from the camera's menus or from Sony's manuals, which settings apply to video recording and which do not. I will unravel that mystery for you, and throw in a few other tips to help improve your movies.

I'll show you how to optimize your settings before you start shooting video, but here are some considerations to be aware of as you get started. Many of these points will be covered in more detail later in this chapter:

- **Use the right card.** Use an SD or SDHC card with Class 6 or higher speed; Class 10 cards are very common today. Should you try using a slower SD card, like a Class 4 or especially Class 2, the recording may stop after a minute or two. Choose a memory card with at least 8GB capacity; 16GB or 32GB are even better. If you're going to be recording a lot of HD video, that could be a good reason to take advantage of the ability to use SDXC cards of 64GB capacity. Just make sure your memory card reader is SDXC compatible and your computer can read the files from that type of card. I've standardized on fast Class 10 32GB SDHC cards when I'm shooting movies; one of these cards will hold hours of video.

 However, the camera can shoot a continuous movie of just under 30 minutes. If you reach that limit, you can stop recording and start shooting the next clip right away; this assumes there's enough space on the memory card and adequate battery power. Of course, you will miss about 30 seconds of the action. (Also see the later item about keeping the camera cool.) Of course that assumes there's enough space on your memory card and adequate battery power.

- **Avoid extraneous noise.** Try not to make too much noise when changing camera controls or when using a conventional zoom lens's mechanical zooming ring. And don't make comments that you will not want to hear on the audio track.

- **Minimize zooming.** While it's great to be able to use the zoom for filling the frame with a distant subject (especially the power zoom on lenses equipped with that feature), think twice before zooming. The sound made by a mechanical zoom ring rotating will be picked up and it will be audible when you play a movie. (Lenses with power zoom are silent, however.) As well, remember that any more than the occasional minor zoom will be very distracting to friends who watch your videos. And digital zoom will definitely degrade video quality. Don't use the digital zoom if quality is more important than recording a specific subject such as a famous movie star far from a distance.

- **Use a fully charged battery.** A fresh battery will allow about one hour of filming at normal (non-Winter) temperatures, but that can be shorter if there are many focus adjustments. Individual clips can be no longer than 29 minutes, however.

- **Keep it cool.** Video quality can suffer terribly when the imaging sensor gets hot so keep the camera in a cool place. When shooting on hot days especially, the sensor can get hot more quickly than usual; when there's a risk of overheating, the camera will stop recording and it will shut down about five seconds later. Give it time to cool down before using it again. And remember that when you record a couple of very long clips in a series, the sensor will start to get warm; it's better to wait a few minutes to let it cool before starting to record another clip.

- **Press the Movie button.** You don't have to hold it down. Press it again when you're done to stop recording. It's recessed so you will not press it inadvertently.

WHY THE 29-MINUTE LIMITATION?

Vendors are really cagey about revealing the reason for the seemingly arbitrary/non-arbitrary 29 minute, 59 second limitation on the length of a single video clip—not only with Sony still cameras, but with other brands as well. So, various theories have emerged, none of which have proven to be definitive.

- The sensor will overheat when you shoot continuously. In a mirrorless camera, the sensor is active virtually all the time the camera is turned on, so that idea doesn't hold water. Plus, you can shoot one clip of the maximum time and immediately begin recording another one. Thermal protection doesn't seem to be a major problem however, or the reason for the limitation.
- Some countries, particularly in the European Union, classify cameras that can capture clips of 30 minutes or more as camcorders, at a higher duty rate.
- The FAT32 file format limits the size of video clips to 2GB, or about 30 minutes. Actually, it's the FAT16 file format (used in pre-SDHC memory cards) that has the 2GB limitation. All memory cards larger than 2GB will let you create a file that's 4GB in size. Further, my 64GB SDXC card allows files up to 2 terabytes in size, but when I insert one into my a5000, I still can't exceed 29 minutes, 59 seconds.
- Theories aside, the only people who want to shoot clips longer than 30 minutes are the proud parents who plop the a5000 down on a tripod and capture an entire Spring Pageant or high school musical. Those who want to go beyond camcorder ennui will shoot segments of only a few seconds each and, perhaps, piece them together into an effective production using easy-to-master editing software.

Preparing to Shoot Video

First, here's what I recommend you do to prepare for your recording session:

- **Choose your file format.** Go to the File Format entry in the Camera Settings 2 menu (as discussed in Chapter 3) and select the file format for your movies. You can set it to MP4, an abbreviation for MPEG-4, or stick with the default, AVCHD.
- **Choose record setting.** Also in the Camera Settings 2 menu, you'll find the Record Setting item which allows you to choose the size, frame rate, and image quality for your movies. Your choices for AVCHD, all at Full HD, are as follows. (The *xx*M stands for megabits per second recording speed.)
 - 60i 24M FX; this provides high quality with interlaced scan video
 - 60i 17M FH; the default, this option gives you fine quality, also with interlaced scan
 - 24p 24M FX; this is another option for maximum quality with progressive scan but employs a "cinematic" framing rate
 - 24p 17M FH; expect fine quality with this option, also at a cinematic framing rate and with progressive scan

If you decide to shoot in MP4 instead, you'll have only two options, the default 1440 × 1080 12M (for very decent quality) and VGA 3M (for small 640 × 480) videos suitable only for web use).

Which of the many options should you choose? It depends in part on your needs. I have provided a brief hint as to what you can expect with each option in terms of quality. When you have very little remaining space on your memory cards, or if your video clip is intended strictly for upload to a website, you might choose MP4 and VGA. For high quality in a file format that's widely supported by editing software and by older computers, stick with the high-quality default MP4 setting. The MP4 format is also more "upload friendly;" in other words, it's the format you'll want to use if you plan to post video clips on a website, including video sharing sites that can accommodate the 1440 × 1080 video clips. The movies may not look perfect on an HDTV but this won't be a problem unless you're a stickler for superb quality.

Note

If you don't have third-party editing software, you'll be pleased to know that the downloadable Sony PlayMemories Home software can be used for editing of your movies and to write your 60p video clips directly to a Blu-ray disc. Of course, not all Blu-ray players support 1080/60p playback.

If your plan is to primarily shoot videos that you'll show to friends and family on an HDTV set, choose AVCHD. That format gives you the best quality, but can be harder to manipulate and edit on a computer than MP4 videos. I'll explain the difference between 60/50 and 24 fps (or 25 fps) rates later in this section.

- **Preview the movie's aspect ratio.** There's an item in the Image Size menu for Aspect Ratio and it's at 3:2 by default, but you can change that to 16:9. *The setting in this item won't affect your video recording.* Setting the 16:9 option will merely cause the camera to display the preview of the scene, before you start movie recording, in the longer format that will be used for the video clip. This gives you a better feel for what will be included in the frame after you press the record button. Only MP4 VGA movies are made in the 3:2 format, which is closer to square than the 16:9 format; if you'll be using VGA to record a clip, leave this menu item at 3:2.

- **Turn on autofocus.** Make sure autofocus is turned on through the Focus Mode entry of the Camera Settings 3 menu. You also have the option of using manual focus, or even Direct Manual Focus, with focus peaking. I find that manual focus is fine for situations such as a stage play where the actors will usually be at roughly the same distance to your position during the entire performance. In other cases you'll probably want to rely on the camera's effective full-time continuous autofocus ability while recording a video clip.

- **Try Flexible Spot AF Area.** As in still image making, you can use the Flexible Spot AF Area (discussed in Chapter 6) while recording a video clip. This feature is most suitable for a static scene you'll record with the a5000 on a tripod, where an important small subject is off-center

and will remain in the same location. By placing the AF Area exactly on that part of the scene, you'll be sure that the focus will remain on the most important part of the scene during the entire recording. (In truth, you could use manual focus for the same purpose.)

If you decide to try this, compose the scene as desired before pressing the record button. Set the AF Area to Flexible Spot. Press the lower directional button and the orange bracket will appear on the screen, indicating the current location of the active focus detection point. Move the brackets so they cover the primary subject and press OK (the center button) to confirm. You can now begin recording the video, confident that the focus will always be on your primary subject (assuming it does not move while you're recording).

- **Set useful functions.** Before you start recording, you can set a desired ISO, white balance, Creative Style, a Picture Effect (for special effects), any of the three metering modes and the level of exposure compensation. You can also set an override in the Creative Style for a specific level of sharpness, contrast, and saturation, if desired. The DRO and Auto HDR features will not be available, however. You'll recall that these functions are not available in fully automatic modes; if you set them while using another mode and then switch to a fully automatic mode for recording the video, the camera will revert back to the defaults.

However, if you elect to bypass Movie mode and shoot from within Intelligent Auto or Superior Auto modes instead, you *do* have access to some overrides. Press the lower directional button and a screen will appear with the Photo Creativity menu superimposed over the live preview of the scene. Scroll left/right among them and the title of the one you're at will appear. (See Figure 8.1.) These include Background Defocus, Brightness, Color (warm to cool), Vividness (saturation), and Picture Effects. You can preset any of these to the desired level while viewing the live preview to guide you in making the settings that will produce the desired effect. After you start recording however, only the Background Defocus control remains available (also activated with the down directional button).

In P, A, S, and M mode, all of the functions discussed above work in the same manner as they do when you're shooting still photos and they're discussed in detail in other chapters. Of course,

Figure 8.1
In either of the two Auto modes, you get access to all of the Photo Creativity overrides prior to recording.

for many purposes you may be content with the default settings, but remember that the a5000 offers great versatility as well. Make the settings before you start recording the movie, using the live preview to decide which will provide the desired effect. After you start recording a movie, you'll be able to change only the ISO and the level of exposure compensation. (Unless you do so intentionally for a desired effect, avoid changing the exposure compensation during recording since changes in brightness during a movie can be very annoying.)

I find ISO Auto to be fine for most circumstances. If you decide to preset a specific ISO level, be very careful. A low ISO in a dark location can produce an "underexposed" video while setting a high ISO in bright light can produce an "overexposed" clip. Of course, you can preview the effect that any ISO level will produce thanks to live view on the LCD or EVF; set an ISO that will ensure a live view that looks fine. You can change the ISO while recording but remember, changing to a very low or very high ISO will sometimes change the brightness of your video.

By the way, when recording a video in a dark location, it's possible to get slightly better movie quality, and slightly greater brightness, by activating the Auto Slow Shutter feature in the Setup menu. It is On by default, but if you had set it to Off, I'd suggest turning it back on.

- **Decide on a shooting mode.** There's no need for a Movie mode item on the mode selector dial since you can use any exposure mode for movie recording. The P mode works well, allowing the camera to set the aperture/shutter speed and giving you access to the other features discussed above. Program shift (to other aperture/shutter speed combinations) can be used before you start recording, but it will not be available during actual recording.

 You might prefer to use Aperture Priority (A) mode for full control over the specific aperture; in that case, you can preset a desired aperture and you can also change it anytime while recording. Be careful however, especially if you have set a specific ISO level. If you switch to a very small aperture while recording in low light, your movie clip may darken; this is particularly likely if you're using a low ISO level. And if you switch to a very wide aperture on a sunny day, especially if using a high ISO, your video will become too bright. Of course, you can see the change in brightness in the live view display before recording a movie and while you're recording.

 Switch to S mode if you want control over the shutter speed; this is a more advanced technique in movie mode. You can preset a shutter speed and you can change it while recording. Again, be careful as to your settings to avoid a very dark or overly bright video especially if you have set a specific ISO level. The live view display before and during recording will help to guide you. I don't recommend using the Manual (M) mode initially but you might want to experiment with it later.

- **Press the record button.** You don't have to hold it down. Press it to start recording and press it again when you're done. Shoot a short test clip and view it to make sure that the settings you had made are producing the overall effect you want. If not, change some settings (White Balance or Creative Style or Exposure Compensation, for example) and try again.

The information display options for the LCD are the same when shooting movies as when shooting stills, except for one aspect: the histogram is not available. Press the DISP button one or more times while recording to switch to another display option when using the LCD. Extra data is provided, including the elapsed recording time, and the time remaining based on the current memory card's available storage.

More About Frame Rates and Formats

Even intermediate movie shooters can be confused by the choice between 24/25 fps and 50/60 fps. The difference lies in the two "worlds" of motion images, film and video. The standard frame rate for motion picture film is 24 fps, while the video rate, at least in the United States, Japan, and other places using the NTSC standard is 30 fps. That's actually 60 interlaced *fields* per second; that's where we get the 60i (60 fps *interlaced* specification). With interlaced video, the capture device grabs odd-numbered lines in one scan, even-numbered video lines in another scan, and they are combined to produce the final image we view. *Progressive* scan images (as in 60p) grab all the video lines of an image in order.

Line-by-line scanning during capture and playback can be done in one of two ways. With *interlaced scanning*, odd-numbered lines (lines 1, 3, 5, 7, … and so forth) are captured with one pass, and then the even-numbered lines (2, 4, 6, 8, …and so forth) are grabbed. With the 1080/60i format, roughly 60 pairs of odd/even line scans, or 60 *fields* are captured each second. (The actual number is 59.94 fields per second.) Interlaced scanning was developed for and works best with analog display systems such as older television sets. It was originally created as a way to reduce the amount of bandwidth required to transmit television pictures over the air. Modern LCD, LED, and plasma-based HDTV displays must de-interlace a 1080i image to display it. (See Figure 8.2.)

Newer displays work better with a second method, called *progressive scanning* or *sequential scanning*. Instead of two interlaced fields, the entire image is scanned as consecutive lines (lines 1, 2, 3, 4,… and so forth). This happens at a rate of 30 frames per second (not fields), or, more precisely, 29.97 frames per second. (All these numbers apply to the NTSC television system used in the United States, Canada, Japan, and some other countries; other places use systems like PAL, where the nominal scanning figures are 50/25 rather than 60/30.)

One problem with interlaced scanning appears when capturing video of moving subjects. Half of the image (one set of interlaced lines) will change to keep up with the movement of the subject while the other interlaced half retains the "old" image as it waits to be refreshed. Flicker or *interline twitter* results. That makes your progressive scan (p) options a better choice for action photography.

Computer-editing software can handle either type (although AVCHD may not be compatible with the programs you own), and convert between them. The choice between 24 fps and 60 fps (or 25 fps and 50 fps) is determined by what you plan to do with your video. The short explanation is that, for technical reasons I won't go into here, shooting at 24 fps (or 25 fps) gives your movie more of the so-called "cinematic" look that film would produce, excellent for showing fine detail. However,

Figure 8.2
The inset shows how lines of the image alternate between odd and even in an interlaced video capture.

if your clip has moving subjects, or you pan the camera, 24 fps (or 25 fps) can produce a jerky effect called "judder." The 60 fps (or 50 fps) option produces a home video look that some feel is less desirable, but which is smoother and less jittery when displayed on an electronic monitor. I suggest you try both and use the frame rate that best suits your tastes and video-editing software.

Movies captured with MP4 format can't be burned to disk with Sony's PMB (Picture Motion Browser) software. However, if you capture using AVCHD, you can create Blu-Ray Discs, AVCHD Disks, or DVD-Video discs using the PMB software.

Steps During Movie Making

Once you have set up the camera for your video session and pressed the Movie button, you have done most of the technical work that's required of you. Now your task is to use your skills at composition, lighting, scene selection, and, perhaps, directing actors, to make a compelling video production.

- **Zoom, autofocus, and autoexposure all work.** If you're new to the world of high-quality still cameras that also take video, you may just take it for granted that functions such as autofocus continue to work normally when you switch from stills to video. But until recently, most such cameras performed weakly in their video modes; they would lock their exposure and focus at the beginning of the scene, and you could not zoom while shooting the video. The a5000 has no such handicaps, and, in fact, it is especially capable in these areas.

Autoexposure works very well, modifying the exposure as the scene brightness changes; the method used depends on the metering mode that you're using. You can zoom to your heart's content (though I recommend that you zoom sparingly). Best of all, autofocus works like a charm; the camera can track moving subjects and quickly snap them back into sharp focus with speedy continuous AF. So don't limit yourself based on the weaknesses of past cameras; the a5000 opens up new horizons of video freedom.

- **Exposure compensation works while filming.** I found this feature to be quite remarkable. Although the autoexposure system works very well (especially with Multi metering) to vary the aperture when the ambient lighting changes, you can certainly dial in exposure compensation when you need to do so or want to do so for a certain effect. You could even use this function as a limited kind of "fade to black" in the camera, though you probably won't be able to fade quite all the way to black.

If the preview display suggests that your movie will be dark (underexposed) and if it does not get brighter after you set plus compensation, there's another problem: the camera cannot provide a good exposure for the movie at the ISO that you have set (as discussed earlier). Switch to a higher ISO level until the brightness is as desired or switch to ISO Auto to enable the camera to set a higher ISO level to prevent the "underexposure."

- **Use AE Lock instead**. Occasionally, you may find that you start having an exposure problem during recording; this might happen when pointing the lens toward a light-tone area that causes the camera to begin underexposing. While plus compensation will allow you to increase brightness, it's preferable to use the defined AE Lock button to maintain a pleasing exposure during the entire video clip.

Why would you need this feature? Let's say you're filming entertainers against grass and foliage but you're moving the camera and will soon be filming a second group against a white sky. As soon as you do so, the backlighting will cause the video to get darker. Don't let that happen. Before pointing the lens toward the backlit area, press AEL and keep it depressed. This will prevent the exposure from changing as you point the lens toward the backlit part of the scene. This is preferable to waiting until an underexposure problem starts and then setting plus exposure compensation that suddenly makes the video brighter.

- **Don't be a Flash in the pan.** With HD video, there is a possibility of introducing artifacts or distortion if you pan too quickly. (This effect is called rolling shutter distortion or the "Jello effect.") That is, because of the way the lines of video are displayed in sequence, if the camera moves too quickly in a sideways motion, some of the lines may not show up on the screen quickly enough to catch up to the rest of the picture. As a result, objects in your video can become somewhat distorted or you may experience a jiggling effect and/or loss of detail. So, if at all possible, make your pans smooth and steady, and slow them down to a comfortable pace.

Tips for Shooting Better Video

Once upon a time, the ability to shoot video with a digital still camera was one of those "Gee whiz" gimmicks camera makers seemed to include just to have a reason to get you to buy a new camera. That hasn't been true for a couple of years now, as the video quality of many digital still cameras has gotten quite good. The Sony a5000 is a stellar example. It's capable of HD quality video and is actually capable of outperforming typical modestly priced digital video camcorders, especially when you consider the range of lenses and other helpful accessories available for it.

Producing good quality video is more complicated than just buying good equipment. There are techniques that make for gripping storytelling and a visual language the average person is very used to, but also pretty unaware of. While this book can't make you a professional videographer in half a chapter, there is some advice I can give you that will help you improve your results with the camera.

Producing high-quality videos can be a real challenge for amateur photographers. After all, by comparison we're used to watching the best productions that television, video, and motion pictures can offer. Whether it's fair or not, our efforts are compared to what we're used to seeing produced by experts. While this chapter can't make you into a pro videographer, it can help you improve your efforts. For example, one thing beginners sometimes forget is that movies need to *move*. Even if you're shooting a static landscape or architectural scene, like the one in Figure 8.3, you should try to incorporate motion in some way. I waited until the powered parasail moved into the picture before capturing my clip of the Alcázar in Segovia, Spain.

Figure 8.3 If possible, incorporate motion into otherwise static scenes.

Keep Things Stable and on the Level

Camera shake's enough of a problem with still photography, but it becomes even more of a nuisance when you're shooting video. While the stabilizer found in lenses with the OSS designation can help minimize this, it can't work miracles. Placing your camera on a tripod will work much better than trying to hand-hold it while shooting. One bit of really good news is that compared to pro dSLRs the a5000 can work very effectively on a lighter tripod, due to the camera's light weight. On windy days however, the extra mass of a heavy tripod is still valuable.

Shooting Script

A shooting script is nothing more than a coordinated plan that covers both audio and video and provides order and structure for your video. A detailed script will cover what types of shots you're going after, what dialogue you're going to use, audio effects, transitions, and graphics.

Storyboards

A storyboard is a series of panels providing visuals of what each scene should look like. While the ones produced by Hollywood are generally of very high quality, there's nothing that says drawing skills are important for this step. Stick figures work just fine if that's the best you can do. The storyboard just helps you visualize locations, placement of actors/actresses, props and furniture, and also helps everyone involved get an idea of what you're trying to show. It also helps show how you want to frame or compose a shot. You can even shoot a series of still photos and transform them into a "storyboard" if you want, such as in Figure 8.4.

Storytelling in Video

Today's audience is used to fast-paced, short scene storytelling. In order to produce interesting video for such viewers, it's important to view video storytelling as a kind of shorthand code for the more leisurely efforts print media offers. Audio and video should always be advancing the story. While it's okay to let the camera linger from time to time, it should only be for a compelling reason and only briefly.

It only takes a second or two for an establishing shot to impart the necessary information. For example, many of the scenes for a video documenting a model being photographed in a Rock and Roll music setting might be close-ups and talking heads, but an establishing shot showing the studio where the video was captured helps set the scene. (See Figure 8.5.)

Provide variety too. Change camera angles and perspectives often and never leave a static scene on the screen for a long period of time. (You can record a static scene for a reasonably long period and then edit in other shots that cut away and back to the longer scene with close-ups that show each person talking.)

Figure 8.4 A storyboard is a series of simple sketches or photos to help visualize a segment of video.

Figure 8.5 An establishing shot from a distance sets the stage for closer views.

When editing, keep transitions basic! I can't stress this one enough. Watch a television program or movie. The action "jumps" from one scene or person to the next. Fancy transitions that involve exotic "wipes," dissolves, or cross fades take too long for the average viewer and make your video ponderous.

Composition

In movie shooting, several factors restrict your composition, and impose requirements you just don't always have in still photography (although other rules of good composition do apply). Here are some of the key differences to keep in mind when composing movie frames:

- **Horizontal compositions only.** Some subjects, such as basketball players and tall buildings, just lend themselves to vertical compositions. But movies are generally shot and shown in horizontal format only. (Unless you're capturing a clip with your smartphone; I see many vertically oriented YouTube videos.) So if you're shooting a conventional video and interviewing a local basketball star, you can end up with a worst-case situation like the one shown in Figure 8.6. If you want to show how tall your subject is, it's often impractical to move back far enough to show him full-length. You really can't capture a vertical composition. Tricks like getting down on the floor and shooting up at your subject can exaggerate the perspective, but aren't a perfect solution.

Figure 8.6
Movie shooting requires you to fit all your subjects into a horizontally oriented frame.

- **Wasted space at the sides.** Moving in to frame the basketball player as outlined by the yellow box in Figure 8.6 means that you're still forced to leave a lot of empty space on either side. (Of course, you can fill that space with other people and/or interesting stuff, but that defeats your intent of concentrating on your main subject.) So when faced with some types of subjects in a horizontal frame, you can be creative, or move in *really* tight. For example, if I was willing to give up the "height" aspect of my composition, I could have framed the shot as shown by the green box in the figure, and wasted less of the image area at either side.

- **Seamless (or seamed) transitions.** Unless you're telling a picture story with a photo essay, still pictures often stand alone. But with movies, each of your compositions must relate to the shot that preceded it, and the one that follows. It can be jarring to jump from a long shot to a tight close-up unless the director—you—is very creative. Another common error is the "jump cut" in which successive shots vary only slightly in camera angle, making it appear that the main subject has "jumped" from one place to another. (Although everyone from French New Wave director Jean-Luc Goddard to Guy Ritchie—Madonna's ex—have used jump cuts effectively in their films.) The rule of thumb is to vary the camera angle by at least 30 degrees between shots to make it appear to be seamless. Unless you prefer that your images flaunt convention and appear to be "seamy."

- **The time dimension.** Unlike still photography, with motion pictures there's a lot more emphasis on using a series of images to build on each other to tell a story. Static shots where the camera is mounted on a tripod and everything is shot from the same distance are a recipe for dull videos. Watch a television program sometime and notice how often camera shots change distances and directions. Viewers are used to this variety and have come to expect it. Professional video productions are often done with multiple cameras shooting from different angles and positions. But many professional productions are shot with just one camera and careful planning, and you can do just fine with your a5000.

Here's a look at the different types of commonly used compositional tools:

- **Establishing shot.** Much like it sounds, this type of composition, as shown earlier in Figure 8.5, establishes the scene and tells the viewer where the action is taking place. Let's say you're shooting a video of your offspring's move to college; the establishing shot could be a wide shot of the campus with a sign welcoming you to the school in the foreground. Another example would be for a child's birthday party; the establishing shot could be the front of the house decorated with birthday signs and streamers or a shot of the dining room table decked out with party favors and a candle-covered birthday cake. Or, in Figure 8.5, I wanted to show the studio where the video was shot.

- **Medium shot.** This shot is composed from about waist to head room (some space above the subject's head). It's useful for providing variety from a series of close-ups and also makes for a useful first look at a speaker. (See Figure 8.7.)

Figure 8.7 A medium shot is used to bring the viewer into a scene without shocking them. It can be used to introduce a character and provide context via their surroundings.

Figure 8.8 A close-up generally shows the full face with a little head room at the top and down to the shoulders at the bottom of the frame.

Figure 8.9 An extreme close-up is a very tight shot that cuts off everything above the top of the head and below the chin (or even closer!). Be careful using this shot since many of us look better from a distance!

Figure 8.10 A "two-shot" features two people in the frame. This version can be framed at various distances such as medium or close up.

Figure 8.11 An "over-the-shoulder" shot is a popular shot for interview programs. It helps make the viewers feel like they're the one asking the questions.

- **Close-up.** The close-up, usually described as "from shirt pocket to head room," provides a good composition for someone talking directly to the camera. Although it's common to have your talking head centered in the shot, that's not a requirement. In Figure 8.8 the subject was offset to the right. This would allow other images, especially graphics or titles, to be superimposed in the frame in a "real" (professional) production. But the compositional technique can be used with a5000 videos, too, even if special effects are not going to be added.
- **Extreme close-up.** When I went through broadcast training, this shot was described as the "big talking face" shot and we were actively discouraged from employing it. Styles and tastes change over the years and now the big talking face is much more commonly used (maybe people are better looking these days?) and so this view may be appropriate. Just remember, the a5000 is capable of shooting in high-definition video and you may be playing the video on a high-def TV; be careful that you use this composition on a face that can stand up to high definition. (See Figure 8.9.)
- **"Two" shot.** A two shot shows a pair of subjects in one frame. They can be side by side or one subject in the foreground and one in the background. This does not have to be a head to ground composition. Subjects can be standing or seated. A "three shot" is the same principle except that three people are in the frame. (See Figure 8.10.)
- **Over-the-shoulder shot.** Long a composition of interview programs, the "over-the-shoulder shot" uses the rear of one person's head and shoulder to serve as a frame for the other person. This puts the viewer's perspective as that of the person facing away from the camera. (See Figure 8.11.)

Lighting for Video

Much like in still photography, how you handle light pretty much can make or break your videography. Lighting for video can be more complicated than lighting for still photography, since both subject and camera movement are often part of the process.

Lighting for video presents several concerns. First off, you want enough illumination to create a useable video. Beyond that, you want to use light to help tell your story or increase drama. Let's take a better look at both.

Illumination

You can significantly improve the quality of your video by increasing the light falling in the scene. This is true indoors or out, by the way. While it may seem like sunlight is more than enough, it depends on how much contrast you're dealing with. If your subject is in shadow (which can help them from squinting) or wearing a ball cap, a video light can help make them look a lot better.

Lighting choices for amateur videographers are a lot better these days than they were a decade or two ago. An inexpensive incandescent video light, which will easily fit in a camera bag, can be found for $15 or $20. You can even get a good-quality LED video light for less than $100. Work lights sold at many home improvement stores can also serve as video lights since you can set the

camera's white balance to correct for any color casts. You'll need to mount these lights on a tripod or other support, or, perhaps, to a bracket that fastens to the tripod socket on the bottom of the camera.

Much of the challenge depends upon whether you're just trying to add some fill light on your subject versus trying to boost the light on an entire scene. A small video light will do just fine for the former. It won't handle the latter. Fortunately, the versatility of the a5000 comes in quite handy here. Since the camera shoots video in Auto ISO mode, it can compensate for lower lighting levels and still produce a decent image. For best results though, better lighting is necessary.

Creative Lighting

While ramping up the light intensity will produce better technical quality in your video, it won't necessarily improve the artistic quality of it. Whether we're outdoors or indoors, we're used to seeing light come from above. Videographers need to consider how they position their lights to provide even illumination while up high enough to angle shadows down low and out of sight of the camera.

When considering lighting for video, there are several factors. One is the quality of the light. It can either be hard (direct) light or soft (diffused) light. Hard light is good for showing detail, but can also be very harsh and unforgiving. "Softening" the light, but diffusing it somehow, can reduce the intensity of the light but make for a kinder, gentler light as well.

While mixing light sources isn't always a good idea, one approach is to combine window light with supplemental lighting. Position your subject with the window to one side and bring in either a supplemental light or a reflector to the other side for reasonably even lighting.

Lighting Styles

Some lighting styles are more heavily used than others. Some forms are used for special effects, while others are designed to be invisible. At its most basic, lighting just illuminates the scene, but when used properly it can also create drama. Let's look at some types of lighting styles:

- **Three-point lighting.** This is a basic lighting setup for one person. A main light illuminates the strong side of a person's face, while a fill light lights up the other side. A third light is then positioned above and behind the subject to light the back of the head and shoulders. (See Figure 8.12.)

- **Flat lighting.** Use this type of lighting to provide illumination and nothing more. It calls for a variety of lights and diffusers set to raise the light level in a space enough for good video reproduction, but not to create a particular mood or emphasize a particular scene or individual. With flat lighting, you're trying to create even lighting levels throughout the video space and minimize any shadows. Generally, the lights are placed up high and angled downward (or possibly pointed straight up to bounce off of a white ceiling). (See Figure 8.13.)

Figure 8.12 With three-point lighting, two lights are placed in front and to the side of the subject (45-degree angles are ideal) and positioned about a foot higher than the subject's head. Another light is directed on the background in order to separate the subject and the background. There's also a supplementary hair light above, behind, and to the left of the model.

Figure 8.13 Flat lighting is another approach for creating even illumination. Here the lights can be bounced off of a white ceiling and walls to fill in shadows as much as possible. It is a flexible lighting approach since the subject can change positions without needing a change in light direction.

- **"Ghoul lighting."** This is the style of lighting used for old horror movies. The idea is to position the light down low, pointed upward. It's such an unnatural style of lighting that it makes its targets seem weird and ghoulish.
- **Outdoor lighting.** While shooting outdoors may seem easier because the sun provides more light, it also presents its own problems. As a general rule of thumb, keep the sun behind you when you're shooting video outdoors, except when shooting faces (anything from a medium shot and closer) since the viewer won't want to see a squinting subject. When shooting another human this way, put the sun behind her and use a video light to balance light levels between the foreground and background. If the sun is simply too bright, position the subject in the shade and use the video light for your main illumination. Using reflectors (white board panels or aluminum foil covered cardboard panels are cheap options) can also help balance light effectively.

Audio

When it comes to making a successful video, audio quality is one of those things that separates the professionals from the amateurs. We're used to watching top-quality productions on television and in the movies, yet the average person has no idea how much effort goes in to producing what seems to be "natural" sound. Much of the sound you hear in such productions is actually recorded on carefully controlled sound stages and "sweetened" with a variety of sound effects and other recordings of "natural" sound.

Your a5000 has a pair of stereo microphones on its top surface, but no way of plugging in an external microphone, so you must be extra careful to optimize the sound captured by those fixed mics. You will find an Audio Recording entry in the Camera Settings 6 menu (it just turns sound on or off), as well as a Wind Noise Reduction on/off switch. But that's as far as your camera adjustments go.

Tips for Better Audio

Since recording high-quality audio is such a challenge, it's a good idea to do everything possible to maximize recording quality:

- **Turn off any sound makers you can.** Little things like fans and air handling units aren't obvious to the human ear, but will be picked up by the microphone. Turn off any machinery or devices that you can plus make sure cell phones are set to silent mode. Also, do what you can to minimize sounds such as wind, radio, television, or people talking in the background.
- **Make sure to record some "natural" sound.** If you're shooting video at an event of some kind, make sure you get some background sound that you can add to your audio as desired in postproduction.

- **Consider recording audio separately.** Lip-syncing is probably beyond most of the people you're going to be shooting, but there's nothing that says you can't record narration separately and add it later. It's relatively easy if you learn how to use simple software video-editing programs like iMovie (for the Macintosh) or Windows Movie Maker (for Windows PCs). Any time the speaker is off-camera, you can work with separately recorded narration rather than recording the speaker on-camera. This can produce much cleaner sound.

> **WIND NOISE REDUCTION**
>
> The a5000 does offer a low-cut filter feature that can further reduce wind noise; it's accessed with the Wind Noise Reduction item of the Camera Settings 6 menu, discussed in Chapter 3. However, this processing feature also affects other sounds, making the wind screen far more useful.

Lens Craft

I'll cover the use of lenses with the a5000 in more detail in Chapter 9, but a discussion of lens selection when shooting movies may be useful at this point. In the video world, not all lenses are created equal. The two most important considerations are depth-of-field, or the beneficial lack thereof, and zooming. I'll address each of these separately.

Depth-of-Field and Video

Have you wondered why professional videographers have gone nuts over still cameras that can also shoot video? The producers of *Saturday Night Live* could afford to have Alex Buono, their director of photography, use the niftiest, most expensive high-resolution video cameras to shoot the opening sequences of the program. Instead, Buono opted for a pair of digital SLR cameras. One thing that makes digital still cameras so attractive for video is that they have relatively large sensors; that provides two benefits compared to cameras with a smaller sensor. In addition to improved low-light performance, the large chip allows for unusually shallow depth-of-field (a limited range of acceptable sharpness) for blurring the background; this effect is difficult or impossible to match with most professional video cameras since they use smaller sensors.

Figure 8.14 provides a comparison of the relative size of sensors. The typical size of a professional video camera sensor is shown at lower left. The APS-C sized sensor used in the a5000 is shown just north of it. You can see that it is much larger, especially when compared with the sensor found in the typical point-and-shoot camera and many other compact camera models (at right). Of course, the full-frame sensors found in some cameras, including the Sony Alpha SLT-a99 and Alpha a7r, are even larger. But, compared with the sensors used in many pro video cameras, and the even smaller sensors found in the typical camcorder, the a5000's image-grabber is larger.

Figure 8.14
Sensor size comparison.

As you'll learn in Chapter 9, a larger sensor calls for the use of longer focal lengths to produce the same field of view, so, in effect, a larger sensor allows for making images with reduced depth-of-field. And *that's* what makes cameras like the a5000 attractive from a creative standpoint. Shallow depth-of-field makes it easier to blur a cluttered background to keep the viewers' eyes riveted on the primary subject. Your a5000, with its larger sensor, has a distinct advantage over consumer camcorders in this regard, and even does a much better job than professional video cameras.

Zooming and Video

When shooting still photos, a zoom is a zoom is a zoom. The key considerations for a zoom lens used only for still photography are the maximum aperture available at each focal length ("How *fast* is this lens?), the zoom range ("How far can I zoom in or out?"), and its sharpness at any given f/stop ("Do I lose sharpness when I shoot wide open?").

When recording video, the priorities may change, and there are two additional parameters to consider. The first two I listed, lens speed and zoom range, have roughly the same importance in both still and video photography. Zoom range gains a bit of importance in videography, because you can always/usually move closer to shoot a still photograph, but when you're zooming during a shot most of us don't have that option (or the funds to buy/rent a dolly to smoothly move the camera during capture). But, oddly enough, overall sharpness may have slightly less importance under certain conditions when shooting video. That's because the image changes in some way many times per second (30/60 times per second), so any given frame doesn't hang around long enough for our eyes to pick out every single detail. You want a sharp image, of course, but your standards don't need to be quite as high when shooting video.

Here are the remaining considerations, and the two new ones:

- **Zoom lens maximum aperture.** The "speed" of the lens matters in several ways. A zoom with a relatively wide maximum aperture (small f/number) lets you shoot in lower light levels with fewer exposure problems. A wide aperture like f/1.8 also enables you to minimize depth-of-field for selective focus. Keep in mind that with most zooms, the maximum aperture gets smaller as you zoom to longer focal lengths. A variable-aperture f/3.5 to 5.6 lens like the power zoom kit lens, offers a fairly wide f/3.5 maximum aperture at its shortest focal length but only f/5.6 worth of light capturing ability at the long end. Zooms with a wide and constant (not variable) maximum aperture such as f/2.8 are available, but they are larger, heavier, and more expensive.

- **Power zoom.** An ideal movie zoom should have a power zoom feature, and that's available with two Sony lenses with the PZ designation, including the 16-50mm kit lens for the a5000 and the large PZ 18-105mm f/4 G OSS zoom. Both PZ lenses offer smooth, silent zooming that's ideal for video shooting. Mechanical zooming with other lenses during capture can produce jerky images, even with vibration reduction turned on.

- **Zoom range.** Use of zoom during actual capture should not be an everyday thing, unless you're shooting a kung-fu movie. However, there are effective uses for a zoom shot, particularly if it's a "long" one from wide angle to telephoto. The Sony 18-200mm zoom, which has a relatively quiet autofocus motor and built-in stabilizer, can be used in this way, with mechanical zooming, of course. Most of the time, you'll use the zoom range to adjust the perspective of the camera *between* shots, and a longer zoom range can mean less trotting back and forth to adjust the field of view. Zoom range also comes into play when you're working with selective focus (longer focal lengths produce shallower depth-of-field), or want to expand or compress the apparent distance between foreground and background subjects. A longer range gives you more flexibility.

- **Linearity.** Interchangeable lenses may have some drawbacks, as many photographers who have been using the video features of their digital SLRs have discovered. That's because lenses with mechanical zooming are rarely linear unless they were specifically designed for shooting movies. Rotating the zoom ring manually at a constant speed doesn't always produce a smooth zoom. There may be "jumps" as the elements of the lens shift around during the zoom. Keep that in mind if you plan to zoom during a shot, and are using a non-linear lens. In practice, those include virtually all the lenses at your disposal, aside from power zoom lenses, a special E-mount cine lens, or a cine lens in an entirely different mount that you can use with your a5000 with an optional third-party adapter.

9

Working with Lenses

A couple of years ago, there were relatively few Sony E-mount lenses for the mirrorless cameras with the typical size (16.5 × 23.5mm) sensor. The situation has improved with additional models released by Sony but even now, you won't find a long telephoto or a fast 70-200mm or similar zoom. However, at least three aftermarket lens companies now make E-mount lenses too, helping to expand the series. Of course, in another sense, there are dozens of lenses that will work reasonably well with the a5000, even if they weren't specifically made for it. Any of the Sony AF or Minolta Maxxum/Dynax A-mount autofocus lenses designed for SLRs or for digital SLT cameras like the A77 ii and A99, can be used with the a5000 if you buy an optional Sony LA-series adapter.

Now that Sony is also making lenses in FE-mount, for the full-frame mirrorless Alpha a7-series, those lenses, too, will work just fine on your camera—although they are a bit out of the price range of most a5000 owners. You can also find third-party brand adapters that allow for using lenses of entirely different brands (such as Nikon F and Pentax K) on your a5000; these mechanical "couplers" cannot support the camera's high-tech features and operate only with manual focus. I'll discuss adapters of all types in detail later in this chapter.

Some recent Sony E-mount lenses are power zoom-designated, indicating a power zooming mechanism instead of the conventional mechanical zoom. This feature is ideal for use when recording video because the zoom action is so smooth and quiet. The first was the 18-200mm f/3.5-6.3 power zoom OSS, and it is quite large. Subsequently, two smaller power zoom lenses were released, the premium-grade 18-50mm f/4 G power zoom OSS and the more affordable 18-50mm f/3.5-5.6 power zoom OSS; in many countries, the latter is one that's packaged with the a5000 kit.

As I write this, Sony's E-mount system includes several superb lenses with the Carl Zeiss ZA branding. These are made by Sony to Zeiss specifications and feature the finest optical elements, unusually rugged mechanical aspects and often, wide maximum apertures. My own favorites of these

Figure 9.1
A full-range of E-mount lenses, including this Sony FE 28-70mm F3.5-5.6 OSS lens work well on the a5000.

include the Carl Zeiss Vario-Tessar T* FE 24-70mm f/4 ZA OSS, which I purchased along with my A7r; and the Carl Zeiss Vario-Tessar E f/4 16-70mm ZA OSS lens that came with my a6000. Note too that Zeiss in Germany makes Zeiss Touit lenses in Sony E mount; these are not marketed by Sony, of course. Fortunately, even Sony's non-Zeiss lenses are excellent. (See Figure 9.1.)

Don't Forget the Crop Factor

From time to time you've heard the term "crop factor," and you've probably also heard the term lens multiplier or focal length multiplication factor. While some of these terms are misleading and inaccurate, they're used to describe the same phenomenon: the fact that cameras like the Sony—and all other digital interchangeable-lens cameras using a sensor smaller than the "full-frame" 24 × 36mm format—provide a field of view (or scene coverage) that's smaller than you get with a camera employing the larger sensor. The a5000 (as well as numerous other cameras of several brands) uses a sensor that's 15.6 × 23.5mm in size.

In practical terms, let's say you're using a 35mm lens on a full-frame Sony Alpha SLT-A99; you get a field of view of 63 degrees. But if you use a 35mm focal length lens on an a5000, the field of view is only 44 degrees because the smaller sensor records only a part of the image that the lens projects. Knowledgeable photographers often discuss this effect as the *crop factor* and you'll often find a reference in lens reviews to a *focal length equivalent;* that's 1.5X with the sensor size used by a camera like the a5000. In other words, a 35mm lens used on the a5000 is equivalent to a 52.5mm focal length on a full-frame camera like the Alpha SLT-A99. The most accurate expression to describe this concept might be something like *field of view equivalency factor.*

Figure 9.2 quite clearly shows the phenomenon at work. The outer rectangle, marked 1X, shows the field of view you might expect with a 50mm lens mounted on a full-frame digital model like the a7r or a 35mm film camera, like the 1985 Minolta Maxxum 7000 (which happened to be the first SLR to feature both autofocus and motorized advance, something we take for granted in the digital

Figure 9.2
This image illustrates the field of view provided by a full-frame camera like the Sony a7r (1X) with a 50mm lens, as well as the field of view you'd get when using a camera with the smaller sensor (1.5X crop) like the a5000.

SLR age). The rectangle marked 1.5X shows the field of view you'd get with that 50mm lens installed on a camera (like most of the Sony Alpha SLTs and all of the Sony mirrorless models other than the A7 series) that uses the more typical 15.6mm × 23.5mm sensor. It's easy to see from the illustration that the 1X rendition provides a wider, more expansive view, while the other view is, in comparison, *cropped*.

There's another way you can look at this. It's possible to calculate the relative field of view by dividing the focal length of the lens by .667. Thus, a 100mm lens mounted on a Sony has the same field of view as a 150mm lens on a full-frame camera like the A99. We humans tend to perform multiplication operations in our heads more easily than division, so such field of view comparisons are usually calculated using the reciprocal of .667—1.5—so we can multiply instead. (100 / .667=150; 100 × 1.5=150.)

Note

Frankly, all of this is useful only if you were previously using a 35mm SLR and frames of 24mm × 36mm film or a full-frame dSLR like the a7 series. In that case, you might find it helpful to use the crop factor "multiplier" to translate a lens's real focal length into the full-frame equivalent, even though, nothing is actually being multiplied. If you have always owned a digital camera with a smaller sensor, you already have a good feel as to the field of view that you get at a focal length such as 35mm or 50mm. It's highly unlikely that you would think in terms that require you to do any calculations.

In any event, I strongly prefer *crop factor* to *focal length multiplier*, because nothing is being multiplied (as I said above). A 100mm lens doesn't "become" a 150mm lens; the depth-of-field and lens aperture remain the same. (I'll explain more about these later in this chapter.) Only the field of view is cropped. Of course, the term *crop factor* has a drawback: it implies that a 24 × 36mm frame is "full" and anything else is "less than full."

I get e-mails all the time from photographers who point out that they own "full-frame" cameras that employ oversized 36mm × 48mm and larger sensors (like the Mamiya 645DF with a Leaf Aptus II digital back, or the Hasselblad H4D-50 medium-format digital camera). By their logical reckoning, the 24 × 36mm sensors found in full-frame cameras like the Sony a7 series are "cropped."

Choosing a Lens

The a5000 is most frequently purchased with a lens, often the retractable 16-50mm f/3.5-5.6 Power Zoom model with OSS, Sony's Optical SteadyShot Stabilizer discussed in previous chapters. (See Figure 9.3.) A zoom is useful but you might prefer the 16mm f/2.8 pancake lens because its minimal size/weight provides great portability that's ideal while hiking or touring for days while on vacation. Or, if you want a do-everything, walk-around lens, you might want the 18-200mm f/3.5-6.3 OSS zoom. If you already own some lenses for an Alpha SLT-A camera or a Maxxum/Dynax SLR, you might want to just purchase one of two E-mount adapters discussed later and use the lenses you already have.

In this section, I'll discuss the smaller Sony E-mount lenses, the starter models, as well as the wide-angle lenses.

Figure 9.3
This 16-50mm f/3.5-5.6mm power zoom OSS is very popular since the a5000 is often sold in a kit that includes this lens.

Here are your choices in these categories:

- **Sony 16-50mm power zoom OSS f/3.5-5.6 (SELP-1650).** If you did not buy the a5000 in a kit, you might still want to consider this lens with power zooming that's ideal for anyone who often shoots movies, as discussed in Chapter 5. It's quite compact when not in use since the internal barrel retracts when the camera is turned off and it's a fine performer overall ($350.)
- **Sony 18-55mm OSS f/3.5-5.6 (SEL-1855).** If you do not own the power zoom lens because you don't often shoot video, consider this ($300) model with conventional (mechanical) zooming and the same maximum apertures. It's sharp, small in size, and fast enough at shorter focal lengths for most available light shooting. Granted, it is a stop and a half slower at the telephoto end; this is typical with lenses of this type. A black version is sold only in a kit with certain cameras but the handsome silver-tone model is available for purchase as a separate item.
- **Sony 16mm f/2.8 (SEL16F28).** This flat, pancake-style wide-angle lens ($250) is also sharp and downright tiny, with dimensions of 0.89 × 2.44 inches. The f/2.8 maximum aperture is much wider than you'll get with most affordable zooms and makes this lens more suitable for available light shooting. Granted it does not zoom.

The 16mm lens accepts two add-on accessories that mount on the front, with the VCL-ECF1 fisheye conversion lens ($150) shown in Figure 9.4. It gives you a fisheye view for interesting landscapes, interiors, and other subjects. Given that fisheye lenses are typically used infrequently by most shooters, the low cost of this accessory offsets the less than tack-sharp results you can expect. Mount the five-ounce VCL-ECU1 wide-angle converter ($130) instead, to transform this 16mm lens into a super-wide 12mm (18mm equivalent) lens. I've gotten great results from mine, although it works best when the host lens is stopped down at least one or two apertures from wide open.

Figure 9.4
The 16mm "pancake" lens is unusually compact, provides extra compactness, even when equipped with the fisheye attachment shown.

- **Sony 20mm f/2.8 (SEL20F28).** Also very compact and featuring the same maximum aperture, this ($350) lens does not accept the add-on converters but provides very fine image quality.

- **Sony 35mm f/1.8 OSS (SEL35F18).** Because of the 1.5X crop factor discussed earlier, this 52.5mm equivalent lens might be considered to be the "normal" lens in the system (that is, comparable to the very popular 50mm f/1.8 lens in a dSLR system). The very wide maximum aperture and OSS stabilizer make it ideal for low light photography. Move very close to the subject, use f/1.8, and you can blur the background with shallow depth-of-field. The lens is pricey ($450) because it's equipped with a superior optical formula to control aberrations and a high-speed linear focusing motor that's almost silent, a definite benefit when shooting video.

- **Sony 50mm f/1.8 OSS (SEL50F18).** This more affordable ($300) model, also with a very wide maximum aperture, is a short telephoto on the a5000 and would be useful for street photography from moderate distances, and for portraits. The f/1.8 aperture is useful for blurring a background in a situation where you're shooting a head-and-shoulders portrait. Since this is a fast lens with OSS stabilizer that compensates for camera shake at slower shutter speeds, it's another fine choice for available light photography.

- **Sony 10-18mm f/4 OSS (SEL1018).** If you're really into wide angle and ultra-wide angle photography, this lens is an ideal choice ($850). At the 10mm end (a 15mm equivalent) an image can encompass more than our two eyes can see without scanning. We often shoot at small apertures in wide-angle image making, but this lens is adequately fast for low light photography indoors when using f/4 and the OSS stabilizer. You should be pleased with the image quality provided by this ultra-wide zoom because it features an impressive optical formula with super extra-low dispersion glass and three aspherical elements to minimize optical distortions (discussed later in this chapter).

The lenses in the E-mount system range from the sublime to the meticulous, and can prove useful for various kinds of photography. Next, let's take a look at zooms that extend beyond 100mm and the macro lens. I'll be covering the high-grade Carl Zeiss ZA series later, but here are your additional E-mount options in the Sony designated line:

- **Sony 18-105mm f/4 G PZ OSS (SELP19105G).** Featuring a relatively wide maximum aperture of f/4 at all focal lengths, this power zoom lens's G designation indicates superior optical elements for fine image quality. It's made with two ED and three aspherical elements for controlling optical aberrations (inherent lens flaws) for across the frame sharpness at most apertures, including f/4. It's a bit pricey ($600) but offers good value. As the power zoom designation indicates, this is another of the Sony lenses with power zooming.

- **Sony OSS 18-200mm f/3.5-6.3 (SEL18200).** This lens dwarfs the a5000, and its maximum aperture is very small at the longest telephoto setting, but it has a great zoom range that makes it suitable for a5000 owners who really prefer to carry only a single lens. It's not inexpensive ($900) but provides great focal length versatility. The built-in OSS stabilization reduces the risk

of blur caused by camera shake, a definite asset in a telephoto lens that's quite slow (with small maximum apertures especially at long focal lengths). At the maximum 200mm focal length, you should be able to get sharp photos when hand-holding the camera/lens at a shutter speed of 1/60th second.

A similar lens that's larger and more expensive ($1,200) because of the power zoom mechanism, the power zoom-designated version (SELP18200) targets a5000 owners who shoot video often and will really appreciate the ability to zoom quietly and extremely smoothly. It's also equipped with the SteadyShot image stabilizer.

- **Sony 55-210mm f/4.5-6.3 OSS (SEL55210).** This is an affordable ($350) OSS lens with enough telephoto reach for some wildlife photography and for shooting amateur sports events. Of course, the maximum apertures are a bit small, especially at long focal lengths. As well, you will get the best image quality at f/8. You will need to use a higher ISO on dark days to be able to shoot at shutter speeds fast enough to "freeze" the motion of your subjects at f/6.3 and especially if you decide to use f/8. At this writing, Sony doesn't have a fast medium to long telephoto in E-mount.

- **Sony 30mm f3.5 Macro (SEL30M35).** This is the current macro lens in the line. You'll find that it features a minimum working distance of about one inch; move in extremely close to the subject and you can make images with 1X magnification (a 1:1 reproduction ratio). That might be a problem with a nature subject like a bee, but it's certainly practical with coins, stamps, and jewelry for example. The maximum aperture of f/3.5 is small, but in macro, we usually use a small aperture such as f/16 for adequate depth-of-field to sharply render an entire three-dimensional subject. This lens is compact, lightweight, and affordable ($280). Of course, because I own both A-mount and E-mount Sony cameras, and an A-mount to E-mount adapter, I ended up purchasing the A-mount version of this lens. For close-up work, having the smallest, lightest lens and the fastest autofocusing isn't essential, and I saved money by not buying both.

Sony's Carl Zeiss E-Mount Lenses

While the Sony-designated E-mount lenses should meet the needs of most photographers, you'll also find several premium-grade (and expensive) products with the Carl Zeiss ZA designation. The Carl Zeiss models all boast rugged metal construction for great durability, the very effective T* multi-layer anti-reflective coating for flare control, and one or more large high-tech optical elements for effective correction of optical aberrations. Here are my favorite E-mount options for a5000 owners who want the very best:

- **Carl Zeiss Vario-Tessar T* 16-70mm f/4 ZA OSS (SEL1670Z).** A mid-range zoom with a relatively wide maximum aperture of f/4 at all focal lengths, this zoom incorporates four aspherical elements for superior image quality and Sony's OSS stabilizer ($1,000). It's shown in Figure 9.5, left, zoomed to the maximum focal length. This is one lens that gets significantly longer as you zoom, making it much less compact at the telephoto settings.

Figure 9.5
The Carl Zeiss 16-70mm f/4 lens (left) and its 24mm f/1.8 stablemate (right).

- **Carl Zeiss Sonar T* 24mm f/1.8 ZA OSS (SEL24F18Z).** This moderately wide-angle (36mm equivalent) lens with OSS stabilizer and a maximum aperture of f/1.8 is perfect for low-light street photography. (See Figure 9.5, right.) I also find it useful indoors for nearby sports action (you might also like it for basketball when shooting at the baseline) and for shooting interiors where an ultra-wide view is not crucial (think larger venues, cathedrals, and museums where flash is prohibited). Frankly this lens could easily be the star of your stable with superb image quality and freedom from distortion thanks to the use of ED glass and aspherical elements.

 A linear stepping motor provides fast, low-noise autofocus that's ideal when shooting video. Sure, it's pricey ($1,100), and not exactly compact at 2-3/8 × 2-1/2-inches and nearly 8 ounces, but if you need f/1.8 and its angle of view, nothing else will do the job. This lens can be hard to find since it's often back-ordered. I have owned mine for over a year now and have gotten excellent results with this superb lens.

Using the LA-EA Series Adapters

Sony makes four A-mount to E-mount adapters, which allow using Sony/Minolta A-mount lenses on an Alpha E-mount camera such as the a5000. Why four different adapters, at four different prices? All four, the LA-EA1, LA-EA2, LA-EA3, and LAEA4, allow connecting an A-mount lens to an NEX/Alpha-series camera. The two odd-numbered adapters use *only* contrast detect autofocus with lenses that are compatible with them. The two even-numbered adapters have built-in SLT-like phase detection AF systems for faster focusing. The LA-EA1 and LA-EA2 are designed for APS-C cameras like the a5000, while the LA-EA3 and LA-EA4 are intended for full-frame models like the A7-series. Table 9.1 should clear things up a bit.

Table 9.1 LA-EA Series Adapters

Adapter	Autofocus	Format
LA-EA1	Contrast detect with lenses with built-in SSR or SAM AF motors. Lenses using motor in the camera body will not autofocus.	APS-C
LA-EA2	Phase detect using Translucent Mirror technology.	APS-C
LA-EA3	Contrast detect with lenses with built-in with or SAM AF motors. Lenses using motor in the camera body will not autofocus.	Full Frame and APS-C
LA-EA4	Phase detect using Translucent Mirror technology.	Full Frame and APS-C

The LA-EA2 adapter (or LA-EA4 if you plan to upgrade to full frame some day) is a much more satisfactory solution, but, at $400, it costs a lot more, too. Both are shown in Figure 9.6. For some, either may be worth the price because they offer full-time phase detection autofocus, just like the Alpha's SLT and dSLR siblings, with A-mount lenses, including useful optics like the 30mm f/2.8 macro lens and 18-200mm zoom shown in Figure 9.7. This miracle solution involves, basically, building a version of Sony's Translucent Mirror Technology, found in the SLT cameras, into an adapter, as you can see in the exploded diagram shown in Figure 9.8. (In actual use, the lens must be physically mounted to the adapter.)

When I am out doing casual shooting, I carry my a5000 with a compact lens mounted (most often the 16-50mm kit lens or the 16mm f/2.8 with fisheye attachment). For more serious work, where weight is not a problem, I end up using my LA-EA2 adapter frequently, with one of my large

Figure 9.6
The LA-EA2 (left) and LA-EA4 (right) adapters allow using A-mount lenses on the a5000.

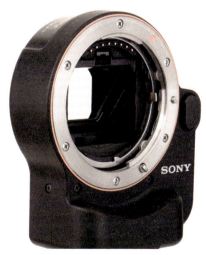
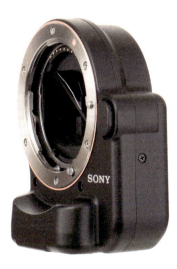

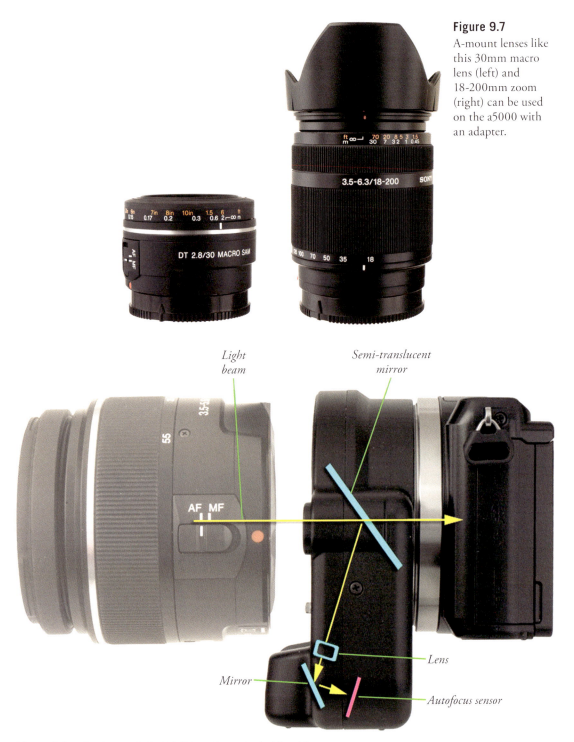

Figure 9.7
A-mount lenses like this 30mm macro lens (left) and 18-200mm zoom (right) can be used on the a5000 with an adapter.

Figure 9.8 The design of the LA-EA2 adapter looks like this.

collection of Minolta and Sony A-mount lenses. An amazing number of like-new optics in A-mount are available at steep discounts at keh.com, and I find myself there scavenging for lenses to add to my collection more often than I care to admit.

If you're not familiar with the SLT cameras, light from the lens reaches a semi-silvered non-moving mirror, with 70 percent continuing through the mirror and adapter to the a5000's sensor. The 30 percent of the light reflected downward by the mirror is directed through a lens and another mirror to a 15-point AF sensor with three extra-sensitive cross-type sensors. The camera magically gains the same on-screen AF point selection options and high-speed phase detection autofocus in both Continuous AF and Single-shot modes as its SLT stablemates, and an electronic aperture drive mechanism allows full autoexposure functions with all A-mount lenses (except those used with a teleconverter). Virtually any Sony/Minolta A-mount lens can be used.

The seven-ounce, 3 1/8 × 3 1/2 × 1 3/4 inch LA-EA2 adapter is large, but it has a built-in tripod mount, so you can use it with large, heavy lenses that don't have a tripod mount of their own. For $400 (plus the cost of your A-mount lenses), you can convert your a5000 mirrorless camera into a camera with a mirror! I'm glad Sony has made these accessories available for the a5000, but find it amusing that such a petite camera can be fitted with pounds and pounds of adapters, lenses, and viewfinders that transform it from a compact model to a model that's easily the same size—or larger—than the SLT and dSLR alternatives.

> **WATCH THAT WEIGHT**
>
> Be aware than the a5000's lens mount isn't constructed to support the weight of very large lenses, such as the ones you might attach using either A-mount adapter. Support the lens by placing your hand under it (the tripod mount shown in the figure is a good choice), and if using the setup on a tripod or monopod, attach the device to the tripod mount on the adapter, and not to the a5000's own tripod thread.

Other Lens Options

Because of the popularity of the camera line, third-party vendors have rushed to produce lenses for these models. You can find several Sigma DN and Carl Zeiss Touit lenses in the E-mount. Tamron makes their 18-200mm f/3.5-6.3 Di III VC lens in E-mount; this lens has the same f/stop range (with a small maximum aperture at long focal lengths) as Sony's own 18-200mm optic. Naturally, Tamron uses its own proprietary image stabilizer called VC (for Vibration Compensation) and stepping motor autofocus mechanism that's fast and quiet.

Because the a5000's "flange to sensor" distance is relatively short, there's room to use various types of adapters between camera and lens and still allow focusing all the way to infinity. There are already a huge number of adapters that allow mounting just about any lens you can think of on the

a5000, if you're willing to accept manual focus and, usually, a ring on the adapter that's used to stop down the "adopted" lens to the aperture used to take the photo. You can find these from Novoflex (www.novoflex.com), Metabones (www.metabones.com), Fotodiox (www.fotodiox.com), Rainbow Imaging (www.rainbowimaging.biz), Cowboy Studio (www.cowboystudio.com), and others.

Some adapters of certain types and brands sell for as little as $20–$30. Don't expect autofocus even if you're using an AF lens from some other system; as well, many of the camera's high-tech features do not operate. However, you can usually retain automatic exposure by setting the a5000 to Aperture Priority, stopping down to the f/stop you prefer, and firing away. Figure 9.9 shows a Nikon-to-E-Mount adapter I bought from Fotodiox.

Figure 9.9 It's possible to mount lenses of entirely different brands on your a5000 with an adapter, but many camera functions are then disengaged.

The ultra-high grade Novoflex and Metabones adapters for using lenses of other brands sell for much higher prices. I found only two that are said to maintain autofocus with a lens of an entirely different brand. The Metabones Canon EF-to-Sony Smart Adapter (Mark III) and their similar Speed Booster model ($400 and $600, respectively) maintain autofocus, auto-exposure, and the Canon lens's image stabilizer feature when used with a camera. However, Metabones indicates that autofocus is "very slow and inadequate for most moving subjects." The "Speed Booster" part of the name comes from the adapter's ability to magically add one f/stop to the maximum aperture of the lens (thanks to the adapter's internal optics), transforming an f/4 lens into an f/2.8 speed demon.

My absolute favorite lens bargain is the 35mm f/1.7 Fujian (no relation to Fuji) optic, which I purchased brand new for a total of $38, with the E-mount adapter included in the price. It's actually a tiny CCTV (closed-circuit television) lens in C-mount (a type of lens mount used for cine cameras). It's manual focus and manual f/stop, of course (and it works in Aperture Priority mode); it's a toy lens, or something like a super cheap Lensbaby (described next), or a great experimental lens for fooling around. It covers the full APS-C frame (more or less; expect a bit of vignetting in the corners at some f/stops), is not incredibly sharp wide open, and exhibits a weird kind of "bokeh" (out-of-focus rendition of highlights) that produces fantasy-like images. The only drawback (or additional drawback, if you will) is that you may have to hunt some to find one; the manufacturer doesn't sell directly in the USA. I located mine on Amazon.com.

Once you own the C-mount to E-mount adapter, you can use any of the host of other similar CCTV lenses on your a5000. Also relatively cheap, but not necessarily of equal quality, are a 25mm f/1.4, 50mm f/1.4 (both in my collection and shown in Figure 9.10), as well as a Tamron 8mm f/1.4, and other lenses that I haven't tried and probably won't cover the APS-C image area, but are worth borrowing to try out if you have a friend who does CCTV.

Figure 9.10 These CCTV lenses make great "toys" for your a5000.

Using the Lensbaby

The current products from Lensbaby include several models, including the Composer Pro with Sweet 35 shown in Figure 9.11. Most of these use glass elements mounted on a system that allows you to bend, twist, and distort the lens's alignment to produce transmogrified images unlike anything else you've ever seen. Like the legendary cheap-o Diana and Holga cameras, the pictures are prized expressly because of their plastic image quality. It's interesting to note that Jack and Meg White of the White Stripes are, in fact, selling personalized Diana and Holga cameras on their website for wacky *lomography* (named after the Lomo, another low-quality/high-concept camera). The various Lensbaby models are for more serious photographers, if you can say that about anyone who yearns to take pictures that look like they were shot through a glob of corn syrup.

Lensbaby optics are capable of creating all sorts of special effects. You use a Lensbaby by shifting the front mount to move the lens's sweet spot (area that will be in focus) to a particular point in the scene. This is basically a selective focus lens that gets very soft outside the sweet spot. Most of the Lensbaby lenses are available in Sony

Figure 9.11 Lensbaby Composer Pro with Sweet 35.

E-mount; for the others, you can buy one of the inexpensive adapters discussed earlier. Do note however that there is no electronic communication between the camera and a Lensbaby even if it has the E-mount; follow the instructions to learn how to get good exposures if using one on your a5000.

The latest Lensbaby models, like the Composer Pro with Double Glass Optic, have the same shifting, tilting lens configuration as previous editions, but are designed for easier and more precise distorting movements. Hold the camera with your finger gripping the knobs as you bend the camera to move the central "sweet spot" (sharp area) to any portion of your image. With two (count 'em) multicoated optical glass lens elements, you'll get a blurry image, but the amount of distortion is under your control. F/stops from f/2 to f/22 are available to increase/decrease depth-of-field and allow you to adjust exposure. The lens focuses down to 12 inches and is strictly manual focus/manual exposure in operation. Most of the Lensbaby optics are not cheap, but there is really no other easy way to achieve the kind of effects you can achieve with one of their lenses.

Figure 9.12 is an example of the type of effect you can get, in a photograph crafted by Cleveland photographer Nancy Balluck. She also produced the back cover photography of yours truly, and one of her specialties is Lensbaby effects. Nancy regularly gives demonstrations and classes on the use of these optics, and you can follow her work at www.nancyballuckphotography.com.

Here's a quick look at the most popular Lensbaby models that were current as I wrote this; check out their website (www.lensbaby.com) for additional specifics.

- **Swivel Series, Composer Pro.** Three models are available. The Sweet 35 Optic ($380) shown in Figure 9.11, features a metal swivel ball and a fluid, dampened focus ring; the 12-bladed adjustable aperture allows for a smooth transition from the focused to the defocused area. A Lensbaby accessory makes it possible to use this one for macro photography. The Composer Pro with Edge 80 Optic ($500) lets you fluidly tilt the plane of focus to create miniature effects, unique portraits, and more. And the Composer Pro with Double Glass Optic ($280) offers exceptionally smooth focus and tilt/swivel ability. The Double Glass Optic creates dynamic blur at 50mm.

- **Squeeze Spark.** This is an inexpensive ($90) alternative that allows for selective focus. It's lightweight and made mostly of plastic, but the multi-coated optical element is made of glass; it features only an f/5.6 aperture for a sweet spot of focus surrounded by blur. This Lensbaby is made only in Canon and Nikon mount.

- **Scout.** This is the only Lensbaby that cannot bend. It's a Fisheye Optic ($250) that provides an ultra-wide (160 degree) angle of view from infinity down to a half inch from the lens. It also produces a unique flare effect with a glow of color around the edges; you'll either love or hate this effect. You can remove the fisheye optic and insert one of the other Lensbaby optics, such as Soft Focus, Pinhole/Zone Plate, Double Glass, Single Glass, and Plastic.

Figure 9.12 Everything is uniquely blurry outside the Lensbaby's "sweet spot," but with the versatile models, you can move that spot around within your frame at will. This capability can be used for unusual selective focus effects, and it can simulate the dreamy look of some old-style cameras.

You can also get various accessories from Lensbaby, such as Macro Converters, a Super Wide converter, a Soft Focus Aperture Kit, and a Creative Aperture Kit with various shaped cutouts that can be used in place of the regular aperture insert that controls depth-of-field. There's also an Optic Swap System kit with various adapters that include a pinhole lens, plastic lens, and single glass lens.

What Lenses Can Do for You

A sane approach to expanding your lens collection is to consider what each of your options can do for you and then choose the type of lens that will really boost your creative opportunities. Here's a general guide to the sort of capabilities you can gain by adding a lens (using an adapter, if necessary) to your repertoire.

- **Wider perspective.** A 16-50mm or 18-55mm lens can serve you well for moderate wide-angle shots. Now you find your back is up against a wall and you *can't* take a step backward to take in more subject matter. Perhaps you're standing on the bank of the Vltava River in Prague, and you want to take in as much of the breathtaking view as you can, as I did for the photo in Figure 9.13, made with the 16mm pancake lens and the VCL-ECF1 fisheye conversion lens. You might find yourself just behind the baseline at a high school basketball game and want an interesting shot with a little perspective distortion tossed in the mix. If you often want to make images with a super wide field of view, the Sony 10-18mm f/4 OSS zoom discussed earlier is in your future.

 If you own one of the A-mount to E-mount adapters, you could use the DT 11-18mm f/4.5-5.6 ultra-wide zoom or the 16mm f/2.8 Fisheye lens from the larger SLT camera system. If you own only the LA-EA1 adapter, you'll have only manual focus with these specific lenses. (Only SAM and SSM lenses will autofocus with this adapter.) Manual focus is fine with very short focal length lenses; they provide such prodigious depth-of-field that exact focus is not critical, except when shooting up close (less than six feet from your subject). Figure 9.15 shows the perspective you get from an ultra-wide-angle lens, like the 16mm f/2.8 used with the Sony VCL-ECU1 wide-angle conversion lens.

- **Bring objects closer.** A long focal length brings distant subjects closer to you, allows you to produce images with very shallow depth-of-field, and avoids the perspective distortion that wide-angle lenses provide. The longest focal length in an E-mount lens zooms to only 210mm, but even that can provide an obvious telephoto effect. If you own one of the Sony A-mount 70-200mm f/2.8 G-series telephoto zooms and an adapter, it's even easier to blur the background because the maximum remains f/2.8 (and not f/6.3) at long focal lengths. With the right adapter, you can also use a much longer super telephoto lens on your a5000. Figures 9.14 and 9.15 were taken from the same position as Figure 9.13, but with an 85mm and 500mm focal length prime lenses, respectively.

Figure 9.13
The 16mm f/2.8 lens with the VCL-ECU1 accessory provided this view of a castle in Prague.

Figure 9.14
This photo, taken from roughly the same distance, shows the view using a short telephoto lens.

Figure 9.15
A long (500mm) telephoto lens captured this view from approximately the same shooting position.

- **Bring your camera closer.** If you don't want to purchase the E-mount 30mm f/3.5 macro lens, Sony has three excellent A-mount macro lenses that would be fine for use with an adapter; you might own one of these or may be able to borrow one: the 30mm f/2.8, 50mm f/2.8, and the 100mm f/2.8 macro lens.

 The need to manually focus an A-mount macro lens when used with the cheaper LA-EA1 adapter is not a tremendous hardship. Most serious photographers use manual focus in extreme close-up photography for the most convenient method of controlling the exact subject element that will be in sharpest focus. (The A-mount 30mm f/2.8 macro does autofocus with the adapter, but AF is so slow, I'll use manual focus anyway.) As hinted earlier in this chapter, the A-mount 100mm f/2.8 macro lens ($800) is preferable to the shorter macro lenses in nature photography because you do not need to move extremely close to a skittish subject for high magnification. And you can get a frame filling photo of a tiny blossom without trampling all the other plants in its vicinity.

- **Look sharp.** Many lenses, particularly the higher-priced Sony optics, are prized for their sharpness and overall image quality. Your run-of-the-mill lens is likely to be plenty sharp for most applications at the optimum aperture (usually f/8 or f/11), but the very best optics are definitely superior. You can expect to get excellent sharpness in much of the image area at the maximum aperture, high sharpness even in the corners by one stop down, more consistent sharpness at various focal lengths with a zoom, and better correction for various types of distortions (discussed shortly). That, along with a constant f/2.8 maximum aperture, is why I consider the Carl Zeiss Vario-Tessar T* 16-70mm f/4 OSS lens a good value although it sells for $1,000.

- **More speed.** Your basic lens might have the perfect focal length and sharpness for sports photography, but the maximum aperture may be small at telephoto focal lengths, such as f/5.6 or f/6.3 at the far end. That won't cut it for night baseball or football games, since you'll need to use an extremely high ISO (where image quality suffers) to be able to shoot at a fast shutter speed to freeze the action. Even outdoor sports shooting on overcast days can call for a high ISO if you're using a slow zoom lens (with small maximum apertures).

 That makes the E-mount lenses with a very wide aperture (small f/number) such as the 24mm f/1.8 optic a prime choice (so to speak) for low light photography when you can get close to the action; that's often possible at an amateur basketball or volleyball game. But, you might be happier with an adapter and an A-mount lens, such as the Carl Zeiss Sonnar T* 135mm f/1.8 lens (if money is no object; it costs $1,400). But there are lower cost fast lens options, such as the 50mm f/1.4 lens ($350), which might be suitable for indoor sports in a gym and whenever you must shoot in dark locations, in a castle or cathedral or theater, for example.

Categories of Lenses

Lenses can be categorized by their intended purpose—general photography, macro photography, and so forth—or by their focal length. The range of available focal lengths is usually divided into three main groups: wide-angle, normal, and telephoto. Prime lenses fall neatly into one of these classifications. Zooms can overlap designations, with a significant number falling into the catchall wide-to-telephoto zoom range. This section provides more information about focal length ranges, and how they are used.

Any lens with an equivalent focal length of 10mm to 20mm is said to be an *ultra-wide-angle lens*; from about 20mm to 40mm (equivalent) is said to be a *wide-angle lens*. *Normal lenses* have a focal length roughly equivalent to the diagonal of the film or sensor, in millimeters, and so fall into the range of about 45mm to 60mm on a full-frame camera; with your a5000, a 30mm or 35mm lens is considered *normal*. *Telephoto lenses* usually fall into the 75mm and longer focal lengths, while those with a focal length much beyond 300mm are referred to as *super telephotos*.

Using Wide-Angle Lenses

To use wide-angle prime lenses and wide zooms, you need to understand how they affect your photography. Here's a quick summary of the things you need to know.

- **More depth-of-field (apparently).** Practically speaking, wide-angle lenses seem to produce more extensive depth-of-field at a particular subject distance and aperture. However, the range of acceptable sharpness actually depends on magnification: the size of the subject in the frame. With a wide-angle lens, you usually include a full scene in an image; any single subject is not magnified very much, so the depth-of-field will be quite extensive. When using a telephoto lens however, you tend to fill the frame with a single subject (using high magnification), so the background is more likely to be blurred. (I'll discuss this in more detail in the sidebar below.)

 You'll find a wide-angle lens helpful when you want to maximize the range of acceptable sharpness in a landscape for example. On the other hand, it's very difficult to isolate your subject (against a blurred background) using selective focus unless you move extremely close. Telephoto lenses are better for this purpose and as a bonus, they also include fewer extraneous elements of the scene because of their narrower field of view.

- **Stepping back.** Wide-angle lenses have the effect of making it seem that you are standing farther from your subject than you really are. They're helpful when you don't want to back up—or can't because of impediments—to include an entire group of people in your photo, for example.

- **Wider field of view.** While making your subject seem farther away, as implied above, a wide-angle lens also provides a more expansive field of view, including more of the scene in your photos.

- **More foreground.** As background objects appear further back than they do to the naked eye, more of the foreground is brought into view by a wide-angle lens. That gives you extra emphasis on the area that's closest to the camera. Photograph your home with a 30mm focal length for example, and the front yard probably looks fairly conventional in your photo (that's why 30mm or 35mm is called a "normal" lens with a camera like your a5000). Switch to a wider lens such as the 16mm, or especially the 10mm end of the 10-18mm zoom, and you'll discover that your lawn now makes up much more of the photo. So, wide-angle lenses are great when you want to emphasize that lake in the foreground, but problematic when your intended subject is located farther in the distance.

- **Super-sized subjects.** The tendency of a wide-angle lens to emphasize objects in the foreground while de-emphasizing objects in the background can lead to a kind of size distortion that may be more objectionable for some types of subjects than others. Shoot a bed of flowers up close with a 16mm or shorter focal length, and you might like the distorted effect of the nearby blossoms looming in the photo. Take a shot of a family member with the same lens from the same distance, and you're likely to get some complaints about that gigantic nose in the foreground.

- **Perspective distortion.** This type of distortion occurs when you tilt the camera so the plane of the sensor is no longer perpendicular to the vertical plane of your subject. As a result, some parts of the subject are now closer to the sensor than they were before, while other parts are farther away. This is what makes buildings, flagpoles, or NBA players appear to be leaning over backwards (building shown in Figure 9.16). While this kind of apparent distortion is actually caused by tilting the camera/lens upward (not by a defect in the lens), it can happen with any lens, but it's most apparent when a wide angle is used.

- **Steady cam.** You'll find that it is easier to get photos without blur from camera shake when you hand-hold a wide-angle lens at slower shutter speeds than it is with a telephoto lens. And if your lens is equipped with the OSS stabilizer, you can take sharp photos at surprisingly long shutter speeds at a long focal length without using a tripod. That's because the reduced magnification of the wide-angle lens or wide-zoom setting doesn't emphasize camera shake like a telephoto lens does.

- **Interesting angles.** Many of the factors already listed combine to produce more interesting angles when shooting with wide-angle lenses. Raising or lowering a telephoto lens a few feet probably will have little effect on the appearance of a distant subject that fills the frame. The same change in elevation can produce a dramatic effect if you're using a short focal length and are close to your subject.

Figure 9.16
Tilting the camera produces this "falling back" look in architectural photos.

> **DOF IN DEPTH**
>
> The depth-of-field advantage of wide-angle lenses disappears when you enlarge your picture. Believe it or not, a wide-angle image enlarged and cropped to provide the same subject size as a telephoto shot will have the same depth-of-field. Try it: take a wide-angle photo of a friend from a fair distance. Then, use a longer (telephoto) zoom setting from the same shooting position to take the same picture; naturally, your friend will appear to be larger in the second because of the greater telephoto magnification.
>
> Download the two photos to your computer. While viewing the wide-angle shot, magnify it with the zoom or magnify tool so your friend is as large as in the telephoto image. You'll find that the wide-angle photo will have the same depth-of-field as the telephoto image; for example, the background will be equally blurred.

Avoiding Potential Wide-Angle Problems

Wide-angle lenses have a few quirks that you'll want to keep in mind when shooting so you can avoid falling into some common traps. Here's a checklist of tips for avoiding common problems:

- **Symptom: converging lines.** Unless you want to use wildly diverging lines as a creative effect, it's a good idea to keep horizontal and vertical lines in landscapes, architecture, and other subjects carefully aligned with the sides, top, and bottom of the frame. To prevent undesired perspective distortion, you must take care not to tilt the camera. If your subject is very tall, like a building, you may need to shoot from an elevated position (like a high level in a parking garage) so you won't need to tilt the lens upward. And if your subject is short, like a small child, get down to a lower level so you can get the shot without tilting the lens downward.

- **Symptom: color fringes around objects.** Lenses often produce photos that are plagued with fringes of color around backlit objects, produced by *chromatic aberration*. This common lens flaw comes in two forms: *longitudinal/axial*, in which all the colors of light don't focus in the same plane, and *lateral/transverse*, in which the colors are shifted to one side. Axial chromatic aberration can be reduced by stopping down the lens (to f/8 or f/11, for example), but transverse chromatic aberration cannot.

 Better quality lenses reduce both types of imaging defect; it's common for reviews to point out these failings, so you can choose the best performing lenses that your budget allows. The Lens Comp.: Chro. Aber. Feature in the Custom Settings 4 menu, described in Chapter 3, can help reduce this problem. Leave it set for Auto to get the chromatic aberration reduction processing that the a5000 can provide.

- **Symptom: lines that bow outward.** Some wide-angle lenses cause straight lines to bow outward, an effect called barrel distortion; you'll see the strongest effect at the edges. Most fisheye (or *curvilinear*) lenses produce this effect as a feature of the lens; it's much more obvious than with any other type of lens. (See Figure 9.17.) The mild barrel distortion you get with a conventional lens is rarely obvious except in some types of architectural photography. If you find it objectionable, you'll need to use a well-corrected lens.

Manufacturers like Sony do their best to minimize or eliminate it (producing a *rectilinear* lens), often using *aspherical* lens elements (which are not cross-sections of a sphere). You can also minimize barrel distortion simply by framing your photo with some extra space all around, so the edges where the bowing outward is most obvious can be cropped out of the picture. The Lens Comp.: Distortion feature, also described in Chapter 3, can help reduce this problem. Leave it set to Auto to allow the processor to minimize the slight barrel distortion that can occur with the more affordable lenses.

Figure 9.17 Many wide-angle lenses cause lines to bow outward toward the edges of the image. That's often not noticeable unless you use a fisheye lens; the effect is considered to be interesting and desirable.

- **Symptom: light and dark areas when using polarizing filter.** You should be aware that polarizers work best when the camera is pointed 90 degrees away from the sun and have the least effect when the camera is oriented 180 degrees from the sun. This is only half the story, however. With lenses having a focal length of 10mm to 18mm (16mm to 28mm equivalents), the angle of view (107 to 75 degrees diagonally, or 97 to 44 degrees horizontally) is extensive enough to cause problems.

 Think about it: if you use the 10mm end of the 10-18mm zoom, and point it at a part of a scene that's at a proper 90-degree angle from the sun, the areas of the scene that are at the edges of the frame will be oriented at 135 to 41 degrees from the sun. Only the center of the image area will be at exactly 90 degrees. When the filter is used to darken a blue sky, the sky will be very dark near the center of your photo. Naturally, the polarizing effect will be much milder at the edges so the sky in those areas will be much lighter in tone (less polarized). The solution is to avoid using a polarizing filter in situations where you'll be including the sky with lenses that have an actual focal length of less than 18mm (or 28mm equivalent).

Using Telephoto and Tele-Zoom Lenses

Telephoto lenses also can have a dramatic effect on your photography, but for now, the longest available focal length in E-mount is 210mm. Of course, A-mount lenses can be used with an adapter on your a5000 and Sony offers many telephotos to enhance your photography in several different ways. Here are the most important things you need to know. In the next section, I'll concentrate on telephoto considerations that can be problematic—and how to avoid those problems.

- **Selective focus.** Long lenses have reduced depth-of-field, a shallow range of acceptably sharp focus, especially at wide apertures (small f/numbers); this is useful for selective focus to isolate your subject. You can set the widest aperture to create shallow depth-of-field (as in Figure 9.18), or close it down (to a small f/number) to allow more of the scene to appear to be in acceptably sharp focus. The flip side of the coin is that even at f/16, a 300mm and longer lens will not provide much depth-of-field, especially when the subject is large in the frame (magnified). Like fire, the depth-of-field aspects of a telephoto lens can be friend or foe.

- **Getting closer.** Telephoto lenses allow you to fill the frame with wildlife, sports action, and candid subjects. No one wants to get a reputation as a surreptitious or "sneaky" photographer (except for paparazzi), but when applied to candids in an open and honest way, a long lens can help you capture memorable moments while retaining enough distance to stay out of the way of events as they transpire.

- **Reduced foreground/increased compression.** Telephoto lenses have the opposite effect of wide angles: they reduce the importance of things in the foreground by squeezing everything together. This so-called *compressed perspective* makes objects in the scene appear to be closer

than they are to the naked eye. You can use this effect as a creative tool. You've seen the effect hundreds of times in movies and on television, where the protagonist is shown running in and out of traffic that appears to be much closer to the hero (or heroine) than it really is.

- **Accentuates camera shakiness.** Telephoto focal lengths hit you with a double whammy in terms of camera/photographer shake. The lenses themselves are bulkier, more difficult to hold steady, and may even produce a barely perceptible seesaw rocking effect when you support them with one hand halfway down the lens barrel. As they magnify the subject, they amplify the effect of any camera shake. It's no wonder that image stabilization like Optical SteadyShot (OSS) is especially popular among those using longer lenses, and why Sony includes this feature in the 18-200mm zooms (and many of the long A-mount lenses).

- **Interesting angles require creativity.** Telephoto lenses require more imagination in selecting interesting angles, because the "angle" you do get on your subjects is so narrow. Moving from side to side or a bit higher or lower can make a dramatic difference in a wide-angle shot, but raising or lowering a telephoto lens a few feet probably will have little effect on the appearance of the distant subjects you're shooting.

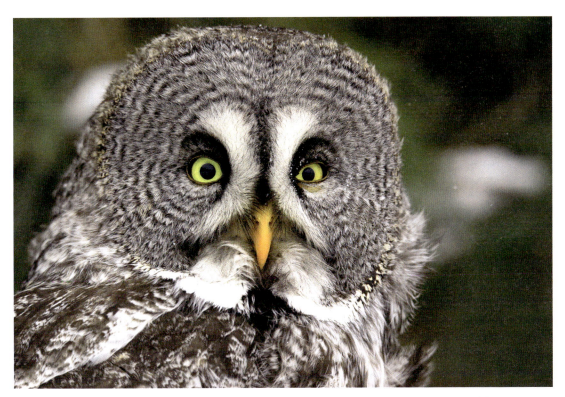

Figure 9.18 A 300mm focal length and a wide aperture (small f/number) helped isolate this owl from its background.

Avoiding Telephoto Lens Problems

Many of the "problems" that telephoto lenses pose are really just challenges and not that difficult to overcome. Here is a list of the seven most common picture maladies and suggested solutions.

- **Symptom: flat faces in portraits.** Head-and-shoulders portraits of humans tend to be more flattering when a focal length of 50mm to 85mm is used with a full-frame camera. With your a5000, a 30mm to 55mm focal length provides the same effect. Longer focal lengths compress the distance between features like the nose and ears, making the face look wider and flat. (Conversely, a wide-angle lens will make the nose look huge and ears tiny if you move close enough for a head-and-shoulders portrait.) So avoid using a focal length much longer than about 60mm with your a5000 unless you're forced to shoot from a greater distance. (Use a wide-angle lens only when shooting three-quarters/full-length portraits, or group shots.)

- **Symptom: blur due to camera shake.** Because a long focal length amplifies the effects of camera shake, make sure the OSS stabilizer is not turned off (with a menu item). Then, if possible, use a faster shutter speed; that may mean that you'll need to set a higher ISO to be able to do so. Of course, a firm support like a solid tripod is the most effective tool for eliminating camera shake, especially if you trip the shutter with a remote commander accessory or the self-timer to avoid the risk of jarring the a5000. Of course, only the fast shutter speed option will be useful to prevent blur caused by *subject* motion; SteadyShot or a tripod won't help you freeze a race car in mid-lap.

- **Symptom: color fringes.** Chromatic aberration is the most pernicious optical problem found in telephoto lenses. There are others, including spherical aberration, astigmatism, coma, curvature of field, and similarly scary-sounding phenomena. The best solution for any of these is to use a better lens that offers the proper degree of correction for aberrations, or stop down the lens (to f/8 or f/11) to minimize the problem. But that's not always possible. Your second-best choice may be to correct the fringing in your favorite RAW conversion tool or image editor. Photoshop's Lens Correction filter offers sliders that minimize both red/cyan and blue/yellow fringing. A feature such as this (also available with some other software) can be useful in situations where the a5000's Lens Comp.: Chro. Aber. feature doesn't fully correct for chromatic aberration.

- **Symptom: lines that curve inward.** Pincushion distortion is common in photos taken with many telephoto lenses; lines, especially those near the edges of the frame, bow inward like the pincushion your grandma might have used. You can take photos of a brick wall at various focal lengths with your zoom lens to find out where the pincushion distortion is the most obvious; that will probably be at or near the longest focal length. Like chromatic aberration, it can be partially corrected using tools like Photoshop's Lens Correction filter (or a similar utility in some other software).

- **Symptom: low contrast from haze or fog.** When you're photographing distant objects, a long lens shoots through a lot more atmosphere, which generally is muddied up with extra haze and fog. The dust or moisture droplets in the atmosphere can reduce contrast and mute colors.

- **Symptom: low contrast from flare.** Lenses are often furnished with lens hoods for a good reason: to minimize the amount of stray light that will strike the front element causing flare or ghost image of the diaphragm containing the aperture. A hood is effective when the light is at your side, but it has no value when you're shooting toward the sun. On the other hand, you'll often be shooting with the light striking the lens from an angle. In this situation, the lens hood is only partially effective, so minimize flare by using your hand or cap to cast a shadow over the front element of the lens. (Just be careful not to let your hand or cap intrude into the image area.)

- **Symptom: dark flash photos.** Edge-to-edge flash coverage isn't as problematic with telephoto lenses as it is with wide angles. (The built-in flash simply cannot provide light that covers the entire field of view that's recorded by a lens shorter than 16mm.) The shooting distance is the problem with longer lenses. A 210mm focal length might allow you to make a distant subject appear close to the camera, but the flash isn't fooled. You'll need extra power for distant flash shots, making a large accessory flash unit a valuable accessory.

Some feel that a skylight or UV filter can help, but this practice is mostly a holdover from the film days. Digital sensors are not sensitive enough to UV light for a UV filter to have much effect. A polarizer might help a bit, but only in certain circumstances. I don't consider this to be a huge problem because it's easy to boost contrast and color saturation in Picture Styles (a menu item) or later in image-editing software.

If you do not have a powerful flash unit and cannot get closer to the subject (like Lady Gaga strutting her stuff on a dark stage), try setting the camera's ISO level to 3200. This increases the sensitivity of the sensor so less light is required to make a bright photo; of course, the photo is likely to be grainy because of digital noise. If that does not solve the problem, you will need to set an even higher ISO, but then you'll get even more obvious digital noise in your photo.

Telephotos and Bokeh

The term *bokeh* describes the aesthetic qualities of the out-of-focus parts of an image and whether out-of-focus points of light (circles of confusion) are rendered as distracting fuzzy discs or smoothly fade into the background. *Boke* is a Japanese word for "blur," and the h was added to keep English speakers from rendering it monosyllabically to rhyme with *broke*. Although bokeh is visible in blurry portions of any image, it's of particular concern with telephoto lenses. That's because the magic of shallow depth-of-field produces more obviously defocused areas in photos made at long focal lengths.

Bokeh can vary from lens to lens, or even within a given lens depending on the aperture (f/stop) that you use. Bokeh becomes objectionable when the circles of confusion are evenly illuminated, making them stand out as distinct discs, or, worse, when these circles are darker in the center, producing an ugly "doughnut" effect. A lens defect called spherical aberration may produce out-of-focus discs that are brighter on the edges and darker in the center. You get this effect because the lens doesn't focus light passing through the edges of the lens exactly as it does light going through the center. (Mirror or *catadioptric* lenses also produce this effect.)

Figure 9.19 Bokeh is less pleasing when the discs are prominent (left), and less obtrusive when they blend into the background (right).

Other kinds of spherical aberration generate circles of confusion that are brightest in the center and fade out at the edges, producing a smooth blending effect, as you can see at right in Figure 9.19. Ironically, when no spherical aberration is present at all, the discs are a uniform shade; this is better than the doughnut effect, but it's not as pleasing as the bright center/dark edge rendition. The shape of the disc also comes into play, with round smooth circles considered the best, and nonagonal or some other polygon (determined by the shape of the lens diaphragm) considered less desirable. Most Sony lenses have near-circular irises, producing very pleasing bokeh at many apertures.

If you plan to use selective focus a lot, you should investigate the bokeh characteristics of a particular lens before you buy. Sony user groups and forums will usually be full of comments and questions about bokeh, so the research is fairly easy.

Fine-Tuning the Focus of Your Lenses

In Chapter 3, I introduced you to the a5000's AF Micro Adjustment feature in the Custom Settings 4 menu, which can be manipulated *only* when you're using a Sony or a Minolta Maxxum/Dynax A-mount lens with the LA-EA2 adapter and the newer LA-EA4 accessory. It is not available when using the LA-EA1 or LA-EA3 adapters. (The micro adjustment may work with an A-mount lens of another brand, but Sony warns that the results may be inaccurate.) Millions of A-mount lenses have been sold over the years, and the adapter is not terribly expensive, so I will assume that many readers will eventually want to consider the fine-tuning feature.

If you do not currently have such lenses or the adapter, you cannot use AF Micro Adjustment (you can turn the feature on or off, but you cannot enter any adjustment factor). But if you do own the relevant equipment, you might find that a particular lens is not focusing properly. If the lens happens to focus a bit ahead or a bit behind the desired area (like the eyes in a portrait), and if it does that consistently, you can use the adjustment feature.

Why is the focus "off" for some lenses in the first place? There are lots of factors, including the age of the lens (an older lens may focus slightly differently), temperature effects on certain types of glass, humidity, and tolerances built into a lens's design that all add up to a slight misadjustment, even though the components themselves are, strictly speaking, within specs. A very slight variation in your lens's mount can cause focus to vary slightly. With any luck (if you can call it that) a lens that doesn't focus exactly right will at least be consistent. If a lens always focuses a bit behind the subject, the symptom is *back focus*. If it focuses in front of the subject, it's called *front focus*.

You're almost always better off sending such a lens in to Sony to have them make it right. But that's not always possible. Perhaps you need your lens recalibrated right now, or you purchased a used lens that is long out of warranty. If you want to do it yourself, the first thing to do is determine whether or not your lens has a back focus or front focus problem.

For a quick-and-dirty diagnosis (*not* a calibration; you'll use a different target for that), lay down a piece of graph paper on a flat surface, and place an object on the line at the middle, which will represent the point of focus (we hope). Then, shoot the target at an angle using your lens's widest aperture (smallest available f/number) and the autofocus mode you want to test. Mount the camera on a tripod so you can get accurate, repeatable results.

If your camera/lens combination doesn't suffer from front or back focus, the point of sharpest focus will be the center line of the chart, as you can see in Figure 9.20. If you do have a problem, one of the other lines will be sharply focused instead. Should you discover that your lens consistently front focuses or back focuses, it needs to be recalibrated. Unfortunately, it's only possible to calibrate a lens for a single focusing distance. So, if you use a particular lens (such as a macro lens) for close-focusing, calibrate for that. If you use a lens primarily for middle distances, calibrate for that. Close-to-middle distances are most likely to cause focus problems, anyway, because as you get closer to infinity, small changes in focus are less likely to have an effect.

Lens Tune-Up

The AF Micro Adj setting in the Setup menu is the key tool you can use to fine-tune your A-mount lens used with the adapter. Of course, this assumes you are using an A-mount lens and the adapter. You'll find the process easier to understand if you first run through this quick overview of the menu options:

- **AF Adjustment Setting. On:** This option enables AF fine-tuning for all the lenses you've registered using this menu entry. If you discover you don't care for the calibrations you make in certain situations (say, it works better for the lens you have mounted at middle distances, but is less successful at correcting close-up focus errors), you can deactivate the feature as you require. You should set this to On when you're doing the actual fine-tuning. Adjustment values range from –20 to +20. **Off:** Disables autofocus micro adjustment.

Figure 9.20 Correct focus (top), front focus (middle), and back focus (bottom).

- **Amount.** You can specify values of plus or minus 20 for each of the lenses you've registered. When you mount a registered lens, the degree of adjustment is shown here. If the lens has not been registered, then +/-0 is shown. If "–" is displayed, you've already registered the maximum number of lenses—up to 30 different lenses can be registered with each camera.
- **Clear.** Erases *all* user-entered adjustment values for the lenses you've registered. When you select the entry, a message will appear. Select OK and then press the center button of the control wheel to confirm.

Evaluate Current Focus

The first step is to capture a baseline image that represents how the lens you want to fine-tune autofocuses at a particular distance. You'll often see advice for photographing a test chart with millimeter markings from an angle, and the suggestion that you autofocus on a particular point on the chart. Supposedly, the markings that actually *are* in focus will help you recalibrate your lens. The problem with this approach is that the information you get from photographing a test chart at an angle doesn't actually tell you what to do to make a precise correction. So, your lens back focuses three millimeters behind the target area on the chart. So what? Does that mean you change the Saved Value by –3 clicks? Or –15 clicks? Angled targets are a "shortcut" that don't save you time.

Instead, you'll want to photograph a target that represents what you're actually trying to achieve: a plane of focus locked in by your lens that represents the actual plane of focus of your subject. For that, you'll need a flat target, mounted precisely perpendicular to the sensor plane of the camera. Then, you can take a photo, see if the plane of focus is correct, and if not, dial in a bit of fine-tuning in the AF Fine Tuning menu, and shoot again. Lather, rinse, and repeat until the target is sharply focused.

You can use the focus target shown in Figure 9.21, or you can use a chart of your own, as long as it has contrasty areas that will be easily seen by the autofocus system, and without very small details that are likely to confuse the AF. Download your own copy of my chart from www.dslrguides.com/FocusChart.pdf. (The URL is case sensitive.) Then print out a copy on the largest paper your printer can handle. (I don't recommend just displaying the file on your monitor and focusing on that; it's unlikely you'll have the monitor screen lined up perfectly perpendicular to the camera sensor.) Then, follow these steps:

1. **Position the camera.** Place your camera on a sturdy tripod with a remote release attached, positioned at roughly eye-level at a distance from a wall that represents the distance you want to test for. Keep in mind that autofocus problems can be different at varying distances and lens focal lengths, and that you can enter only *one* correction value for a particular lens. So, choose a distance (close-up or mid range) and zoom setting with your shooting habits in mind.
2. **Set the autofocus mode.** Choose the autofocus mode you want to test.

Figure 9.21 Use this focus test chart, or create one of your own.

3. **Level the camera (in an ideal world).** If the wall happens to be perfectly perpendicular, you can use a bubble level, plumb bob, or other device of your choice to ensure that the camera is level to match. Many tripods and tripod heads have bubble levels built in. Avoid using the center column, if you can. When the camera is properly oriented, lock the legs and tripod head tightly.

4. **Level the camera (in the real world).** If your wall is not perfectly perpendicular, use this old trick. Tape a mirror to the wall, and then adjust the camera on the tripod so that when you look through the viewfinder at the mirror, you see directly into the reflection of the lens. Then, lock the tripod and remove the mirror.

5. **Mount the test chart.** Tape the test chart on the wall so it is centered in your camera's viewfinder.

6. **Photograph the test chart using AF.** Allow the camera to autofocus, and take a test photo using the remote release to avoid shaking or moving the camera.

7. **Make an adjustment and rephotograph.** Navigate to the Custom Settings 4 menu and choose AF Micro Adj. Make sure the feature has been turned on, then press down to Amount and make a fine-tuning adjustment, plus or minus, and photograph the target again.

8. **Lather, rinse, repeat.** Repeat steps 6 and 7 several times to create several different adjustments to check.

9. **Evaluate the image(s).** If you have the camera connected to your computer with a USB cable or through a Wi-Fi connection, so much the better. An Eye-Fi card is very handy for this, as it can be set to upload each image as taken automatically, with no intervention from you. You can view the image(s) after transfer to your computer. Otherwise, *carefully* open the camera card door and slip the memory card out and copy the images to your computer.

10. **Evaluate focus.** Which image is sharpest? That's the setting you need to use for this lens. If your initial range doesn't provide the correction you need, repeat the steps between –20 and +20 until you find the best fine-tuning. Once you've made an adjustment, the –7 will automatically apply the AF fine-tuning each time that lens is mounted on the camera, as long as the function is turned on.

MAXED OUT

If you've reached the maximum number of lenses (which is unlikely—who owns 30 lenses?), mount a lens you no longer want to compensate for, and reset its adjustment value to +/-0. Or you can reset the values of all your lenses using the Clear function and start over.

SteadyShot and Your Lenses

Many of the Sony lenses are equipped with the Optical SteadyShot (OSS) stabilizer that provides camera steadiness that's the equivalent of at least two or three shutter speed increments. In other words, if you can get a sharp photo with a 55mm focal length using a shutter speed of 1/50th second when hand-holding it, you should be able to get an equally blur-free photo at about 1/13th second, or perhaps 1/10th second when OSS is active. (See the examples shown in Figure 9.22.) This extra margin can be invaluable when you're shooting under dim lighting conditions or hand-holding a long lens. While visiting Prague, I found that I was often shooting inside beautiful old buildings where flash or a tripod were impractical or prohibited. The OSS stabilizer was often very useful. I'm sure you can think of similar situations where you'll appreciate this feature.

However, keep these facts in mind:

- **Optical SteadyShot doesn't stop action.** Unfortunately, no stabilization is a panacea to replace the action-stopping capabilities of a faster shutter speed. If you need to use 1/1,000th second to freeze a high jumper in mid-air, the OSS won't achieve the desired effect at a longer shutter speed. The only benefit is compensation for camera shake to reduce the risk of blurry photos. SteadyShot works great in certain situations: when you're shooting in low light, when using long lenses, and for macro photography where the high magnification really amplifies the blurring effect of any camera movement.

- **Stabilization might slow you down.** The process of adjusting the sensor to counter camera shake takes time, just as autofocus does, so you might find that SteadyShot adds to the lag between when you press the shutter and when the picture is actually taken. In a situation where you want to capture a fleeting instant that can happen suddenly, image stabilization might not be a good choice.

- **Use when appropriate.** Sometimes, stabilization produces worse results if used while you're panning. You might want to switch off IS when panning the camera with a moving subject while using a long shutter speed. In this situation, you might appreciate compensation for up/down camera shake, but OSS may also consider your horizontal movement of the camera as a type of shake and produce an unsatisfactory compensation. Be sure to turn it off when your a5000 is mounted on a tripod; leaving OSS on can cause the stabilizer to produce shake when it finds none to correct.

- **Give SteadyShot a helping hand.** When you simply do not want to carry a tripod all day and you'll be relying on the OSS system, brace the camera or your elbows on something solid, like the roof of a car or a piece of furniture. Remember that an inexpensive monopod can be quite compact when not extended; many camera bags include straps that allow you to attach this accessory. Use a monopod with a lens equipped with OSS for extra camera-shake-compensation. Brace the accessory against a rock, a bridge abutment, or a fence and you might be able to get blur-free photos at surprisingly long shutter speeds. When you're heading out into the field to photograph wild animals or flowers and think a tripod isn't practical, at least consider packing a monopod.

Figure 9.22
When hand-holding a lens at a 55mm focal length (top) I was unable to get a blur-free photo at 1/13th sec. Activating the OSS provided a photo that's sharp (bottom) except for slight blurring of the moving lady behind the bananas.

10

Making Light Work for You

Successful photographers and artists have an intimate understanding of the importance of light in shaping an image. Rembrandt was a master of using light to create moods and reveal the character of his subjects. The late artist Thomas Kinkade's official tagline was "Painter of Light." Dean Collins, co-founder of Finelight Studios, revolutionized how a whole generation of photographers learned and used lighting. It's impossible to underestimate how the use of light adds to—and how misuse can detract from—your photographs.

All forms of visual art use light to shape the finished product. Sculptors don't have control over the light used to illuminate their finished work, so they must create shapes using planes and curved surfaces so that the form envisioned by the artist comes to life from a variety of viewing and lighting angles. Painters, in contrast, have absolute control over both shape and light in their work, as well as the viewing angle, so they can use both the contours of their two-dimensional subjects and the qualities of the "light" they use to illuminate those subjects to evoke the image they want to produce.

Photography is a third form of art. The photographer may have little or no control over the subject (other than posing human subjects) but can often adjust both viewing angle *and* the nature of the light source to create a particular compelling image. The direction and intensity of the light sources create the shapes and textures that we see. The distribution and proportions determine the contrast and tonal values: whether the image is stark or high key, or muted and low in contrast. The colors of the light (because even "white" light has a color balance that the sensor can detect), and how much of those colors the subject reflects or absorbs, paint the hues visible in the image.

As a Sony photographer, you must learn to be a painter and sculptor of light if you want to move from *taking* a picture to *making* a photograph. This chapter provides an introduction to using the two main types of illumination: *continuous* lighting (such as daylight, incandescent, or fluorescent sources) and the brief, but brilliant snippets of light we call *electronic flash*.

Continuous Illumination versus Electronic Flash

Continuous lighting is exactly what you might think: uninterrupted illumination that is available all the time during a shooting session. Daylight, moonlight, and the artificial lighting encountered both indoors and outdoors count as continuous light sources (although all of them can be "interrupted" by passing clouds, solar eclipses, a blown fuse, or simply by switching off a lamp). Indoor continuous illumination includes both the lights that are there already (such as incandescent lamps or overhead fluorescent lights indoors) and fixtures you supply yourself, including photoflood lamps or reflectors used to bounce existing light onto your subject.

The surge of light we call electronic flash is produced by a burst of photons generated by an electrical charge that is accumulated in a component called a *capacitor* and then directed through a glass tube containing xenon gas, which absorbs the energy and emits the brief flash. Electronic flash is notable because it can be much more intense than continuous lighting, lasts only a brief moment, and can be much more portable than supplementary incandescent sources. It's a light source you can carry with you and use anywhere.

Indeed, your Sony a5000 comes with a built-in flash unit, shown elevated in Figure 10.1. Like all small flash tubes, this one is seriously underpowered. If you're using the kit lens set to f/3.5, with an ISO 100 setting, the maximum flash range is about 3.7 feet. Effectively, that means you'll need to use ISO settings much higher than ISO 100 to use the flash. At ISO 1600, for example, the flash range extends to a more reasonable 14.5 feet. When you boost the ISO, the range increases because of greater sensor sensitivity.

Figure 10.1
One form of light that's always available is the built-in flash on your a5000.

Since we do not usually want to shoot at very high ISO where digital noise can degrade image quality, the built-in flash is not ideal for all purposes. It's best reserved for fill-in flash to illuminate inky shadows in outdoor photography (where less power is required to achieve that effect), or for close-up photography in low light.

Before moving on to discussing flash in detail, let's review the advantages and disadvantages of each type of illumination. Here's a quick checklist of pros and cons:

- **Lighting preview—Pro: continuous lighting.** With continuous lighting, such as incandescent lamps or daylight (see Figure 10.2), you always know exactly what kind of lighting effect you're going to get. If you're using multiple lights, you can visualize how they will interact with each other. With electronic flash, the general effect you're going to see may be a mystery until you've built some experience.

- **Lighting preview—Con: electronic flash.** The built-in flash does not provide a "modeling light" function found in external flash units (which are not compatible with the a5000 in any case).

- **Exposure calculation—Pro: continuous lighting.** Your a5000 has no problem calculating exposure for continuous lighting, because the lighting remains constant and can be measured through a sensor that interprets the light reaching the sensor. The amount of light available just before the exposure will, in almost all cases, be the same amount of light present when the shutter mechanism is opened to take the shot. The Spot metering mode can be used to measure brightness in the bright areas of the scene and the dark areas; if you have a bit of expertise in this technique, you'll know whether it would be useful to bounce some light into the shadow areas using a reflector panel accessory. You can also buy a hand-held light meter to measure the light falling onto the subject, instead of the light reflected by the subject.

- **Exposure calculation—Con: electronic flash.** A flash unit provides no illumination until it actually fires so the exact exposure can't be measured by the a5000's exposure sensor before you take a photo. Instead, the light must be measured by metering the intensity of a pre-flash triggered an instant before the main flash, as it is reflected back to the camera and through the lens.

- **Evenness of illumination—Pro/con: continuous lighting.** Of continuous light sources, daylight, in particular, provides illumination that tends to fill an image completely, lighting up the foreground, background, and your subject almost equally. A sunlit scene may have shadow areas too, of course, so you might need to use reflectors or fill-in light sources to even out the illumination. Barring objects that block large sections of your image from daylight, the light is spread fairly evenly. Indoors, however, continuous lighting is much less likely to be evenly distributed. The average living room, for example, has hot spots and dark corners. But on the plus side, you can *see* this uneven illumination and compensate with additional lamps.

Figure 10.2 You always know how the lighting will look when using continuous illumination.

- **Evenness of illumination—Con: electronic flash.** Electronic flash units, like the continuous light provided by lamps, don't have the advantage of being located 93 million miles from the subject as the sun is. Because of this factor, they suffer from the effects of their proximity.

 The *inverse square law*, first applied to both gravity and light by Sir Isaac Newton, dictates that as a light source's distance increases from the subject, the amount of light reaching the subject falls off proportionately to the square of the distance. In plain English, that means that a flash or lamp that's 12 feet away from a subject provides only one-quarter as much illumination as a source that's 6 feet away (rather than half as much). (See Figure 10.3.) This translates into relatively shallow "depth-of-light." That's why your built-in flash can only be used at close distances.

- **Action stopping—Pro: electronic flash.** When it comes to the ability to freeze moving objects in their tracks, the advantage goes to electronic flash. The brief duration of the emitted light serves as a very fast "shutter speed" when the flash is the main or only source of illumination for the photo. In other words, this effect is possible when shooting in a dark area without much if any lighting provided by ambient sources but assumes that subject is not beyond the range of the flash.

 In flash photography, your a5000's shutter speed (called sync speed in flash photography) is set to 1/160th second, but when flash is the primary light source, the *effective* exposure time will be the 1/1,000th to 1/50,000th second or less; this is the actual duration of the flash illumination. As you can see in Figure 10.4, it's possible to freeze motion with flash of very short duration. The only fly in the ointment is that, if the ambient light is strong enough, it may produce a secondary "ghost" exposure, as I'll explain later in this chapter.

Figure 10.3
A light source that is twice as far away provides only one-quarter as much illumination.

Figure 10.4 Electronic flash can freeze almost any nearby motion because of its extremely short duration.

- **Action stopping—Con: continuous lighting.** Action stopping with continuous light sources is completely dependent on the shutter speed you've dialed in on the camera. And the speeds available are dependent on the amount of light available and your camera's ISO sensitivity setting. Outdoors in daylight, there will probably be enough sunlight to let you shoot at 1/2,000th second and f/6.3 with a non-grainy ISO of 400. That's a fairly useful combination of settings if you're not using a super-telephoto with a small maximum aperture.

 But indoors, the reduced illumination quickly has you pushing your a5000 to its limits. For example, if you're shooting indoor sports in a dark arena, there probably won't be enough available light to allow you to use a 1/2,000th second shutter speed unless you use a lens with an extremely wide aperture (such as f/1.8) or set a very high ISO where image quality can suffer. (In truth, the gym where I shoot indoor basketball allows me to do so at 1/500th second at f/4 using ISO 1600.) In many indoor sports situations, you may find yourself limited to a shutter speed of 1/500th second or slower.

- **Flexibility—Pro: electronic flash.** The action-freezing power of electronic flash, at least for nearby subjects in a dark location, allows you to work without a tripod; that provides extra flexibility and speed when choosing angles and positions.

- **Flexibility—Con: continuous lighting.** Because incandescent and fluorescent lamps are not as bright as electronic flash, the slower shutter speeds required (see "Action stopping," above) mean that you may have to use a tripod more often, especially when shooting portraits. The incandescent variety of continuous lighting gets hot, especially in the studio, and the side effects range from discomfort (for your human models) to disintegration (if you happen to be shooting perishable foods like ice cream).

Continuous Lighting Basics

While continuous lighting and its effects are generally much easier to visualize and use than electronic flash, there are some factors you need to take into account, particularly the color temperature of the light. (Color temperature concerns aren't exclusive to continuous light sources, of course, but the variations tend to be more extreme and less predictable compared to electronic flash.)

Color temperature, in practical terms, is how "bluish" or how "reddish" the light appears to the digital camera's sensor. Indoor illumination is often quite warm, comparatively, and appears reddish to the sensor. Daylight, in contrast, especially on an overcast day, seems much bluer to the sensor. Our eyes (our brains, actually) are quite adaptable to these variations, so white objects don't appear to have an orange tinge under a tungsten lamp or a blue tint on a cloudy day. Yet, these color temperature variations are real and the camera will record them unless you use an appropriate white balance setting.

It's important to be aware of the color temperature of the light when you want to get an accurate overall color balance (or *white balance*)—either using the White Balance system's smarts or making

manual settings, using your own knowledge and experience. Color temperature can be confusing, because of a seeming contradiction in how color temperatures are named.

We are all more familiar with the concept of ambient temperatures in the Arctic (low equaling cold) and at the equator (high or warm), but color temperature measurements (in degrees Kelvin) use the opposite approach. The *lower* numbers indicate warmer (reddish) light, while the higher numbers refer to cooler (bluer) light. It might not make sense to say that 3,400K is *warmer* than 6,000K, but that's the way it is. If it helps, think of a glowing red ember contrasted with a white-hot welder's torch, rather than fire and ice.

The confusion comes from physics. Scientists calculate color temperature from the light emitted by a mythical object called a black body radiator, which absorbs all the radiant energy that strikes it, and reflects none at all. Such a black body not only *absorbs* light perfectly, but it *emits* it perfectly when heated (and since nothing in the universe is perfect, that makes it mythical).

At a particular physical temperature, this imaginary object always emits light of the same wavelength or color. That makes it possible to define color temperature in terms of actual temperature in degrees on the Kelvin scale that scientists use. Incandescent light (from a light bulb that's not daylight balanced), for example, typically has a color temperature of 2,700K to 3,000K. If a room is lit only by candles, the color temperature will be in the 1,000K to 2,000K range. Outdoors in daylight however, the color temperature might range from 5,500K to 6,000K. Each type of illumination we use for photography has its own color temperature range—with some cautions. The next sections will summarize everything you need to know about the qualities of these light sources.

Daylight

Daylight is produced by the sun, and so is moonlight (which is just reflected sunlight). Daylight is present, of course, even when you can't see the sun. When sunlight is direct, the illumination can be bright and harsh. If daylight is diffused by clouds, softened by bouncing off objects such as walls or your photo reflectors, or when filtered by shade, it can be much dimmer and less contrasty.

Daylight's color temperature can vary quite widely. It is highest (most blue) at noon when the sun is directly overhead, because the light is traveling through a minimum amount of the filtering layer we call the atmosphere. The color temperature at high noon may be around 5,500K to 6,000K. Earlier and later in the day, the sun is lower in the sky and the particles in the air provide a filtering effect that warms the illumination to about 4,500K on a sunny day. (If clouds completely cover the sun, the color temperature will be around 7,000K, slightly blue.) Starting an hour before dusk and for an hour after sunrise, the warm appearance of the sunlight is even visible to our eyes as shown in Figure 10.5; in such conditions, the color temperature may dip to around 4,500K and even to 3,200K.

Because you'll be taking so many photos in daylight, you'll want to learn how to use or compensate for the brightness and contrast of sunlight, as well as how to deal with its color temperature. I'll provide some hints later in this chapter.

Figure 10.5 At dawn and dusk, the color temperature of the sunlight will dip to 4,500K or even to 3,200K depending on the atmospheric conditions.

Incandescent/Tungsten Light

The term incandescent or tungsten illumination is usually applied to the direct descendents of Thomas Edison's original electric lamp. Such lights consist of a glass bulb that contains a vacuum, or is filled with a halogen gas, and contains a tungsten filament that is heated by an electrical current, producing photons and heat. Tungsten-halogen lamps are a variation on the basic light bulb, using a more rugged (and longer lasting) filament that can be heated to a higher temperature; it's housed in a thicker glass or quartz envelope, and filled with iodine or bromine ("halogen") gases. The higher temperature allows tungsten-halogen (or quartz-halogen/quartz-iodine, depending on their construction) lamps to burn "hotter" and whiter. Used for many automobile headlamps today, they've also been popular for photographic illumination.

Although a tungsten flood lamp intended for photography isn't a perfect black body radiator, it's close enough that the color temperature of the light it emits can be precisely calculated (about 3,000K to 3,550K, depending on the type of lamp). With this type of lighting, there's little concern about color variation, at least until you get very close to the lamp's life. By comparison, the tungsten (incandescent) light bulbs intended for household use can vary in color temperature, and these days, many such bulbs are rated as "White" or "Daylight Balanced"; this indicates a modification that causes the light output to be bluer, closer to 5,500K to 6,000K, depending on the bulb.

The other qualities of this type of lighting, such as contrast, are dependent on the distance of the lamp from the subject, type of reflectors used, and other factors that I'll explain later in this chapter.

Fluorescent Light/Other Light Sources

Fluorescent light has some advantages in terms of illumination, but some disadvantages from a photographic standpoint. This type of lamp generates light through an electro-chemical reaction that emits most of its energy as visible light, rather than heat; that's why the bulbs don't get as hot. The type of light produced varies depending on the phosphor coatings and type of gas in the tube. So, the illumination produced by fluorescent tubes or bulbs can vary widely in its characteristics.

That's not great news for photographers. Different types of lamps have different "color temperatures" that can't be precisely measured in degrees Kelvin, because the light isn't produced by heating. Worse, fluorescent lamps have a discontinuous spectrum of light that can have some colors missing entirely. A particular type of tube can lack certain shades of red or other colors (see Figure 10.6), which is why fluorescent lamps and other alternative technologies such as sodium-vapor

Figure 10.6 The fluorescent lighting in this huge indoor arena added a distinct greenish cast to the image.

illumination can produce ghastly looking human skin tones. Their spectra can lack the reddish tones we associate with healthy skin and emphasize the blues and greens popular in horror movies.

Adjusting White Balance

I showed you how to adjust white balance in Chapter 3.

In most cases, however, the a5000 will do a good job of calculating white balance for you, so Auto can be used as your choice most of the time. Use the preset values or set a custom white balance that matches the current shooting conditions when you need to. The only really problematic light sources are likely to be fluorescents. Vendors, such as GE and Sylvania, may actually provide a figure known as the *color rendering index* (or CRI), which is a measure of how accurately a particular light source represents standard colors, using a scale of 0 (some sodium-vapor lamps) to 100 (daylight and most incandescent lamps). Daylight fluorescents and deluxe cool white fluorescents might have a CRI of about 79 to 95, which is perfectly acceptable for most photographic applications. Warm white fluorescents might have a CRI of 55. White deluxe mercury vapor lights are less suitable with a CRI of 45, while low-pressure sodium lamps can vary from CRI 0-18.

Remember that if you shoot RAW format photos with the a5000, you can set any desired white balance for an image in the converter software whether you use the Sony Image Data Converter SR, Photoshop, Photoshop Elements, or another image editor that supports the Sony RAW format. While color-balancing filters that fit on the front of the lens still exist, they are primarily useful for film cameras, because film's color balance can't be tweaked as extensively as that of a sensor.

Electronic Flash Basics

Until you delve into the situation deeply enough, it might appear that serious photographers have a love/hate relationship with electronic flash. You'll often hear that flash photos are less natural looking, and that on-camera flash in most cameras should never be used as the primary source of illumination because it provides a harsh, garish look. Some photographers strongly praise available ("continuous") lighting while denouncing electronic flash.

In truth, however, the bias is against *bad* flash photography. Indeed, flash—often with light modifier accessories—has become the studio light source of choice for pro photographers. That's understandable, because the light is more intense (and its intensity can be varied to order by the photographer), freezes action, frees you from using a tripod (unless you want to use one to lock down a composition), and has a snappy, consistent light quality that matches daylight. (While color balance changes as the flash duration shortens, some Sony flash units can communicate to the camera the exact white balance provided for that shot.) And even conservative photographers will concede that electronic flash has some important uses as an adjunct to existing light, particularly to fill in dark shadows.

But electronic flash isn't as inherently easy to use as continuous lighting. As I noted earlier, flash units are more expensive and they don't show you exactly what the lighting effect will be, unless you use a second source such as the rudimentary pulsed light called a *modeling light* (discussed earlier) for a preview of limited value. As well, when you're using several electronic flash units, the exposure can be more difficult to calculate accurately than it would be with continuous light.

How Electronic Flash Works

Electronic flash illumination is produced by a flash of photons generated by an electrical charge that is accumulated in a component called a *capacitor* and then directed through a glass tube containing xenon gas, which absorbs the energy and emits the brief flash. For the built-in flash furnished with the camera, the full burst of light lasts about 1/1,000th second, and provides enough illumination to shoot a nearby subject, unless you're using a wide aperture and/or a high ISO level as discussed earlier. As you can see, the built-in flash is relatively underpowered and not your best choice when photographing distant subjects.

The Sony Alpha's built-in flash is always available as required. There are several flash modes available in the Camera Settings 2 menu:

- **Flash Off.** The flash never fires; this may be useful in museums, concerts, or religious ceremonies where electronic flash would prove disruptive. (This option is not available in P, A, S, or M mode; if you do not want flash to fire, simply press it down into place.)
- **Auto Flash.** The flash fires as required, depending on lighting conditions. (Not available in P, A, S, or M mode because flash always fires in these modes if it's in the up position.)
- **Fill-Flash.** When this option is set, the flash will always fire when using one of the two Auto modes or in SCN modes where flash is available. The camera balances the available illumination with flash to provide a balanced lighting effect. (See Figure 10.7.)
- **Slow Sync.** The a5000 combines flash with slow shutter speeds; the nearby subject can be illuminated by flash, but during the longer shutter speed, there's enough time for the darker surroundings (lit by ambient light) to record on the sensor.
- **Rear Sync.** Fires the flash at the end of the exposure time, after the ambient light exposure has been made, producing more satisfying photos of moving subjects when using a long exposure; light trails will be behind the "ghost" image, as illustrated in Figure 10.8.

The built-in flash is a handy accessory because it is available as required, without the need to carry an external flash around with you constantly. This section explains how to use the flip-up flash. Start by pressing the flash button (on the upper left edge of the back of the camera). Use the P, A, S, or M mode to ensure that all flash features will be available.

Figure 10.7 The owl (left) was in shadow. Fill flash (right) brightened up the bird, while adding a little catch light to its eye.

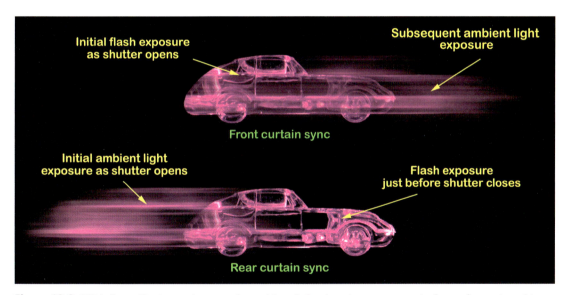

Figure 10.8 With front (first) curtain sync, the ambient light ghost image appears in front of a moving object. With rear (second) curtain sync, the ghost image trails behind the subject.

> **BOUNCE FLASH**
>
> Although the built-in flash doesn't have detents to allow variable angles, you can easily tilt it with the tip of your index finger while shooting to provide additional flexibility. For example, you can carefully angle the flash downward when shooting close-ups (perhaps with mixed results), or tilt it backward to bounce it off a ceiling or other diffusing surface. Of course, the light may not actually reach the subject; you would need to use a high ISO (to increase sensor sensitivity) for this technique to provide any effect. Of course, if the ceiling is low or you're bouncing the light off a large white sheet of cardboard—and the subject is close to the camera—it may work well when using ISO 800 or higher.

Flash Exposure Compensation

This is a feature discussed previously in Chapter 3. It's important to keep in mind how the a5000's exposure compensation system works when you're using electronic flash. To activate exposure compensation for flash, visit the Flash Comp. item in the Camera Settings 2 menu and set the amount of plus or minus compensation you want. This function is not available when using Auto or SCN modes or Panorama mode. When you find that your flash photos are too dark even after you have set +2, then the flash simply cannot provide more power; you must move closer to the subject, or use a wider aperture, or set a higher ISO, or take all of these steps. Note too that when a subject is extremely close to the camera, even a –2 setting may not prevent an excessively bright image.

Flash exposure compensation affects only the amount of light emitted by the flash. If you want to adjust the brightness of the ambient light exposure, you would also need to use the conventional exposure compensation feature. In fact, you can use both features at the same time, to get a brighter subject and a darker background, or vice versa. Let's say you're taking a photo of a friend posing against a light-toned background such as a white cabana on a beach. A plus exposure compensation setting (perhaps +1 when using multi-segment metering) will ensure that the cabana won't be underexposed while a –1/3 or –2/3 flash exposure compensation will ensure that shadows on your friend's face will be lightened by a very gentle burst of flash. This is an advanced technique that requires some experimentation but can be valuable when used with some expertise.

Red Eye Reduction

When using semi-automatic or manual exposure modes (or any SCN mode in which flash is used), red-eye reduction is available if Red Eye Reduction is On in the Camera Settings 2 menu (as described in Chapter 3). The flash will fire a burst before the photo is actually taken as you depress the shutter release button. That will theoretically cause your subjects' irises to contract (if they are looking toward the camera), thereby reducing the red-eye effect in your photograph.

11

Using Wi-Fi

Your a5000 is equipped with a built-in Wi-Fi system that can be used for transferring files to a networked computer or to a networked HDTV or to a smartphone or tablet computer. As we'll see later, there's also an option (with an app) to use the smartphone or tablet as a remote controller for the camera. The a5000 includes both traditional Wi-Fi capabilities and a newer protocol called Near Field Communications (NFC), which allows linking devices directly without an intervening network.

While basic Wi-Fi has become available with an increasing number of digital cameras, your Alpha a5000 goes a giant step further. Once connected to a network or hotspot, you can download apps (some free; others for $4.99 or $9.99) from a Sony website for increased versatility. These apps can expand existing a5000 features with extra options or add entirely new functions. For example, one app enables you to retouch JPEGs to improve them while two others allow for direct uploading (via Wi-Fi) from the a5000 to certain social media sites on the Internet.

This chapter provides an introduction to NFC and making Wi-Fi connections. You'll learn how to transfer photos to a computer or to a smart device. Later, I'll discuss downloading and installing apps, the available apps, and other benefits provided by the wireless connectivity available with Wi-Fi from your home network or from a Wi-Fi hotspot. These days, you can find numerous hotspots where Wi-Fi is provided (often free of charge), at restaurants, supermarkets, stores, and theme parks, for example.

Making a Wi-Fi Connection

The first step, of course, is to establish Wi-Fi connectivity. Setting up a link to a network/hot spot can be done in two different ways: manually or using a simplified alternative called WPS (Wi-Fi Protected Setup) Push. Your best bet is to start with WPS, if it's available with your router, before taking the more traditional route, described later in this chapter.

Using WPS Push

Wi-Fi Protected Setup works only when you're in range of a network provided by a wireless router that is equipped with a WPS button. Not all are. Examine your router and look for a button labeled WPS, or with a WPS symbol. Or, find the owner's manual for your router or use a Google search (try "*routername* manual PDF") in order to locate the WPS button, if one is available. Some routers that support WPS provide it with software instead of a physical button; in that case, you'll need to access the router's control panel using a computer and click the button on the WPS page. The WPS Push tactic is great, but it would not work at a Wi-Fi hotspot in a supermarket, for instance, since the network owner is unlikely to use the WPS feature for hundreds of customers.

> **WHAT'S WPS?**
>
> The abbreviation WPS indicates Wi-Fi Protected Setup. This is a security standard that makes it easier and quicker to connect a device, including your a5000, to a wireless home network. It eliminates the need to key in the password. Because it's possible for an aggressive hacker to recover the WPS PIN number, some experts suggest turning the router's WPS feature off when you're not actually using it; this may not be possible with all router models but check the owner's manual for the one you own.

Just follow these steps:

1. **Access Wireless 1 menu.** If your router provides WPS, scroll to the WPS Push item in the camera's Wireless 1 menu and press the center button. (See Figure 11.1.)
2. **Press router's WPS button.** A screen will appear advising you to press the router's WPS button within 2 minutes. When you press the button (or use the software) to do so, the camera should be able to establish connectivity.
3. **Confirm registration.** Once the connection is established, a screen reporting "Registered. SSID *network name*" appears. Press the center button to confirm.

Registering Manually

You can also select an access point manually when within range of a wireless network; you'll need to know the network password, if one is in place, in order to do so. Just follow these steps:

1. **Access the Wireless 2 menu and scroll to Access Point Set (see Figure 11.2).** Press the center button. A Wi-Fi Standby screen will appear confirming that the camera is searching for available access points.

Figure 11.1 WPS Push, located at the bottom of the Wireless 1 menu, is the fastest way to connect to a network.

Figure 11.2 Access Point Settings can be used to select an access point/hot spot.

2. **Wait for the camera to find your network.** The a5000 will find the nearby access points (networks) in less than a minute. (See Figure 11.3.) If there is more than one network or available access point, all of those found will be shown. When several networks are displayed, some may belong to nearby businesses or your neighbors, and you can ignore them (their signal strength is probably weaker than your own network in any case, even if your neighbor's network is not protected by a password). In my case, my wireless router resides in my office; in other, more distant rooms is a wired access point, and, on the second floor, a wireless repeater. Scroll to the one you intend to use and press the center button to confirm.

3. **Input the password (if necessary).** The next screen that appears may have a field for entering your network password, if your router/access point is set up to require one. If not, proceed to Step 4. Otherwise, press the center button and a virtual keyboard will appear. Using this keyboard, enter the password for your network. The keyboard works a bit like the physical keyboard found on some (older) cell phones. Use the directional buttons to highlight a letter group, such as abc, def, ghi, and press the center button once to enter the first character in the group, twice for the second character, three times for the third character, and four times for the fourth. Some of the virtual keys allow you to backspace, delete characters, and toggle between upper and lowercase. When finished, highlight OK and press the center button.

4. **IP Address Setting.** The next screen will appear; showing the IP Address Setting as Auto and Priority Setting as Off. (See Figure 11.4.) These defaults should work perfectly. Select OK and press the center button. A screen will appear showing the camera trying to connect to the network.

If the Auto IP Address Setting option does not work, and you have some networking expertise, change from Auto to Manual, and a screen appears that allows you to enter the IP address, Subnet Mark, and Default Gateway. You can safely leave the Priority Connection parameter set to Off. Fortunately, you probably won't have to resort to these additional steps.

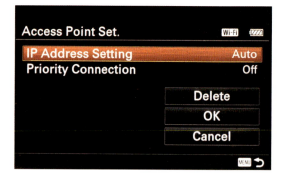

Figure 11.3 The camera displays the available networks that are within range.

Figure 11.4 You can enter the IP address manually.

5. **Confirm connectivity.** After the Wi-Fi connectivity has been made, a screen will appear confirming that your network has been registered. The screen will look like the one in Figure 11.3 (shown earlier) but an orange dot will appear next to the connected network. If you get a screen with a note stating *cannot authenticate*, or that the *input value is invalid*, you'll need to start again at step 1; make sure you have the correct password for the network and be extra careful when keying it in. Remember that when a capital letter is required, you must use the shift feature (an arrow pointing upward) on the virtual keyboard.

6. **Try it again later.** After you have established Wi-Fi connectivity, you can revert to using the a5000 as usual; a touch of the shutter release button returns it to shooting mode. The camera will retain the connection to the network until you turn it off or it goes into power-saving sleep mode; Wi-Fi is then temporarily disconnected. When you're ready to use Wi-Fi again, activate the a5000 while in range of the same network, scroll to Access Point Settings in the Wireless menu, and press the center button. The camera will quickly find your network to re-establish Wi-Fi connectivity.

If you're connecting to a public Wi-Fi hotspot, the steps should be the same, but you'll most likely find a screen that requires you to agree to the hotspot's terms and conditions. Some hotspots may not require you to enter a password.

Selecting an Access Point Manually

If the desired access point (network) is not displayed on the screen as described in Step 2 above, you may need to enter it yourself. Just follow these steps:

1. **Choose Manual Setting.** Scroll down to Manual Setting (visible at the bottom of Figure 11.3) and press the center button. The screen shown in Figure 11.5 appears.

2. **Select Manual Registration.** Press the center button to begin the manual registration process. The screen shown in Figure 11.6 appears.

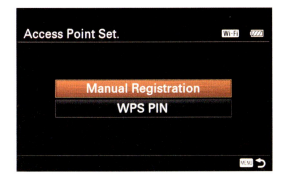

Figure 11.5 Manual registration requires you to complete extra steps.

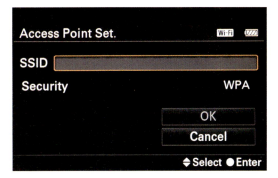

Figure 11.6 Enter the SSID (network/access point name).

3. **Enter SSID.** On the Manual Registration screen, there's a field for entering the SSID name of the access point (network) you plan to use. Press the center button when this field is visible and the virtual keyboard appears. Enter the data. When you're finished press the center button.

4. **Change Security (if necessary).** Again, if you have some networking expertise, you'll know if the security setting on your router is WPA (Wi-Fi Protected Access, the default), WEP (Wired Equivalent Privacy, an older, easily "hacked" protection scheme), or None (effectively, no security). If you want to change the Security setting, highlight that field and press the center button. The screen shown in Figure 11.7 appears. Select your choice and press the MENU button to return.

5. **Enter password.** The next screen will ask for your password, which you can enter using the virtual keyboard.

6. **Enter WPS PIN (if necessary).** If your WPS connection requires a PIN, you can enter it using the screen shown in Figure 11.8.

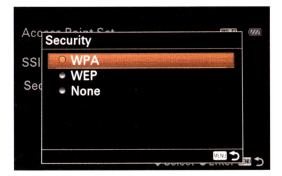

Figure 11.7 You can change the security protocol used.

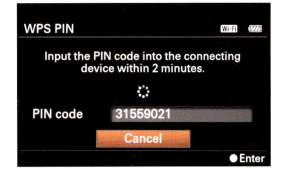

Figure 11.8 If your router requires a WPS PIN, enter it here.

Take care not to lose the network connection by inadvertently using the Initialize or the Reset Network Settings item of the Wireless menu. (I discussed both items in Chapter 3.) If you do so, the camera will eliminate all of your network settings and you'll need to repeat the steps in this section.

Wi-Fi Settings

The Wireless 2 menu, shown earlier in Figure 11.2, has additional entries beyond those we've used so far. Their functions should be fairly obvious:

- **Edit Device Name.** By default, your camera is assigned the device name ILCE-5000. Select this entry and you can change it to something else.
- **Disp MAC Address.** Each device on a network has a unique Media Access Control number. You generally have no need to know this, unless you want to block a particular device from your network and use the MAC address to identify the unwanted device.
- **SSID/PW Reset.** Deletes the current SSID and password. You might want to do this for security reasons (say, you load/give/sell your a5000 to someone else), or need to start over in registering your camera with a network.
- **Reset Network Set.** Removes all network settings from the camera.

Wi-Fi Functions

Once Wi-Fi connectivity has been established, you can consider using other features that I mentioned earlier. Begin by transferring some photos from the a5000 to your computer that's also connected to the same wireless network. Do note that you must first download and install Sony's PlayMemories Home for Windows, or Sony's Wireless Auto Import for Mac to your computer.

The functions you can access are shown in the Wireless 1 menu, as seen in Figure 11.1:

- **Send to Smartphone.** Transfer files to a smart device.
- **Send to Computer.** Send files to a computer.
- **View on TV.** View images with a wireless connection to a compatible HDTV.
- **One-touch (NFC).** Near Field Communications with a compatible Android phone.
- **Airplane Mode.** Disable all wireless functions.
- **WPS Push.** Register your camera, as described at the beginning of this chapter.

Sending Photos to a Smart Device

To transfer photos from your camera to a smartphone or tablet, the device must be running the free PlayMemories Mobile app for Android or iOS; you can get it from your usual app store. After you have downloaded the PlayMemories Mobile app (for iOS or Android) and are running it in your smart device, you can send one or more images to the smart device. (The app, and hence the camera's Wi-Fi features like this one, are not available in a few countries where many aspects of Internet use are restricted.) This feature does not work for video clips. Here are the steps you'll follow:

1. **Turn on the camera and the smart devices.** Ensure that both the a5000 and the smart device have found your network. With the a5000 you'll do so using the Access Point Settings as discussed earlier.

2. **Use the View on Smartphone item.** Access this Wireless 1 menu item in the camera. (The term Smartphone actually means smart *device* since it works with a tablet computer, too, in the same manner.) The a5000 will display a screen with three options: This Image, All Images on This Date, and All Images in the Device. Scroll to the one that specifies the types of files you want to transfer to the smart device and press the center button.

3. **Enter the SSID and password in the smart device.** At this point, the a5000 will be displaying both its unique ID (SSID) and a Password. Using the smart device's virtual keyboard, enter the SSID and password that your a5000 is displaying. Remember, it's all case sensitive so use capital letters when necessary. If you get an *incorrect password* message from the smart device, start again using greater care to be accurate. Click on Join or whatever command your device requires in order to proceed.

4. **Run the PlayMemories Mobile app in the smart device.** After starting the app in your smartphone or tablet, wait for it to find the a5000. Your device's screen will indicate that it's searching for the camera. When that's finished, the image transfer from the camera to the smart device will begin.

5. **View the Images.** After the smart device has completed importing files from the a5000, you can view the thumbnails on its screen. Naturally, you can enlarge any photo so it fills the device's screen.

6. **Use the smart device to send photos, etc.** You can now use any of the smart device's capabilities: modify any of the images, send it to friends via e-mail, upload it to any website, and so on.

Wi-Fi Transfer to a Computer

You can transfer photos from the a5000 to a computer that's also connected to the same wireless network. Do note that you must first install Sony's PlayMemories Home for Windows, or Sony's Wireless Auto Import for Mac to your computer.

Use this Wireless menu item when you're ready to transfer images from the a5000 via Wi-Fi to a computer that is connected to the network. (Review the items under the Networks heading for advice on establishing Wi-Fi connectivity between your camera and a network.)

Before you can transfer photos to a computer with Wi-Fi, be sure to install the PlayMemories Home software on a Windows computer or Wireless Auto Import to a Mac; you can download the latter from http://support.d-imaging.sony.co.jp/imsoft/Mac/wai/us.html. Then, you'll need to register the a5000 in the software; this will also instruct the camera as to where photos should be sent in future, using Wi-Fi. The process is automatic after you connect the camera to the computer with the USB cable; the software will recognize it after a few seconds and proceed to register it. Afterwards, image transfer will be possible without cable connection.

Use the following steps. These are based on the ones I used with PlayMemories Home in a Windows PC; they may be slightly different if you own a Mac computer and are using the Wireless Auto Import software.

1. **Begin to authenticate your a5000.** Before using Wi-Fi, you must sync the two devices. Launch the Sony software and connect the camera to the computer with the USB cable and turn it on in order to start the process. (If any auto run wizard opens, offering to transfer images, close it.) The Sony Software in the computer will recognize the a5000 and confirm it; you'll also see a screen on your computer monitor indicating that a compatible device has been found. If the computer software displays a screen indicating that the USB mode must be changed (to Mass Storage), click on Yes. (Surprisingly, this was necessary for me although the USB mode in the camera was at Auto which should have worked without any problem.)

2. **Proceed with the software-recommended step.** When you see the screen on your computer monitor asking how you want to set up Wi-Fi import, the Recommended item will be checked. Click on Next. A Settings Completed screen will appear. Click on Finish.

3. **Disconnect the camera**. Since you'll be sending photos from the a5000 to the computer using Wi-Fi, there's no need for any cable connection from this point on.

4. **Access the Send to Computer menu item.** Turn the a5000 on, access the Wireless menu and scroll to this item; then, press the center button. (I discussed this feature in Chapter 3.) The camera will find the network and connect to it; it will then find your computer and make that connection, using Wi-Fi. This can take a minute or two. The camera's LCD will display a confirmation that files are being shared with the computer via Wi-Fi. PlayMemories Home in your computer will display a bar on your monitor confirming the wireless connection to the a5000 and that it's importing (bringing in) the files on the memory card.

5. **Wait for the file transfer to finish.** There is no method for importing only certain files to a computer. The transfer process can be very time consuming if the memory card contains numerous images, especially RAW photos, and long movie clips. The camera should shut down automatically after saving the files to your computer; if not, turn it off yourself.

6. **Confirm that the files have arrived**. Use any software to access the drive/folder that was the destination for the photos and video clips. You should find them in the expected location, in individual folders. Delete any files that you do not want to keep.

> **BYPASS SECURITY SOFTWARE**
>
> If during Step 4 you get a note on the a5000's display screen indicating that the camera could not connect to your computer, the problem is being caused by a computer firewall and you'll need to make a change to allow incoming data to be received. For example, my Norton 360's firewall was set by default to Block incoming data. I changed that to Allow and then all went exactly as discussed in the steps. After the data transfer has been completed, it's essential that you reactivate the blocking features of the firewall so it will again provide full security.

Viewing Images on a TV

As with any current digital camera, it's possible to view JPEG photos and video clips on an HDTV when you connect the a5000 to the TV using an HDMI cable. This is an extra cost accessory. Buy the Type C cable with a mini HDMI connector at one end (for plugging into the camera) and a conventional HDMI plug (to connect to the TV's HDMI port). An inexpensive cable is fine; there's no need to pay more for one of the premium brands unless you need a cable that's longer than about 6 feet. Make the cable connection and you can now display photos and movies on the oversized screen.

After Wi-Fi connection has been made with a Digital Living Network Alliance/DLNA-compatible (network-enabled or Wi-Fi Direct-enabled) HDTV, you can use this menu item, the first of the second full screen of items in the Wireless menu. Use it to play photos on the HDTV without cable connection after Wi-Fi connectivity has been confirmed. The benefit of Wi-Fi Direct is that you do not need to register your access point on the camera before doing so; in other words, the TV need not be connected to the network if you are using Wi-Fi Direct. Movie clips cannot be transferred to a TV for display over Wi-Fi; to show those, connect the camera to the HDTV using an optional Type C HDMI cable.

Use the menu options to instruct the camera as to which device (TV) it should send to, which photos to display (all or only those in a specific folder), and whether the display time should be long or short if using the slide show feature. Press the center button if you do want to use the slide show feature. At any time, you can move to another image for the display by scrolling to the left or right.

It's also possible to transfer JPEG photos, but not videos, to an HDTV without cable connection. If you have a networked TV (or a network-friendly game machine such as PlayStation or xBox), you can view the images in your camera on that display without using the HDMI cable.

Of course, the HDTV must be DLNA (Digital Living Network Alliance) compliant and it must first be connected to your home network via Wi-Fi as per the instructions that came with the device. The a5000 must also be communicating with your network via Wi-Fi, of course. (Use the steps provided earlier.)

> **Note**
>
> There is an exception to the DLNA rule. Some HDTVs are Wi-Fi Direct enabled; if yours is, then it need not be connected to your network. Mine is not, so I have not been able to try this feature.

There are simply too many types of Wi-Fi enabled HDTV's to provide full specifics on exactly how you'll transfer JPEGs to the device. Sony's published documents specifically recommend their Bravia HDTV, as you might expect, but you can use any DLNA (or Wi-Fi Direct) enabled TV. A Bravia HDTV does provide a few extra display features that are possible only when using a Sony camera.

In any event, start by accessing the View on TV item in the camera's Wireless menu and press the center button. The camera will confirm the Wi-Fi connection to your network and it will search for a compatible TV. Be sure to consult your TV's instructions for setting the media display component to receive information from the camera. When connectivity with the TV has been confirmed, you can begin the sharing process using connection controls similar to those described earlier in this chapter.

Downloading Apps to Your a5000

Unlike most other cameras with Wi-Fi, the a5000 can download apps from the Sony Entertainment PlayMemories Camera Apps website while Wi-Fi connectivity is active. (Sony does not plan to offer its Camera apps via the other app stores.) This enables you to add extra functions to existing features or to arm the camera with some entirely new functions to expand its versatility. Here's how you can do so, step by step:

1. **Sign up for a service account at http://www.sony.net/pmca using a computer.** This is an essential first step and will include specifying a credit card that will be charged for any apps that are not free. You can also check out the available apps (on your large computer monitor) in order to appreciate the features they will provide if you later install them in your a5000.

2. **Log into the app store from the a5000.** While the camera is connected to a network via Wi-Fi, scroll to the PlayMemories Camera Apps item in the Application menu. Press the center button and wait a few seconds until you're connected to the Sony Entertainment Network app store.

3. **Find the available apps with the a5000.** You'll now be viewing a screen on the camera with tabs along the left side. You can scroll to: New (list only the new camera apps), All (list all available camera apps), and My App (list any apps already downloaded to the camera). Start by scrolling to All; press the center button and you'll be able to view a display of all available apps. Not all of the many icons are visible at any one time so scroll down to view the others. The price

for each is shown. If an app is available free of charge, the word Install appears below it instead of the price. If you have previously installed an app, the word Installed appears under it.

4. **Download and install an app.** Scroll to an app you might want to try. Go for a free one initially, such as Direct Upload and press the camera's center button. A screen will appear with information about that app and how it works. If you do want this app, scroll to the Install bar and press the camera's center button.

5. **Complete the Sign In process**. You'll need to sign in using the password you had created while connected to the Sony website with your computer in step 1. When you scroll to a field and press the center button the virtual keyboard appears so you can enter the data. When you have finished entering your data in a field, scroll down to END and press the center button.

6. **Wait for the app to upload to your a5000**. This can take up to a minute for some apps; a note on the camera's screen will keep you advised as to the status. Do not turn the camera off during the process. When the app has been installed, you'll get a screen confirming it was successful.

7. **Try the new app.** If you're ready to do so, scroll down to the Use the installed application bar and press the camera's center button. The other option, View other applications, is useful in case you want to download other apps right away.

8. **Access your apps**. Access the camera's Application menu to find the list of apps that you have already installed. If there are several you may need to scroll down to reveal any that are not immediately visible in the display. Scroll to one you want to try and press the center button. This will take you to a screen that will provide guidance on how to proceed with the app.

Since the a5000 allows for direct download of apps, I recommend becoming familiar with that procedure instead of using a computer to do so. If you accept this advice, here are a few more comments about the process. When you're ready to download an app with the a5000 (using Wi-Fi connectivity) you'll need to enter your ID and password. You'll get a confirmation on the camera's screen after an app has been successfully installed.

A TRADITIONAL ALTERNATIVE TO DOWNLOADING APPS

If you prefer not to use Wi-Fi for uploading apps to your a5000, it's also possible to do so with the camera connected to a computer with the USB cable. After making that connection, access the www.sony.net/pmca app store and open an account as discussed in Step 5. Connect the a5000 to your computer with the USB cable. Scroll to an app displayed on your computer monitor (by the Sony Entertainment website), and click on Install. (If there's a fee, you'll need to agree to pay that.) The transfer to the a5000 will then start; it's automatic and simple. When it's finished, you'll see a note on your computer monitor (from the Sony app store) confirming that the installation has been completed. Disconnect the a5000 (using the safe eject feature). The new app will appear in the list of apps in the camera's Application menu.

Current Sony Apps

At the time of this writing Sony offered a series of conventional apps, some free and others priced at $4.99 or $9.99 in the US; prices in other countries may be entirely different. Additional apps (all free) were in Beta test mode: Snapshot Me, Time Lapse LE, Catch Light, Stop Motion, and ID Photo were available in the US. (The Beta apps are not available in all countries.) I won't discuss the Beta series since they may no longer be available when you read this. Of course, it's also possible that some other, entirely new conventional apps will be available then.

> **Note**
>
> Sony provides sample video clips, and occasionally still photos, that illustrate how most of the following apps work, how to install them, and the effects you can expect. Check them out at www.sony.net/Products/playmemories/pm/pmca.html.

Several of the conventional apps are various free keyboards such as International, Chinese, Japanese, and Korean; these are self-explanatory so I won't provide a summary. In any event, here's a brief overview of the other conventional apps that were available in the US and Canada as I wrote this chapter.

- **Direct Upload (free).** Use this app to upload photos directly from the a5000 to Facebook or to the Sony PlayMemories site via Wi-Fi. (Perhaps other sites will be added in future.) Of course, the camera must be connected to a network to do so. Because the 16 megapixel images are huge, they're automatically downsized to 2 megapixels. Select the photos you want to upload and you can specify the destination album. If you're uploading to Facebook, you can also add a comment to each photo, if desired. (You will need to key in your ID and password and that can be tedious; you might consider checking the box that instructs the app to remember this data to eliminate the need to sign in every time.)

- **Flickr Add-On (free).** This is companion app to Direct Upload and available only after you have installed that one. This app merely adds the ability to upload images directly to Flickr. It becomes part of Direct Upload in the camera's Application menu.

- **Picture Effect+ (free).** The camera already provides many special effects options but this app adds others and modifies some existing effects for greater versatility.

- **Multi Frame Noise Reduction ($4.99).** As the name implies, this app is similar in concept to the two SCN modes that provide high ISO photos by taking a burst of multiple JPEG frames and compositing them into one after discarding much of the digital noise data. (See Chapter 4 for a discussion of the Anti Motion Blur and Hand-held Twilight modes.) The app is available for use when the camera is set to P, A, S, or M mode so you get a lot more versatility in terms of camera settings than you do with the fully automatic SCN modes. You can set a desired ISO level, exposure compensation, and a Creative Style plus its overrides, for example.

- **Photo Retouch (free).** This app enables you to modify the technical aspects of JPEG photos you've already taken. A variety of tools are available for adjusting aspects such as brightness, saturation, and contrast while you view the photo. The app also offers resizing (downsizing an image), horizon correction, skin softening, and applying the auto portrait framing feature.

- **Smart remote (free).** Get this app to take advantage of an important feature provided by Wi-Fi: control of the a5000 from a smart device that's running the PlayMemories Mobile app. (The a5000 becomes the access point.) Set up the camera pointing toward a bird's nest for example, and you can get a live preview of the scene on the device's LCD screen. You can control the exposure if the camera is set for A or P mode, activate a 2-second self timer, and trip the shutter from the smart device to take photos. (You cannot control camera features such as zooming, ISO level, mode, etc.)

- **Bracket Pro ($4.99).** The a5000 already provides a feature for autoexposure bracketing but this app provides a lot more bracketing options. It expands the exposure range to +/-5EV and provides a simplified interface. More importantly, the app provides additional features: focus bracket (three shots at various focused distances), shutter speed bracket (three shots, each at a different shutter speed), aperture bracket (three shots at various f/stops), and flash bracketing (two shots, one with and one without flash).

- **Cinematic Photo ($4.99).** This app is unusual in that it creates *cinemagraphs,* still photos of which a portion is animated. In other words, it provides a video in which most of the frame is a still photo but with a single animated element.

 For example, your subject might be a friend pouring milk from a clear bottle. The camera will fire 18 JPEGs and then it will provide a preview image with a brush tool that you can use to specify the area that will be animated: depicted as moving in the cinemagraph. In this example, you would brush only the area of the flowing milk so it would be the area depicted as moving; your friend would be static. The painting process is slow since you'll be using the control wheel. After you finish your artistic work, you can view the finished video; if it's not quite right, you can start again with the painting process. A cinemagraph video is about 20 seconds long and 640 × 360 pixels in resolution.

- **Time Lapse ($9.99).** Activate this really cool app to automatically shoot a series of photos at various intervals with settings made automatically by the camera; use it to record the opening of a blossom during the period from 8am to 10am, for example. Because the exposure is locked after the first shot, this feature works best when the brightness of the light will not change (as on a cloudy day) while the series of photos are being made. You can set the interval between shots, the number of photos to be taken, and whether the self-timer will be used. After the series is finished, it's combined into one HD video clip.

 If you don't want a video, you can choose to have the camera merely save the still images as a series. You get seven presets, each providing a different look: Cloudy Sky, Night Sky, Night Scene, Sunset, Sunrise, Miniature, and Standard. There's also a Custom option with more user control.

- **Lens Compensation ($9.99).** This a5000 already includes some lens compensation features that make minor changes automatically to correct certain optical flaws that are inherent to every lens to some extent. This app is more versatile, enabling you to manually select correction values for lens peripheral shading (darkening at the corners of an image), chromatic aberration, and distortion. I'd recommend this app only for photographers with some expertise in these issues.
- **Multiple Exposure ($4.99).** Some other cameras offer a feature that lets the user take several photos that are composited into one, a straightforward function. Add this app and the a5000 can also do so, but you get far more versatility. You can select a theme and the app will automatically composite your series of photos into one, after optimizing the exposure. Seven themes are available: Easy silhouette, Sky, Texture, Rotate, Mirror, Soft Filter, and Manual. If you choose the latter, you can preview the results you'd get with any of the five options and then select the one that will provide the results you prefer.
- **Motion Shot ($4.99).** Also a type of multiple exposure app, this one is intended for photos of moving subjects, such as race cars, cyclists, or runners. After you take a sequence of shots with continuous drive, it's composited into one. You can choose the first and last images of the sequence, adjust spacing between the images to be composited, and customize other settings. All of the photos, including the composite, are saved to the memory card. (Check out the sample that Sony provides at https://www.playmemoriescameraapps.com/portal/.)
- **Portrait Lighting ($4.99).** This app can accentuate people's faces by adjusting the contrast and brightness. It can also lighten or darken the background. You can select any of five lighting levels or use a custom setting; the latter lets you choose from six levels of emphasis on either the person or the background. When experimenting, start by making a portrait photo of a friend and use this app to brighten the face and darken the surroundings for a dramatic effect.
- **Light Shaft ($4.99).** Perhaps a bit gimmicky, this app can add a *splash of light* to your photos in one of four different light shapes: Ray, Star, Flare, and Beam. You get some control since you can specify where you want the light shape to fall as well as adjust its intensity, length, width, and number of light rays.

As mentioned earlier, any apps you download will be available for access in the camera's Application menu. If many have been installed, you may need to scroll down to find the icon for the app you want to use. The a5000 includes an Application Management item as well, described in Chapter 4. This feature offers options that allow you to sort your apps, delete any of them, and display your Sony account information. When you scroll to one of these options, on-screen guidance is provided, such as the steps required to remove an app. (If you remove an app, you can later reinstall it if you decide that you do want it—at no extra charge.) All of this is quite intuitive so experiment with the available options. Pressing the up directional button at any time will return you to the previous screen.

Near Field Communications (NFC)

If you know Bluetooth, then you already understand much of what you need to know about One-Touch (Near Field Communications). Like Bluetooth, NFC is a radio communications protocol that allows smart devices to establish a link with each other simply by touching them together or moving them close to each other (a few inches is sufficient). Currently, NFC is supported only by Android devices and cameras using a compatible operating system, including the a5000.

Pairing your smart device and your camera couldn't be easier:

1. Download PlayMemories Mobile to your Android device.
2. Activate the NFC function of the smart device. An N-like icon should be displayed on your device's screen when NFC is available.
3. Locate the NFC marking on the right side of the a5000 (when you're holding the camera in shooting position).
4. Touch the marking to the corresponding mark on the smart device for about 1-2 seconds.
5. When the devices are paired, the PlayMemories Mobile app launches on the smart device.
6. You may now select One Touch (NFC) in the Wireless 1 menu. The option cannot be used if the camera is in Airplane Mode.
7. You can access applications using NFC, or transfer images on the camera to the smart device.

Index

A

A (Aperture Priority) mode, 14, 16
bracketing in, 140
DRO (D-Range Optimizer) with, 195
equivalent exposure and, 122–123
focus areas in, 18
ISO sensitivity changes and, 127
for movies, 210
working with, 131–133
AC adapters, 4
access lamp, 30–31
action-stopping. *See* freezing action
adapters. *See also* lens adapters
AC adapters, 4
Adobe Camera Raw
chromatic aberration, correction of, 252
overriding RAW settings with, 50–51
Adobe Photoshop/Photoshop Elements. *See also* Adobe Camera Raw; Merge to HDR
chromatic aberration, correction of, 252
focus stacking with, 172–174
HDR photos, creating, 198–202
pincushion distortion, correction of, 252
Adobe RGB color space, 75–77
AE-L/AF-L lock
Custom Key Settings, Custom Settings menu, 90–92
Custom Settings menu options, 88–92
LCD data display for, 37–38
for movies, 213

AF (autofocus). *See also* focus areas; focus modes; Lock-on AF
AF Micro Adjustment options, Custom Settings menu, 93, 254–257
circles of confusion, 158–160
contrast detection, 154
explanation of, 153–156
for movies, 208
phase detection, 154–156
Pre-AF options, Custom Settings menu, 85
AF Micro Adjustment options, Custom Settings menu, 93, 254–257
AF-assist lamp, 28–29
Camera Settings menu options, 60
LCD data display for, 37–38
working with, 168
AF-C (continuous AF), 18, 157
Camera Settings menu options, 58
continuous shooting and, 188
working with, 163–164
AF-S (single-shot AF), 17, 55, 157
AF Lock with, 171
Camera Settings menu options, 58
working with, 163
airplane mode
LCD data display for, 37, 39
setting Wi-Fi to, 282
A-mount lenses, 237
30mm f/2.8 macro lens, 244
100mm f/2.8 macro lens, 244
macro lenses, 244
micro adjustment with, 254

Android devices, NFC (Near Field Communications) and, 291
angles
 with telephoto lenses, 251
 with wide-angle lenses, 246
Anti Motion Blur mode, 14, 16
 ISO sensitivity and, 143
 Lock-on AF with, 167
 working with, 150–151
aperture. *See also* **f/stops**
 bokeh and, 253
 equivalent exposure and, 122–123
 LCD data display for, 37, 39
 M (Manual) mode and, 136
 for movies, 22
 movies and maximum aperture, 226
Aperture Priority (A) mode. *See* **A (Aperture Priority) mode**
Application List, Application menu, 95–96
Application Management item, 98, 290
Application menu, 95–98
 Application List, 95–96
 Application Management options, 98, 290
 Service Introduction options, 95
 Sony PlayMemories Camera Apps, 97–98
apps
 current Sony apps, 288–290
 downloading, 286–287
APS-C sensors, 29
 Fujian 35mm f/1.7 optic and, 238
 for movies, 224
architectural photography
 falling back effect with wide-angle lenses, 245, 247
 invisible people with long exposures, 181
.ARW files. *See* **RAW formats**
aspect ratio
 Camera Settings menu options, 47–49
 image size options, 47–48
 LCD data display for, 36–37
 for movies, 208
aspherical lens elements, 249

astigmatism, 252
audio, 223–226. *See also* **wind noise reduction**
 Camera Settings menu options for recording, 77
 Signals settings, Setup menu, 106
 tips for, 223–224
 Volume settings, Setup menu, 106
Audio level button, 32, 35
Auto DRO options, Camera Settings menu, 64–65
Auto Flash mode, 274
 Camera Settings menu options, 56–57
Auto HDR
 bracketing with, 139
 Camera Settings menu options, 64–65
 explanation of, 196–198
Auto ISO
 Camera Settings menu options, 60–61
 for movies, 210
 working with, 126–127
Auto modes, 148
 bracketing with, 139
Auto Object Framing
 Camera Settings menu options, 74
 LCD data display for, 37, 39
 working with, 169–170
Auto Portrait Framing option, Camera Settings menu, 74
Auto Review options, Custom Settings menu, 80–81
Auto WB (white balance)
 Camera Settings menu options, 61–64
 working with, 192
AVCHD format, 21–22, 212
 Camera Settings menu options, 54–55
 deleting images by, 99–100
 Demo Mode options, Setup menu, 107–108
 movies captured with, 212
 preparing to use, 207–208
 viewing images by, 100
AWB (Auto WB (white balance)). *See* **Auto WB (white balance)**

B

back focus, 255–256
Background Defocus, 14
 for movies, 209
backlighting, 117
Balluck, Nancy, 241
barrel distortion
 Custom Settings menu options for correcting, 93–94
 with wide-angle lenses, 249
batteries
 charging, 6–7
 compartment door for, 41
 inserting, 6–7
 LCD data display for, 36–37
 for movies, 206
 unpacking, 4
 USB cables, charging with, 6–7
battery chargers, 4–5
BIONZ X chips, 50, 141
black body radiators, 190, 270
black-and-white
 High contrast Monochrome effect, 65, 67
 Rich-tone Monochrome effect, 65, 68
Black & White Creative Style, 203
 Camera Settings menu options, 65
blinkies
 histograms and, 144
 Zebra options, Custom Settings menu, 78–79
blue/amber WB (white balance), 193
Blu-Ray Discs, 212
blurring. *See also* Anti Motion Blur mode
 bokeh, 253–254
 circles of confusion, 158–160
 with long exposures, 183–184
 with telephoto lenses, 252
body cap, 6
 removing, 8
bokeh, 253–254
bottom view of camera, 41

bouncing flash, 276
bowing outward lines. *See* barrel distortion
Bracket Pro app, 289
bracketing. *See also* DRO (D-Range Optimizer)
 base value, adjusting, 140
 Bracket Pro app, 289
 Camera Settings menu options, 56
 single bracket mode, Camera Settings menu, 56
 WB (white balance) bracketing, 57
 working with, 138–140
brightness. *See also* LCD; zebra patterns
 for movies, 209
 Scene (SCN) modes and, 14
buffer and continuous shooting, 189
built-in flash, 20–21, 30, 40, 264
 bouncing flash, 276
 red-eye reduction with, 276
 working with, 274–276
bulb exposures, 180–181
Buono, Alex, 224

C

cables. *See also* HDMI/HDMI cables; USB cables
 Type C cables, 31
Camera Settings menu, 46–78. *See also* Picture Effects
 AF Illuminator options, 60
 Aspect Ratio options, 47–49
 Audio Recording options, 77
 Auto Object Framing options, 74
 Auto Slow Shutter options, 77
 Color Space options, 75–77
 EV (exposure compensation) options, 60
 Face Detection options, 72–73
 FEV (flash exposure compensation) options, 57
 File Format options, 54
 Flash Mode options, 56–57

Focus Area options, 18–19, 59
Focus Magnifier options, 69–71
Focus Mode options, 58–59
High ISO Noise Reduction options, 71–72
Image Size options, 47–48
ISO sensitivity options, 60–61
Lock-on AF options, 72
Metering Mode options, 61
Panorama: Direction options, 53
Panorama: Size options, 52–53
Record Setting options, 54–55
Red-Eye Reduction mode, 57–58
Shoot Mode options, 47
Shooting Tip List, 78
Smile Detection options, 72–73
Soft Skin Effect options, 74
WB (white balance) options, 61–64
Wind Noise Reduction options, 77
camera shake. *See also* **OSS (Optical SteadyShot)**
 movies and, 215
 telephoto lenses and, 251–252
 with wide-angle lenses, 246
capacitors, 264, 274
card readers
 SDXC cards, compatibility with, 9
 transferring images to computer with, 24–25
Carl Zeiss lenses, 227–228
 Sonnar T* 24mm f/1.8 ZA OSS (SEL24F18A) lens, 234
 Sonnar T* 135mm f/1.8 lens, 244
 Touit lenses, 228, 237
 Vario-Tessar E 16-70mm f/4 ZA OSS lens, 228
 Vario-Tessar T* 16-70mm f/4 ZA OSS (SEL1670Z) lens, 233, 244
 Vario-Tessar T* FE 24-70mm f/4 ZA OSS lens, 228
cascades, blurring of, 183–184
catadioptric lenses, 253
Catch Light app, 288
CC (Color Compensation) filters, 194

CCTV lenses, 238–239
Center button, 32, 35
 Custom Key Settings, Custom Settings menu, 90–92
center focus area, 19
 Camera Settings menu option, 59
 working with, 165–166
center metering, 17
 Camera Settings menu option, 61
 EV (exposure compensation) with, 135
 exposure and, 124
 working with, 128, 130
charge lamp, 31
chromatic aberration
 Custom Settings menu options for, 93–94
 with telephoto lenses, 252
 with wide-angle lenses, 248
cinemagraphs, app for creating, 289
Cinematic Photo app, 289
circles of confusion, 158–160
ClearImage Zoom options, Custom Settings menu, 87
close-ups
 lenses for, 242–244
 in movies, 219–220
 with telephoto lenses, 250
Cloudy WB (white balance), 61–62, 192
CMOS sensors, 29
 long exposure noise and, 141
C-mount to E-mount adapters, 238
Collins, Dean, 263
color fringing. *See* **chromatic aberration**
color rendering index (CRI), 273
color space options, Camera Settings menu, 75–77
color temperature, 190. *See also* **degrees Kelvin**
 Camera Settings menu options, 62
 and continuous light, 269–270
 of daylight, 270–271
 of fluorescent light, 272–273
 of incandescent/tungsten light, 271
 setting WB (white balance) by, 194

colors. *See also* peaking colors; saturation
　for movies, 209
　Scene (SCN) modes and, 14
coma, 252
CombineZM, 174
composition in movies, 217–220
compressed perspective with telephoto lenses, 250–251
computers. *See also* transferring images to computer
　formatting memory cards and, 10–11
　Wi-Fi, transferring files by, 282–284
continuous AF (AF-C). *See* AF-C (continuous AF)
continuous light
　basics of, 269–273
　color temperature of, 269–270
　evenness of illumination with, 265
　exposure calculation with, 265
　flash compared, 264–269
　flexibility of, 269
　freezing action with, 269
　previewing with, 265–266
　WB (white balance) of, 268–269, 273
continuous shooting, 55
　self-timer and, 185
　Speed Priority Continuous mode, 55–56, 188
　working with, 185–189
contrast
　Creative Style parameter, 203
　histograms for fixing, 147
　telephoto lenses, problems with, 252–253
contrast detection, 154
control wheel, 34
　LCD data display for, 37–38
converging lines with wide-angle lenses, 248
Creative Styles. *See also* specific styles
　Camera Settings menu options, 65
　contrast parameter, 203
　LCD data display for, 37–38
　for movies, 209

saturation parameter, 203
setting, 189
sharpness parameter, 203
working with, 202–203
crop factor, 228–230
cropping/trimming
　Auto Object Framing and, 170
　crop factor, 228–230
cross fades in movies, 217
CTRL for HDMI options, Setup menu, 109
curvature of field, 252
curvilinear lenses. *See* fisheye lenses
curving inward lines with telephoto lenses, 252
Custom Settings menu, 78–94
　AEL w/Shutter options, 88–89
　AF Micro Adjustment options, 93, 254–257
　Auto Review options, 80–81
　Custom Key Settings, 90–92
　DISP button options, 81–82
　Exposure Settings Guide, 84
　Face Registration options, 90
　Focus Magnifier Time options, 80
　Grid Line options, 80
　Lens Compensation options, 93–94
　Live View Display options, 85
　Movie button options, 92
　Peaking Color options, 83–84
　Peaking Level options, 83
　Pre-AF options, 85
　Release w/o Lens options, 88
　Self-Portrait/-Timer options, 89
　Superior Auto Image Extract options, 90
　Zebra options, 78–79
　Zoom Setting options, 86–88
Custom Setup WB (white balance) options, Camera Settings menu, 62
Custom WB (white balance)
　Camera Settings menu options, 62
　setting, 189–192, 194–195
　steps for setting, 195

D

Dali, Salvador, 177
darkness with long exposures, 183
database indicator in LCD data display, 37, 39
Date Form folder naming, 114
dates and times
 deleting images by, 99–100
 folder names in date form, setting, 114
 Power Save Start Time options, Setup menu, 107–108
 Setup menu options, 111
 viewing images by, 100
dawn, color temperature of, 270–271
daylight, color temperature of, 270–271
Daylight WB (white balance), 61–62, 192
DCIM folder, 113
default settings, resetting, 116
degrees Kelvin, 190
 of continuous light, 270
 of fluorescent light, 272
 previewing, 194
delayed exposures, 185
deleting. *See also* Trash button
 face registration options, Custom Settings menu, 90
 on reviewing images, 80
 Setup menu options for confirming deletes, 107
Demo Mode options, Setup menu, 107–108
depth-of-field (DOF). *See* DOF (depth-of-field)
diag+square grid option, Custom Settings menu, 80
Diana and Holga cameras, 239
Digital Living Network Alliance/DLNA-compatible HDTV, 285–286
digital zoom, 30
 Custom Settings menu options, 87–88
Direct Upload app, 288
direction for Sweep Panorama mode. *See* Sweep Panorama mode
direction keys, 32, 34
DISP button, 32–34
 Custom Settings menu options, 81–82
display all information option, Custom Settings menu, 81–82
Display Media Information options, Setup menu, 115
Display Rotation options, Playback menu, 101
dissolves in movies, 217
distortion. *See also* barrel distortion
 Custom Settings menu options for, 93–94
 movies, panning in, 213
 pincushion distortion with telephoto lenses, 252
 with wide-angle lenses, 246–248
DMF (direct manual focus), 18, 156
 Camera Settings menu options, 59
 working with, 162
DNoise, Topaz, 143
DOF (depth-of-field)
 A (Aperture Priority) mode and, 131–132
 circles of confusion, 158–160
 focus and, 154
 focus stacking and, 172–174
 and movies, 224–225
 with wide-angle lenses, 245, 248
downloading apps, 285–287
Drive Mode button, 32, 35
drive modes. *See also* self-timer
 bracketing choices in, 140
 Camera Settings menu options, 55–56
 LCD data display for, 37–39
DRO (D-Range Optimizer)
 Auto DRO options, Camera Settings menu, 64–65
 Camera Settings menu options, 56, 64–65
 contrast, fixing, 147
 details in shadow areas with, 145
 explanation of, 196–198
 harsh lighting and, 147
 LCD data display for, 37–38
 working with, 195–198

duration of light, 120
dusk, color temperature of, 270–271
DVD-Video discs, 212
DXO Optics Pro version 9, 143
dynamic range. *See also* **DRO (D-Range Optimizer); HDR (High Dynamic Range)**
 limits on, 118

E

editing. *See also* **Adobe Camera Raw**
 Wi-Fi device name, 282
18-percent gray cards. *See* **gray cards**
electrical contacts on lens, 29
E-mount lenses, 227–228. *See also* **Carl Zeiss lenses**
 10-18mm f/4 OSS (SEL1018) lens, 232, 242
 16mm f/2.8 (SEL16F28) lens, 231
 16-50mm PZ OSS f/3.5-5.6 (SELP-1650) lens, 230–231
 18-55mm OSS f/3.5-5.6 (SEL-1855) lens, 231
 18-105mm f/4 G PZ OSS (SELF19105T) lens, 232
 18-200mm f/3.5-6.3 OSS (SEL18200) lens, 232–233
 20mm f/2.8 (SEL20F28) lens, 232
 28-70mm f/3.5-5.6 OSS FE lens, 228
 30mm f/3.5 Macro (SEL30M35) lens, 233
 35mm f/1.8 OSS (SEL35F18) lens, 232
 50mm f/1.4 lens, 244
 50mm f/1.8 OSS (SEL50F18) lens, 232
 55-210mm f/4.5-6.3 OSS (SEL55210) lens, 233
 Lensbabies and, 240
 Nikon-to-E-Mount adapter, 238
 for speed, 244
Enhance, Topaz, 143
Enlarge Image options, Playback menu, 102–103

equivalent exposure, 122–123
establishing shots in movies, 218–219
EV (exposure compensation). *See also* **FEV (flash exposure compensation)**
 adjusting, 135
 Camera Settings menu options, 60
 ISO sensitivity adjustments and, 138
 LCD data display for, 37, 39
 for movies, 213
EV (exposure compensation) button, 32, 35
evenness of illumination
 with continuous light, 265
 with flash, 267
exposure. *See also* **bracketing; EV (exposure compensation); histograms; overexposure; underexposure**
 calculation of, 123–126
 continuous light, calculating with, 265
 correct exposure, example of, 123–124
 Custom Settings menu, Exposure Settings Guide in, 84
 delayed exposures, 185
 equivalent exposure, 122–123
 explanation of, 118–122
 flash, calculating with, 265
 long exposure noise, 141–143
 mid-tones, metering of, 125–126
 short exposures, 176–179
 working with exposure modes, 131–138
exposure compensation (EV). *See* **EV (exposure compensation)**
extreme close-ups in movies, 219–220
Eye-Fi cards
 transferring images to computer with, 25–26
 Upload Settings options, Setup menu, 107

F

Face Detection mode
 Auto Object Framing options, Camera Settings menu, 74
 LCD data display for, 37, 39
 Lock-on AF with, 168
 working with, 167

Face Priority Tracking, Lock-on AF with, 168

Face Registration mode
 Custom Settings menu options, 90
 Order Exchanging option, 169
 working with, 169

faces. *See also* **Face Detection mode; Face Registration mode**
 Face Priority Tracking, Lock-on AF with, 168
 flat faces with telephoto lenses, 252

falling back effect with wide-angle lenses, 245, 247

FAT16 file format, 207

FAT32 file format, 207

FE-mount lenses, 227

FEV (flash exposure value/compensation)
 Camera Settings menu options, 57
 LCD data display for, 36–37
 working with, 276

field of view
 equivalency factor, 228
 with wide-angle lenses, 245

file formats. *See also* **AVCHD format; MP4 format**
 for movies, 207–208

File Number options, Setup menu, 112

fill flash/fill light, 274–275
 Camera Settings menu options, 56–57
 for movies, 221

filters. *See also* **polarizing filters**
 Camera Settings menu options, 62
 CC (Color Compensation) filters, 194
 invisible people with neutral-density (ND) filters, 181
 UV filters with telephoto lenses, 253
 wide-angle lenses, light/dark areas with, 250

final setup, 7–10
Finelight Studios, 263
fine-tuning lenses, focus of, 254–259
firmware version options, Setup menu, 115
first-curtain sync, 274–275
fisheye lenses, 231, 244
 16mm f/2.8 fisheye lens, 242
 working with, 249

flare with telephoto lenses, 253

flash. *See also* **built-in flash; FEV (flash exposure compensation); fill flash/fill light**
 basics of, 273–276
 continuous light compared, 264–269
 evenness of illumination with, 267
 explanation of, 274–276
 exposure calculation with, 265
 flexibility of, 269
 freezing action with, 177, 267–268
 LCD data display for flash modes, 37–39
 previewing with, 265
 red-eye reduction with, 276
 Scene (SCN) modes and, 14
 studio flash, M (Manual) mode with, 136
 telephoto lenses, dark photos with, 253

flash exposure compensation (FEV). *See* **FEV (flash exposure compensation)**

Flash Off mode, 274
 Camera Settings menu options, 56–57

Flash pop-up button, 32–33

Flash WB (white balance), 61–62, 192

flat faces with telephoto lenses, 252

flat lighting for movies, 221–222

flexibility
 of continuous light, 269
 of flash, 269

Flexible Spot, 19
 Camera Settings menu option, 59
 direction keys with, 34
 for movies, 208–209
 positioning focus detection with, 159
 spot metering and, 129
 working with, 166

flicker, 211
Flickr Add-On app, 288
fluorescent light, color temperature of, 272–273
Fluorescent WB (white balance), 61–62, 192
focal lengths, 175
 crop factor and, 228–230
 multiplier, 228–230
focal planes, 40
focus. *See also* AF (autofocus); focus modes; MF (manual focus); selective focus
 circles of confusion, 158–160
 explanation of, 153–156
focus areas. *See also* center focus area; Face Detection mode; Flexible Spot; wide focus area; zone focus area
 AF Lock and, 171
 Camera Settings menu options, 59
 LCD data display for, 37, 39
 limitations of, 166
 phase detection and, 156
 selecting, 18–19
 setting, 164–168
focus detection points. *See* focus areas
focus indicator, LCD data display for, 37, 39
focus magnifier
 Camera Settings menu options, 69–71
 Custom Settings menu time options, 80
 steps for using, 70–71
focus modes, 156–157
 LCD data display for, 37, 39
 options for, 162–164
 selecting, 17–18
focus peaking. *See* peaking levels
focus points, 159–160
focus rings, MF (manual focus) and, 161–162
focus stacking, 172–174
focus tracking, LCD data display for, 37, 39
FocusChart.pdf, 257–259

foggy contrast with telephoto lenses, 252–253
folders
 Date Form, naming folder in, 114
 deleting images in, 99–100
 Name options, Setup menu, 113–114
 New Folder options, Setup menu, 113
 Select REC Folder options, Setup menu, 113
 viewing images by, 100
foregrounds
 with telephoto lenses, 250–251
 with wide-angle lenses, 246
foreign languages
 apps in, 288
 Setup menu options, 110–111
formatting memory cards. *See* memory cards
4K Still Image Playback options, Playback menu, 102
frame rates
 LCD data display for, 36–37
 for movies, 211–212
framing. *See also* Auto Object Framing
 Auto Portrait Framing option, Camera Settings menu, 74
freezing action
 with continuous light, 269
 with flash, 177, 267–268
 OSS (Optical SteadyShot) and, 260
 S (Shutter Priority) mode and, 133–134
 with short exposures, 176–179
front focus, 255–256
front view of camera, 26–32
f/stops
 bokeh and, 253
 equivalent exposure and, 122–123
 explanation of, 122
Fujian 35mm f/1.7 optic, 238

G

GE color rendering index (CRI), 273
Gefen HDMI to Composite Scaler, 32
ghost images
 with flash, 267
 with second-curtain sync, 274–275
ghoul lighting for movies, 223
Goddard, Jean-Luc, 218
Google's Nik Dfine, 143
graphic display options, Custom Settings menu, 81–82
gray cards, 123–126
 confusion about, 126
 mid-tones, metering of, 125–126
green/magenta WB (white balance), 194
grids. *See also* Rule of Thirds grids
 display options, Custom Settings menu, 80

H

Halsman, Philippe, 177
hand grip, 28–29
Hand-held Twilight mode, 14, 15
 ISO sensitivity and, 143
 Lock-on AF with, 167
 working with, 149–151
hard light for movies, 221
Hasselblad H4D-50 camera, 230
hazy contrast with telephoto lenses, 252–253
HDMI/HDMI cables
 micro HDMI port, 31–32
 Setup menu options, 109
 television, connecting, 285
HDR (High Dynamic Range), 118–119. *See also* Auto HDR; Merge to HDR
 bracketing and, 138, 140
 Camera Settings menu options, 64–65
 focus stacking and, 172
 post-processing, creating HDR photos in, 198–202

HDR Painting effect, 65, 67
HDTV, viewing images on, 282, 285–286
Helicon Focus, 174
Help button options, Custom Settings menu, 90–92
Help Guide, 43
High contrast Monochrome effect, 65, 67
high ISO noise
 Camera Settings menu options, 71–72
 dealing with, 141–142
highlights. *See also* histograms
 Zebra options, Custom Settings menu, 78–79
histograms, 143–147
 contrast, histograms for fixing, 147
 DISP button options, Custom Settings menu, 81–82
 interpretation of, 145–147
 live histograms, 143–144
 overexposure, histogram showing, 146–147
 playback histograms, 144–145
 underexposure, histogram showing, 145–146
horizontal composition in movies, 217

I

icons for menus, 46
ID Photo app, 288
Illustration effect, 65, 68
Image Data Converter, 195
 noise reduction with, 143
 overriding RAW settings with, 50–51
image editors. *See also* Adobe Camera Raw; Adobe Photoshop/Photoshop Elements
 red-eye reduction with, 57
image quality
 Camera Settings menu options, 49–52
 LCD data display for, 36–37
image review. *See* reviewing images

image size options, Camera Settings menu, 47–48
image stabilization (IS). *See* OSS (Optical SteadyShot)
iMovie, 224
In-camera guide button, 32, 35
Incandescent WB (white balance), 192
incandescent/tungsten light
 color temperature of, 271
 degrees Kelvin of, 270
index view. *See* thumbnails
information display in LCD, 36–38
initial setup, 6–7
instruction manuals, 6
 Help Guide, 43
Intelligent Auto mode, 14
 working with, 148
interlaced scanning, 211–212
interline twitter, 210
inverse square law, 267
IP address for Wi-Fi network, 279–280
IRE (Institute of Radio Engineers), 78
ISO sensitivity. *See also* Auto ISO; high ISO noise
 adjusting, 19
 Camera Settings menu options, 60–61
 DRO (D-Range Optimizer) and, 196
 importance of, 126–127
 LCD data display for, 37–38
 M (Manual) mode, adjusting exposure with ISO in, 127, 138
 for movies, 209
 pixels, minimizing/maximizing, 121
 superior image quality with, 143
ISO sensitivity button, 32, 35

J

Jello effect in movies, 213
JPEG formats. *See also* DRO (D-Range Optimizer); RAW+JPEG format
 bracketing with, 139
 Camera Settings menu options, 49–52
 for continuous shooting, 188–189
 HDTV, transferring files to, 285
 image size options, Camera Settings menu, 47–48
 long exposure noise and, 141
 RAW formats compared, 50–52
 shots remaining with, 12–13
judder, 212
jump cuts in movies, 218
jumping photos, 177

K

Kelvin scale. *See* degrees Kelvin
Kinkade, Thomas, 263

L

LA-EA series lens adapters, 234–237
Landscape Creative Style, 202
 Camera Settings menu options, 65
Landscape mode, 14–15
 flash with, 14
 working with, 149
landscape photography, invisible people with long exposures, 181
languages. *See* foreign languages
large subjects with wide-angle lenses, 246
lateral/transverse chromatic aberration, 248
LCD, 32–33. *See also* histograms
 brightness
 histograms, effect on, 143
 Setup menu options, 104–106
 Focus Magnifier options, Camera Settings menu, 69–71
 information displays, 36–38
 Sunny Weather setting, Setup menu, 104–105

Leaf Aptus II digital backs, 230
LED video lights, 220–221
Left/Right/Down buttons options, Custom Settings menu, 90–92
lens adapters, 227
 C-mount to E-mount adapters, 238
 with DT 11-18mm f/4.5-5.6 ultra-wide zoom lens, 244
 flange to sensor distance, 237
 micro adjustment with, 254
 Nikon-to-E-Mount adapter, 238
 weight and, 237
 working with, 234–237
lens bayonet mount, 29
Lens Compensation app, 290
lens hoods, 8–9
 flare, reduction of, 253
lens mount index mark, 29
Lens release button, 28–29
lens release locking pin, 28–29
Lensbabies
 Composer Pro, 239–240
 models of, 240–241
 Release w/o Lens options, Custom Settings menu, 88
 working with, 239–242
lenses, 227–262. *See also* A-mount lenses; Carl Zeiss lenses; E-mount lenses; f/stops; lens adapters; OSS (Optical SteadyShot)
 capabilities of, 242–244
 categories of, 245
 for close-ups, 242–244
 crop factor and, 228–230
 current focus, evaluating, 257–259
 fine-tuning focus of, 254–259
 Lens Compensation app, 290
 light passed by, 120–121
 mounting, 7–9
 for movies, 224–226
 Release w/o Lens options, Custom Settings menu, 88
 for sharpness, 244
 for speed, 244

light, 263–276. *See also* continuous light; exposure; fill flash/fill light; flash; incandescent/tungsten light
 duration of, 120
 emitted light, 120
 fluorescent light, color temperature of, 272–273
 lens, light passed by, 120–121
 for movies, 220–223
 Portrait Lighting app, 290
 reflected light, 120
 sensors, light captured by, 121
 shutter, light passing through, 120
 source, light at, 120
 transmitted light, 120
light meter and bulb exposures, 181
Light Shaft app, 290
light trails with long exposures, 182–183
linearity of lenses and movies, 226
lithium-ion batteries. *See* batteries
live histograms, 143–144
live view options, Custom Settings, 85
Lock-on AF, 171
 Camera Settings menu options, 72
 working with, 167–168
Lomo cameras, 239
lomography, 239
long exposure noise, 141–143
long exposures, 179–181
 bulb exposures, 180–181
 long exposure noise, 141–143
 timed exposures, 179–180
 working with, 181–184
longitudinal/axial chromatic aberration, 248
lossless compression, 51
LUN Settings, Setup menu, 110

M

M (Manual) mode, 16
 basic techniques with, 136–137
 bracketing in, 140
 DRO (D-Range Optimizer) with, 195
 focus areas in, 18
 ISO sensitivity changes and, 127, 138
 for movies, 210
 working with, 135–138
Macro mode, 15
 working with, 149
Mamiya 645DF camera, 230
manual focus (MF). *See* **MF (manual focus)**
maximum aperture and movies, 226
media information, displaying, 115
medium shots in movies, 218–219
megapixel options, Camera Settings menu, 47–48
memory cards. *See also* **Eye-Fi cards; transferring images to computer**
 formatting, 10–13
 Setup menu options, 11–13, 111–112
 steps for, 11–13
 by transferring files to computer, 10
 inserting, 9–10
 LCD data display for, 36–37
 for movies, 206
 NO CARD warning, 9
 slot for, 31–32
 typical shots with, 12–13
Memory Stick cards. *See* **memory cards**
MENU button
 navigating in menus with, 44–46
 reviewing images with, 23
menus. *See also* **specific menus**
 grayed out items, 45–46
 mountain icon, description of, 46
 navigating through, 44–46
 structure of, 43–44

mercury vapor light, 273
Merge to HDR, 140, 198–202
 steps for using, 199–201
Metabones
 Canon EF-to-Sony Smart Adapter, 238
 Speed Booster lens adapter, 238
metering modes. *See also* **center metering; multi metering; spot metering**
 Camera Settings menu options, 61
 LCD data display for, 36–37
 for movies, 209
 selecting, 17
 working with, 127–130
MF (manual focus), 18. *See also* **DMF (direct manual focus); MF assist**
 advantages/disadvantages of, 157–158
 Camera Settings menu options, 59
 flexibility with, 156–157
 with focus magnifier, 70
 steps for using, 161–162
 working with, 161–162
MF assist
 Custom Settings menu options, 79
 with focus magnifier, 70–71
microphones, 40. *See also* **wind noise reduction**
mid-tones, metering of, 125–126
Miniature effect, 65, 68
Minolta Maxxum 7000 lens, 228
mirror lenses, 253
modeling light, 274
monitor. *See* **LCD**
motion. *See also* **blurring; freezing action**
 Sweep Panorama mode and, 152
Motion Shot app, 290
motor drive. *See* **continuous shooting**
mountain icon, description of, 46

mounting lenses, 7–9
Movie button, 206
 Custom Settings menu options, 92
Movie mode, 16
Movie record button, 32–33
movies, 205–226. *See also* **audio**
 AE-L/AF-L lock for, 213
 AF (autofocus) for, 208
 aperture for, 22
 aspect ratio for, 208
 Auto ISO for, 210
 batteries for, 206
 camera shake and, 215
 composition in, 217–220
 creative lighting for, 221
 Creative Styles for, 209
 DOF (depth-of-field) and, 224–225
 EV (exposure compensation) for, 213
 file formats for, 207–208
 Flexible Spot for, 208–209
 frame rates for, 211–212
 fundamentals of making, 205–207
 introduction to, 21–22
 ISO sensitivity for, 209
 Jello effect in, 213
 LCD data display for, 36–37
 lenses for, 224–226
 lighting for, 220–223
 memory cards for, 206
 metering modes for, 209
 noise and, 206
 overheating and, 206
 panning in, 213
 Picture Effects for, 209
 preparing to shoot, 207–211
 previewing aspect ratio for, 208
 Record button for, 210–211
 record setting for, 207–208
 rolling distortion in, 213
 sensors for, 224–225
 shooting modes for, 210
 shooting scripts for, 215
 shot types in, 218–220
 shutter speed for, 22
 side space in, 217–218
 steps for making, 212–213
 storyboards for, 215–216
 storytelling in, 215–216
 styles of lighting for, 221–222
 thumbnails depicting, 24
 time dimension in, 218
 tips for shooting, 214–226
 transitions in, 217–218
 29-minute limit on, 207
 viewing clips, 22
 WB (white balance) for, 209
 zoom lenses for, 225–226
 zooming in/out in, 206, 212
MP4 format, 21–22
 Camera Settings menu options, 54–55
 movies captured with, 212
 preparing to use, 207–208
 viewing images by, 100
MTP (Media Transfer Protocol) options, Setup menu, 110
Multi Frame Noise Reduction app, 288–289
multi metering, 17
 Camera Settings menu option, 61
 EV (exposure compensation) with, 135
 exposure and, 124
 working with, 128–129
multi/micro USB port. *See* **USB cables**
Multiple Exposure app, 290
multiple images, deleting, 99

N

N Mark, 29
naming/renaming
 Folder Name options, Setup menu, 113–114
 Wi-Fi device name, editing, 282
natural sounds, recording, 223
Near Field Communications (NFC). *See* NFC (Near Field Communications)
neck/shoulder straps, 5
neutral-density (ND) filters, invisible people with long exposures, 181
newegg.com, 32
Newton, Isaac, 267
NFC (Near Field Communications), 29, 277, 282
 explanation of, 291
 LCD data display for, 36–37
Night Portrait mode, 16
 working with, 149
Night Scene mode, 15
 flash with, 14
 working with, 149
night with long exposures, 183
Nik
 Dfine, 143
 HDR Efex Pro, 198
Nikon-to-E-Mount adapter, 227, 238
Nixon, Richard, 177
NO CARD warning, 9
no display information, Custom Settings menu, 81–82
noise, 71. *See also* high ISO noise; wind noise reduction
 dealing with, 140–143
 long exposure noise, 141–143
 movies and, 206
 Multi Frame Noise Reduction app, 288–289
Noise Ninja, 143
normal lenses, 245
Novoflex lens adapters, 238
NTSC video standard, 55, 211

O

One-Touch. *See* NFC (Near Field Communications)
On/Off switch, 10, 28–29, 40
Optical SteadyShot (OSS). *See* OSS (Optical SteadyShot)
Optical Zoom Only option, Custom Settings menu, 86–87
OSS (Optical SteadyShot), 4
 Camera Settings menu options, 74–75
 with telephoto lenses, 251–252
 working with, 260–261
outdoor lighting for movies, 223
overexposure, 124
 backlighting and, 117
 example of, 118–119
 histogram showing, 146–147
overheating and movies, 206
over-the-shoulder shots in movies, 219–220

P

P (Program) mode, 14, 16
 DRO (D-Range Optimizer) with, 195
 equivalent exposure and, 122
 focus areas in, 18
 ISO sensitivity changes and, 127
 for movies, 210
 working with, 134
PAL video standard, 55, 211
panning in movies, 213
Panorama mode. *See* Sweep Panorama mode
Partial Color effect, 65, 67
passwords. *See* Wi-Fi
peaking colors
 Custom Settings menu options, 83–84
 MF (manual focus) and, 162
peaking levels
 Custom Settings menu options, 83
 with focus magnifier, 70

Pentax K lenses, 227
perspectives
 compressed perspective with telephoto lenses, 250–251
 lenses for, 244
 short exposures, unseen perspectives with, 178–179
phase detection, 154–155
 advantages of, 155–156
Photo Creativity menu, 34
 for movies, 209–210
Photo Ninja, 143
Photo Retouch app, 289
PhotoAcute, 174
Photomatix Pro, 198–202
Photoshop/Photoshop Elements. *See* **Adobe Photoshop/Photoshop Elements**
Pict-Bridge compatible printers. *See* **printers/printing**
Picture Effect+ app, 288
Picture Effects, 14, 65–68
 DRO (D-Range Optimizer) and, 195–196
 LCD data display for, 37–38
 for movies, 209
pincushion distortion with telephoto lenses, 252
Pixel Super Resolution Technology with Auto Object Framing, 170
pixels. *See also* **cropping/trimming; histograms**
 megapixel options, Camera Settings menu, 47–48
 By Pixel Super Resolution Technology, 74
Playback button, 22, 32, 34
Playback menu, 99–104
 Delete options, 99–100
 Display Rotating options, 101
 Enlarge Image options, 102–103
 4K Still Image Playback options, 102
 Image Index options, 100
 Protect options, 103
 Rotate options, 102
 Slide Show options, 102
 Specify Printing options, 104
 View Mode options, 100
playing back images. *See* **Playback menu; reviewing images**
PMB (Picture Motion Browser), 212
polarizing filters
 with telephoto lenses, 253
 wide-angle lenses, light/dark areas with, 250
Pop Color effect, 65–66
pop-up flash. *See* **built-in flash**
port cover, 30–31
Portrait Creative Style, 202
 Camera Settings menu options, 65
Portrait Lighting app, 290
Portrait mode, 14–15
 working with, 148–149
portraits
 Auto Portrait Framing option, Camera Settings menu, 74
 flat faces with telephoto lenses, 252
 Portrait Lighting app, 290
 Self-Portrait/-Timer options, Custom Settings menu, 89
Posterization effect, 65–66
power. *See also* **batteries**
 On/Off switch, 10, 28–29, 40
 Setup menu's Power Save Start Time options, 107–108
power zoom
 lenses for movies, 226
 lever, 30
Pre-AF options, Custom Settings menu, 85
previewing
 with continuous light, 265–266
 degrees Kelvin, 194
 with flash, 265
 movies, aspect ratio for, 208

printers/printing, 24
 color spaces and, 76
 Specify Printing options, Playback menu, 104
progressive scanning, 211
Protect options, Playback menu, 103

Q

quartz-halogen/quartz-iodine light, 271
Quick Charger, 4–5, 7

R

rangefinder system, 155
RAW formats. *See also* Adobe Camera Raw; RAW+JPEG format
 bracketing with, 139
 Camera Settings menu options, 49–52
 dynamic range effects for, 195
 high ISO noise and, 72, 141
 image size options, Camera Settings menu, 47–48
 JPEG formats compared, 50–52
 shots remaining with, 12–13
 WB (white balance), adjusting, 51, 64, 273
RAW+JPEG format
 advantages of, 52
 Camera Settings menu options, 49–52
 for continuous shooting, 189
 image size options, Camera Settings menu, 47–48
rear lens cap, removing, 8
rear view of camera, 32–35
rear-curtain sync. *See* second-curtain sync
Record button for movies, 210–211
Recover Image Database options, Setup menu, 114
rectilinear lenses, 249
red-eye reduction
 with built-in flash, 276
 Camera Settings menu options, 57–58

reflected light, 120
reflectors for movies, 223
registration. *See also* Face Registration mode
 Wi-Fi, manual registration of, 278–282
Release w/o Lens options, Custom Settings menu, 88
remaining shots. *See* shots remaining
Rembrandt, 263
remote control
 PC Remote options, Setup menu, 110
 Smart remote app, 289
renaming. *See* naming/renaming
resolution
 HDMI Resolution options, Setup menu, 109
 image size options, Camera Settings menu, 47–48
 By Pixel Super Resolution Technology, 74
Retro Photo effect, 65–66
revealing images with short exposures, 177
reviewing images, 22–24. *See also* Playback menu
 Auto Review options, Custom Settings menu, 80–81
 deleting on, 80
 histograms for, 144–145
 movie clips, viewing, 22
 zooming in/out on, 23
Rich-tone Monochrome effect, 65, 68
Ritchie, Guy, 218
rolling distortion in movies, 213
rotating images
 Display Rotation options, Playback menu, 101
 Playback menu options, 102
Rule of Thirds grids
 for Auto Object Framing, 74
 Custom Settings menu option, 80

S

S (Shutter Priority) mode, 14, 16
 bracketing in, 140
 DRO (D-Range Optimizer) with, 195
 equivalent exposure and, 122–123
 focus areas in, 18
 ISO sensitivity changes and, 127
 for movies, 210
 Panorama mode with, 46
 working with, 133–134
SAM lenses, 244
saturation
 Creative Style parameter, 203
 for movies, 209
Scene (SCN) modes, 1–2, 148–151. *See also* **specific modes**
 bracketing with, 139
 focus areas in, 18
Scene Selection screen, 1, 13
SCN (Scene) modes. *See* **Scene (SCN) modes**
Scout Lensbaby, 240
SDHC cards. *See* **memory cards**
SDXC cards. *See also* **memory cards**
 card reader compatibility with, 9
seamless transitions in movies, 218
second-curtain sync
 Camera Settings menu options, 56–57
 ghost images and, 274–275
Secure Digital cards. *See* **memory cards**
selective focus
 bokeh and, 254
 with telephoto lenses, 250–251
Self-Portrait/-Timer options, Custom Settings menu, 89
self-timer, 19–20
 Camera Settings menu options, 56
 Self-Portrait/-Timer options, Custom Settings menu, 89
 working with, 185
Self-timer lamp, 28–29

sensors, 29. *See also* **APS-C sensors; CMOS sensors; ISO sensitivity**
 crop factor and, 228–230
 explanation of, 159–160
 focal planes, 40
 light captured by, 121
 for movies, 224–225
separately recording audio, 224
Sepia Creative Style, 65
sequential scanning, 211
setting effects, LCD data display for, 37, 39
Setting Reset options, Setup menu, 116
setup
 final setup, 7–10
 initial setup, 6–7
Setup menu, 104–116
 Area Setting, 111
 Audio Signals settings, 106
 CTRL for HDMI options, 109
 Date/Time Setup options, 111
 Delete Confirm options, 107
 Demo Mode options, 107–108
 Display Media Information options, 115
 File Number options, 112
 Folder Name options, 113–114
 Format options, 11–13, 111–112
 HDMI Resolution options, 109
 Language options, 110–111
 Monitor Brightness options, 104–106
 New Folder options, 113
 Power Save Start Time options, 107–108
 Recover Image Database options, 114
 Select REC Folder options, 113
 Setting Reset options, 116
 Tile Menu settings, 106
 Upload Settings options, 107
 USB Connection options, 109–110
 USB LUN Settings, 110
 Version options, 115
 Volume settings, 106

Shade WB (white balance), 61–62, 192
shading compensation options, Custom Settings menu options, 93–94
sharpness
 Creative Style parameter, 203
 lenses for, 244
shooting modes. *See also* Scene (SCN) modes
 Camera Settings menu options, 47
 LCD data display for, 36–37
 for movies, 210
 selecting, 13–16
shooting scripts for movies, 215
Shooting Tip List, Camera Settings menu, 78
short exposures, 176–179
shots remaining
 LCD data display for, 36–37
 memory cards, typical shots with, 12–13
shoulder straps, 5
shutter. *See also* shutter speed
 light passing through, 120
Shutter Priority (A) mode. *See* S (Shutter Priority) mode
Shutter release button, 28–29, 40–41
shutter speed. *See also* sync speed
 A (Aperture Priority) mode and, 132
 Auto Slow Shutter options, Camera Settings menu, 77
 equivalent exposure and, 122–123
 explanation of, 122
 LCD data display for, 37, 39
 M (Manual) mode and, 136
 for movies, 22
 S (Shutter Priority) mode and, 133–134
 short exposures, 176–179
Sigma lenses, 237
silhouettes
 histograms for, 147
 underexposure for, 117
single-shot AF (AF-S). *See* AF-S (single-shot AF)

sizing/resizing
 image size options, Camera Settings menu, 47–48
 Panorama: Size options, Camera Settings menu, 52–53
slave triggers and M (Manual) mode, 136
Slide Show options, Playback menu, 102
slow sync, 274
 Camera Settings menu options, 56–57
smart devices, Wi-Fi for transferring files to, 282–283
Smart remote app, 289
Smile Detection, LCD data display for, 37, 39
Smile Shutter
 bracketing with, 139
 Camera Settings menu options, 73
 working with, 169
Snapshot Me app, 288
sodium-vapor light, 272–273
Soft Focus effect, 65, 67
Soft High-key effect, 65, 67
soft light for movies, 221
Soft Skin Effect options, Camera Settings menu, 74
software. *See also* Adobe Camera Raw; Adobe Photoshop/Photoshop Elements; Image Data Converter
 application software, 6
 computer-editing software, 211–212
 PMB (Picture Motion Browser), 212
 security software, bypassing, 285
Sony a5000
 bottom view of, 41
 front view of, 26–32
 rear view of, 32–35
 top view of, 40–41
 unpacking, 4
Sony Bravia protocol, 32
Sony Entertainment Network, setting up accounts with, 95

Sony PlayMemories Camera Apps, 95
 Application menu options, 97–98
 website, 286
Sony PlayMemories Home
 for movie editing, 208
 Wi-Fi, transferring files by, 284
source, light at, 120
Specify Printing options, Playback menu, 104
speed. *See also* **shutter speed; sync speed**
 lenses for, 244
 OSS (Optical SteadyShot) and, 260
Speed Booster lens adapter, 238
Speed Priority Continuous mode, 55–56, 188
spherical aberration, 252
 and bokeh, 253–254
Sports Action mode, 14, 15
 flash with, 14
 working with, 149
sports photography
 continuous shooting and, 185–189
 JPEG formats for, 52
 short exposures for, 176–179
 telephoto lenses for, 250
spot metering, 17
 Camera Settings menu option, 61
 EV (exposure compensation) with, 135
 exposure and, 126
 working with, 129–130
square grid option, Custom Settings menu, 80
Squeeze Spark Lensbaby, 240
sRGB color space, 75–77
SSM lenses, 244
Standard Creative Style, 202
 Camera Settings menu options, 65
Standard Form folder naming, 113–114
SteadyShot. *See also* **OSS (Optical SteadyShot)**
 Camera Settings menu options, 74–75
 LCD data display for, 37–38

Stegmeyer, Al, 5
stepping back effect with wide-angle lenses, 245, 247
stills. *See* **Playback menu**
Stop Motion app, 288
stopping action. *See* **freezing action**
storyboards for movies, 215–216
storytelling in movies, 215–216
streaks with long exposures, 181–182
studio flash, M (Manual) mode with, 136
Sunset Creative Style, 203
 Camera Settings menu options, 65
Sunset mode, 14, 15
 flash with, 14
 working with, 149
super telephoto lenses, 245
Superior Auto mode, 2, 14–15
 Custom Settings menu options, 90
 working with, 148
svideo.com, 32
Sweep Panorama mode, 14, 16
 bracketing with, 139
 direction
 Camera Settings menu options, 53
 selecting, 151
 menus for, 45–46
 motion and, 152
 setting changes in, 151
 Size options, Camera Settings menu, 52–53
 working with, 151–152
Swivel Series, Composer Pro, 240
Sylvania color rendering index (CRI), 273
sync speed. *See also* **second-curtain sync; slow sync**
 first-curtain sync, 274–275
 flash and, 267

T

Tamron lenses
 8mm f/1.4 lens, 238
 18-200mm f/3.5-6.3 Di III VC lens, 237
target frame, 167
telephoto lenses, 245
 and bokeh, 253–254
 problems, avoiding, 252–253
 working with, 250–251
television, viewing images on, 282, 285–286
three shots in movies, 220
three-point lighting for movies, 221–222
thumbnails
 movie clips, use for, 24
 Playback menu options, 100
 reviewing images as, 23–24
TIF format, 50
Tile Menu settings, Setup menu, 106
Time Laps LE app, 288
Time Lapse app, 289–290
time zones, Setup menu for setting, 111
timed exposures, 179–180
times. *See* **dates and times**
top view of camera, 40–41
Topaz
 DNoise, 143
 Enhance, 143
Toy Camera effect, 65–66
transferring images to computer, 24–26
 with card readers, 24–25
 with USB cables, 24–25
 Wi-Fi, transferring files by, 282–284
 wireless file transfers, 25–26
transitions in movies, 217–218
Translucent Mirror Technology, 235
transmitted light, 120
Trash button, 32, 35
 Custom Key Settings, Custom Settings menu, 90–92

trimming. *See* **cropping/trimming**
tripods
 for long exposures, 179
 for movies, 215
 socket for, 41
tungsten light. *See* **incandescent/tungsten light**
tungsten-halogen light, 271
12-percent gray cards. *See* **gray cards**
29-minute limit on movies, 207
two shots in movies, 219–220
Type C cables, 31

U

ultra-wide-angle lenses, 245
underexposure, 125
 example of, 118–119
 histogram showing, 145–146
 for silhouette effect, 117
Underwater Auto WB (white balance), 62–63
unpacking box, 3–6
unreal images with short exposures, 177–178
Upload Settings options, Setup menu, 107
UPstrap, 5
USB cables
 apps, downloading, 287
 charging batteries with, 6–7
 LUN Settings, Setup menu, 110
 mass storage options, 109
 MTP (Media Transfer Protocol) options, Setup menu, 110
 PC Remote options, Setup menu, 110
 port for, 31
 Setup menu connection options, 109–110
 transferring images to computer with, 24–25
 unpacking, 4
UV filters with telephoto lenses, 253

V

VCL-ECF1 fisheye conversion lens, 231, 242
Version options, Setup menu, 115
vertical composition in movies, 217
VGA format for movies, 208
video. *See* movies
View Mode options, Playback menu, 100
Vivid Creative Style, 202
 Camera Settings menu options, 65
Vividness, 14
Volume settings, Setup menu, 106

W

Watercolor effect, 65, 68
waterfalls/cascades, blurring of, 183–184
WB (white balance), 19. *See also* Auto WB (white balance); Custom WB (white balance)
 biasing WB (white balance), 193
 bracketing, 56
 Camera Settings menu options, 61–64
 color temperature, setting WB by, 194
 continuous light and, 269–270, 273
 cooler/warmer WB (white balance), 193
 Custom Setup WB (white balance), 62
 fine-tuning, 193–194
 LCD data display for, 37–38
 mismatched settings, 190–191
 for movies, 209
 RAW formats, adjusting in, 51, 64, 273
WBB (white balance bracketing) options, Camera Settings menu, 57
wedding photography, JPEG formats for, 52
weight and lens adapters, 237
White, Jack and Meg, 239
white balance (WB). *See* WB (white balance)
white balance bracketing (WBB), 57

wide focus area, 18
 Camera Settings menu option, 59
 working with, 164
wide-angle lenses, 245
 problems, avoiding, 248–250
 working with, 245–248
Wi-Fi. *See also* apps
 access point, manually selecting, 280–282
 battery use and, 6
 connecting, 277–278
 editing device name, 282
 functions of, 282
 LCD data display for, 36–37
 MAC Address, displaying, 282
 manual registration, 278–282
 passwords
 for network, 279
 resetting, 282
 SSID/PW Reset, 282
 television, viewing images on, 282, 285–286
 transferring images to computer with, 25–26
 Upload Settings options, Setup menu, 107
Wi-Fi Direct, 285
Wi-Fi Positioning System (WPS), 277–278
 WPS Push, 278, 282
wildlife photography, telephoto lenses for, 250
wind noise reduction, 224
 Camera Settings menu options, 77
Windows Movie Maker, 224
Windsor, Duke and Duchess of, 177
wipes in movies, 217
WPS (Wi-Fi Positioning System), 277–278
 WPS Push tactic, 278, 282
W/T (Wide/Telephoto) switch, 102

Y

YouTube videos, vertical composition in, 217

Z

zebra patterns
 Custom Settings menu options, 78–79
 histograms and, 144

Zeiss lenses. *See* **Carl Zeiss lenses**

zone focus area, 19
 Camera Settings menu option, 59
 working with, 165

zoom lenses, 245
 focus rings on, 161
 for movies, 225–226
 power zoom lever, 30

zoom range for movies, 226

zooming in/out. *See also* **digital zoom; power zoom**
 Custom Settings menu options, 86–88
 LCD data display for, 37, 39
 in movies, 206, 212
 on reviewing images, 23

Like the Book?

Let us know on Facebook or Twitter!

facebook.com/cengagelearningptr

www.twitter.com/cengageptr

Like us on Facebook or Follow us on Twitter to learn about upcoming books, promotions, contests, events and more!

NEED HELP SELECTING A LENS? LET DAVID BUSCH HELP!

The new **FREE** David Busch Lens Finder app for iPhone/iPad is now available for download from the Apple app store. The app will help you learn more about camera lenses and how to select the right ones for various cameras and shooting situations!

Download *David Busch's* Lens Finder now!

cengageptr.com